THE BODLEY HEAD

FORD MADOX FORD

VOLUME V

THE BODLEY HEAD

FORD MADOX FORD

VOLUME V

MEMORIES AND IMPRESSIONS

selected and introduced by

MICHAEL KILLIGREW

THE BODLEY HEAD
LONDON SYDNEY
TORONTO

PUBLISHER'S NOTE

This edition was first published by Holt, Rinehart and Winston, Inc. in the United States, 1971, with the title: YOUR MIRROR TO MY TIMES, *The Selected Autobiographies and Impressions of Ford Madox Ford.*

The selections in this book originally appeared in the following works by Ford Madox Ford:
Portraits from Life, Copyright 1937 by Ford Madox Ford. Copyright © renewed 1964 by Janice Biala.
Return to Yesterday, Copyright 1932 by Ford Madox Ford. Copyright © renewed 1959 by Janice Biala.
Joseph Conrad: A Personal Remembrance, Copyright 1924 by Ford Madox Ford. Copyright © renewed 1952 by Janice Brustlein.
It Was the Nightingale, Copyright 1933 by Ford Madox Ford. Copyright © renewed 1961 by Janice Biala.
Provence, From Ministrels to the Machine, Copyright 1935 by Ford Madox Ford. Copyright © renewed 1962 by Janice Biala.
Great Trade Route, Copyright 1937 by Ford Madox Ford. Copyright © renewed 1964 by Janice Biala.
Memories and Impressions, rights controlled by Janice Biala throughout the world, except the United States.

ISBN 0 370 01376 x
Printed and bound in Great Britain for
The Bodley Head Ltd
9 Bow Street, London WC2E 7AL
by William Clowes & Sons Ltd
London, Beccles and Colchester
Set in Linotype Plantin
This edition first published in Great Britain 1971

CONTENTS

Sources, 9

Introduction by Michael Killigrew, 13

PART ONE: A PRE-RAPHAELITE YOUTH

The Writer to His Children; *Ancient Lights,* 31
The Nature of the Beast; *Ancient Lights,* 34
My Grandfather and His Circle; *Ancient Lights,* 36
Principles; *Ancient Lights,* 49
The Chinese Tea-Things; *Ancient Lights,* 50
A Lion in the Strand; *Ancient Lights,* 51
My Old Nurse Atterbury; *Return to Yesterday,* 52
Creatures Frail but Awful; *Ancient Lights,* 54
Charlotte's Conversations; *Mightier than the Sword,* 58
Pre-Raphaelite Love; *Ancient Lights,* 63
Mr Carlyle . . . and Mr Pepper; *Ancient Lights,* 64
That Terrible Word 'Genius'; *Ancient Lights,* 65
Mixing Up Names; *Return to Yesterday,* 67
My Great-Grandmother's Virtue; *Ancient Lights,* 68
My Father; *Ancient Lights, It Was the Nightingale,* 68
My Fate Settled; *Ancient Lights,* 75
The Pines, Putney; *Mightier than the Sword,* 75
Beef-Tea in the Night; *Return to Yesterday,* 78
Tired of Parades; *Return to Yesterday,* 81
The Death of English Poetry; *Return to Yesterday,* 81
City of Dreadful Night; *Ancient Lights,*
 Return to Yesterday, 87
The Gloom of London; *Return to Yesterday,* 89
Monstrous Solemn Fun; *Ancient Lights,* 91
The Triumph of the Bourgeoisie; *Ancient Lights,* 93
Rossetti's Inverness Cape; *Ancient Lights,* 95

My Music Master; *Return to Yesterday*, 95
Tradition Amply Carried On; *Ancient Lights*, 97
My Oldest Literary Recollection; *Return to Yesterday*, 100
Regrets; *Return to Yesterday*, 101
A Philosopher's Silence; *Ancient Lights*, 102
A Mr Hardy; *Mightier than the Sword*, 102

PART TWO: PORTRAITS AND PERSONALITIES I

The King of Hearts (Ford Madox Brown); *Ancient Lights*, 111
The Abbé Liszt; *Ancient Lights*, 119
The Beautiful Genius (Ivan Turgenev); *Mightier than the Sword*, 122
The Spirit of an Age: The Nineties; *Return to Yesterday*, 135
The Heart of the Country; *Return to Yesterday*, 149

PART THREE: BEFORE ARMAGEDDON

A Ring of Foreign Conspirators; *Return to Yesterday*, 169
I Meet the Master; *Return to Yesterday*, 181
Mr Kipling's Motor Car; *Return to Yesterday*, 187
Rabbits and Steamed Sole; *Return to Yesterday*, 190
Potatoes and Thistles; *Return to Yesterday*, 192
An Otherworldly Being; *Return to Yesterday*, 196
On Obsolete Words; *Ancient Lights*, 203
Walter Crane's Gloves; *Return to Yesterday*, 204
Agents; *Return to Yesterday*, 204
The Old Athenaeum; *Return to Yesterday*, 207
A Fabian Debate; *Ancient Lights*, 209
During the Great Dock Strike; *Return to Yesterday*, 210
Political Predilections; *Return to Yesterday*, 210
Superstitions; *Return to Yesterday*, 213
All the Old Devils; *Return to Yesterday*, 214
The Education of Children; *Return to Yesterday*, 215
A Degree of Intimacy; *Ancient Lights*, 217
Kind and Valuable Advice; *Return to Yesterday*, 217
Portrait of the Artist as a Dandy; *Return to Yesterday*, 219
Starting a Review; *Return to Yesterday*, 221

Enter Ezra Pound . . .; *Return to Yesterday,* 229
. . . And Another Conspirator; *Return to Yesterday,* 232
The End of My Tenure; *Return to Yesterday,* 234
Fund-Raising; *Return to Yesterday,* 237
For the Price of a Pint; *Return to Yesterday,* 240
They; *Ancient Lights,* 241
Finished! Exploded! Blast!; *Return to Yesterday,* 243
The End of a World; *Return to Yesterday,* 247

PART FOUR: PORTRAITS AND PERSONALITIES II

The Old Man (Henry James); *Return to Yesterday, Mightier
 than the Sword,* 251
Collaborating with Conrad; *Joseph Conrad, Return to Yester-
 day,* 269
A Naturalist from La Plata (W. H. Hudson); *Joseph Conrad,
 Return to Yesterday, Mightier than the Sword,* 290
The Glacial Gaze of the Serpent (George Moore); *It Was the
 Nightingale,* 301

PART FIVE: CHANGES

After the Armistice; *It Was the Nightingale,* 309
The Return of the Native; *It Was the Nightingale,* 313
The Peasant Frame of Mind; *It Was the Nightingale,* 314
At Red Ford; *It Was the Nightingale,* 325
Visitors from the West; *It Was the Nightingale,* 331
Just Before . . .; *Return to Yesterday,* 336
. . . And Just After; *Return to Yesterday,* 337
Not Really English; *It Was the Nightingale,* 338
Duels; *Return to Yesterday,* 341
In the Absence of Mr Joyce; *It Was the Nightingale,* 342
Before the Crisis . . .; *Provence,* 347
. . . And During the War; *Provence,* 350
The Transatlantic Review; *It Was the Nightingale,* 352
A Novelist's Credo; *Return to Yesterday,* 376

PART SIX: PORTRAITS AND PERSONALITIES III

The Fox (D. H. Lawrence); *Mightier than the Sword,* 379

A Man of Infinite Pity (John Galsworthy); *Return to Yester-
 day, It Was the Nightingale, Mightier than the Sword*, 395
The Little General (H. G. Wells); *Mightier than
 the Sword*, 413

PART SEVEN: THE PHILOSOPHY OF THE KITCHEN
 GARDEN

Beginnings . . .; *Return to Yesterday*, 427
. . . And Beginning Again; *Great Trade Route*, 427
Frescoes and Asphodel; *Provence*, 428
An Internationalist Anarchism; *Provence*, 429
The *Mise à Mort* and a Prophecy; *Provence*, 430
A Little Plot of Ground; *Great Trade Route*, 433
Maxims That Will Save the World; *Great Trade Route*, 435
Those Disgusting Fellows; *Great Trade Route*, 438
The Breakdown of Democracy; *Great Trade Route*, 441
Our Northern Virtues; *Great Trade Route*, 441
Patriotism Doesn't Pay; *Great Trade Route*, 443
Making It Safe for Children; *Great Trade Route*, 444
The Story of Self-Help; *Great Trade Route*, 445
An Unmentionable Sin; *Great Trade Route*, 446
Rolling My Hump, Putting It Down; *Great Trade Route*, 448
The Abominations of the Law; *Great Trade Route*, 449
How Long?; *Great Trade Route*, 451
The Small Producer . . .; *Great Trade Route*, 452
. . . Is the Revolution; *Great Trade Route*, 454
A Change of Heart; *Great Trade Route*, 454
A Change in Values; *Great Trade Route*, 458
Sitting over the Sea, Thinking; *Great Trade Route*, 461
Convictions; *Great Trade Route*, 461
Good Government and Peace; *Great Trade Route*, 465
The Greatest Joy . . .; *Great Trade Route*, 467
. . . And Nothing Else; *Provence*, 467

Index, 469

SOURCES

———————

Ancient Lights, 1911
(*U.S.A.: Memories and Impressions, 1911*)

Joseph Conrad, 1924

Return to Yesterday, 1931 (*U.S.A.: 1932*)

It Was the Nightingale, 1933

Provence, 1935

Great Trade Route, 1937

Mightier than the Sword, 1938
(*U.S.A.: Portraits from Life, 1937*)

The American spellings and usage to be found in many of these pieces, especially towards the end of the volume, reflect the fact that Ford Madox Ford left England for good in 1923 and turned increasingly to an American readership.

To all who have taken in hand
'the sweetening of the world . . .
the making it safe for children.'

INTRODUCTION

To the Reader

To present in a few trifling words of introduction the monstrously variegated personae, masks and contradictory identities of that large, large-hearted and in his own life-time so much larger-than-common-life figure of Ford Madox Ford seems an impossible task. Not even H. G. Wells could come up with anything more definite than, 'What he is really or if he is really, nobody knows now and he least of all.' That was in 1934 and Wells, a hostile friend and friendly enemy from before the turn of the century, recognized that in Ford there walked the earth a creature so vast and diffuse and blurred at the edges into different people and other times that there could be no one adequate characterization of him. Ford then was sixty-one, a controversial literary phenomenon on both sides of the Atlantic, with five more years of life and some of his most lasting work still ahead of him. In the course of his career he had thrown up clouds of ink around himself like a cuttlefish. He existed somewhere behind the extravagantly dramatized personalities of the last Pre-Raphaelite, the Tory English gentleman, the simple kitchen-gardener or the literary pundit, the benevolent, omniscient headmaster of a whole school of writers in Paris and New York, indeed, as D. H. Lawrence put it, 'everybody's blessed Uncle and Headmaster.'

Today, from the perspective of a time more than thirty years after his death, Ford's masks become a vast entertainment and in this assembly of autobiographies his bulky figure appears on the well-lit stage he prepared for himself, unencumbered by the acrimonious carping of contemporaries, a man of many parts free to speak his lines and address posterity. For it is for posterity as much as for

13

his contemporaries that he wrote these chronicles of his life. Clearly now we can see him, the product of an age whose end he recorded, the harbinger of an age still in the future; a man who learned and kept learning and shared of his learning and love liberally and grew wise in the practice of life and was of the most generous. As a writer his position is unassailable; you might say that out of a flood of nervous, technique-obsessed trivia he brought forth triumphantly some of the masterpieces of twentieth-century English prose. And it is out of the realization that some of his most accomplished writing is in the form of memories of times past that there must come these words of encouragement and warning for the accompaniment of the following autobiographies and impressions. That is part of the romance of this book, that the reader must be warned!

But the warning can wait. First let it be made plain why you might today in the present and continuing age of anxiety with profit make the acquaintance of the mind and being of this gentle, humorous and sympathetic man. I have hinted at at least one of the reasons. If you know *The Good Soldier* or the novels of *Parade's End*, that sinister story of sexual jealousy set against the spectacle of war and a disintegrating society, you know you will be taken care of expertly, safe in the accomplished hands of a master craftsman, a magician of words. So it is in these pages of portraiture and self-portraiture: the pure enjoyment of the professional telling of tales of infinitely picturesque people, of eccentric situations of high comedy and ironic tragedy. You will be entertained; you might even come away with certain illuminations as to the human condition. And that seems possibly the most compelling reason; in these memories of England's last large-scale, all-round man of letters, ranging over sixty years and three generations of writers, the human condition is delineated in terms of some of the greatest figures of our modern literature and art, the family and friends of Ford cast as characters in the astounding novel of his life. He

wishes to show you how they spoke and how they lived, their hopes and secret agonies, their high standards and ideals. You get as it were a look behind the scenes. Behind the scenes of say the Forsyte family as brought into your living room out of Edwardian England by the grace and electronics of the B.B.C. and a mighty fine job they do. Give you a hand out of the past and say, 'Here, hold on, take a look at civilized anguish and uncertainties way back then before Armageddon. It's a bit windy where you are.'

In those tranquil days long before the war to end all wars Ford and the author of *The Forsyte Saga* had breakfasts together in the sun and talked shop; Ford had known Galsworthy as an indolent young man-about-town in late-Victorian London, saw him 'get religion,' and, with Joseph Conrad and the smiling shade of Turgenev, watched over the beginning of the future Nobel Laureate's career. Then say after the television returns to its customary pap you want to pursue a thread of thought and you might in 'A Man of Infinite Pity' read Ford on Galsworthy; you turn the pages and you think, how they both desired to alleviate the suffering of others! How they wrote so often (and here the one about the other) earnestly and nobly striving to render the core of mysterious human nature, our brief and troubled joys, our misery and cruelties ... and how they desired change—Ford as much and as profoundly as the Man of Infinite Pity! In the last decade of his life he wrote to define and propagate the idea of such radical change as would certainly have shocked and distressed John Galsworthy and the aristocratic Jozef Konrad Korzeniowski and the even more aristocratic Russian genius: Abolish nationalities! To hell with politicians! Tear down the obscene and useless superstructures of industrialism and let us begin to live like human beings again!

All at once you are struck by the immense range and depth of the vital concerns of this man. You are transported from Edwardian England to the heart of the problems of the present—problems approached with an idealism

and common sense that may once have seemed naïve but are now only too gravely appropriate. You see that the picture of the whole includes the Forsytes, but is much larger: you turn to 'The Philosophy of the Kitchen-Garden' and you find that Ford's latest audience would 'if there were justice' be the young of all ages and the whole modern university far beyond the traditional preserves of the academics of literature. You imagine an audience of literate hipsters moving out of the destructive insanity of the contemporary urban crush into the country to free the land from mechanized death and the money-mad developers. To start a school, a commune, a society such as Ford envisioned when he talked of his small holders, small producers, his pacifist apolitical internationalist anarchist artists, craftsmen, farmers and free-form organic gardeners; people who realize that 'patriotism doesn't pay' and that with a garden of vegetables and fruit and a spring on your land 'you need never feel poor.' Just as with Galsworthy, a certain missionary earnestness steals over Ford in these manifestations of a philosophy inspired by his Pre-Raphaelite forebears and confirmed by the lessons of experience. He insists you will be a better man 'watching the seeds swell and burst and send up their green filaments. . . . You will be less of a clod and just a little in touch with the mysteries of the earth from which you are segregated.' And he adds, 'This is not the exasperating patronage of the alien talking to the inhabitants of the United States in the familiar way. It is a depressed optimist telling the whole world how it may better itself.'

'The sweetening of the world. . . .' That ambition springs directly from his Pre-Raphaelite upbringing in the household of his grandfather, the fiercely humanist painter Ford Madox Brown. At the time of Ford's birth in a suburb of London on December 17, 1873, the Pre-Raphaelite Brotherhood had long since disbanded, but the original members and their disciples were still a most potent force in the cultural life of England in Queen

Victoria's reign. All or most of them were frequent visitors at Madox Brown's. From William Morris, Ford must first have heard of socialism, while Swinburne might be drunk in the bath upstairs composing an ode to Mazzini. Certainly he heard Morris preach convincingly that art is the only real and permanent salvation of mankind. Ford forever believed that. He believed that 'every artist of whatever race was my fellow countryman—and the compatriot of every other artist. The world divided itself for me into those who were artists and those who were merely the stuff to fill graveyards.' Dante Gabriel and Christina Rossetti were members of the family; Tennyson and Holman Hunt, Ruskin, Morris and Carlyle, Turgenev or Zola came to dinner or to tea; Dr Francis Hueffer, Ford's formidable German-born father, wrote poetry in Provençal and was principal music critic of *The Times* and little Ford was taken to hear Liszt play and saw a florid earl weep with emotion. Poetry, painting, music or, as Graham Greene imagines it, 'a staggered laudanum death.' Nothing else was possible. Ford was born to the purple, doomed to become an artist, expected to be a genius. So his first book was published when he was seventeen; there were seventy-seven to follow.

The events and personalities of his childhood are the subject of *Ancient Lights* (1911), the first of eight volumes of reminiscence from which these autobiographies were drawn. It was published in America as *Memories and Impressions* in the same year. By then Ford was in mid-career and in serious personal difficulties. His marriage to Elsie Martindale, with whom he eloped seven months after his grandfather's death in October, 1893—when she was seventeen and he not yet twenty-one—had, after two children, ended in dismal failure. His subsequent stormy and unhappy affair with the novelist Violet Hunt became a public scandal when Elsie, who refused Ford a divorce, went to court to prevent Violet from giving herself out as his legally married wife. There were anguished correspondences, angry exchanges, estrangements, articles in

The Times and distinct intimations of disapproval in society. And these rumblings of the respectable were of some consequence. Ford in those days was one of the great influences and powers in literary London. He was known as a poet and as a novelist with the wonderful Tudor trilogy *The Fifth Queen* to his credit, as author of some intelligent books of sociological impressionism and biographer also of Ford Madox Brown and Rossetti. His experimental career as a writer had become serious when, in 1898, he was introduced to Joseph Conrad. The two became fast friends and collaborated on three novels, and it was mainly to give the perennially indigent Conrad a boost that Ford in 1908 took over the editorship of *The English Review*. Under his brilliant and benevolent guidance there met in its pages and offices the likes of Thomas Hardy and W. H. Hudson, Henry James and Yeats and Walter de la Mare and Hilaire Belloc, Norman Douglas, Wyndham Lewis, Ezra Pound, Edward Thomas, Arnold Bennett, D. H. Lawrence and Galsworthy, Conrad and Wells. It was one of the most distinguished reviews of its own or any other time, and the unerring good taste and wide-ranging personal contacts of its editor made it so.

Thomas Hardy, Ford had met at the time of the publication of his first book; Henry James, Stephen Crane, Conrad, Hudson and Galsworthy all made their appearance in Ford's life at the turn of the century, when he and Elsie lived in various small cottages and farms in Kent, Sussex and Surrey. He holds them up to us as ideal men of heroic proportions; he holds up to himself and to us as a mirror the highest aspirations of their lives, and even in their faults he recognized virtue. Stephen Crane a transparent figure on a huge horse, Conrad bowing and contorting himself with oriental politeness and Henry James bursting out in sudden furies on the Rye Road. Our remote schoolroom legends are clothed with an awesome presence. And in the midst of these monumental encounters Ford began his true career as a kitchen-gardener!

Portraits from Life (1937, published in England as

Mightier than the Sword in 1938), *Return to Yesterday* (1931), *Joseph Conrad: A Personal Remembrance* (1924) and *Thus to Revisit* (1921) are the books in which Ford remembered the great romance of those friends and that time. Then came the war. In spite of his age, and after two books of highly literate, enthusiastic and effective propaganda written for the British Government, he joined up and was wounded and severely gassed in the trenches in France. When he returned to civilian life in England after the Armistice at the end of 1918 he found he was a forgotten man. Stella Bowen, the Australian painter with whom he shared his life during the decade of the twenties and who bore him his third daughter, remembers that he then 'revealed himself as a lonely and very tired person who wanted to dig potatoes and raise pigs and never write another book.' As soon as circumstances allowed, they did indeed move to Sussex and raised pigs and dug potatoes named after literary friends and ancestors, but of course Ford couldn't keep from writing books. It was at this time—having refused to do so during the war—that he at last legally dropped his German baptismal name, Ford Hermann Hueffer, and became Ford Madox Ford. But then it turned out he could no longer abide the soggy mentality and lush green landscape of England no matter what name he lived under. In 1923 he left the country of his birth for good and from then on divided his time be-tween France and the United States. France he loved with a real and enduring loyalty; in America he found his own most loyal support. The war and the desperately cynical time of the Armistice had profoundly affected him and when in Paris he returned to the writing of serious fiction it was as a mature artist, conscious of the craft he had so laboriously acquired with Conrad, conscious that he needed to use it now to set down soberly what he had experienced of life, and consciously in need of disciples to whom to pass on the word.

This is the time of his great triumphs; he was success-ful in his endeavours. As always he worked frenetically

and in that one decade he managed to produce besides
the usual countless magazine articles and reviews a total
of eighteen books, including the four novels of *Parade's
End*. In America he was at last a best seller; in Paris he
became with his pre-war London friend Ezra Pound, and
with James Joyce and Gertrude Stein, the literary guru
of a group of extraordinarily talented young Americans.
It Was the Nightingale (1933) takes us from the end of
the transatlantic review, in which Ford published some of
the older generation as well as his new expatriate friends.
Hemingway contributed and became sub-editor, James
Joyce gave the magazine an episode from 'Work in Progress,'
as Ford called *Finnegans Wake*; they and H. D. and Elinor
Wylie and William Rose Benét, William Carlos Williams,
E. E. Cummings, Djuna Barnes, Glenway Wescott, John
Dos Passos, Robert McAlmon, Tristan Tsara, Eric Satie,
George Antheil, Picasso, Brancusi, Braque, Juan Gris and
many known and nameless others made the review and the
exuberantly drunken parties Ford gave in its cause one of
the most prominent centres of the movement of the inter-
national arts in that decade of the arts in the city of light.

After this time of personal, professional and finally
financial good fortune, the thirties were full of increasing
difficulties and despair for the world at large and for Ford
no less so. He had during the height of his popularity
on several trips to America in the late twenties let himself
go in a blaze of supreme, self-conscious theatricality and
lived extravagantly and gloriously as a great literary
celebrity. There were literary luncheons and interviews in
New York and lecture tours and society parties and parties
in the Village with impoverished poets. And if it is true
that his free-and-easy self-assurance and the continuous
stream of impossibly impressionistic tales made him
enemies among the legions of the small and petty-minded
(and so his reputation suffered), to Ford himself it seemed
that Gotham had clasped him to her kind and grimy
heart. After the crash—and with most of his money gone
—he returned and New York became the city in which he

lived by preference. And whether he was well-off or almost down-and-out, praised for a masterpiece or righteously taken to task for the latest potboiler, at his little house above the Mediterranean in Provence or in a succession of Manhattan apartments, he would be always at home to old and new friends and above all always to new writers.

With his new wife, the Polish-American painter Janice Biala, he travelled back and forth between the old world and the new, ceaselessly in the service of his beloved Republic of Letters. A Paris friend, Katherine Anne Porter, remembers that 'he led an existence of marvellous discomfort, of insecurity, of deep and pressing anxiety as to his daily bread; but no matter where he was, what his sufferings were, he sat down daily and wrote, in his crabbed fine hand, with pen, the book he was working on at the moment; and I never knew him when he was not working on a book.' With her and Sherwood Anderson and his friends Allen Tate and Caroline Gordon he contributed in the last two years of his life to the free and creative literary curriculum of the tiny Midwestern college of Olivet, Michigan. There in a tiny house Ford and Biala lived through bitter winter snows and the heat of summer, and if it wasn't exactly comfortable there were stimulating classes and there was the Paris flat to escape to; there was always France! Olivet gave him a minimum income and an honorary doctorate, his only academic degree, and there he finished his last book, the monumental, immense, immensely erudite and characteristically eccentric *March of Literature*, a history from Confucius to Conrad, a joyous ode to sweet letters that illuminates its subject and should not be out of print. By now his reputation was such that literally hundreds of young writers asked for his assistance; thirty years earlier he had befriended Willa Cather, now in the true spirit of his grandfather he helped Eudora Welty, Robert Lowell, Jean Stafford and countless other promising devotees of the Muse; Louise Bogan, Josephine Herbst, John Peale

Bishop, Robert Penn Warren, Edward Dahlberg in America ... Graham Greene and Edward Crankshaw in England; Ford was involved with the best, the most intelligent of the young. But not only the young need assistance and when it came to old friends Ford outdid himself. Earlier, from Toulon, he had organized a testimonial pamphlet to be distributed with Ezra Pound's *XXX Cantos*. He had extracted contributions from Eliot and Joyce, Hemingway, Hugh Walpole, Archibald MacLeish, Allen Tate, Edmund Wilson, H. D. and William Carlos Williams. Now, in New York, he felt that Williams was insufficiently praised and so he brought about the dinners of a society he called 'The Friends of William Carlos Williams.' And with that gentle poet and himself at the head of the table and amongst the members Miss Porter and Pound and Cummings and Henry Miller, Alfred Stieglitz, Marianne Moore, Dahlberg and Christopher Isherwood, these meetings were, as Dahlberg remembers them, no 'place of dada nonsense,' but 'a wonderful galaxy of genuine people in the arts.'

But the shadows of another war lengthened inexorably over the divided world and during his travels in America and in his garden in Provence Ford took stock and came to the realization that if it was business as usual civilization was doomed. Out of the very depths of his being he cried out against the system that threatened to destroy all he held dear. More than a generation before the ecology movement he understood how it is we must all of us live if we are to survive as a species. The thoughts of this last phase are recorded in *Provence* (1935) and *Great Trade Route* (1937), part of a never-completed trilogy and both free-flowing, discursive combinations of memories, travel, history and social philosophy. The great trade route was to Ford the ancient artery of commerce and culture that flowed between Cathay and Cornwall in the temperate regions of the fortieth parallel. And only a return to the humane customs of that route will keep us from ever greater holocausts. Once he had been on the

fringes of power and had had personal friends amongst the members of the Cabinets of Asquith and Lloyd George; now he finally and unequivocally rejected politics. And the former Captain Ford of the Welch Regiment, of Ypres and the Somme, turned decisively to pacifism. 'For do not believe that the murders called wars are ever "gotten over,"' he writes. 'They remain curses for ever both for him that murders and to eternal generations of the children of the murdered. The one is accused by prosperity in sin that time shall fully avenge; the other is accursed by a bitterness that will prove an unending drag on his civilization. And round them all the world is cursed.' Once again we bear that burden and are accursed, and Ford speaks to us as truthfully and directly as man can speak to man on the eternal struggle between war and peace, civilization and barbarism. He himself did not live to see the final workings of the curse of his generation— the curse of Hitler. In these last years of intense creativity before the end, and what he feared would be the end of civilization, he was afflicted with a bad heart and a rheumatism that sometimes had him so he could hardly move, nor dress nor shave nor brush his hair unaided. He did not live to see the war; he did not live to see again his beloved Provence. He died in Normandy on June 26, 1939, just barely back from New York, a contract for a new book on his desk and a pile of manuscripts of *les jeunes* in his hotel room.

There then is the tremendous range of his life. From the professional preoccupations of the modern novelist to the moral convictions of a contemporary man turned prophet by the pressures of his time. From the little boy with long blond curls who offered the colossal Turgenev-in-the-flesh a chair in his grandfather's drawing room to the wheezing old man on the eve of World War Two thinking up ways for us all to survive on our spaceship Earth. It seems in retrospect an amazing distance to travel in the course of one life for an Anglo-German Roman-Catholic Victorian Pre-Raphaelite Tory gentleman, acting

out his roles as poet, novelist, critic, editor, historian, hog-farmer, kitchen-gardener, cook, carpenter, soldier, pacifist and philosopher. . . .

The changes! The changed faces! The masks! But we have glimpsed also the man behind the masks and, *pace* Mr Wells, he is, he really is . . . as firmly and as solidly and as permanently here to stay as is . . . Mr Wells himself! Whatever questions now remain must be answered by Ford Madox Ford in his own words. And here I must give that warning to the reader which is really at the core of all the encouragement I have tried to give him. . . . Because here is romance: 'My business in life is to attempt to discover and to try to let you see where we stand. . . . This cannot be done with facts. . . . I have for facts a most profound contempt. . . .' And to make sure you understand, he adds, 'This book, in short, is full of inaccuracies as to facts, but its accuracy as to impressions is absolute. . . .' 'Impressions' is the key word. Ford was supremely an impressionist. After all he studied in the French School of Flaubert and Maupassant, of Manet and Monet, and in the movements of modern poetry he could rightly be ranged with the Imagists. And that is another key: he wants to give you an image, to render in images 'what I see to be the spirit of an age, of a town, of a movement. . . .'

Ford was a man who very much lived in his own head and if the world intruded into the pattern of his colourful imagination in the guise of a reality that did not fit into the scheme, Ford was compelled to create his own version. 'Even as a little boy,' he confessed, 'I knew that I had the trick of imagining things and that those things would be more real to me than the things that surrounded me.' The marvel of it is that in the midst of his theatre we continue to see always, in dramatic terms, the truth. The truth of poetry in 'the statelier vehicle' of Ford's prose. 'Where it has seemed expedient to me I have altered episodes that I have witnessed but I have been careful never to distort the character of the episodes. The

accuracies I deal in are the accuracies of my impressions. If you want factual accuracies you must go to. . . . But no, no, don't go to anyone, stay with me!' As he and Conrad wrote in their last collaboration, 'A lie is a figurative truth —and it is the poet who is the master of these illusions.'

'It is possible I romance,' writes Ford. In fairness it must be added that the principles of this impressionism are sometimes reinforced by the respect for English libel-law his experience had taught him. One example of this is his invention of a politician as his original partner in *The English Review*. The politician was in fact H. G. Wells. One could think of other instances. The point is, it makes no difference to the intent of the story. And that is where we must simply trust Ford. We must trust his motivations as an artist, dedicated as he was to the fulfilment of Conrad's maxim, 'It is above all to make you see.' In 1931, when his fortunes were at a low ebb, he looked at what he had tried to do and remarked, 'I have gone about the world looking for the person of the Sacred Emperor in low teashops. . . . I have seen some Emperors—and not a few pretenders. These and the tea-shops of the Chinese proverb I have tried to make you see. If you sometimes see my coat-tails whisking round the corners you must pardon it. My true intent is only for your delight. Had I the cap of Fortunatus you should not see even so much of me or my garments. The Chinese proverb I have mentioned says that it is hypocrisy to seek for the person of the Sacred Emperor in a low tea-shop; they are cynics those fellows—or pessimists. There is really no other pursuit in life. Our geese *must* be swans. . . . So this is a novel: a story mirroring such pursuits. If that pursuit is indeed hypocrisy that is the only hypocrisy in this book.'

Alas, this particular book cannot be the novel, complete with time-shift and consummate interior construction, that Ford would have built out of his life. But it is one possible version. I have arranged the selections in roughly chrono-logical sequence in chapters that mark off the main

phases of the story. In order to accomplish this I have occasionally had to reconstruct sentences or the beginning or end of a paragraph, particularly in making up the composite pieces in 'Portraits and Personalities.' Some of these are assembled out of three or four different books and joined into a continuous narrative: if the sequence therein is mine, all the words are Ford's own. In choosing titles for the individual selections I have followed the example of Graham Greene, who in his *The Bodley Head Ford Madox Ford* (published in four volumes only in England in 1962–63) took for the same purpose mostly phrases from Ford himself. It is in the nature of this book that I have nowhere attempted to indicate omissions in the text; the frequent ellipses therefore are Ford's own or appear where he would have used them. Footnotes also have been kept to a minimum. Although I have tried to include every aspect of his life, there are some obvious and inevitable lacunae. In his 1933 dedication of *It Was the Nightingale* to Katherine Anne Porter's husband, Eugene Pressly, Ford announced his intention of continuing the 'novel' of his life in 'another decade.' Alas! And in the case of his war years, I can do no better than refer the reader to, of course, *Parade's End* (Christopher Tietjens is at least partly a self-portrait), the autobiographical novel *No Enemy*, which preceded the tetralogy in composition but was not published until 1920, and some wonderfully descriptive letters to Conrad written from the front in 1916.

Finally, I must add a word of caution of my own. Just as the above has been no scholarly dissection of Ford Madox Ford but rather a free-wheeling tribute to his memory and the continuing presence of his work, this collection of autobiographies was not edited for scholars. They can only be satisfied by the original texts and for the facts of Ford's life have already been served admirably by Professor Frank MacShane's biography, Professor David Dow Harvey's fascinating and exhaustive bibliography, Professor Richard Ludwig's *Letters*, and the

biography by and reminiscences of Douglas Goldring,
Ford's sub-editor on *The English Review*. And Professor
Arthur Mizener, the sympathetic biographer of F. Scott
Fitzgerald, will no doubt add Ford to his laurels in a
definitive portrait now in preparation. No, this is a book
for the curious and romantic reader like yourself, to be
read as the record of a great and romantic life, or to be
read at random for a taste of literary gossip, social com-
mentary, brilliant character sketches, benevolent reminis-
cence, the feel of the past, the ideas of the future, the
wisdom of the earth . . . and atmosphere, romantic atmos-
phere. . . . A plum pudding to be tasted nightly, as Henry
James said of Conrad's and Ford's *Romance*. And that
said, the stage is clear for Ford who, in seriousness or
jest, as entertainer or high priest, subscribes himself,
'humbly, gratefully and affectionately, your mirror to my
times.'

MICHAEL KILLIGREW

Animal Farm
Middleton, California
July, 1970

A
PRE-RAPHAELITE
YOUTH

PRE-RAPHAELITE
YOUTH

A PRE-RAPHAELITE YOUTH

THE WRITER TO HIS CHILDREN

I MADE for myself the somewhat singular discovery that I can only be said to have grown up a very short time ago— perhaps three months, perhaps six. I discovered that I had grown up only when I discovered quite suddenly that I was forgetting my own childhood. My own childhood was a thing so vivid that it certainly influenced me, that it certainly rendered me timid, incapable of self-assertion and, as it were, perpetually conscious of original sin, until only just the other day. For you ought to consider that upon the one hand as a child I was very severely dis- ciplined, and, when I was not being severely disciplined, I moved among somewhat distinguished people who all appeared to me to be morally and physically twenty-five feet high. The earliest thing that I can remember is this, and the odd thing is that, as I remember it, I seem to be looking at myself from outside. I see myself a very tiny child in a long, blue pinafore, looking into the breeding- box of some Barbary ring-doves that my grandmother kept in the window of the huge studio in Fitzroy Square. The window itself appears to me to be as high as a house, and I myself to be as small as a door-step, so that I stand on tiptoe and just manage to get my eyes and nose over the edge of the box, while my long curls fall forward and tickle my nose. And then I perceive greyish and almost shapeless objects with, upon them, little speckles like the very short spines of hedge-hogs, and I stand with the first surprise of my life and with the first wonder of my

31

life. I ask myself, can these be doves—these unrecognis-
able, panting morsels of flesh? And then, very soon, my
grandmother comes in and is angry. She tells me that if
the mother dove is disturbed she will eat her young. This,
I believe, is quite incorrect. Nevertheless, I know quite
well that for many days afterwards I thought I had
destroyed life, and that I was exceedingly sinful. I never
knew my grandmother to be angry again, except once,
when she thought I had broken a comb which I had
certainly not broken. I never knew her raise her voice; I
hardly know how she can have expressed anger; she was
by so far the most equable and gentle person I have ever
known that she seemed to me to be almost not a person-
ality but just a natural thing. Yet it was my misfortune
to have from this gentle personality my first conviction—
and this, my first conscious conviction, was one of great
sin, of a deep criminality. Similarly with my father, who
was a man of great rectitude and with strong ideals of
discipline. Yet for a man of his date he must have been
quite mild in his treatment of his children. In his bringing-
up, such was the attitude of parents toward children that
it was the duty of himself and his brothers and sisters at
the end of each meal to kneel down and kiss the hands of
their father and mother as a token of thanks for the
nourishment received. So that he was, after his lights, a
mild and reasonable man to his children. Nevertheless,
what I remember of him most was that he called me 'the
patient but extremely stupid donkey.' And so I went
through life until just the other day with the conviction
of extreme sinfulness and of extreme stupidity.

For such persons the world of twenty-five years ago was
rather a dismal place.* You see there were in those days
a number of those terrible and forbidding things—the
Victorian great figures. To me life was simply not worth
living because of the existence of Carlyle, of Mr Ruskin,
of Mr Holman Hunt, of Mr Browning or of the gentleman

* Written in 1910.

who built the Crystal Palace. These people were perpetu-
ally held up to me as standing upon unattainable heights,
and at the same time I was perpetually being told that if
I could not attain these heights I might just as well not
cumber the earth. What then was left for me? Nothing.
Simply nothing.

Now, my dear children—and I speak not only to you,
but to all who have never grown up—never let yourselves
be disheartened or saddened by such thoughts. Do not,
that is to say, desire to be Ruskins or Carlyles. Do not
desire to be great figures. It will crush in you all ambition;
it will render you timid, it will foil nearly all your efforts.
Now-a-days we have no great figures, and I thank Heaven
for it, because you and I can breathe freely. With the pass-
ing the other day of Tolstoy, with the death just a few
weeks before of Mr Holman Hunt, they all went away to
Olympus, where very fittingly they may dwell. And so
you are freed from these burdens which so heavily and
for so long hung upon the shoulders of one—and of how
many others? For the heart of another is a dark forest, and
I do not know how many thousands other of my fellow-
men and women have been so oppressed. Perhaps I was
exceptionally morbid, perhaps my ideals were excep-
tionally high. For high ideals were always being held be-
fore me. My grandfather, as you will read, was not only
perpetually giving; he was perpetually enjoining upon all
others the necessity of giving never-endingly. We were
to give not only all our goods, but all our thoughts, all
our endeavours; we were to stand aside always to give
openings for others. I do not know that I would ask you
to look upon life otherwise or to adopt another standard
of conduct; but still it is as well to know beforehand that
such a rule of life will expose you to innumerable miseries,
to efforts almost superhuman, and to innumerable be-
trayals—or to transactions in which you will consider
yourself to have been betrayed. I do not know that I would
wish you to be spared any of these unhappinesses. For the
past generosities of one's life are the only milestones on

that road that one can regret leaving behind. Nothing else matters very much, since they alone are one's achievement. And remember this, that when you are in any doubt, standing between what may appear right and what may appear wrong, though you cannot tell which is wrong and which is right, and may well dread the issue— act then upon the lines of your generous emotions, even though your generous emotions may at the time appear likely to lead you to disaster. So you may have a life full of regrets, which are fitting things for a man to have behind him, but so you will have with you no causes for remorse. So at least lived your ancestors and their friends, and, as I knew them, as they impressed themselves upon me, I do not think that one needed, or that one needs to-day, better men. They had their passions, their extravagances, their imprudences, their follies. They were sometimes unjust, violent, unthinking. But they were never cold, they were never mean. They went to shipwreck with high spirits. I could ask for nothing better for you if I were inclined to trouble Providence with petitions.

THE NATURE OF THE BEAST

Just a word to make plain the actual nature of this book: it consists of impressions. When some parts of it appeared in serial form, a distinguished critic fell foul of one of the stories that I told. My impression was and remains that I heard Thomas Carlyle tell how at Weimar he borrowed an apron from a waiter and served tea to Goethe and Schiller, who were sitting in eighteenth-century court-dress beneath a tree. The distinguished critic of a distinguished paper commented upon this story, saying that Carlyle never was in Weimar, and that Schiller died when Carlyle was aged five. I did not write to this distinguished critic, because I do not like writing to the papers, but I did write to a third party. I said that a few days before

that date I had been talking to a Hessian peasant, a veteran of the war of 1870. He had fought at Sedan, at Gravelotte, before Paris, and had been one of the troops that marched under the Arc de Triomphe. In 1910 I asked this veteran of 1870 what the war had been all about. He said that the Emperor of Germany, having heard that the Emperor Napoleon had invaded England and taken his mother-in-law, Queen Victoria, prisoner— that the Emperor of Germany had marched into France to rescue his distinguished connection. In my letter to my critic's friend I said that if I had related this anecdote I should not have considered it as a contribution to history, but as material illustrating the state of mind of a Hessian peasant. So with my anecdote about Carlyle. It was intended to show the state of mind of a child of seven brought into contact with a Victorian great figure. When I wrote the anecdote I was perfectly aware that Carlyle never was in Weimar while Schiller was alive, or that Schiller and Goethe would not be likely to drink tea, and that they would not have worn eighteenth-century court-dress at any time when Carlyle was alive. But as a boy I had that pretty and romantic impression, and so I presented it to the world—for what it was worth. So much I communicated to the distinguished critic in question. He was kind enough to reply to my friend, the third party, that, whatever I might say, he was right and I was wrong. Carlyle was only five when Schiller died, and so on. He proceeded to comment upon my anecdote of the Hessian peasant to this effect: at the time of the Franco-Prussian War there was no Emperor of Germany; the Emperor Napoleon never invaded England; he never took Victoria prisoner, and so on. He omitted to mention that there never was and never will be a modern Emperor of Germany.

I suppose that this gentleman was doing what is called 'pulling my leg,' for it is impossible to imagine that any one, even an English literary critic or a German professor or a mixture of the two, could be so wanting in a sense of

humour—or in any sense at all. But there the matter is, and this book is a book of impressions.

MY GRANDFATHER AND HIS CIRCLE

Says Thackeray:

'On his way to the city, Mr Newcome rode to look at the new house, No. 120 Fitzroy Square, which his brother, the Colonel, had taken in conjunction with that Indian friend of his, Mr Binnie.... The house is vast but, it must be owned, melancholy. Not long since it was a ladies' school, in an unprosperous condition. The scar left by Madame Latour's brass plate may still be seen on the tall black door, cheerfully ornamented, in the style of the end of the last century, with a funeral urn in the centre of the entry, and garlands and the skulls of rams at each corner.... The kitchens were gloomy. The stables were gloomy. Great black passages; cracked conservatory; dilapidated bath-room, with melancholy waters moaning and fizzing from the cistern; the great large blank stone staircase—were all so many melancholy features in the general countenance of the house; but the Colonel thought it perfectly cheerful and pleasant, and furnished it in his rough-and-ready way.'—*The Newcomes*.

And it was in this house of Colonel Newcome's that my eyes first opened, if not to the light of day, at least to any visual impression that has not since been effaced. I can remember vividly, as a very small boy, shuddering, as I stood upon the door-step, at the thought that the great stone urn, lichened, soot-stained and decorated with a great ram's head by way of handle, elevated only by what looked like a square piece of stone of about the size and shape of a folio-book, might fall upon me and crush me entirely out of existence. Such a possible happening, I remember, was a frequent subject of discussion among Madox Brown's friends.

Ford Madox Brown, the painter of the pictures called 'Work' and 'The Last of England,' and the first painter in England, if not in the world, to attempt to render light exactly as it appeared to him, was at that time at the height of his powers, of his reputation and of such prosperity as he enjoyed. His income from his pictures was considerable, and since he was an excellent talker, an admirable host and, indeed, unreasonably open-handed, the great, formal and rather gloomy house had become a meeting-place for almost all the intellectually unconventional of that time. Between 1870 and 1880 the real Pre-Raphaelite movement was long since at an end; the Aesthetic movement, which also was nicknamed Pre-Raphaelite, was, however, coming into prominence, and at the very heart of this movement was Madox Brown. As I remember him, with a square white beard, with a ruddy complexion and with thick white hair parted in the middle and falling to above the tops of his ears, Madox Brown exactly resembled the king of hearts in a pack of cards. In passion and in emotions—more particularly during one of his fits of gout—he was a hard-swearing, old-fashioned Tory; his reasoning, however, and circumstances made him a revolutionary of the romantic type. I am not sure, even, that towards his latter years he would not have called himself an Anarchist, and have damned your eyes if you had faintly doubted this obviously extravagant assertion. But he loved the picturesque, as nearly all his friends loved it. About the inner circle of those who fathered and sponsored the Aesthetic movement there was absolutely nothing of the languishing. They were to a man rather burly, passionate creatures, extraordinarily enthusiastic, extraordinarily romantic and most impressively quarrelsome. Neither about Rossetti nor about Burne-Jones, neither about William Morris nor P. P. Marshall—and these were the principal upholders of the firm of Morris & Company, which gave aestheticism to the western world—was there any inclination to live upon the smell of the lily. It was the outer ring, the

disciples, who developed this laudable ambition for poetic pallor, for clinging garments and for ascetic countenances. And it was, I believe, Mr Oscar Wilde who first formulated this poetically vegetarian theory of life in Madox Brown's studio at Fitzroy Square. No, there was little of the smell of the lily about the leaders of this movement. Thus it was one of Madox Brown's most pleasing anecdotes—at any rate, it was one that he related with the utmost gusto—how William Morris came out onto the landing in the house of the 'Firm' in Red Lion Square and roared downstairs:

'Mary, those six eggs were bad. I've eaten them, but don't let it occur again.'

Morris, also, was in the habit of lunching daily off roast beef and plum-pudding, no matter at what season of the year, and he liked his puddings large. So that, similarly, upon the landing one day he shouted:

'Mary, do you call that a pudding?'

He was holding upon the end of a fork a plum-pudding about the size of an ordinary breakfast-cup, and having added some appropriate objurgations, he hurled the edible downstairs onto Red-Lion Mary's forehead. This anecdote should not be taken to evidence settled brutality on the part of the poet-craftsman. Red-Lion Mary was one of the loyalest supporters of the 'Firm' to the end of her days. No, it was just in the full-blooded note of the circle. They liked to swear, and, what is more, they liked to hear each other swear. Thus another of Madox Brown's anecdotes went to show how he kept Morris sitting monumentally still, under the pretence that he was drawing his portrait, while Mr Arthur Hughes tied his long hair into knots for the purpose of enjoying the explosion that was sure to come when the released Topsy—Morris was always Topsy to his friends—ran his hands through his hair. This anecdote always seemed to me to make considerable calls upon one's faith. Nevertheless, it was one that Madox Brown used most frequently to relate, so that no doubt something of the sort must have occurred.

No, the note of these aesthetes was in no sense ascetic. What they wanted in life was room to expand and to be at ease. Thus I remember, in a sort of golden vision, Rossetti lying upon a sofa in the back studio with lighted candles at his feet and lighted candles at his head, while two extremely beautiful ladies dropped grapes into his mouth. But Rossetti did this not because he desired to present the beholder with a beautiful vision, but because he liked lying on sofas, he liked grapes and he particularly liked beautiful ladies. They desired, in fact, all of them, room to expand. And when they could not expand in any other directions they expanded enormously into their letters. And—I don't know why—they mostly addressed their letters abusing each other to Madox Brown. There would come one short, sharp note, and then answers occupying reams of note-paper. Thus one great painter would write:

'Dear Brown—Tell Gabriel that if he takes my model Fanny up the river on Sunday I will never speak to him again.'

Gabriel would take the model Fanny up the river on Sunday, and a triangular duel of portentous letters would ensue.

Or again, Swinburne would write:

'Dear Brown—If P. says that I said that Gabriel was in the habit of——, P. lies.'

The accusation against Rossetti being a Gargantuan impossibility which Swinburne, surely the most loyal of friends, could impossibly have made, there ensued a Gargantuan correspondence. Brown writes to P. how, when and why the accusation was made; he explains how he went round to Jones, who had nothing to do with the matter, and found that Jones had eaten practically nothing for the last fortnight, and how between them they had decided that the best thing that they could do would be to go and tell Rossetti all about it and of how Rossetti had had a painful interview with Swinburne, and how unhappy everybody was. P. replies to Brown that he had never uttered any such words upon any such occasion; that

upon the occasion he was not present, having gone round to Ruskin, who had the toothache, and who read him the first hundred and twenty pages of *Stones of Venice*; that he could not possibly have said anything of the sort about Gabriel, since he knew nothing whatever of Gabriel's daily habits, having refused to speak to him for the last nine months because of Gabriel's intolerable habit of back-biting, which he was sure would lead them all to destruction, and so deemed it prudent not to go near him. Gabriel himself then enters the fray, saying that he has discovered that it is not P. at all who made the accusation, but Q., and that the accusation was made not against him, but about O. X., the Academician. If, however, he, P., accuses him, Gabriel, of back-biting, P. must be perfectly aware that this is not the case, he, Gabriel, having only said a few words against P.'s wife's mother, who is a damned old cat. And so the correspondence continues, Jones and Swinburne and Marshall and William Rossetti and Charles Augustus Howell and a great many more joining in the fray, until at last everybody withdraws all the charges, six months having passed, and Brown invites all the contestants to dinner, Gabriel intending to bring old Plint, the picture-buyer, and to make him, when he has had plenty of wine, buy P.'s picture of the 'Lost Shepherd' for two thousand pounds.

These tremendous quarrels, in fact, were all storms in tea-cups, and although the break-up of the 'Firm' did cause a comparatively lasting estrangement between several of the partners, it has always pleased me to remember that at the last private view that Madox Brown held of one of his pictures every one of the surviving Pre-Raphaelite brothers came to his studio, and every one of the surviving partners of the original firm of Morris & Company.

The arrival of Sir Edward Burne-Jones and his wife brought up a characteristic passion of Madox Brown's. Sir Edward had persuaded the President of the Royal Academy to accompany them in their visit. They were

actuated by the kindly desire to give Madox Brown the idea that thus at the end of his life the Royal Academy wished to extend some sort of official recognition to a painter who had persistently refused for nearly half a century to recognize their existence. Unfortunately it was an autumn day and the twilight had set in very early. Thus not only were the distinguished visitors rather shadowy in the dusk, but the enormous picture itself was entirely indistinguishable. Lady Burne-Jones, with her peculiarly persuasive charm, whispered to me, unheard by Madox Brown, that I should light the studio gas, and I was striking a match when I was appalled to hear Madox Brown shout, in tones of extreme violence and of apparent alarm:

'Damn and blast it all, Fordie! Do you want us all blown into the next world?'

And he proceeded to explain to Lady Burne-Jones that there was an escape of gas from a pipe. When she suggested candles or a paraffin-lamp, Madox Brown declared with equal violence that he couldn't think how she could imagine that he could have such infernally dangerous things in the house. The interview thus concluded in a gloom of the most tenebrous, and shortly afterwards he went downstairs, where, in the golden glow of a great many candles set against a golden and embossed wall-paper, tea was being served. The fact was that Madox Brown was determined that no 'damned Academician' should see his picture. Nevertheless, it is satisfactory to me to think that there was among these distinguished and kindly men still so great a feeling of solidarity. They had come, many of them, from great distances, to do honour, or at least to be kind, to an old painter who at that time was more entirely forgotten than he has ever been before or since.

The lily tradition of the disciples of these men is, I should imagine, almost entirely extinguished. But the other day, at a particularly smart wedding, there turned up one staunch survivor in garments of prismatic hues—a

mustard-coloured ulster, a green wide-awake, a blue shirt, a purple tie and a suit of tweed. This gentleman moved distractedly among groups of correctly attired people. In one hand he bore an extremely minute painting by himself. It was, perhaps, of the size of a visiting-card, set in an ocean of white mount. In the other he bore an enormous spray of Madonna-lilies. That, I presume, was why he had failed to remove his green hat. He was approached by the hostess and he told her that he wished to place the picture, his wedding-gift, in the most appropriate position that could be found for it. And upon her suggesting that she would attend to the hanging after the ceremony was over, he brushed her aside. Finally he placed the picture upon the ground beneath a tall window, and perched the spray of lilies on top of the frame. He then stood back and, waving his emaciated hands and stroking his brown beard, surveyed the effect of his decoration. The painting, he said, symbolized the consolation that the arts would afford the young couple during their married life, and the lily stood for the purity of the bride. This is how in the seventies and the eighties the outer ring of the aesthetes really behaved. It was as much in their note as were the plum-pudding and the roast beef in William Morris's. The reason for this is not very far to seek. The older men, the Pre-Raphaelites, and the members of the 'Firm' had too rough work to do to bother much about the trimmings.

It is a little difficult now-a-days to imagine the acridity with which any new artistic movement was opposed when Victoria was Queen of England. Charles Dickens called loudly for the immediate imprisonment of Millais and the other Pre-Raphaelites, including my grandfather, who was not a Pre-Raphaelite. Blasphemy was the charge alleged against them, just as it was the charge alleged against the earliest upholders of Wagner's music in England. This may seem incredible, but I have in my possession three letters from three different members of the public addressed to my father, Dr Francis Hueffer, a man of

great erudition and force of character, who, from the early seventies until his death, was the musical critic of *The Times*. The writers stated that unless Doctor Hueffer abstained from upholding the blasphemous music of the future—and in each case the writer used the word blasphemous—he would be respectively stabbed, ducked in a horse-pond and beaten to death by hired roughs. Yet to-day I never go to a place of popular entertainment where miscellaneous music is performed for the benefit of the poorest classes without hearing at least the overture to *Tannhäuser*. Now-a-days it is difficult to discern any new movement in any of the arts. No doubt there is movement, no doubt we who write and our friends who paint and compose are producing the arts of the future. But we never have the luck to have the word 'blasphemous' hurled at us. It would, indeed, be almost inconceivable that such a thing could happen, that the frame of mind should be reconstructed. But to the Pre-Raphaelites this word was blessed in the extreme. For human nature is such—perhaps on account of obstinacy or perhaps on account of feelings of justice—that to persecute an art, as to persecute a religion, is simply to render its practitioners the more stubborn and its advocates in their fewness the more united, and the more effective in their union. It was the injustice of the attack upon the Pre-Raphaelites, it was the fury and outcry, that won for them the attention of Mr Ruskin. And Mr Ruskin's attention being aroused, he entered on that splendid and efficient championing of their cause which at last established them in a position of perhaps more immediate importance than, as painters, they exactly merited. As pioneers and as sufferers they can never sufficiently be recommended. Mr Ruskin, for some cause which my grandfather was used to declare was purely personal, was the only man intimately connected with these movements who had no connection at all with Madox Brown. I do not know why this was, but it is a fact that, although Madox Brown's pictures were in considerable evidence at all places where

the pictures of the Pre-Raphaelites were exhibited, Mr Ruskin in all his works never once mentioned his name. He never blamed him; he never praised him; he ignored him. And this was at a time when Ruskin must have known that a word from him was sufficient to make the fortune of any painter. It was sufficient not so much because of Mr Ruskin's weight with the general public as because the small circle of buyers, wealthy and assiduous, who surrounded the painters of the moment, hung upon Mr Ruskin's lips and needed at least his printed sanction for all their purchases.

Madox Brown was the most benevolent of men, the most helpful and the kindest. His manifestations, however, were apt at times to be a little thorny. I remember an anecdote which Madox Brown's housemaid of that day was in the habit of relating to me when she used to put me to bed. Said she—and the exact words remain upon my mind:

'I was down in the kitchen waiting to carry up the meat, when a cabman comes down the area steps and says: "I've got your master in my cab, He's very drunk." I says to him'—and an immense intonation of pride would come into Charlotte's voice—'My master's a-sitting at the head of his table entertaining his guests. That's Mr Swinburne. Carry him upstairs and lay him in the bath.'

Madox Brown, whose laudable desire it was at many stages of his career to redeem poets and others from dipsomania, was in the habit of providing several of them with labels upon which were inscribed his own name and address. Thus, when any of these geniuses were found incapable in the neighbourhood they would be brought by cabmen or others to Fitzroy Square. This, I think, was a stratagem more characteristic of Madox Brown's singular and quaint ingenuity than any that I can recall. The poet being thus recaptured would be carried upstairs by Charlotte and the cabman and laid in the bath—in Colonel Newcome's very bath-room, where, according to Thackeray, the water moaned and gurgled so mournfully in the

cistern. For me, I can only remember that room as an apartment of warmth and lightness; it was a concomitant to all the pleasures that sleeping at my grandfather's meant for me. And indeed, to Madox Brown as to Colonel Newcome—they were very similar natures in their chivalrous, unbusinesslike and naïve simplicity—the house in Fitzroy Square seemed perfectly pleasant and cheerful.

The poet having been put into the bath would be reduced to sobriety by cups of the strongest coffee that could be made (the bath was selected because he would not be able to roll out and to injure himself). And having been thus reduced to sobriety, he would be lectured, and he would be kept in the house, being given nothing stronger than lemonade to drink, until he found the régime intolerable. Then he would disappear, the label sewn inside his coat-collar, to reappear once more in the charge of a cabman.

Of Madox Brown's acerbity I witnessed myself no instances at all, unless it be the one that I have lately narrated. A possibly too-stern father of the old school, he was as a grandfather extravagantly indulgent. I remember his once going through the catalogue of his grandchildren and deciding, after careful deliberation, that they were all geniuses with the exception of one, as to whom he could not be certain whether he was a genius or mad. Thus I read with astonishment the words of a critic of distinction with regard to the exhibition of Madox Brown's works that I organized at the Grafton Gallery ten years ago. They were to the effect that Madox Brown's pictures were very crabbed and ugly—but what was to be expected of a man whose disposition was so harsh and distorted? This seemed to me to be an amazing statement. But upon discovering the critic's name I found Madox Brown once kicked him downstairs. The gentleman in question had come to Madox Brown with the proposal from an eminent firm of picture-dealers that the painter should sell all his works to them for a given number of years at a very low price. In return they were to do what

would be called now-a-days 'booming' him, and they would do their best to get him elected an associate of the Royal Academy. That Madox Brown should have received with such violence a proposition that seemed to the critic so eminently advantageous for all parties justified that gentleman in his own mind in declaring that Madox Brown had a distorted temperament. Perhaps he had.

But if he had a rough husk he had a sweet kernel, and for this reason the gloomy house in Fitzroy Square did not, I think, remain as a shape of gloom in the minds of many people. It was very tall, very large, very grey, and in front of it towered up very high the mournful plane-trees of the square. And over the porch was the funeral urn with the ram's head. This object, dangerous and threatening, has always seemed to me to be symbolical of this circle of men, so practical in their work and so romantically unpractical, as a whole, in their lives. They knew exactly how, according to their lights, to paint pictures, to write poems, to make tables, to decorate pianos, rooms or churches. But as to the conduct of life they were a little sketchy, a little romantic, perhaps a little careless. I should say that of them all Madox Brown was the most practical. But his way of being practical was always to be quaintly ingenious. Thus we had the urn. Most of the Pre-Raphaelites dreaded it; they all of them talked about it as a possible danger, but never was any step taken for its removal. It was never even really settled in their minds whose would be the responsibility for any accident. It is difficult to imagine the frame of mind, but there it was, and there to this day the urn remains. The question could have been settled by any lawyer, or Madox Brown might have had some clause that provided for his indemnity inserted in his lease. And, just as the urn itself set the tone of the old immense Georgian mansion fallen from glory, so perhaps the fact that it remained for so long the topic of conversation set the note of the painters, the painter-poets, the poet-craftsmen, the painter-musicians, the fili-buster verse-writers, and all that singular collection of men

versed in the arts. They assembled and revelled compara-
tively modestly in the rooms where Colonel Newcome
and his fellow-directors of the Bundelcund Board had
partaken of mulligatawny and spiced punch before the
side-board that displayed its knife-boxes with the green-
handled knives in their serried phalanxes.

But, for the matter of that, Madox Brown's own side-
board also displayed its green-handled knives, which
always seemed to me to place him as the man of the old
school in which he was born and remained to the end of
his days. If he was impracticable, he hadn't about him a
touch of the Bohemian; if he was romantic, his romances
took place along ordered lines. Every friend's son of his who
went into the navy was destined to his eyes to become,
not a pirate, but at least a port-admiral. Every young
lawyer that he knew was certain, even if he were only a
solicitor, to become Lord Chancellor, and every young
poet who presented him with a copy of his first work was
destined for the Laureateship. And he really believed in
these romantic prognostications, which came from him
without end as without selection. So that if he was the
first to give a helping hand to D. G. Rossetti, his patronage
in one or two other instances was not so wisely bestowed.

He was, of course, the sworn foe of the Royal Academy.
For him they were always, the members of that august
body, 'those *damned* Academicians,' with a particular note
of acerbity upon the expletive. Yet I very well remember,
upon the appearance of the first numbers of *The Daily
Graphic*, that Madox Brown, being exceedingly struck by
the line-engravings of one of the artists that paper regularly
employed to render social functions, exclaimed:

'By Jove! if young Cleaver goes on as well as he has
begun, those damned Academicians, supposing they had
any sense, would elect him President right away!' Thus it
will be seen that the business of romance was not to
sweep away the Royal Academy, was not to found an
opposing salon, but it was to capture the established body
by storm, leaping, as it were, on to the very quarter-deck,

and setting to the old ship a new course. The charac-
teristic, in fact, of all these men was their warm-hearted-
ness, their enmity for the formal, for the frigid, for the
ungenerous. It cannot be said that any of them despised
money. I doubt whether it would even be said that any
of them did not, at one time or another, seek for popu-
larity, or try to paint, write or decorate pot-boilers. But
they were naïvely unable to do it. To the timid—and the
public is always the timid—what was individual in their
characters was always alarming. It was alarming even when
they tried to paint the conventional dog-and-girl pictures
of the Christmas supplement. The dogs were too like dogs
and did not simper; the little girls were too like little girls.
They would be probably rendered as just losing their first
teeth.

In spite of the Italianism of Rossetti, who was never in
Italy, and the medievalism of Morris, who had never
looked medievalism, with its cruelties, its filth, its stenches
and its avarice, in the face—in spite of these tendencies
that were forced upon them by those two contagious
spirits, the whole note of this old, romantic circle was
national, was astonishingly English, was Georgian even.
They seemed to date from the Regency, and to have
skipped altogether the baneful influence of early Victorian-
ism and of the commerciality that the Prince Consort
spread through England. They seem to me to resemble
in their lives—and perhaps in their lives they were greater
than their works—to resemble nothing so much as a
group of old-fashioned ships' captains. Madox Brown, in-
deed, was nominated for a midshipman in the year 1827.
His father had fought on the famous *Arethusa* in the
classic fight with the *Belle Poule*. And but for the fact
that his father quarrelled with Commodore Coffin, and so
lost all hope of influence at the Admiralty, it is probable
that Madox Brown would never have painted a picture or
have lived in Colonel Newcome's house. Indeed, on the
last occasion when I saw William Morris I happened to
meet him in Portland Place. He was going to the house

of a peer, that his firm was engaged in decorating, and he took me with him to look at the work. He was then a comparatively old man, and his work had grown very flamboyant, so that the decoration of the dining-room consisted, as far as I can remember, of one huge acanthus-leaf design. Morris looked at this absent-mindedly, and said that he had just been talking to some members of a ship's crew whom he had met in Fenchurch Street. They had remained for some time under the impression that he was a ship's captain. This had pleased him very much, for it was his ambition to be taken for such a man. I have heard, indeed, that this happened to him on several occasions, on each of which he expressed an equal satisfaction. With a grey beard like the foam of the sea, with grey hair through which he continually ran his hands, erect and curly on his forehead, with a hooked nose, a florid complexion and clean, clear eyes, dressed in a blue serge coat, and carrying, as a rule, a satchel, to meet him was always, as it were, to meet a sailor ashore. And that in essence was the note of them all. When they were at work they desired that everything they did should be ship-shape; when they set their work down they became like Jack ashore. And perhaps that is why there is, as a rule, such a scarcity of artists in England. Perhaps to what is artistic in the nation the sea has always called too strongly.

PRINCIPLES

I should say that Rossetti was a man without any principles at all, who earnestly desired to find some means of salvation along the lines of least resistance. Madox Brown, on the other hand, was ready to make a principle out of anything that was at all picturesque.

THE CHINESE TEA-THINGS

Rossetti wanted to fill his house with anything that was odd, Chinese or sparkling. If there was something grue-some about it, he liked it all the better. Thus, at his death, two marauders out of the shady crew that victimized him, and one honest man, each became possessed of the dark-lantern used by Eugene Aram. I mean to say that quite lately there were in the market three dark-lanterns, each of which was supposed to have come from Rossetti's house at his death, only one of which had been bought with honest money at Rossetti's sale. Even this one may not have been the relic of the murderer which Rossetti had purchased with immense delight. He bought, in fact, just anything or everything that amused him or tickled his fancy, without the least idea of making his house resemble anything but an old curiosity shop.

This collection was rendered still more odd by the eccentricities of Mr Charles Augustus Howell, an extra-ordinary personage who ought to have a volume all to himself. There was nothing in an odd-jobbing way that Mr Howell was not up to. He supported his family for some time by using a diving-bell to recover treasure from a lost galleon off the coast of Portugal, of which country he appears to have been a native. He became Ruskin's secre-tary, and he had a shop in which he combined the framing and the forging of masterpieces. He conducted the most remarkable of dealers' swindles with the most consum-mate ease and grace, doing it, indeed, so loveably that when his misdeeds were discovered he became only more beloved. Such a character would obviously appeal to Ros-setti, and as, at one period of his career, Rossetti's income ran well into five figures, while he threw gold out of all the windows and doors, it is obvious that such a character as Rossetti's must have appealed very strongly to Mr Charles Augustus Howell. The stories of him are endless.

At one time, while Rossetti was collecting *chinoiseries*, Howell happened to have in his possession a nearly price-less set of Chinese tea-things. These he promptly proceeded to have duplicated at his establishment where forging was carried on more wonderfully than seems possible. This forgery he proceeded to get one of his concealed agents to sell to Rossetti for an enormously high figure. Coming to tea with the poet-artist on the next day, he remarked to Rossetti:

'Hello, Gabriel! where did you get those clumsy imita-tions?'

Rossetti, of course, was filled with consternation, where-upon Howell remarked comfortingly: 'Oh, it's all right, old chap, I've got the originals, which I'll let you have for an old song.'

And, eventually, he sold the originals to Rossetti for a figure very considerably over that at which Rossetti had bought the forgeries. Howell was then permitted to take away the forgeries as of no value, and Rossetti was left with the originals. Howell, however, was for some time afterward more than usually assiduous in visiting the painter-poet. At each visit he brought one of the forged cups in his pocket, and while Rossetti's back was turned he substituted the forgery for one of the genuine cups, which he took away in his pocket. At the end of the series of visits, Rossetti once more possessed the copies and Howell the genuine set, which he sold, I believe, to M. Tissot.

A LION IN THE STRAND

I had a very elderly and esteemed relative who once told me that while walking along the Strand he met a lion that had escaped from Exeter Change.* I said, 'What did you

* The site of a menagerie in the sixties and seventies of the last century.

do?' and he looked at me with contempt as if the question were imbecile. '*Do?*' he said. 'Why, I took a cab.'

MY OLD NURSE ATTERBURY

My old nurse Atterbury was married to a descendant of the great Atterbury of Rochester; her daughter to one of the great Racine's. Thus even in the lower part of the house I lived among resounding names whilst the great of those days—at least in the arts—thundered and declaimed upstairs.

M. Racine, the cook's husband, had been a member of the Commune in 1870. He was a striking, very tall man, with an immense hooked nose that leaned to one side and blank, black, flashing eyes. I used to listen to his declamations against MacMahon and Gambetta with a great deal of edification. He must have been the first politician of the extreme Left that I ever listened to, but about the same time I must have had my first lessons in French literature from a M. Andrieux *fils*. He was another Communard. He comes back to me as the most elegant man I ever knew. His little moustaches were most comically waxed and he had the enviable gift of being able to make two cigarettes at once. The crook to the right of M. Racine's nose I always put down to the Versaillais troops, figuring that they had done it with an immense paper-clip. Thus I early developed a hatred for tyrants and a love for lost causes and exiles that still, I hope, distinguish me. Poland, Alsace-Lorraine, Ireland and even the Jews exiled from their own country—those were the names of romance of my childhood. They so remain for me.

My nurse, Mrs Atterbury, had one singularity; she had come in contact with more murders and deaths by violence than any person I ever met—at any rate until 1914. In consequence, I imagine, my childhood was haunted by imaginary horrors and was most miserable. I can still see

the shadows of wolves if I lie awake in bed with a fire in the room. And indeed I had the fixed belief for years that except for myself the world was peopled with devils. I used to peep through the cracks of doors to see the people within in their natural forms.

Mrs Atterbury had been in the great railway accident near Doncaster where innumerable persons were burned to death; she had seen seven people run over and killed and her milder conversations abounded in details of deaths by drowning. I don't think she was present at the sinking of the *Princess Alice* but she talked about it as if she had been. Her normal conversations ran:

'When I lived with me yuncle Power in the Minories time of the Crimea wower, me yuncle let 'is top front to a master saddler. 'N' wen wower broke out the master saddler 'e worked niteanday fer sevin weeks without stop er stay. 'N' 'e took 'is saddles to the Wower Orfis 'n' drawed 'is pay. All in gowlden sovrins in a Gledstun beg. 'N' wen 'e got 'ome 'e cut 'is froat on the top front landin' 'n' the blood 'n' the gowld run down the staircase together like the awtificial cascades in Battersea Pawk.' ... 'The blood 'n' the gowld!' she would repeat and catch my wrist in her skinny fingers.

She was a witness—or an almost-witness—of one of the Jack-the-Ripper murders in Whitechapel. She certainly came on the body of one of the victims and claimed to have seen a man vanish into the fog. I never actually heard the details of that. My mother, worried by the advent of a questioning police-sergeant and the hysterics of the household below stairs, forbade the old lady to tell us children about it. But her impressive and mysterious absence in her best black bonnet and jet-beaded cloak, and the whispers of the household made me fully aware that she was giving evidence at the Inkwedge. For long afterwards heaven knew what horrors were not concealed for me in the pools of shadow beneath the lamp-posts. In solitary streets her footsteps echoing and a smudge of fog in the gaslight!

The last time I saw the old lady she was sitting—as she did day in day out for years—in the window of a parlour that occupied the apex of a corner lot in an outer suburb. She could look right up and down two long streets.

She greeted me with great vivacity. The day before there had been a tremendous thunderstorm. The streets up which she looked had been almost obscured by falling water. She said to me:

'I calls out to Lizzie. . . . Good gracious me! That man! 'E's struck dead! . . . 'N' 'e *was*!' she added triumphantly.

CREATURES FRAIL BUT AWFUL

The poet—and still more the poetess—of the seventies and eighties, though an awful, was a frail creature, who had to be carried about from place to place, and generally in a four-wheeled cab. Indeed, if my recollection of these poetesses in my very earliest days was accompanied always by thunders and expostulations, my images of them in slightly later years, when I was not so strictly confined to the nursery—my images of them were always those of somewhat elderly ladies, forbidding in aspect, with grey hair, hooked noses, flashing eyes and continued trances of indignation against reviewers. They emerged ungracefully—for no one ever yet managed to emerge gracefully from the door of a four-wheeler—sometimes backward, from one of those creaking and dismal tabernacles and pulling behind them odd-shaped parcels. Holding the door open, with his whip in one hand, would stand the cabman. He wore an infinite number of little capes on his overcoat; a grey worsted muffler would be coiled many times round his throat, and the lower part of his face and his top hat would be of some unglossy material that I have never been able to identify. After a short interval, his hand would become extended, the flat palm displaying such coins as the poetess had laid in it. And, when the

poetess with her odd bundles was three-quarters of the way up the door-steps, the cabman, a man of the slowest and most deliberate, would be pulling the muffler down from about his mouth and exclaiming: 'Wot's this?'

The poetess, without answering, but with looks of enormous disdain, would scuffle into the house and the front door would close. Then upon the knocker the cabman would commence his thunderous symphony.

Somewhat later more four-wheelers would arrive with more poetesses. Then still more four-wheelers with elderly poets; untidy-looking young gentlemen with long hair and wide-awake hats, in attitudes of dejection and fatigue, would ascend the steps; a hansom or two would drive up containing rather smarter, stout, elderly gentlemen wearing as a rule black coats with velvet collars and most usually black gloves. These were reviewers, editors of *The Athenaeum* and of other journals. Then there would come quite smart gentlemen with an air of prosperity in their clothes and with deference somewhat resembling that of undertakers in their manners. These would be publishers.

You are to understand that what was about to proceed was the reading to this select gathering of the latest volume of poems by Mrs Clara Fletcher—that is not the name—the authoress of what was said to be a finer sequence of sonnets than those of Shakespeare. And before a large semicircle of chairs occupied by the audience that I have described, and with Mr Clara Fletcher standing obsequiously behind her to hand to her from the odd-shaped bundles of manuscripts the pages that she required, Mrs Clara Fletcher, with her regal head regally poised, having quelled the assembly with a single glance, would commence to read.

Mournfully then, up and down the stone staircases, there would flow two hollow sounds. For, in those days, it was the habit of all poets and poetesses to read aloud upon every possible occasion, and whenever they read aloud to employ an imitation of the voice invented by the late

Lord Tennyson and known, in those days, as the *ore rotundo*—'with the round mouth mouthing out their hollow o's and a's.'

The effect of this voice heard from outside a door was to a young child particularly awful. It went on and on, suggesting the muffled baying of a large hound that is permanently dissatisfied with the world. And this awful rhythm would be broken in upon from time to time by the thunders of the cabman. How the housemaid—the housemaid was certainly Charlotte Kirby—dealt with this man of wrath I never could rightly discover. Apparently the cabman would thunder upon the door. Charlotte, keeping it on the chain, would open it for about a foot. The cabman would exclaim. 'Wot's this?' and Charlotte would shut the door in his face. The cabman would remain inactive for four minutes in order to recover his breath. Then once more his stiff arm would approach the knocker and again the thunders would resound. The cabman would exclaim: 'A bob and a tanner from the Elephant and Castle to Tottenham Court Road!' and Charlotte would again close the door in his face. This would continue for perhaps half an hour. Then the cabman would drive away to meditate. Later he would return and the same scenes would be gone through. He would retire once more for more meditation and return in the company of a policeman. Then Charlotte would open the front door wide and by doing no more than ejaculating, 'My good man!' she would appear to sweep out of existence policeman, cab, cab-horse, cabman and whip, and a settled peace would descend upon the house, lulled into silence by the reverberation of the hollow o's and a's. In about five minutes' time the policeman would return and converse amiably with Charlotte for three-quarters of an hour through the area railings. I suppose that was really why cabmen were always worsted and poetesses protected from these importunities in the dwelling over whose destinies Charlotte presided for forty years.

The function that was proceeding behind the closed

doors would now seem incredible; for the poetess would read on from two to three and a half hours. At the end of this time—such was the fortitude of the artistic when Victoria was still the Widow at Windsor—an enormous high babble of applause would go up. The forty or fifty poetesses, young poets, old poets, painter-poets, reviewers, editors of *Athenaeums* and the like would divide themselves into solid bodies, each body of ten or twelve surrounding one of the three or four publishers and forcing this unfortunate man to bid against his unfortunate rivals for the privilege of publishing this immortal masterpiece. My grandfather would run from body to body, ejaculating: 'Marvellous genius!' 'First woman poet of the age!' 'Lord Tennyson himself said he was damned if he wasn't envious of the sonnet to Mehemet Ali!'

Mr Clara Fletcher would be trotting on tiptoes fetching for the lady from whom he took his name—now exhausted and recumbent in a deep arm-chair—smelling-bottles, sponges full of aromatic vinegar to press upon her brow, glasses of sherry, thin biscuits, and raw eggs in tumblers. As a boy I used to think vaguely that these comestibles were really nectar and ambrosia.

In the early days I was only once permitted to be present at these august ceremonies. I say I was permitted to be present, but actually I was caught and forced very much against my will to attend the rendition by my aunt, Lucy Rossetti, who, with persistence, that to me at the time appeared fiendish, insisted upon attempting to turn me into genius too. Alas! hearing Mr Arthur O'Shaughnessy read 'Music and Moonlight' did not turn poor little me into a genius. It sent me to sleep, and I was carried from the room by Charlotte, disgraced and destined from that time forward only to hear those hollow sounds from the other side of the door. Afterward I should see the publishers, one proudly descending the stairs, putting his chequebook back into his overcoat pocket, and the others trying vainly to keep their heads erect under the glances of scorn that the rest of the departing company poured upon

them. And Mr Clara Fletcher would be carefully folding the cheque into his waist-coat pocket, while his wife, from a large reticule, produced one more eighteenpence wrapped up in tissue-paper.

CHARLOTTE'S CONVERSATIONS

I do not know how many of my details of the lives of the great of the early eighties do not come to me from listening, unobserved, to Charlotte's conversations with my mother in the great linen-room of the Fitzroy Square house. . . . Long, quiet monologues about Mr Swinburne and Mrs Lizzie Rossetti and the carryings on of Mr Rossetti and that Mr Burne-Jones and *that* Mrs Ruskin, poor dear thing. . . . Her husband says to her on their wedding-day as they drove away in their carriage. . . . A shame I calls it. . . . And the Queen acting so cruel! . . . Fair threw the President's chain in Sir Everett's face as he knelt before her, they say she did. . . . And her such a pretty thing when she was Miss Euphemia Grey. . . . But he never forgive your father, Mr Ruskin didn't. . . . Always thought he connived because, the night they eloped, your father had him to dinner. . . . Charlotte twice had Queen Alexandra's prize for having been longest in any family in the kingdom . . . after sixty years of it and after seventy. . . . When she was eighty-two she was sitting on a bench on Primerose Ill and a gentleman sat down beside er an says e ad the nest and e wanted a little bird to put in it and ad she any savins? . . . Threw er bonnet in is face she did 'n' tole im what she thought v im. . . . I bet his ears burned!

The great seen from the linen-room were thus diminished for me—the awful, monumental, minatorily bearded tumultuous and moral Great of those days. . . . Insupportably moral they were, and I imagine the sense of original sin that in those days possessed me in their presences would have overwhelmed me altogether but for

the moral support that the anecdotes in the linen-room
afforded me.

To stand, say, at the age of eleven between the painter
of the 'Light of the World,' Mr Holman Hunt, and Mr
Ruskin would have been an insupportable ordeal. Mr Hunt
had a voice like a creaking door, endlessly complaining;
in moments of virtuous emotion Mr Ruskin fairly hissed
like an adder.... The whole world had conspired to mis-
judge, vilify, misrepresent, misunderstand, misestimate
... even to rob, both of them, singly and together. It was
as if they were mountainous islands entirely surrounded
by villains. Mr Hunt would creak:

'Gabriel...Gabriel was nothing but a thief....A
common sneak-thief. I could have had him up before the
magistrate at Bow Street. At any moment.'

Mr Ruskin would dither, 'Dear, dear, dear, dear!'

'At any moment,' Mr Hunt would repeat. 'He bor-
rowed my copy of Browne's *Hydriotaphia* with Flaxman's
plates... worth three pun ten, at least... and never re-
turned it.... A common vulgar sneak-thief....'

I heard Mr Hunt use those very words not so long after
his friend Rossetti's death.... If I think about it hard it
was perhaps not to Mr Ruskin but to Lord Justice Ford
North, who was the only human being I ever knew who
was more disagreeable than Mr Ruskin. He would, in
moments of fury, snatch off his wig and throw it in the
face of his Clerk of the Court. He was a militant church-
man and was translated from the King's Bench to the
Court of Chancery because he sentenced Foote the Atheist
to penal servitude for life... for denying in a penny
pamphlet the existence of the Deity....

Well, they were that sort of alarming persons for a
little boy... the members of the Pre-Raphaelite circle,
and certainly their society would have been an insupport-
able ordeal if I hadn't been able, when they weren't look-
ing at me, to squint sideways into their faces and say
to myself:

'Ah, yes, you're Mr Ruskin.... My grandfather says

you look like a cross between a fiend and a tallow-chandler
and Charlotte says. . . .' Well, I have already adumbrated
what Charlotte said of Mr Ruskin. . . . What she said of
Mr Hunt would not bear even adumbration but it was
very fortifying for me. . . . As for the Judge I never heard
anything worse of him than that he suffered from an internal
ulcer, which was what made him so obstreperous. He
once cursed Charlotte at the top of his voice all the way
from the studio to the front door. . . . But she had seemed
rather to like it. Collected burial urns, he did. . . .

But as for Mr Swinburne. . . . Ah, that! . . .

I don't know whether it was Charlotte's adoration for
him or whether I worked it out for myself. . . . But he at
least was a solar myth with the voice of a Greek god,
beautiful and shining and kind so that when *he* came on
the scene, drunk or sober, all was gas and gingerbread
and joy-bells and jujubes. . . . Well, he used to give me
jujubes, slipping them out of his waistcoat pocket in his
beautiful, long, white fingers. . . . And now and then it
would be a poem suited to my comprehension and written
in his beautiful clear hand, minutely, on valentine paper
with lacey edgings and Father Christmas embossed on the
reverse, or pink roses. . . . Usually, as far as I can
remember, about my dog Dido . . . rhyming 'dog' with
'fog' and 'bog'. . . . I think Mr Swinburne once came on me
on Wimbledon Common, which was near my birth-place,
on a misty day, immensely distressed because my dog
Dido had gone into one of the ponds and would not come
out. . . . So Mr Swinburne wrote me a series of little
jingles about the adventures of that faithful hound, and
used to deliver them furtively as if he were slipping me
little parcels of candy. . . .

He was like that to children—and I daresay to grown-
ups. And if you think that his coming home occasionally
in four-wheel cabs from which he had to be conveyed
upstairs to the bath-room . . . if you think that that made
any difference to my—or even Charlotte's—childish
adoration, you are mistaken indeed. . . . It didn't make

even any difference to me that he was unduly short in stature. When the door opened before him and you looked to see a man's head appear at about the middle of the upper panel, his chin would not be much above the level of the door-handle ... not much. But then it was such a glorious head that you immediately forgot.

And then he was so much the great gentleman ... which is a thing as to which the servants' hall and the nursery never make mistakes. He was one of the great, ruffian Swinburnes of the Border ... with the Eliots and Crasters and Armstrongs and Jocks o' Hazeldean, reiving the cattle and burning the towers of the fause Scots, for ever in revolt against the Tudors, giving their lives in defence of Mary Stewart, chronicled in all the border ballads from Chevy Chase to Preston Pans. ...

It meant nothing to me that Mr Swinburne had occasionally to be carried past between Charlotte and a keb-man. ... For the matter of that Charlotte would have carried him all by herself. ... And you should have heard her defending him in the linen-room.

'That Mrs Lizzie Rossetti,' she used to exclaim. 'If the poor dear young gentleman wants to drink, why shouldn't e? ... Not that e drinks like Mr Blank does ... not to say soak. ... No, he gits rearing tearing boosed when e as the mind ter ... n calls for pen n paper in the bath n writes n ode. ... E wrote two last Friday as ever was. ... To Mister Mazzini n against the Emperor of the French. ... N why shouldn't e? ... That Mrs Lizzie Rossetti. ... A powerful pernicketty lady *she* was. N would have things jest so. ... Why shouldn't e git drunk in er box at Common Garden Oppra if he ad the mind? If so be s she ed bin faithful to er usband she might have spoken. ... But she must go n take n overdose'v opium. ... Onreasonable I call it. ... Now look here Miss Catherine. ...' My mother was Miss Catherine for her until her death ... and to her death her Mr Swinburne was more sinned against than ... but no, for her he never sinned at all. ... It was all that Mrs Lizzie

Rossetti's fault . . . when it wasn't the indigestion, all them poor fellows avin no one to look after ther meals.

I suppose it to be generally known to the world interested in such matters that Swinburne entertained a passion for Mrs D. G. Rossetti—the Elizabeth Siddal of earlier days, the model for Millais's *Ophelia*, the Félise of Swinburne's ballad. . . . The famous Miss Siddal, in short.* According to Charlotte his interest was reciprocated by the lady to the extent of her being ready to elope with Swinburne. . . . Though, Charlotte used to say, it was astonishing that anyone so cold-blooded and hearted as Mrs Lizzie, should want to elope with anyone. And on the night before the planned elopement Mr and Mrs Rossetti were in a box at the opera and Swinburne joined them in a state of inebriation so insupportable that Mrs Rossetti went home and took an overdose of some opiate. . . .

There were, of course, in Charlotte's account other gloomy and harrowing details of miscarriages and misunderstandings in a lugubriously oil-lamp-lit, indigestion-ridden, gin-sodden, always dripping London of the seventies —than which city none other could be imagined less suited for the sports and loves of lyric balladists of origin whether North Country or Italian. . . . On those you can employ your imaginations to any extent or, as to them, read legions of other writers. . . . The reports of the inquest —which Charlotte needless to say attended—state duly that before taking her overdose Mrs Rossetti had been at the Opera with Mr Rossetti and Mr Swinburne . . . and the coroner and jury passed a vote of sympathy for Mr Rossetti, thus left without anyone to sew on his shirt-buttons. But they say nothing of Mr Swinburne's intoxication, which you can take or not as you please.

The point is that neither for Charlotte nor for me did any of these lugubriousnesses in the least dim the shine of the figure of Swinburne, the great little gentleman. He

* Who was known as Guggums (!) to the inner circle of the Brotherhood.

remained for us the glorious, reckless Border cattle-reiver, champion of Mary Queen o' Scots and of Liberty, Hellene, near-Godhead, golden in voice, infinitely chivalrous. . . .

PRE-RAPHAELITE LOVE

Love, according to the Pre-Raphaelite canon, was a great but rather sloppy passion. Its manifestations would be Paolo and Francesca, or Launcelot and Guinevere. It was a thing that you swooned about on broad, general lines, your eyes closed, your arms outstretched. It excused all sins, it sanctified all purposes, and if you went to hell over it you still drifted about among snow-flakes of fire with your eyes closed and in the arms of the object of your passion. For it is impossible to suppose that when Rossetti painted his picture of Paolo and Francesca in hell, he or any of his admirers thought that these two lovers were really suffering. They were not. They were suffering perhaps with the malaise of love, which is always an uneasiness, but an uneasiness how sweet! And the flakes of flames were descending all over the rest of the picture, but they did not fall upon Paolo and Francesca. No, the lovers were protected by a generalized swooning passion that formed, as it were, a moral and very efficient mackintosh all over them. And no doubt what D. G. Rossetti and his school thought was that, although guilty lovers have to go to hell for the sake of the story, they will find hell pleasant enough, because the aroma of their passion, the wings of the great god of love, and the swooning intensity of it all will render them insensible to the inconveniences of their lodgings. As much as to say that you do not mind the bad cooking of the Brighton Hotel if you are having otherwise a good time of it.

MR CARLYLE...AND MR PEPPER

There were all these things jumbled up in my poor little mind together.... I could not think that D. G. Rossetti was a person any more remarkable than the gentleman with gold braid round his hat who opened for me the locked gates of Fitzroy Square, or that when I shook hands with a clergyman called Franz Liszt was it any more of an event than when, as I was enjoined to do, I performed the same ceremony with the cook's husband. Dimly, but with vivid patches, I remember being taken for a walk by my father along what appeared to me to be a grey-stone quay. I presume it was the Chelsea Embankment. There we met a very old, long-bearded man. He frightened me quite as much as any of the other great Victorian figures, who, to the eye of a child, appeared monumental, loud-voiced and distressing. This particular gentleman at the instance of my grandfather related to me how he had once been at Weimar. In a garden restaurant beneath a May-tree in bloom he had seen Schiller and Goethe drinking coffee together. He had given a waiter a thaler to be allowed to put on a white apron and to wait upon these two world-shaking men, who, in court-dress with wigs and swords, sat at a damask-covered table. He had waited upon them. Later, I remember that while I was standing with my father beside the doorstep in Tite Street of the house that he was entering, I fell down and he bent over to assist me to rise. His name was Thomas Carlyle, but he is almost confounded in my mind with a gentleman called Pepper. Pepper very much resembled Carlyle, except that he was exceedingly dirty. He used to sell penny-dreadfuls, which I was forbidden to purchase....

THAT TERRIBLE WORD 'GENIUS'

Then there was that terrible word 'genius.' I think my grandfather, with his romantic mind, first obtruded it on my infant notice. But I am quite certain that it was my aunt, Mrs William Rossetti, who filled me with a horror of its sound that persists to this day. In school-time the children of my family were separated from their cousins, but in the holidays, which we spent as a rule during our young years in lodging-houses side by side, in places like Bournemouth or Hythe, we were delivered over to the full educational fury of our aunt. For this, no doubt, my benevolent but misguided father was responsible. He had no respect for schoolmasters, but he had the greatest possible respect for his sister-in-law. In consequence, our mornings would be taken up in listening to readings from the poets or in improving our knowledge of foreign tongues. My cousins, the Rossettis, were horrible monsters of precocity. Let me set down here with what malignity I viewed their proficiency in Latin and Greek at ages incredibly small. Thus, I believe, my cousin Olive wrote a Greek play at the age of something like five. And they were perpetually being held up to us—or perhaps to my-self alone, for my brother was always very much the sharper of the two—as marvels of genius whom I ought to thank God for merely having the opportunity to emulate. For my cousin Olive's infernal Greek play, which had to do with Theseus and the Minotaur, draped in robes of the most flimsy butter-muslin, I was drilled, a lanky boy of twelve or so, to wander round and round the back drawing-room of Endsleigh Gardens, imbecilely flapping my naked arms before an audience singularly distinguished who were seated in the front room. The scenery, which had been designed and painted by my aunt, was, I believe, extremely beautiful, and the *chinoiseries*,

the fine furniture and the fine pictures were such that, had I been allowed to sit peaceably among the audience, I might really have enjoyed the piece. But it was my unhappy fate to wander round in the garb of a captive before an audience that consisted of Pre-Raphaelite poets, ambassadors of foreign powers, editors, Poets Laureate, and Heaven knows what. Such formidable beings at least did they appear to my childish imagination. From time to time the rather high voice of my father would exclaim from the gloomy depths of the auditorium, 'Speak up, Fordie!' Alas! my aptitude for that sort of sport being limited, the only words that were allotted to me were the Greek lamentation 'Theu! Theu! Theu!' and in the meanwhile my cousin, Arthur Rossetti, who appeared only to come up to my knee, was the hero Theseus, strode about with a large sword, slew dragons and addressed perorations in the Tennysonian 'o' and 'a' style to the candle-lit heavens, with their distant view of Athens. Thank God, having been an adventurous youth, whose sole idea of true joy was to emulate the doings of the hero of a work called *Peck's Bad Boy and His Pa*, or at least to attain to the lesser glories of Dick Harkaway, who had a repeating rifle and a tame black jaguar, and who bathed in gore almost nightly—thank God, I say, that we succeeded in leading our unsuspecting cousins into dangerous situations from which they only emerged by breaking limbs. I seem to remember the young Rossettis as perpetually going about with fractured bones. I distinctly remember the fact that I bagged my cousin Arthur with one collar-bone, broken on a boat-slide in my company, while my younger sister brought down her cousin Mary with a broken elbow, fractured in a stone hall. Olive Rossetti, I also remember with gratification, cut her head open at a party given by Miss Mary Robinson, because she wanted to follow me down some dangerous steps and fell onto a flower-pot. Thus, if we were immolated in butter-muslin fetters and in Greek plays, we kept our own end up a little and we never got hurt. Why, I remember pushing my brother out of a

second-floor window so that he fell into the area, and he didn't have even a bruise to show, while my cousins in the full glory of their genius were never really all of them together quite out of the bone-setter's hands.

My aunt gave us our bad hours with her excellent lessons, but I think we gave her hers; so let the score be called balanced. Why, I remember pouring a lot of ink from the first-storey banisters onto the head of Ariadne Petrici when she was arrayed in the robes of her namesake, whose part she supported. For let it not be imagined that my aunt Rossetti foisted my cousin Arthur into the position of hero of the play through any kind of maternal jealousy. Not at all. She was just as anxious to turn me into a genius, or to turn *anybody* into a genius. It was only that she had such much better material in her own children.

MIXING UP NAMES

Nothing can prevent my mixing up names. I suppose I inherit the characteristic from my grandfather, who had it to a dangerous degree. I would come in and say to him:

'Grandpa, I met Lord Leighton in the Park and he sent his regards to you.' He would exclaim with violence· 'Leighton! How dare you be seen talking to him. And how dare he presume to send messages to me. He is the scoundrel who . . .' I would interrupt:

'But, Grandpa, he is the President of the Royal Academy. . . .' He would interrupt in turn: 'Nonsense. I tell you he is the fellow who got seven years for. . . .' A few minutes after he would exclaim:

'Leighton? Oh, Leighton? Why didn't you say Leighton if you meant Leighton. I thought you said Fothergill-Bovey Haines. Of course there is no reason why you should not be civil to Leighton.'

MY GREAT-GRANDMOTHER'S VIRTUE

My German great-grandmother, the wife of the Bürger-meister of one of the capital cities of Germany, could never get over what appeared to her a disastrous new habit that was beginning to be adopted in Germany towards the end of her life, about 1780. She said that it was sinful, that it was extravagant, that it would lead to the downfall of the German nation. This revolutionary new habit was none other than that of having a dining-room. In those days Germany was so poor a country that even though my great-grandparents were considered wealthy people they were always accustomed to eat their meals in the bedroom. There was, that is to say, only one room and a kitchen in their house. The beds of the whole family were in niches in the walls surrounding the living-room, and it was here that they ate, slept, changed their clothes or received their guests. The families of merchants less wealthy even cooked in their bedrooms. This appeared to my great-grand-mother the only virtuous arrangement. And it was no doubt in the same spirit that Madox Brown considered it a proof of decadent luxury to wash one's hands more than three times a day. Now-a-days, I suppose, we should con-sider my great-grandmother's virtue a disgusting affair, and one that, because it was insanitary, was also immoral, or at least antisocial; whilst my grandfather, who washed his hands only three times a day—before breakfast, lunch and dinner—would be considered as only just scraping through the limits of cleanliness. Yet the price of soap is increasing daily.

MY FATHER

My father was a man of an encyclopedic knowledge and had a great respect for the attainments of the distinguished.

He used, I remember, habitually to call me 'the patient but extremely stupid donkey.' This phrase occurred in Mavor's spelling-book, which he read as a boy in the city of Münster in Westphalia, where he was born. He had a memory that was positively extraordinary, and a gift of languages no less great. Thus while his native language was German, he was for a long course of years musical critic to *The Times*, London correspondent to the *Frankfurter Zeitung*, London musical correspondent to *Le Menestrel* of Paris, and the *Tribuna*, Rome. He was also, I believe, in his day the greatest authority upon the Troubadours and the Romance Languages, and wrote original poems in modern Provençal, and he was a favourite pupil of Schopenhauer, and the bad boy of his family. He was a doctor of philosophy of Göttingen University, at that time premier university of Germany, though he had made his studies at the inferior institution in Berlin. From Berlin he was expelled because of his remarkable memory. The circumstances were as follows:

My father occupied a room in a hotel which had a balcony overlooking the Spree. In the same hotel, but in the next room, there dwelt the Rector of the university, and it happened that one of the Prussian Princes was to be present at the ceremony of conferring degrees. Thus one evening my father was sitting upon his balcony, while next door the worthy Rector read the address that he was afterward to deliver to the Prince. Apparently the younger members of the institution addressed the Prince before the dons. At any rate, my father, having heard it only once, delivered word for word the Rector's speech to His Royal Highness. The result was that the poor man, who spoke only with difficulty, had not a single word to say, and my father was forthwith expelled without his degree. Being, though freakish, a person of spirit, the same day he took the express to Göttingen and, as a result, in the evening he telegraphed to his mother: 'Have passed for doctor with honors at Göttingen,' to the consternation of his parents, who had not yet heard of his expulsion from Berlin. The

exploit pleased nobody. Berlin did not desire that he should be a doctor at all; Göttingen was disgusted that a student from an inferior university should have passed out on top of their particular tree, and I believe that in consequence in Germany of to-day a student can only take his doctor at his own particular university.

It was at the suggestion of Schopenhauer, or, possibly, because his own lively disposition made parts of Germany too hot to hold him, that Dr Hueffer came to England. He had letters of introduction to various men of letters in England, for, for time out of mind, in the city of Münster the Hueffer family had belonged to the class that battens upon authors. They have been, that is to say, printers and publishers. Following his intention of spreading the light of Schopenhauer in England, that country for which Schopenhauer had so immense a respect, Dr Hueffer founded a periodical called the *The New Quarterly Review*, which caused him to lose a great deal of money and to make cordial enemies among the poets and literary men to whom he gave friendly lifts. I fancy that the only traces of *The New Quarterly Review* are contained in the limerick by Rossetti which runs as follows:

> There was a young German called Huffer,
> A hypochondriacal buffer;
> To shout Schopenhauer
> From the top of a tower
> Was the highest enjoyment of Huffer.

In the seventies and eighties there were cries for the imprisonment alike of the critics who upheld and the artistes who performed the Music of the Future. The compositions of Wagner were denounced as being atheistic, sexually immoral, and tending to further Socialism and the throwing of bombs. Wagnerites were threatened with assassination, and assaults between critics of the rival schools were things not unknown in the foyer of the opera. I really believe that my father, as the chief exponent of Wagner in these islands, did go in some

personal danger. Extraordinary pressures were brought to bear upon the more prominent critics of the day, the pressure coming, as a rule, from the exponents of the school of Italian opera. Thus, at the opening of the opera seasons packing-cases of large dimensions and considerable in number would arrive at the house of the ferocious critic of the chief newspaper of England. They would contain singular assortments of comestibles and of objects of art. Thus I remember half a dozen hams, the special product of some north Italian towns; six cases of Rhine wine, which were no doubt intended to propitiate the malignant Teuton; a reproduction of the Medici Venus in marble, painted with phosphoric paint, so that it gleamed blue and ghostly in the twilight; a case of Bohemian glass, and several strings of Italian sausage. And these packing-cases, containing no outward sign of their senders, would have to be unpacked and then once more repacked, leaving the servants with fingers damaged by nails, and passages littered with straw. Inside would be found the cards of Italian *prime donne*, tenors or basses, newly arrived in London, and sending servile homage to the illustrious critic of the 'Giornale Times.' On one occasion a letter containing bank-notes for fifty pounds arrived from a *prima donna* with a pathetic note begging the critic to absent himself from her first night. Praise from a Wagnerite she considered to be impossible, but she was ready to pay for silence. I do not know whether this letter inspired my father with the idea of writing to the next suppliant that he was ready to accept her present—it was the case of Bohemian glass—but that in that case he would never write a word about her singing. He meant the letter, of course, as a somewhat clumsy joke, but the lady—she was not, however, an Italian— possessing a sense of humour, at once accepted the offer. This put my father rather in a quandary, for Madame H. was one of the greatest exponents of emotional tragic music that there had ever been, and the occasion on which she was to appear was the first performance in England of one of the great operas

of the world. I do not exactly know whether my father went through any conscientious troubles—I presume he did, for he was a man of a singular moral niceness. At any rate he wrote an enthusiastic notice of the opera and an enthusiastic and deserved notice of the impersonatrix of Carmen. And since the Bohemian glass—or the poor remains of the breakages of a quarter of a century—still decorate my side-board, I presume that he accepted the present, I do not really see what else he could have done.

Pressure of other sorts was also not unknown. Thus, there was an opera produced by a foreign Baron who was a distinguished figure in the diplomatic service, and who was very well looked on at Court. In the middle of the performance my father received a command to go into the royal box, where a royal personage informed him that in his august opinion the work was one of genius. My father replied that he was sorry to differ from so distinguished a connoisseur, but that, in his opinion, the music was absolute rubbish—*lauter Klatsch*. The reply was undiplomatic and upon the whole regrettable, but my father had been irritated by the fact that a good deal of Court pressure had already been brought to bear upon him. I believe that there were diplomatic reasons for desiring to flatter the composer of the opera, who was attached to a foreign embassy—the embassy of the nation with whom, for the moment, the diplomatic relations of Great Britain were somewhat strained. So that, without doubt, His Royal Highness was as patriotically in the right as my father was in a musical sense. Eventually the notice of the opera was written by another hand. The performance of this particular opera remains in my mind because, during one of its scenes, which represented the frozen circle of hell, the cotton-wool, which figured as snow on the stage, caught fire and began to burn. An incipient panic took place among the audience, but the orchestra, under a firm composer whose name I have unfortunately forgotten, continued to play, and the flames were extinguished by one of the singers using his cloak. But I still remember being

in the back of the box and seeing in the foreground, silhouetted against the lights of the stage, the figures of my father and of someone else—I think it was William Rossetti—standing up and shouting down into the stalls: 'Sit down, brutes! Sit down, cowards!'

On the other hand, it is not to be imagined that acts of kindness and good-fellowship were rare under this seething mass of passions and of jealousies. Thus at one of the Three Choir Festivals, my father, having had the misfortune to sprain his ankle, was unable to be present in the cathedral. His notice was written for him by the critic of the paper which was most violently opposed to views at all Wagnerian—a gentleman whom, till that moment, my father regarded as his bitterest personal enemy. This critic happened to be staying in the same hotel, and, having heard of the accident, volunteered to write the notice out of sheer good feeling. This gentleman, an extreme *bon vivant* and a man of an excellent and versatile talent, has since told me that he gave himself particular trouble to imitate my father's slightly cumbrous Germanic English and his extreme modernist views. This service was afterward repaid by my father in the following circumstances. It was again one of the Three Choir Festivals—at Worcester, I think, and we were stopping at Malvern—my father and Mr S. going in every day to the cathedral city. Mr S. was either staying with us or in an adjoining house, and on one Wednesday evening, his appetite being sharpened by an unduly protracted performance of *The Messiah*, Mr S. partook so freely of the pleasures of the table that he omitted altogether to write his notice. This fact he remembered just before the closing of the small local telegraph-office, and, although Mr S. was by no means in a condition to write his notice, he was yet sufficiently mellow with wine to be lachrymose and overwhelmed at the idea of losing his post. We rushed off at once to the telegraph-office and did what we could to induce the officials to keep the wires open while the notice was being written. But all inducements failed. My

father hit upon a stratagem at the last moment. At that date it was a rule of the post-office that if the beginning of a long message were handed in before eight o'clock the office must be kept open until its conclusion as long as there was no break in the handing in of slips. My father therefore commanded me to telegraph anything that I liked to the newspaper-office as long as I kept it up while he was writing the notice of *The Messiah*. And the only thing that came into my head at the moment was the church service. The newspaper was therefore astonished to receive a long telegram beginning: '*When the wicked man turneth away from the sin that he has committed*' and continuing through the 'Te Deum' and the 'Nunc Dimittis,' till suddenly it arrived at 'The Three Choirs Festival. Worcester, Wednesday, July 27th, 1887.'

My father represents for me the Just Man! ... *In memoriam aeternam erit justus* and I do not believe he can ever have faltered before any judgement seat. He was enormous in stature, had a great red beard and rather a high voice. He comes back to me most frequently as standing back on his heels and visibly growing larger and larger. . . . My mother, who was incurably romantic and unreasonable with the unreason that was proper to the femininity of pre-Suffrage days, comes back to me as saying:

'Frank: isn't it just that Fordie should give his rabbit to his brother?' My brother having accidentally stepped on his own rabbit and killed it, my mother considered that I as the eldest should shew an example of magnanimity by giving him mine.

So my father, as large as Rhadamanthus and much more terrible, says: 'No, my dear, it is not *just* that Fordie should give his rabbit to his brother but if you wish it he must obey your orders as a matter of filial piety. . . .' And then the dread, slow: 'Fordie ... give your ... rabbit ... to your ... brother. . . . *Et plus vite que ça!*' He was fond of throwing in a French phrase.

I don't know who was more dissatisfied with that judge-

ment, I or my mother. But that is no doubt what justice is for.

MY FATE SETTLED

My father's last words to me were: 'Fordie, whatever you do, never write a book.' Indeed, so little idea had I of meddling with the arts that, although to me a writer was a very wonderful person, I prepared myself very strenuously for the Indian civil service. This was a real grief to my grandfather, and I think he was exceedingly overjoyed when the doctors refused to pass me for that service on the ground that I had an enlarged liver. And when, then, I seriously proposed to go into an office, his wrath became tempestuous.

Tearing off his night-cap—for he happened at the time to be in bed with a bad attack of gout—he flung it to the other end of the room.

'God damn and blast my soul!' he exclaimed. 'Isn't it enough that you escaped providentially from being one kind of a cursed clerk, but you want to go and be another? I tell you, I will turn you straight out of my house if you go in for any kind of commercial life.' So that my fate was settled for me.

THE PINES, PUTNEY

Well, time went on; my father died; Mr Watts-Dunton became my mother's trustee and my guardian. He also threw his comether over Mr Swinburne and took him to live with him in The Pines, Putney. There they both grew deaf together under the housekeepership of Mr Watts-Dunton's sister, the widow of an attorney who had not made good—in a white, high, widow's cap, white mittens

and a black silk shoulder-cape. Deaf, too.... You may imagine all three deaf people sitting together in the dusk of The Pines waiting for the argand colza-oil lamp to be lighted, when Mr Swinburne and Mrs Mason would play cribbage whilst the poet sipped his glass of Worcester Sauce and Mr Watts-Dunton pored over a crabbed volume of forgotten gipsy lore ... or made pretence so to do.

The Pines, Putney, as its name shews, was no place for the stabling of Pegasus. It was, upon the whole, the most lugubrious London semi-detached villa that it was ever my fate to enter. It was spacious enough, but, built at the time of the 1850–60 craze for Portland cement, its outer surfaces had collected enough soot to give it the aspect of the dwelling of a workhouse-master or chief gaoler. In the sooty garden grew a single fir that, in my time at least, could have gone as a Christmas-tree into the villa's dining-room. In the next garden there had been another, but that had died.

I don't mean to say that the house was poverty-stricken. It was the residence of the highly prosperous family lawyer that Mr Watts-Dunton was, well staffed with servants, the windows and furniture always kept at a high pitch of polish, the cut-steel fire implements always shining.... I imagine the walls must have been covered with brown paper in the proper aesthetic fashion of the advanced of the day and that that drank up the light.... At any rate the rooms of The Pines, Putney, were always dim.... I had occasion to go there pretty frequently ... once a quarter at least when my mother's dividends were due; and on occasion when she had outrun the constable and needed an advance ... or when I myself! ... So it was pretty often.

Then I would be received with an extraordinary pomp of praise by Mr Watts-Dunton. He would address to me studied periods of laudation of my latest published book. ... I had published I think six before I came of age ... and Mr Watts-Dunton addressed me as if I were a public meeting. And Mr Swinburne would add some nervous

phrases to the effect that he intended to read my book as soon as time served. . . . He would be floating somewhere about in the dimnesses like a shaft of golden light. . . . But when I came seriously to prefer my request for a cheque and Mr Watts-Dunton had exhausted the praise with which he put me off . . . then, if I was at all insistent, extraordinary things would happen. . . . Loud bells would ring all over the establishment. Housemaids would rush in, their cap-strings floating behind, bearing the orange envelopes of telegrams on silver salvers. And Mr Watts-Dunton would start like a ship suddenly struck by a gale, would tear open an envelope and exclaim dramatically:

'Sorry, me dear faller. . . . Extraordinarily sorry, me dear faller. . . . Tallegram from Hazlemere. From Lord Tennyson. . . . Have to go . . . ah . . . and correct his proofs at once. . . . M'm, m'm, m'm. . . . Desolated to be unable to be further delighted by most int'rustin' conversa . . .' And he would have disappeared, the dimnesses swallowing him up with improbable velocity. . . .

When it wasn't Lord Tennyson, it would be Browning . . . or Coventry Patmore or Lewis Morris. . . .

And you are not to believe that Mr Watts-Dunton was merely a toady. He was an extraordinarily assiduous and skilful family lawyer and adviser as to investments and solvent of brawls and poets' fallings-out. . . . So that where those poor Pre-Raphaelites would have been without him there is no knowing. . . . His one novel . . . *Aylwin* . . . had the largest sale ever enjoyed by any novel up to that date and for decades after. It was what his friends called bilge, and his innumerable poems seemed to be all devoted to proving that he had once been kissed by a Rommany lal . . . a sort of watered-down Isopel Berners. . . . But what else could the poems and novels of the proprietors of The Pines, Putney, be? . . . And when reading his poems aloud to Mr Swinburne, he would coyly hold his head on one side as if the better to afford you the view of the spot on the side of his jaw where the gipsy maiden had kissed him. . . . And I really believe one must have done so once. . . .

But he did save ever so many of those outrageous poet-painters from the workhouse or the gaol and kept as many more on this side of delirium tremens. . . .

On the less dramatic occasions when Mr Watts-Dunton really produced a cheque I would be invited to stay to lunch. . . . And owing to the increasing deafness of the two friends and of Mrs Mason the meals passed in ever deeper and deeper silence. . . . Mr Swinburne ate, lost in his dreams, with beside his plate, an enormous Persian cat to whom he fed alternate forkfuls of food. Mr Watts-Dunton gobbled his meats with voracity. The cooking was exquisite, the wines quite impeccable—though Mr Swinburne touched none. Mrs Mason addressed inaudible remarks to the maids. . . .

At a given point she would catch the eye of non-existent ladies and rise stiffly. . . . Immediately, with an extremely jerky movement so rapid as to be almost imperceptible, Mr Swinburne would be on his toe-points, positively running to the door, his coat-tails flapping behind him. . . . It was the singular action of an extremely active man. At one moment he was sitting sunk in his chair; at the next he was on the points of his toes and in extraordinarily rapid motion. . . . Mrs Mason would be passing out of the doorway with a rigid inclination of the head to Mr Swinburne, who had opened the door for her; and slowly and meditatively the poet would regain his chair . . . with the litheness of a slow cat . . . and would begin to talk in long, wonderful monologues . . . about the *Bacchae* or the *Birds*.

BEEF-TEA IN THE NIGHT

I never spoke to Mr Gladstone, but I saw him once extraordinarily close to. I was in a train going north—I should think in 1887. The train stopped at Swindon. Immediately alongside my carriage was another that contained Mr Gladstone. He was sitting reading a memo-

randum with his feet on the cushions of the opposite seat. His face was expressionless, or rather morose. He was quite alone. He was wearing a black woollen cap with ear-flaps tied under his chin. It struck me that anyone could easily have assassinated him if they had wanted to. And plenty did then!

I only once heard Mr Gladstone speak. Then he was in an outrageous temper. He was talking about Egyptian finance and someone—I think Lord Randolph Churchill —ejaculated: 'Remember Gordon!' Mr Gladstone was apparently still sensitive about the accusation that he had allowed Gordon to be murdered at Khartum. He let out a perfect flood of invective as to the unmannerliness of the interjection and menaced his interrupter with a wagging forefinger. His voice was of extreme beauty and of an amazing carrying power. In the Strangers' Gallery you could hear his merely whispered asides—almost his very breathing.

He was said to resemble an eagle. But in his anger he seemed to be very much more like the eagle-owl with all its feathers ruffled up into a shape like the sun. I would have sworn that his eyes were yellow. I wonder if anyone knows what colour his eyes were. Nobody knows that of Napoleon's.

I don't know if you know how many material comforts were lacking in the civilization of those days, I was told by one of the frequent hostesses of Mr. Gladstone that that statesman and his wife always took to bed with them a hot-water bottle filled with beef-tea. They drank the fluid in the night. At six in the morning Mr Gladstone had a grilled chicken leg and an egg beaten up in sherry brought to his bed-side. At eight he ate a great breakfast.

I remember going to a tea-party at the house of the lady who afterwards told me of Mr Gladstone's beef-tea. Mrs Gladstone came in with the tapes of her bodice hanging down on her bustle. No one dared inform her of it. The incident created an extraordinary sensation in London and was widely used as an argument against Home Rule by the

Tories. The argument was this: the Grand Old Man spent so much money in houses of ill fame that, firstly, his wife could not afford a proper lady's maid and, secondly, his behaviour drove Mrs Gladstone mad, so that she ran about with her clothing in disarray. Actually Mrs Gladstone was provided with a perfectly adequate and devoted staff of servants. But as old age came on she disliked standing still whilst her maid adjusted the armour of proof, the whale-bones, the hooks and eyes, bustles and jet caparisons that finished the lady's—and the charwoman's—uniform of that day. So whenever she could escape from her maid's hands she would.

The legends that the Tories invented as to Mr Glad-stone's incontinence were extraordinary—and they died hard. It is only a few years since a scabrous memoir-writer revived some of them and was suppressed. As a matter of fact, both the Grand Old Man and his wife interested themselves in reclaiming the 'fallen' amongst females—a Victorian pursuit that, if it was as odious as most Victorian moral activities, might still be said to leave its practitioners on the side of the angels.

I remember hearing a dear old lady, Miss Boyd of Penkill, who was not without artistic intelligence and the habit of the great world, definitely assert that the Grand Old Man was in the pay of the Pope and personally officiated at Black Masses. She said she had that on the authority of a Dean of the Anglican Church. I daresay she had.

I had a personal prejudice against Mr Gladstone. He resigned finally on the day when my first book of poems was published. So, although *The Pall Mall Gazette* gave that work a two-column review, it passed unnoticed. The tumult of that awful fall obscured all other events in England!

TIRED OF PARADES

It must have been in 1891—or possibly in 1892—that I met Bismarck walking all alone in the Popplesdorfer Allée. He was moving very slowly, leaning laboriously upon a cane—in the uniform of his old regiment—the Bonn Cuirassiers. His immense Great Dane, Tiras, the gift of the German nation, followed him, his great head lowered, so that his dewlaps nearly reached his master's heels. The Prince acknowledged my salute with a weary and as if distasteful raising of his heavy lids. It was as if he disliked me intensely. But I daresay it was only that, then, in the period of his fall and loneliness, he disliked the whole world. I remember thinking at the time: 'It is queer he should wear a uniform when now he must be tired of all parades and ceremonies.' But I understand it now. I should like to be wearing a uniform again myself. I suppose I never shall.*

THE DEATH OF ENGLISH POETRY

Wilde I can never forgive. You may maintain that he had a right to live his own life and, for the sake of sheer vanity, get himself into Reading Gaol. For there was no reason for his going to prison and the last thing that the British authorities wanted to do was to put him there. On the day of his arrest his solicitor received warning that the warrant would not be issued until after 7.00 P.M., the night train for Paris leaving at 6.50 from Charing Cross. I remember still the feeling of anxiety and excitement of the day. Practically everybody in London knew what was agate.

* Written in 1930.

Wilde went to his solicitor—Mr Robert Humphreys; I once had him for my lawyer—about eleven in the morning. Humphreys at once began to beg him to go to Paris. Wilde declared that the authorities dared not touch him. He was too eminent and there were too many others implicated. To that he stuck. He was immovable and would listen to no arguments. There came a dramatic moment in the lawyer's office. Wilde began to lament his wasted life. He uttered a tremendous diatribe about his great talents thrown away, his brilliant genius dragged in the mud, his early and glorious aspirations come to nothing. He became almost epic. Then he covered his face and wept. His whole body was shaken by his sobs. Humphreys was extremely moved. He tried to find consolations.

Wilde took his hands down from his face. He winked at Humphreys and exclaimed triumphantly:

'Got you then, old fellow.' He added: 'Certainly I shall not go to Paris.' He was arrested that evening.

I always intensely disliked Wilde, faintly as a writer and intensely as a human being. No doubt, as a youth he was beautiful, frail and illuminated. But when I knew him he was heavy and dull. I only once heard him utter an epigram. He used to come to my grandfather's with some regularity at one time—every Saturday, I should say. My grandfather was then known as the Grandfather of the Pre-Raphaelites and Wilde passed as a Pre-Raphaelite poet.

He would sit beside the high fire-place and talk very quietly—mostly about public matters: Home Rule for Ireland and the like. My grandfather was a rather down-to-the-ground sort of person, so that Wilde to him talked very much like anyone else and seemed glad to be in a quiet room beside a high fire-place.

Once, at a garden-party at the Bishop of London's, I heard a lady ask him if he were going to the dinner of the O. P. Club that evening. The O. P. Club had some grievance against Wilde. It was a dramatic society or something

of the sort. Dramatic organizations are excitable and mina-
tory when they disliked anybody. It was a dramatic society
that booed and hissed at Henry James when he took his
curtain-call after *Guy Domville*. But really they were
venting their wrath against Sir George Alexander, the
actor-manager who had that evening for the first time
made a charge for programmes. So Wilde would have had
a rough-house at the dinner of the O. P. Club. He there-
fore replied to the lady at the Bishop's party:

'I go to the dinner of the O. P. Club! I should be like
a poor lion in a den of savage Daniels.'

I saw Wilde several times in Paris and he was a truly
miserable spectacle, the butt usually of a posse of merciless
students. He possessed—and it was almost his only pos-
session—a walking-stick of ebony with ivory insertions,
the handle representing an elephant. This he loved very
much because it had been a gift of someone—Lady Mount
Temple, I think. He would be of an evening in one or
another disagreeable *bouge* in Montmartre. The students
would get about him. It was the days of the apaches.
There would be a fellow there called Bibi La Touche or
something of the sort. The students would point him out
to Wilde and declare that Bibi had taken a fancy to his
stick and would murder him on his homeward way if he
did not surrender it. Wilde would cry, the tears pouring
down his great cheeks. But always he surrendered his stick.
The students would return it to his hotel next morning
when he would have forgotten all about it. I, once or per-
haps twice, rescued his stick for him and saw him home.
It would not be agreeable. He did not have a penny and
I had very little more. I would walk him down the miser-
ably lit Montmartrois streets, he completely silent or
muttering things that I did not understand. He walked
always as if his feet hurt him, leaning forward on his
precious cane. When I thought we were near enough to
the Quartier for my resources to let me pay a cab—usually
in the neighbourhood of the Boulevard de la Madeleine—
we would get into one and would at last reach the Rue

Jacob. This happened I think twice, but the memory is one as if of long-continued discomfort. It was humiliating to dislike so much one so unfortunate. But the feeling of dislike for that shabby and incoherent immensity was unavoidable. It had proved so strong that, the locality taking on an aspect of nightmare, I have only once since visited Montmartre at night in, say, thirty-five years and then found it very disagreeable. Of course, the sight of the young people, like starlings, tormenting that immense owl had a great deal to do with my revulsions.

On one occasion—I should think in the Chat Noir—I was with Robert de la Sizéranne and, looking at Wilde who was across the room, he said:

'*Vous voyez cet homme-là. Il péchait par pur snobisme.*'

He meant that, even in his offences against constituted society, Wilde was out to *épater les bourgeois*—to scandalize the middle classes. Sizéranne added: '*Cela le faisait chaque fois vomir!*'

That was pretty generally the French view and, on the face of it, I should say it was just. Sizéranne who was then accounted a very sagacious critic of art, mostly Pre-Raphaelite, moved in French circles where Wilde had once throned it almost as an Emperor.

The rather idle pursuit of *épaté*-ing the bourgeoisie was very much the fashion amongst the *Yellow Book* group who surrounded Wilde. In order to 'touch the Philistine on the raw,' as they called it, the Thompsons, Dowsons, Davidsons, Johnsons and the rest found it necessary to introduce an atmosphere of the Latin Quarter in its lighter —or more dismal side—into London haunts. The Latin Quarter is in fact a very grave, silent and austere region. But it has its Bohemian fringes—and a non-Anglo-Saxon population bred to survive such dissipations as are there to be found. Anglo-Saxons are not so bred. They resemble the populations of Central Africa succumbing before the clothing, gin and creeds of white men. That in the bulk. There are, of course, individuals who survive.

The Bodley Head group did not survive. They suc-

cumbed in London's Soho haunts—to absinthe, to tuber-
culosis, to starvation, to reformers or to suicide. But in
their day, they were brilliantly before the public, and
London was more of a literary centre then than it has ever
been before or since.

The book world was then electric. Books were every-
where. Accounts of the personal habits of writers filled the
daily papers. Minute volumes of poems in limited editions
fetched unheard prices at auction. It was good to be a
writer in England. And it is to be remembered that, as far
as that particular body was concerned, the rewards were
earned. They were skilful and earnest writers. They were
an immense improvement on their predecessors. They
were genuine men of letters.

I was looking last night at the works of Ernest Dowson.
They are faint, like drypoint etchings. Their daringnesses
are the common coin of to-day. But they have the authentic
note. When you read them you have a faint flavour of
what was good in those days: the tentativeness of thought,
the delicacy, the refinement of point of view. In their day
they were international and brilliant. I do not think they
will ever appear ignoble.

But all that went with the trial of Wilde.

I hardly came at all in contact with either the Henley
or the *Yellow Book* group at that date, though later, I
just knew Henley, and Messrs. Whibley, Wedmore and
Marriott Watson. I thought then that the others were too
harshly brilliant for me. So I was astonished to find in the
work of Dowson just now, almost New England delicacies
—an as it were Bostonian after-taste. And, if you consider
what a considerable part was played by Americans of that
type in the art worlds of London and Paris, you will be
less astonished to find that flavour.

Those were the days when James and Howell and
Harland and Whistler and Sargent and Abbey, not to men-
tion lesser lights like G. H. Boughton, more popular ones
like Bret Harte or immensely great ones like Mark Twain,

bulked enormously in politely advanced artistic circles in London.

The Yellow Book was an American venture and made for those American virtues of delicacy, French technical achievement and New England refinements—thus touching hands with both sides of the Atlantic. And *The Yellow Book* as nearly captured the stronghold of the Established Comfortable that London is, as later—and I hope to show you that—the American movement led by Ezra and called indifferently Vorticism, Futurism, Imagism, so nearly achieved that feat. Then condemnation of Wilde wiped out the one, a large cataclysm the other.

Wilde, then, brought down the *Yellow Book* group and most of the other lyrists of a London that for its year or two had been a nest of singing birds. James and Harland were almost the only survivors. Poets died or fled to other climes, publishers also fled, prosateurs were fished out of the Seine or reformed and the great public said: 'Thank heavens, we need not read any more poetry!'

You may think that an exaggeration. So did I at the time. But, just after the papers had announced the conviction and sentence on Wilde, I was going up the steps of the British Museum. On them I met Dr Garnett, the Keeper of Printed Books, a queer, very tall, lean, untidily bearded Yorkshire figure in its official frock-coat and high hat. I gave him the news. He looked for a moment away over the great yard of the Museum, with its pigeons and lamps and little lions on the railings. Then he said:

'Then that means the death of English poetry for fifty years.'

I can still hear the high tones of my incredulous laughter. At the moment he seemed to me an old obstinate crank, though I knew well how immense was his North Country common sense.

Having a passion for cats, Egyptology, palmistry and astrology, the great scholar could assume some of the aspect of deaf obstinacy that distinguishes cats that do not intend to listen to you. He cast the horoscope of all

his friends and reigning sovereigns; he knew the contents of a hundred thousand books and must have stroked as many thousand 'pussies' pronouncing the 'pus' to rhyme with 'bus.' He was inseparable from his umbrella with which he once beat off two thieves, when at five in the morning he had gone to Covent Garden to buy the household fruit. He was the author of the most delightful volume of whimsico-classical stories that was ever written and the organiser of the compilers of the catalogue of the British Museum Library—an achievement that should render him immortal if his *Twilight of the Gods* fails to do so. He would say to you that the ancient Egyptians were the only really civilized race, for, when fires occurred in their great buildings, they organized environing cordons, not to put out the fires but to see that no cats re-entered their burning homes.

On this occasion he held his top-hatted head obstinately and deftly on one side and repeated, with half-closed eyes:

'That means the death-blow to English poetry. It will not be resuscitated for fifty years.'...

CITY OF DREADFUL NIGHT

Those were grim enough times for artists—the eighties and early nineties. I don't know that they are any better now. Thus poor James Thomson, writing as B. V., sang of the City of Dreadful Night, and, we are told, drank himself to death. That was the grisly side of it. If you were a poet you lived in deep atmospheric gloom and, to relieve yourself, to see colour, you must sing of Launcelot and Guinevere. If the visions would not come, you must get stimulants to give you them. I remember as a child being present in the drawing-room of a relative just before a dinner at which Tennyson and Browning had been asked to meet a rising poet to whom it was desired to give a

friendly lift. It was the longest and worst quarter of an hour possible. The celebrities fidgeted, did not talk, looked in Olympian manner at their watches. At last they went in to dinner without the young poet. I was too little and too nervous to tell them that half an hour before I had seen the poor fellow lying hopelessly drunk across a whelk-stall in the Euston Road.

One of the grimmest stories that I have heard even of that time and neighbourhood was told me by the late Mr William Sharp. Mr Sharp was himself a poet of the Pre-Raphaelites, though later he wrote as Fiona Macleod, and thus joined the Celtic school of poetry that still flourishes in the person of Mr W. B. Yeats. Mr Sharp had gone to call on Philip Marston, the blind author of 'Songtide,' and of many other poems that in that day were considered to be a certain passport to immortality. Going up the gloomy stairs of a really horrible house near Gower Street Station, he heard proceeding from the blind poet's rooms a loud sound of growling, punctuated with muffled cries for help. He found the poor blind man in the clutches of the poet I have just omitted to name, crushed beneath him and, I think, severely bitten. This poet had an attack of delirium tremens and imagined himself a Bengal tiger. Leaving Marston, he sprang on all fours toward Sharp, but he burst a blood-vessel and collapsed on the floor. Sharp lifted him onto the sofa, took Marston into another room, and then rushed hatless through the streets to the hospital that was round the corner. The surgeon in charge, himself drunk and seeing Sharp covered with blood, insisted on giving him in charge for murder; Sharp, always a delicate man, fainted. The poet was dead of hemorrhage before assistance reached him.

But in gloom and amidst horror they sang on bravely of Launcelot and Guinevere, Merlin and Vivien, ballads of Staffs and Scrips, of music and moonlight. They did not —that is to say—much look at the life that was round them; in amid the glooms they built immaterial pleasure-

houses. They were not brave enough—that, I suppose, is why they are very few of them remembered, and few of them great.

I have, however, very little sense of proportion in this particular matter. There were Philip Bourke Marston, Arthur O'Shaughnessy, 'B. V.,' Theo Marzials, Gordon Hake, Christina Rossetti, Mr Edmund Gosse, Mr Hall Caine, Oliver Madox Brown, Mr Watts-Dunton, Mr Swinburne, D. G. Rossetti, Robert Browning! ...

THE GLOOM OF LONDON

I fancy the physical gloom of London adds to the heaviness of my memory of those days. A city whose streets are illuminated only by the flicker of rare street-lamps seems almost darker than one not lit at all. And the corners of rooms are always filled with shadows when the sole illuminant is a dim oil-lamp or a bluish gas-flame. And in London it was always winter. I remember, at any rate, no spring.

Above the darkness brooded the Hard Times. I am talking now of the early nineties. It is difficult to think how people lived then. In cold, in darkness, lacking sufficient clothes or sufficient food. With the aid of gin perhaps, or beer when you could cadge a pint. Charles Booth in his *Life and Labour of the Poor in London* states that 90 per cent of the population of London in those days depended for its *menus plaisirs*—its glimpses of light, of pleasure, its beanfeasts, its pints at the pubs—on windfalls. A working-man got the price of a pint of beer for dexterously holding a lady's skirts off the wheel as she stepped out of a carriage. He would get as much for hailing a cab on a wet night. A charwoman got an old dress given her and sold it in a rag-and-bone shop for the price of a quartern of gin. Cooks had their perquisites—their 'perks.' Old women with 'puffity pockets' beneath their

skirts slunk up and down area railings. When they went up, the pockets would contain pounds of dripping: mutton-fat, half plum-cakes, remains of joints of beef. With the price of them the cook would get a new hat and some tobacco for her father in the workhouse. You lived in slums in Seven Dials, Whitechapel, Notting Dale. You burned the stair-rails and banisters, the door-jambs, the window-frames for fuel. The rest of the world was no better. In Paris half the population was insufficiently fed; on sunny days the most horrible, half-nude creatures sunned themselves on the benches of the Champs-Elysées. In Berlin the greater part of the population never thought of tasting meat. In St Petersburg the condition of the poor would not bear thinking of. When you did witness it, you went mad or divested yourself of all your goods. Kropotkin had done that and was only one of scores of Princes and great land-owners. 'The poor,' the middle-class householder said, 'are always with us. These are the words of Jesus Christ.' So he put on several mufflers, buried his purse in an inner pocket and buttoned up his overcoat to the chin, the better to avoid the temptation to give a starving woman a ha'penny. I remember taking the young daughter of my father's most intimate friend, who was Queen Victoria's Master of Music, on the River Blythe in a canoe. I talked to her about the conditions of the poor. Next day her mother Lady Cusins said to me:

'Fordie, you are a dear boy. Sir George and I like you very much. But I must ask you not to talk to dear Beatrice ... about Things!' *Punch* itself was once almost suppressed. It printed a drawing of Charles Read's, showing two miserable women of the 'Unfortunate Class' soaked by rain and shivering under one of the Adelphi arches. One of them says to the other: 'Dearie.... 'Ow long 'ave *you* been gay!' 'Gay,' of course, signified 'unfortunate.' The consternation in Victorian London was terrific. *Punch* had spoken about Things. It never has again.

The natural corollary of these pressures was ... Anar-

chism, Fabianism, dynamitings, Nihilism. I saw a good deal of the inner workings of these.

MONSTROUS SOLEMN FUN

I don't know where the crowds came from that supported us as Anarchists, but I have seldom seen a crowd so great as that which attended the funeral of the poor idiot who blew himself to pieces in the attempt on Greenwich Observatory. This was, of course, an attempt fomented by the police agents of a foreign state with a view to forcing the hand of the British Government. The unfortunate idiot was talked by these *agents provocateurs* into taking a bomb to Greenwich Park, where the bomb exploded in his pocket and blew him into many small fragments. The idea of the Government in question was that this would force the hand of the British Government so that they would arrest wholesale every Anarchist in Great Britain. Of course, the British Government did nothing of the sort, and the crowd in Tottenham Court Road which attended the funeral of the small remains of the victim was, as I have said, one of the largest that I have ever seen. Who were they all? Where did they all come from? Whither have they all disappeared? I am sure I don't know, just as I am pretty certain that, in all those thousands who filled Tottenham Court Road, there was not one who was more capable than myself of beginning to think of throwing a bomb. I suppose it was the spirit of romance, of youth, perhaps of sheer tomfoolery, perhaps of the spirit of adventure, which is no longer very easy for men to find in our world of grey and teeming cities. I couldn't be Dick Harkaway with a Winchester rifle, so I took it out in monstrous solemn fun, of the philosophic Anarchist kind, and I was probably one of twenty thousand. My companion upon this occasion was Comrade P., who, until quite lately, might be observed in the neighbourhood of

the British Museum—a man with an immensely long beard, with immensely long hair, bare-headed, bare-legged, in short running-drawers, and a boatman's jersey, that left bare his arms and chest. Comrade P. was a medical man of great skill, an eminently philosophic Anarchist. He was so advanced in his ideas that he dispensed with animal food, dispensed with alcohol and intensely desired to dispense with all clothing. This brought him many times into collision with the police, and as many times he was sent to prison for causing a crowd to assemble in Hyde Park, where he would appear to all intents and purposes in a state of nature. He lived, however, entirely upon crushed nuts. Prison diet, which appeared to him sinfully luxurious, inevitably upset his digestion. They would place him in the infirmary and would feed him on boiled chicken, jellies, beef-tea and caviare, and all the while he would cry out for nuts, and grow worse and worse, the prison doctors regularly informing him that nuts were poison. At last Comrade P. would be upon the point of death, and then they would give him nuts. P. would immediately recover, usually about the time that his sentence had expired. Then, upon the Sunday, he would once more appear like a Greek athlete running through Hyde Park. A most learned and gentle person, most entertaining and the best of company, this was still the passion of his life. The books in the British Museum were almost a necessity of his existence, yet he would walk into the reading-room attired only in a blanket, which he would hand to the cloak-room attendant, asking for a check in return. Eventually his reader's ticket was withdrawn, though with reluctance on the part of the authorities, for he was a fine scholar, and they very humane men. Some time after this Comrade P. proposed to me that I should accompany him on the top of a bus. His idea was that he would be attired in a long ulster; this he would take off and hand to me, whereupon I was to get down and leave him in this secure position. My courage was insufficient—the united courages of all Comrade P.'s friends were insufficient to

let them aid him in giving thus early a demonstration of
what nowadays we call the Simple Life, and Comrade P.
had to sacrifice his overcoat. He threw it, that is to say,
from the top of the bus, and, with his hair and beard
streaming over his uncovered frame, defied alike the
elements and the police. The driver took the bus, Com-
rade P. and all, into an empty stable, where they locked
him up until the police arrived with a stretcher from
Bow Street. At last the magistrate before whom Comrade
P. habitually appeared grew tired of sentencing him.
Comrade P. was, moreover, so evidently an educated and
high-minded man that the stipendiary perhaps was
touched by his steadfastness. At all events, he invited P.
to dinner—I don't know what clothes P. wore upon this
occasion. Over this friendly meal he extracted from P. a
promise that he would wear the costume of running-
drawers, an oarsman's jersey and sandals which I have
already described, and which the magistrate himself de-
signed. Nothing would have persuaded P. to give this
promise had not the magistrate promised in return to get
for P. the reader's ticket at the British Museum which he
had forfeited. And so, for many years, in this statutory
attire P., growing greyer and greyer, might be seen walk-
ing about the streets of Bloomsbury. Some years afterward,
when I occupied a cottage in the country, P. wrote and
asked to be permitted to live in my garden in a state of
nature. But, dreading the opinions of my country neigh-
bours, I refused, and that was the last I heard of him.

THE TRIUMPH OF THE BOURGEOISIE

My grandfather, a romantic old gentleman of the Tory
persuasion by predisposition, was accustomed to express
himself as being advanced in the extreme in his ideas.
Such was his pleasant fancy that I am quite certain he
would have sported a red tie had it not clashed with the

blue linen shirts that he habitually wore. And, similarly, my Aunt Rossetti, to whom my infant thoughts were so frequently entrusted—this energetic and romantic lady was of such advanced ideas that I have heard her regret that she was not born early enough to be able to wet her handerkerchief in the blood of the aristocrats during the French Reign of Terror. Nay, more, during that splendid youth of the world in the eighties and nineties, the words 'the Social Revolution' were forever on our lips. We spoke of it as if it were always just around the corner, like the three-horse omnibus which used to run from Portland Place to Charing Cross Station—a bulky conveyance which we used to regard with longing eyes as being eminently fitted, if it were upset, to form the very breastwork of a barricade—in these young, splendid and stern days my cousins, the Rossettis, aided, if not pushed to it, by my energetic, romantic aunt, founded that celebrated Anarchist organ known as *The Torch*. But, though my grandfather hankered after wearing a red tie, said that all lords were damned flunkeys, that all Her Majesty's judges were venial scoundrels, all police magistrates worse than Judas Iscariot and all policemen worse even than Royal Academicians— it would never, no, it would never have entered his head to turn one of his frescoes in the Town Hall, Manchester, into a medium for the propaganda of the Social Revolution. He hated the bourgeoisie with a proper hatred, but it was the traditional hatred of the French artist. The bourgeoisie returned his hatred to more purpose, for, just before his death, the Town Council of Manchester, with the Lord Mayor at its head, sitting in private, put forward a resolution that his frescoes in the Town Hall should be whitewashed out and their places taken by advertisements of the wares of the aldermen and the councillors. Thus perished Ford Madox Brown—for this resolution, which was forwarded to him, gave him his fatal attack of apoplexy. The bourgeoisie had triumphed.*

* This resolution was never carried out, and the triumph of the bourgeoisie short lived.

ROSSETTI'S INVERNESS CAPE

Upon Rossetti's death his Inverness, which was made in the year 1869, descended to my grandfather. Upon my grandfather's death it descended to me, it being then twenty-three years old. I wore it with feelings of immense pride, as if it had been—and indeed, was it not?—the mantle of a prophet. And such approbation did it meet in my young friends of that date that this identical garment was copied seven times, and each time for the use of a gentleman whose works when Booksellers' Row still existed might ordinarily be found in the twopenny box. So this garment spread the true tradition, and, indeed, it was imperishable and indestructible, though what has become of it by now I do not know. I wore it for several years until it must have been aged probably thirty, when, happening to wear it during a visit to my tailor's and telling that gentleman its romantic history, I was distressed to hear him remark, looking over his pince-nez:

'Time the moths had it!'

This shed such a slight upon the garment from the point of view of tailors that I never wore it again. It fell, I am afraid, into the hands of a family with little respect for relics of the great, and I am fairly certain that I observed its capacious folds in the mists of an early morning upon Romney Marsh some months ago, enveloping the limbs of an elderly and poaching scoundrel called Slingsby.

MY MUSIC MASTER

I used to have violin lessons from the queer, tragic Borschitzky whose dismal adventure caused Euston Square

to be re-christened. He came home late at night and found his landlady murdered in the kitchen. Being nearly blind he fell over the body, got himself covered with blood and as a foreigner and a musician was at once arrested by the intelligent police. He was of course acquitted but the trial caused so much sensation as the 'Euston Square murder' that the respectable inhabitants petitioned to have the name of the square changed and it became Endsleigh Gardens.

Poor Borschitzky was a small, bald man with an immense nose who wore his greyish hair brushed stiffly forward into peaks, and his Gladstone collars came forward into peaks equally stiff. He was usually dressed in an immensely long frock-coat that nearly hid his tiny legs and enormous feet. He spoke the most extravagantly pidgin English I have ever imagined and told the longest and most extraordinary stories.

His stories went like this:

'Zair voss a Gris-chun met a Chew. 'E sez to 'im: "You uckly Chew I haf ad a mos' 'orible tream. It voss a mos' 'orible tream. I tream I co to dhe Chewish Evven an it voss a mos' 'orible place. Ze spidoons voss all filzy an ze daples coffred viz creese and dher voss no sand on de floor and de praziers voss dhick wiz rust. O it voss a mos' 'orible place and it voss fooll fooll fooll of 'orible uckly Chews spiddin on ze floor and shmoking; shmoking filthy filthy paipes."

'"Dad voss vairy curious," sez ze Chew. "I allso haf a tream. I tream I co to dhe Gris-chun Evven. O, and it voss a mos' loffly place. De spidoons voss of prass zat shone laike colld and dhe sand on der floor laike silber. Ond de daples voss viter ass a snotrift ond de praziers voss silber ond de dobacco poxes oll retty do be smoaked: O it voss a mos' loffly place. Loffly; loffly! ontly ... zer vos nowun in it!"'

Towards the end of his life great troubles fell on poor Borschitzky. His mainstay had for years been the preparatory school to which I was sent. All his other pupils fell

away; no orchestra would any longer employ him or play his compositions. Then his old friends, the owners of the school, died. They had supported him for years in spite of his peculiarities. The new owners of the school dismissed him. Then he had nothing and was perhaps seventy-two. He packed up his never-played compositions in several bundles and took them to the British Museum Library. Doctor Garnett told him kindly that the Museum only accepted the compositions of the dead. He went to the Post-Office at the corner of Endsleigh Gardens, mailed the parcel to the Museum and then back to his room. He tidied it very thoroughly and destroyed a number of papers. Then he went out and by the railings of the Square before his windows he cut his throat. If he had done it indoors it would have caused his landlady a great deal of trouble and have made a horrid mess for her to clean up.

But still, when in Continental cathedrals I hear the boom of the serpent and the sharp tap of the cantor as he starts the choir in its plain-song, I see the form of poor Borschitzky with his bow held over his beloved fiddle and the school choir with its mouths all open before him. He taps magisterially three times with his bow, his side-locks stick forward, his coat-tails hanging down to his enormous boots. 'Van! Doo! Dree . . . Pom-Pom,' he shouts and off we all go on his rendering of the words that accompany the Ninth Symphony. God send him an old leather cushion stuffed with straw for his hard chair in his Chewish Evven . . . and send to all old, worn-out artists to be as considerate in their final distress.

TRADITION AMPLY CARRIED ON

At the last public school which I attended—for my attendances at schools were varied and singular, according as my father ruined himself with starting new periodicals

or happened to be flush of money on account of new
legacies—at my last public school I was permitted to
withdraw myself every afternoon to attend concerts. This
brought down upon me the jeers of one particular Ger-
man-master who kept order in the afternoons, and upon
one occasion he set for translation the sentence:

'Whilst I was idling away my time at a concert the rest
of my class-mates were diligently engaged in the study of
the German language.'

Proceeding mechanically with the translation—for I paid
no particular attention to Mr P., because my father, in his
reasonable tones, had always taught me that schoolmasters
were men of inferior intelligence to whom personally we
should pay little attention, though the rules for which
they stood must be exactly observed—I had got as far
as '*Indem ich faulenzte . . .*' when it suddenly occurred to
me that Mr P., in setting this sentence to the class, was
aiming a direct insult not only at myself, but at Beethoven,
Bach, Mozart, Wagner and Robert Franz. An extraordinary
and now inexplicable fury overcame me. At all my schools
I was always the good boy of my respective classes, but on
this occasion I rose in my seat, propelled by an irresistible
force, and I addressed Mr P. with words the most insult-
ing and the most contemptuous. I pointed out that music
was the most divine of all arts: that German was a lan-
guage fit only for horses; that German literature con-
tained nothing that any sensible person could want to read
except the works of Schopenhauer, who was an Anglo-
maniac, and in any case was much better read in an
English translation; I pointed out that Victor Hugo has
said that to alter the lowest type of inanities, '*il faut être
stupide comme un maître d'école qui n'est bon à rien que
pour planter des choux.*' I can still feel the extraordinary
indignation that filled me, though I have to make an effort
of the imagination to understand why I was so excited; I
can still feel the way the breath poured through my dis-
tended nostrils. With, I suppose, some idea of respect for
discipline, I had carefully spoken in German, which none

of my class-mates understood. My harangue was suddenly ended by Mr P.'s throwing his large inkpot at me; it struck me upon the shoulder and ruined my second-best coat and waist-coat.

I thought really no more of the incident. Mr P. was an excellent man, with a red face, a bald head, golden side-whiskers and an apoplectic build of body. Endowed by nature with a temper more than volcanic, it was not unusual for him to throw an inkpot at a boy who made an exasperating mistranslation, but he had never before hit anybody; so that meeting him afterward in the corridors I apologised profusely to him. He apologised almost more profusely to me, and we walked home together, our routes from school being exactly similar. I had the greatest difficulty in preventing his buying me a new suit of clothes, while with a gentle reproachfulness he reproved me for having uttered blasphemies against the language of Goethe, Schiller, Lessing and Jean Paul Richter. It was then toward the end of the term, and shortly afterward the headmaster sent for me and informed me that I had better not return to the school. He said—and it was certainly the case—that it was one of the founder's rules that no boy engaged in business could be permitted to remain. This rule was intended to guard against gambling and petty huckstering among the boys. But Mr K. said that he understood I had lately published a book and had received for it not only publicity but payment, the payment being against the rules of the school, and the publicity calculated to detract from a strict spirit of discipline. Mr K. was exceedingly nice and sympathetic, and he remarked that in his day my uncle Oliver Madox Brown had had the reputation of being the laziest boy at that establishment, while I had amply carried on that splendid tradition.

MY OLDEST LITERARY RECOLLECTION

Thinking and walking up and down in the tall room of a friend in Greenwich Village I looked at a bookshelf, then took out a dullish-backed book at random. At the bottom of a page were the words:

'So you see, darling, there is really no fear, because, as long as I know you care for me and I care for you, nothing can touch me.'

I had a singular emotion. I was eighteen when I first read those words. My train was running into Rye Station and I had knocked out the ashes of my first pipe of shag tobacco. Shag was the very cheapest, blackest and strongest of tobaccos in England of those days. I was therefore economizing. My first book had just been published. I was going courting. My book had earned ten pounds. I desired to be a subaltern in H.B.M.'s Army. The story was Mr Kipling's 'Only a Subaltern.' The next station would be Winchelsea, where I was to descend. I had given nine of the ten pounds to my mother. If I was to marry and become a subaltern, I must needs smoke shag. And in a short clay pipe, to give the fullest effect to retrenchment! Briars were then eighteenpence, short clays two for a penny.

That is my oldest literary recollection.

It is one of my most vivid. More plainly than the long curtains of the room in which I am writing, I see now the browning bowl of my pipe, the singularly fine grey ashes, the bright placards as the train runs into the old-fashioned station and the roughness of the paper on which there appeared the words——

So you see, darling, there is really no fear——

I suppose they are words that we all write one day or another. Perhaps they are the best we ever write.

The fascicle of Kipling stories had a blue-grey paper

cover that shewed in black a fierce, whiskered and turbaned *syce* of the Indian Army. I suppose he was a *syce*, for he so comes back to me. At any rate, that cover and that Mohammedan were the most familiar of objects in English homes of that day. You have no idea how exciting it was in those days to be eighteen and to be meditating, writing for the first time *there is really no fear.* . . .

REGRETS

I saw Samuel Butler bearing down on us.* I disliked Samuel Butler more than anyone I knew. He was intolerant and extraordinarily rude in conversation—particularly to old ladies and young persons. He had perhaps cause to be, for he was conscious of great gifts and of being altogether neglected. In those days he was almost unknown. *Erewhon* was nearly forgotten, *The Way of All Flesh* unpublished and not even fully written. Otherwise he was unfavourably known as having pirated the ideas of Darwin and as having behaved with extraordinary rudeness to that great and aged scientist. It struck me that, as he was bearing down on us, he had the air of a pirate. His complexion was fresh, his hair and torpedo beard of silver grey; he kept his hands usually in his coat-pocket. His coat was a square blue reefer; his red necktie was confined in a gold scarf ring. It is one of the regrets of my life that I made nothing at all of two of the most remarkable men I ever met casually and fairly frequently. Butler was too arrogant, Synge too modest. I saw Synge rather often when he was a journalist in Paris. He said very little and seemed to be merely another, florid, tuberculous Irishman. Yet I suppose that *The Way of All Flesh* and *The Playboy of the Western World* are the two great milestones on the

* At a tea party in Dr Richard Garnett's rooms in the British Museum.

road of purely English letters between *Gulliver's Travels*
and Joyce's *Ulysses*.

A PHILOSOPHER'S SILENCE

The late Mr Herbert Spencer once sat at table next to a
connection of my own for three consecutive days. He sat
in deep silence. Upon the fourth day he took from his
ears two little pads of cotton-wool. He exhibited them to
the lady and remarking, 'I stop my ears with these when
I perceive there is no one at the table likely to afford
rational conversation,' he put them back again.

A MR HARDY

I was keenly aware of a Mr Hardy who was a kind, small
man, with a thin beard, in the background of London
tea-parties . . . and in the background of my mind. . . . I
remember very distinctly the tea-party at which I was
introduced to him by Mrs Lynn Lynton with her paralys-
ing, pebble-blue eyes, behind gleaming spectacles. Mrs
Lynn Lynton, also a novelist, was a Bad Woman, my
dear. One of the Shrieking Sisterhood! And I could never
have her glance bent on me from behind those glasses
without being terrified at the fear that she might shriek
. . . or be Bad. I think it was Rhoda Broughton who first
scandalized London by giving her heroine a Latchkey.
But Mrs Lynn Lynton had done something as unspeak-
ably wicked. . . . And I was a terribly proper young man.

So, out of a sort of cloud of almost infantile paralysis—
I must have been eighteen to the day—I found myself
telling a very very kind, small, ageless, soft-voiced gentle-
man with a beard, the name of my first book, which had
been published a week before. And he put his head on one

side and uttered, as if he were listening to himself, the syllables: 'Ow . . . Ow. . . .'

I was petrified with horror . . . not because I thought he had gone mad or was being rude to me, but because he seemed to doom my book to irremediable failure. . . .

I do not believe I have ever mentioned the name of one of my own books in my own print . . . at least I hope I have been too much of a little gentleman ever to have done so. But I do not see how I can here avoid mentioning that my first book was called *The Brown Owl* and that it was only a fairy-tale. . . . I will add that the publisher—for whom Mr Edward Garnett was literary adviser—paid me ten pounds for it and that it sold many thousands more copies than any other book I ever wrote . . . and keeps on selling to this day.

And on that day I had not got over the queer feeling of having had a book published. . . . I hadn't wanted to have a book published. I hadn't tried to get it published. My grandfather had, as it were, ordered Mr Garnett to get it published. . . . I can to this day hear my grandfather's voice saying to Mr Garnett, who was sitting to him on a model's throne:

'Fordie has written a book, too. . . . Go and get your book, Fordie!' . . . and the manuscript at the end of Mr Garnett's very thin wrist disappearing into his capacious pocket. . . . And my mother let me have ten shillings of the money paid by Mr Garnett's employer. . . . And that had been all I had got of authorship. . . . So that I thought authorship was on the whole a mug's game and concealed as well as I could from my young associates the fact that I was an Author. I should have told you that that was my attitude and should have believed it. My ambition in those days was to be an Army Officer!

And then suddenly, in Mrs Lynn Lynton's dim, wicked drawing-room, in face of this kind, bearded gentleman, I was filled with consternation and grief. Because it was plain that he considered that the vowel sounds of the title of my book were ugly and that, I supposed, would mean

that the book could not succeed. So I made the discovery
that I—but tremendously!—wished that the book should
succeed ... even though I knew that if the book should
succeed it would for ever damn my chances as one of Her
Majesty's officers. ...

And I could feel Mr Hardy feeling the consternation
and grief that had come up in me, because he suddenly
said in a voice that was certainly meant to be consolatory:

'But of course you meant to be onomatopoeic. Ow—ow
—representing the lamenting voices of owls. ... Like the
repeated double O's of the opening of the Second Book
of *The Aeneid*. ...'

On that distant day in Mrs Lynton's drawing-room, I
was struck as dumb as a stuck pig. I could not get out a
word whilst he went on talking cheerfully. He told me
some anecdotes of the brown owl and then remarked that
it might perhaps have been better if, supposing I had
wanted to represent in my title the cry of the brown owl,
instead of two 'ow' sounds I could have found two 'oo's.'
... And he reflected and tried over the sound of 'the
brooding coots' and 'the muted lutes.'. ...

And then he said, as if miraculously to my easement:

'But of course you're quite right. ... One shouldn't
talk of one's books at tea-parties. ... Drop in at Max
Gate when you are passing and we'll talk about it all in
peace. ...'

Marvellously kind ... and leaving me still a new emo-
tional qualm of horror. ... Yes, I was horrified ... because
I had let that kind gentleman go away thinking that my
book was about birds ... whereas it was about Princesses
and Princes and magicians and such twaddle. ... I had
written it to amuse my sister Juliet. ... So I ran home and
wrote him a long letter telling him that the book was not
about birds and begging his pardon in several distinct
ways. ...

Then a storm burst on the British Museum. The young
Garnetts went about with appalled, amused, incredulous
or delighted expressions, according as the particular young

Garnett was a practicing Anglican, an Agnostic or a Nihilist. . . . It began to be whispered by them that Mrs Hardy, a Dean's daughter, had taken a step. . . . She had been *agonised* . . . she hadn't been able to *stand* it. . . . The reception of *Tess* had been too *horrible* . . . for a Dean's daughter. . . . All the Deans in Christendom had been driven to consternation about *Tess*. They had all arisen and menaced Max Gate with their croziers. (I know that Deans do not wear croziers. But that was the effect the young Garnetts had produced.)

It came out at last. . . . Mrs Hardy had been calling on Dr Garnett as the Dean of Letters of the British Isles and Museum to beg, implore, command, threaten, anathematize her husband until he should be persuaded or coerced into burning the manuscript of his new novel—which was *Jude*. She had written letters; she had called. She had wept; like Niobe she had let down her blond hair. . . . The Agnostic and Nihilist young Garnetts rejoiced, the Anglicans were distraught. Doctor Garnett had obdurately refused. . . . I don't believe I cared one way or the other. I didn't like the Church of England. On the other hand I didn't want any lady or a multitude of Deans to be distressed. . . .

A long time after—six months, I dare say—I had my answer from Mr Hardy. It seemed to be part of his immense kindness that, though he should have so long delayed the answer, nevertheless he should have answered. The tendency of ordinary men, if they have not answered a letter for a long time, is to tear it up and throw it into the waste-paper basket. I imagined him to have waited until the tremendous stir and racket over *Jude the Obscure* should have died away, but never to have put out of his mind altogether the letters that his kindness told him he ought eventually to write.

Mr Hardy told me again to drop in on him any time I might be in the neighbourhood of Dorchester. He told me not to be ashamed of writing fairy-tales. Some of the greatest literature in the world was enshrined in that form.

When I came to Dorchester he would perhaps be able to give me points out of his store of Wessex folklore. So I staged a walking-tour that should take me by Weymouth and Wooler and the Lyme Regis of Jane Austen and Charmouth ... and of course Dorchester, for I could not bring myself to take the straight train down to that city. I had to obey his orders and 'drop in' casually whilst strolling about that country of chalk downs and the sea.

Alas, when I got to Max Gate, Mr Hardy was away for the day. He had gone, I think, to witness a parade of the militia at Weymouth which I had just left. So, instead of listening to Mr Hardy's Wessex folklore, I listened nervously whilst Mrs Hardy in her Junonian blondness of a Dean's daughter read me her own poems over a perfectly appointed tea-table in a room without roses peeping in at the windows but properly bechintzed.

I don't know whether it was really a militia parade that he had gone to Weymouth to witness any more than Mrs Hardy was really a Dean's daughter. That was merely the Garnettian slant on the Hardy household. Those lively young people, whose father was really very intimate with the novelist, had projected such an image of that household that I had gone there expecting to find in a low inner room of a long white farmhouse with monthly roses peeping in at the window, the kind elderly gentleman who had held his head on one side and said: 'Ow ... ow.'. ... And in another room the Dean's daughter would be burning the manuscript of *Jude the Obscure*.

It was all naturally nothing of the sort. Max Gate was not an old, long, thatched farmhouse; it was quite new, of brick, with, as it were, high shoulders. Not a single rose grew on it at that date. And the Dean's daughter was not a Dean's daughter but an Archdeacon's Niece ... the Archdeacon of London's niece. And she was not burning *Jude the Obscure*, but read me her own innocuous poems. And the kind bearded gentleman whose beardedness made him resemble any one of the elder statesmen of the day— Sir Charles Dilke, or Lord Salisbury, or the Prince of

Wales of those days, or Mr Henry James ... that kind bearded gentleman was not there....

And immediately on hearing that he was out, my mind had jumped to the conclusion that he was witnessing a review of the militia ... I suppose because I knew that one of his stories was called *The Trumpet Major*....

And then nothing more for years. *Jude the Obscure* came out amidst a terrific pother. But the pother took place in circles remote from my own ... circles where they still fought bloodily about the Real Presence, the Virgin Birth or whether the human race had in the beginning been blessed with prehensile tails ... none of which seemed to be any affair of mine.... And the Literary Great of the country sat about each on their little hill ... Mr Meredith at Box Hill, Mr Kipling at Burwash, Mr Hardy at Max Gate, and the William Blacks and James Payns and Marion Crawfords and Lord Tennysons each on his little monticule.... Official Literature in short drowsed on on its profitable way and we, *les jeunes*, had other fish to fry.

PORTRAITS
AND
PERSONALITIES
I

PORTRAITS AND
PERSONALITIES I

THE KING OF HEARTS

Ford Madox Brown

MADOX BROWN has been dead for twenty years now, or getting on for that.* I would not say that the happiest days of my life were those that I spent in his studio, for I have spent in my life days as happy since then; but I will say that Madox Brown was the finest man I ever knew. He had his irascibilities, his fits of passion when, tossing his white head, his mane of hair would fly all over his face, and when he would blaspheme impressively after the manner of our great-grandfathers. And in these fits of temper he would frequently say the most unjust things. But I think that he was never either unjust or ungenerous in cold blood, and I am quite sure that envy had no part at all in his nature. Like Rossetti and like William Morris, in his very rages he was nearest to generosities. He would rage over an injustice to someone else to the point of being bitterly unjust to the oppressor. I do not think that I would care to live my life over again—I have had days that I would not again face for a good deal—but I would give very much of what I possess to be able, having still such causes for satisfaction as I now have in life, to be able to live once more some of those old evenings in the studio.

The lights would be lit, the fire would glow between the red tiles; my grandfather would sit with his glass of weak

* Written in 1910.

whisky and water in his hand, and would talk for hours. He had anecdotes more lavish and more picturesque than any man I ever knew. He would talk of Beau Brummell, who had been British Consul at Calais when Madox Brown was born there; of Paxton, who built the Crystal Palace, and of the mysterious Duke of Portland, who lived underground, but who, meeting Madox Brown in Baker Street outside Druces', and hearing that Madox Brown suffered from gout, presented him with a large quantity of colchicum grown at Welbeck. . . .

Well, I would sit there on the other side of the rustling fire, listening, and he would revive the splendid ghosts of Pre-Raphaelites, going back to Cornelius and Overbeck and to Baron Leys and Baron Wappers, who taught him first to paint in the romantic, grand manner. He would talk on. Then Mr William Rossetti would come in from next door but one, and they would begin to talk of Shelley and Browning and Mazzini and Napoleon III, and Mr Rossetti, sitting in front of the fire, would sink his head nearer and nearer to the flames. His right leg would be crossed over his left knee, and, as his head went down, so, of necessity, his right foot would come up and out. It would approach nearer and nearer to the fire-irons which stood at the end of the fender. The tranquil talk would continue. Presently the foot would touch the fire-irons and down they would go into the fender with a tremendous clatter of iron. Madox Brown, half-dozing in the firelight, would start and spill some of his whisky. I would replace the fire-irons in their stand.

The talk would continue, Mr Rossetti beginning again to sink his head toward the fire, and explaining that, as he was not only bald but an Italian, he liked to have his head warmed. Presently, bang! would go the fire-irons again. Madox Brown would lose some more whisky and would exclaim:

'Really, William!'

Mr Rossetti would say:

'I am very sorry, Brown.'

I would replace the fire-irons again, and the talk would continue. And then for the third time the fire-irons would go down. Madox Brown would hastily drink what little whisky remained to him, and, jumping to his feet, would shout:

'God damn and blast you, William! Can't you be more careful?'

To which his son-in-law, always the most utterly calm of men, would reply:

'Really, Brown, your emotion appears to be excessive. If Fordie would leave the fire-irons lying in the fender there would be no occasion for them to fall.'

The walls were covered with gilded leather; all the doors were painted dark green; the room was very long, and partly filled by the great picture that was never to be finished, and, all in shadow, in the distant corner was the table covered with bits of string, curtain-knobs, horseshoes, and odds and ends of iron and wood.

I remember my grandfather laying down a rule of life for me. He said:

'Fordie, never refuse to help a lame dog over a stile. Never lend money; always give it. When you give money to a man that is down, tell him that it is to help him to get up, tell him that when he is up he should pass on the money you have given him to any other poor devil that is down. Beggar yourself rather than refuse assistance to any one whose genius you think shows promise of being greater than your own.'

This is a good rule of life. I wish I could have lived up to it. The Pre-Raphaelites, as I have tried to make plain, quarrelled outrageously, as you might put it, about their boots or their washing. But these quarrels as a rule were easily made up; they hardly ever quarrelled about money, and they never, at their blackest moments, blackened the fame of each other as artists. One considerable convulsion did threaten to break up Pre-Raphaelite society. This was caused by the dissolution of the firm of Morris, Marshall, Faulkner & Company. Originally in this firm

there were seven members, all either practising or aspiring artists. The best known were William Morris, Rossetti, Burne-Jones and Madox Brown. The 'Firm' was founded originally by these men as a sort of co-operative venture. Each of the artists supplied designs, which originally were paid for in furniture, glass or fabrics. Each of the seven partners found a certain proportion of the capital—about one hundred pounds apiece, I think. As time went on they added more capital in varying proportions, Morris supplying by far the greater part. Gradually the 'Firm' became an important undertaking. It supplied much furniture to the general public; it supplied a great number of stained-glass windows to innumerable churches and cathedrals. It may be said to have revolutionized at once the aspect of our homes and the appearance of most of our places of worship. But, while the original partnership existed, the finances of the 'Firm' were always in a shaky condition.

The day came when Morris perceived that the only way to save himself from ruin was to get rid of the other partners of the 'Firm,' to take possession of it altogether, and to put it in a sound and normal financial position. Now-a-days I take it there would be the makings of a splendid and instructive lawsuit. But Morris & Company passed into the hands of William Morris; Rossetti, Madox Brown and the rest were displaced, and there was practically no outcry at all. This was very largely due to the self-sacrificing labours of Mr Watts-Dunton—surely the best of friends recorded in histories or memoirs. How he did it I cannot begin to imagine; but he must have spent many sleepless nights and have passed many long days in talking to these formidable and hot-blooded partners. Of course he had to aid him the fact that each of these artists cared more for their work than for money, and more for the decencies of life and good-fellowship than for the state of their pass-books.

A certain amount of coldness subsisted for some time between all the parties, and indeed I have no doubt that they all said the most outrageous things against each

other. Some of them, indeed, I have heard, but in the end that gracious and charming person, Lady Burne-Jones, succeeded in bringing all the parties together again. William Morris sent Madox Brown copies of all the books he had written during the estrangement, Madox Brown sent William Morris a tortoise-shell box containing a dozen very brilliant bandana pocket-handkerchiefs, and joined the Kelmscott House Socialist League. Indeed, one of the prettiest things I can remember was having seen Madox Brown sitting in the central aisle of the little shed attached to Morris's house at Hammersmith. Both of them were white-headed then; my grandfather's hair was parted in the middle and fell, long and extremely thick, over each of his ears. It may interest those whose hair concerns them to know that every morning of his life he washed his head in cold water and with common yellow soap, coming down to breakfast with his head still dripping. I don't know if that were the reason; but at any rate he had a most magnificent crop of hair. So these two picturesque persons re-cemented their ancient friendship under the shadow of a social revolution that I am sure my grandfather did not in the least understand, and that William Morris probably understood still less. I suppose that Madox Brown really expected the social revolution to make an end of all 'damned Academicians.' Morris, on the other hand, probably expected that the whole world would go dressed in curtain-serge, supplied in sage-green and neutral tints by a 'Firm' of Morris & Company that should constitute the whole state. Afterward we all went in to tea in Kelmscott House itself—Morris, my grandfather and several disciples. The room was large and, as I remember it, white. A huge carpet ran up one of its walls so as to form a sort of dais; beneath this sat Mrs Morris, the most beautiful woman of her day. At the head of the table sat Morris, at his right hand my grandfather, who resembled an animated king of hearts. The rest of the long table was crowded in a medieval sort of way by young disciples with low collars and red ties, or by maidens in the

inevitable curtain-serge, and mostly with a necklace of bright amber. The amount of chattering that went on was considerable. Morris, I suppose, was tired with his lecturing and answering of questions, for at a given period he drew from his pocket an enormous bandana handkerchief in scarlet and green. This he proceeded to spread over his face, and leaning back in his chair he seemed to compose himself to sleep after the manner of elderly gentlemen taking their naps. One of the young maidens began asking my grandfather some rather inane questions—what did Mr Brown think of the weather, or what was Mr Brown's favourite picture at the Academy? For all the disciples of Mr Morris were not equally advanced in thought.

Suddenly Morris tore the handkerchief from before his face and roared out:

'Don't be such an intolerable fool, Polly!' Nobody seemed to mind this very much—nor, indeed, was the reproved disciple seriously abashed, for almost immediately afterward she asked:

'Mr Brown, do you think that Sir Frederick Leighton is a greater painter than Mr Frank Dicksee?'

Morris, however, had retired once more behind his handkerchief, and I presume he had given up in despair the attempt to hint to his disciple that Mr Brown did not like Royal Academicians. I do not remember how my grandfather got out of this invidious comparison, but I do remember that when, shortly afterward, the young lady said to him:

'You paint a little too, don't you, Mr Brown?'

He answered:

'Only with my left hand.'

This somewhat mystified the young lady, but it was perfectly true, for shortly before then Madox Brown had had a stroke of paralysis which rendered his right hand almost entirely useless. He was then engaged in painting with his left the enormous picture of 'Wycliffe on His Trial,' which was to have been presented by subscribing admirers to the National Gallery.

This was the last time that Madox Brown and Morris met. And they certainly parted with every cordiality. Madox Brown had indeed quite enjoyed himself. I had been rather afraid that he would have been offended by Morris's retirement behind the pocket-handkerchief. But when we were on the road home Madox Brown said:

'Well, that was just like old Topsy. In the Red Lion Square days he was always taking naps while we jawed. That was how Arthur Hughes was able to tie Topsy's hair into knots. And the way he talked to that gal—why, my dear chap—it was just the way he called the Bishop of Lincoln a bloody bishop! No, Morris isn't changed much.'

It was a few days after this, in the evening, that Madox Brown, painting at his huge picture, pointed to the top of the frame that already surrounded the canvas. Upon the top was inscribed 'Ford Madox Brown,' and on the bottom, 'Wycliffe on His Trial Before John of Gaunt. Presented to the National Gallery by a Committee of Admirers of the Artist.' In this way the 'X' of Madox Brown came exactly over the centre of the picture. It was Madox Brown's practice to begin a painting by putting in the eyes of the central figure. This, he considered, gave him the requisite strength of tone that would be applied to the whole canvas. And indeed I believe that, once he had painted in those eyes, he never in any picture altered them, however much he might alter the picture itself. He used them as it were to work up to. Having painted in these eyes, he would begin at the top left-hand corner of the canvas, and would go on painting downward in a nearly straight line until the picture was finished. He would, of course, have made a great number of studies before commencing the picture itself. Usually there was an exceedingly minute and conscientious pencil-drawing, then a large charcoal cartoon, and after that, for the sake of the colour scheme, a version in water colour, in pastels, and generally one in oil. In the case of the Manchester frescoes, almost every one was preceded by a small version painted in oils upon a panel, and this was the case with the large Wycliffe.

On this, the last evening of his life, Madox Brown pointed with his brush to the 'X' of his name. Below it, on the left-hand side, the picture was completely filled in; on the right it was completely blank—a waste of slightly yellow canvas that gleamed in the dusk studio. He said:

'You see I have got to that 'X.' I am glad of it, for half the picture is done and it feels as if I were going home.'

Those, I think, were his last words. He laid his brushes upon his painting-cabinet, scraped his palette of all mixed paints, laid his palette upon his brushes and his spectacles upon his palette. He took off the biretta that he always wore when he was painting—he must have worn such a biretta for upward of half a century—ever since he had been a French student. And so, having arrived at his end-of-the-day routine, which he had followed for innumerable years, he went upstairs to bed. He probably read a little of the *Mystères de Paris*, and died in his sleep, the picture with its inscriptions remaining downstairs, a little ironic, a little pathetic, and unfinished.

THE ABBÉ LISZT

When I was a very small boy indeed I was taken to a concert. In those days, as a token of my Pre-Raphaelite origin, I wore very long golden hair, a suit of greenish-yellow corduroy velveteen with gold buttons, and two stockings, of which the one was red and the other green. These garments were the curse of my young existence and the joy of every street-boy who saw me. I was taken to this concert by my father's assistant on *The Times* newspaper. Mr Rudall was the most kindly, the most charming, the most gifted, the most unfortunate—and also the most absent-minded of men. Thus, when we had arrived in our stalls—and in those days the representative of *The Times* always had the two middle front seats—when we had arrived in our stalls Mr Rudall discovered that he had omitted to put on his necktie that day. He at once went out to purchase one and, having become engrossed in the selection, he forgot all about the concert, went away to the Thatched House Club and passed there the remainder of the evening. I was left, in the middle of the front row, all alone and feeling very tiny and deserted—the sole representative of the august organ that in those days was known as 'The Thunderer.'

Immediately in front of me, standing in the vacant space before the platform, which was all draped in red, there were three gilt armchairs and a gilt table. In the hall there was a great and continuing rustle of excitement. Then suddenly this became an enormous sound of applause. It volleyed and rolled round and round the immense space; I had never heard such sound, and I have never again heard such another. Then I perceived that from beneath the shadow of the passage that led into the artists' room—in the deep shadow—there had appeared a silver head,

a dark-brown face, hook-nosed, smiling the enigmatic Jesuit's smile, the long locks falling backward so that the whole shape of the apparition was that of the Sphinx head. Behind this figure came two others that excited no proportionate attention, but, small as I then was, I recognized in them the late King and the present Queen Mother.

They came closer and closer to me; they stood in front of the three gilt arm-chairs; the deafening applause continued. The old man with the terrible enigmatic face made gestures of modesty. He refused, smiling all the time, to sit in one of the gilt arm-chairs. And suddenly he bowed down upon me. He stretched out his hands; he lifted me out of my seat, he sat down in it himself and left me standing, the very small, lonely child with the long golden curls, underneath all those eyes and stupefied by the immense sounds of applause.

The King sent an equerry to entreat the Master to come to his seat; the Master sat firmly planted there, smiling obstinately. Then the Queen came and took him by the hand. She pulled him—I don't know how much strength she needed—right out of his seat and—to prevent his returning to it she sat down there. After all it was *my* seat. And then, as if she realized my littleness and my loneliness, she drew me to her and sat me on her knee. It was a gracious act.

There is a passage in Pepys's *Diary* in which he records that he was present at some excavations in Westminster Abbey when they came upon the skull of Jane Seymour, and he kissed the skull on the place where once the lips had been. And in his *Diary* he records: 'It was on such and such a day of such and such a year that I did kiss a Queen,' and then, his feelings overcoming him, he repeats: 'It was on such and such a day of such and such a year that I did kiss a Queen.' I have forgotten what was the date when I sat in a Queen's lap. But I remember very well that when I came out into Piccadilly the cab-men, with their three-tiered coats, were climbing up the lamp-posts and shouting out: 'Three cheers for the Habby

Liszt!' And, indeed, the magnetic personality of the Abbé Liszt was incredible in its powers of awakening enthusiasm. A few days later my father took me to call at the house where Liszt was staying—it was at the Lyttel-tons', I suppose. There were a number of people in the drawing-room and they were all asking Liszt to play. Liszt steadfastly refused. A few days before he had had a slight accident that had hurt one of his hands. He refused. Suddenly he turned his eyes upon me, and then, bending down, he said in my ear:

'Little boy, I will play for you, so that you will be able to tell your children's children that you have heard Liszt play.'

And he played the first movement of the 'Moonlight Sonata.' I do not remember much of his playing, but I remember very well that I was looking, while Liszt played, at a stalwart, florid Englishman who is now an Earl. And suddenly I perceived that tears were rolling down his cheeks. And soon all the room was in tears. It struck me as odd that people should cry because Liszt was playing the 'Moonlight Sonata.'

Ah! that wonderful personality; there was no end to the enthusiasms it aroused. I had a distant connection—oddly enough an English one—who became by marriage a lady-in-waiting at the court of Saxe-Weimar. I met her a few years ago, and she struck me as a typically English and unemotional personage. But she had always about her a disagreeable odour that persisted to the day of her death. When they came to lay her out they discovered that round her neck she wore a sachet, and in that sachet there was the half of a cigar that had been smoked by Liszt. Liszt had lunched with her and her husband thirty years before.

THE BEAUTIFUL GENIUS

Ivan Turgenev

For me, my life is glorified as by nothing else, by being able to state that I once offered that white-haired, white-bearded and surely beautiful colossus . . . a chair. He was immense of stature in spite of the fact that his legs—though I don't remember the fact—are said to have been disproportionately short. But that gave him the aspect, when he was seated—because his trunk was naturally proportionately-disproportionately long—of something awesomely fabulous in bulk.

But it was no doubt symptomatic that, in spite of the fact that, short though his legs may have been, I can't have reached above his knee, I did not feel any awe at all in the presence of the beautiful genius. I had certainly the feeling that he must have come from among the roosalki and strange apparitions that swung from tree to tree or loomed in the deep shadows of Russian forests and could only be dismissed by making the sign of the cross in the elaborate Russian fashion. But I was conscious simply of a singular, compassionate smile that still seems to me to look up out of the pages of his books when—as I constantly do, and always with a sense of amazement—I re-read them. I felt instinctively that I was in presence of a being that could not but compassionately regard anything that was very young, small and helpless. The year was 1881. He, sixty-three.

But I certainly can't have been awed, for I brought out in a high, squeaky voice and with complete composure, the words:

'Won't you and your friend be seated. Mr Ralston?'

Mr Ralston, Turgenev's first translator, almost the only English friend of any intellectual closeness that he had—

and the only foreigner who ever visited him at Spasskoye —was another man exactly as tall and as white-headed and white-bearded as Turgenev himself. But, though he was an intimate friend of my family's—in which capacity he had brought Turgenev to call—and though for night after night he had told me the fairy-tales of Krylof—which is how I came to know of the roosalki with the green hair who swing from tree to tree and the other beings who come back to me as *domvostvoi* and manifest themselves by making the wooden sides and beams of sheds creak all round you.—Oh, and of course the Cat of the House who swallowed the wedding procession and the funeral procession and the sun and the moon and the stars. And the dreadful lamb that shewed its teeth just beside your face and said horrible things—but in spite of my having sat on Mr Ralston's knees night after night, drinking in those breathlessnesses, Ralston himself comes back to me as being the merest pale shadow beside the shining figure of the author of *A Sportsman's Sketches*. It was perhaps a merely physical fact because Ralston's hair, white as it was, had a bluish quality in the shadows, whereas Turgenev's had that tawnyish glow that you see in the foam of tidal estuaries. Or it may have been because the shadow of his approaching suicide—for one of the most preposterous reasons of misery and shyness after a fantastic *cause célèbre* that I have ever heard of—was already upon Ralston.

At any rate, there I was all alone in my grandfather's studio in the great house once inhabited by Thackeray's Colonel Newcome—who I dare say might physically have resembled either Ralston or Turgenev. And I come back to myself as being a very small boy in a blue pinafore, with long pale golden curls—as befitted a Pre-Raphaelite infant—standing on tiptoe to look in at the newly hatched doves in my grandmother's dovecage. It had, as it were, a private compartment for the children. And suddenly I was aware of being walled in and towered over by those two giants—who looked down on the pink panting morsels in

the cage-box . . . with even more curiosity and enthusiasm than I myself was shewing.

So I asked them to be seated.

I don't pretend that Turgenev discussed literary technique or the nature of things with me sitting on his knee. . . . The only thing that comes back to me is that he talked about the doves and then about grouse and that I called him to myself a bird man.

Indeed it does not really come back to *me* that I asked him to be seated. I know it because he told my mother and my mother frequently afterwards told me, imitating Turgenev's imitation of my squeaky voice. For my mother—who along with her sister and Mrs Stillman was one of the belles of the then Pre-Raphaelite day—he fell with the heaviness with which, till his dying day, he fell for any charming young woman in or near her early thirties. He was then, as I have said, sixty-three and my mother not quite thirty. . . . I remember her, later, standing in the space between the front and back studios, that were lit with branch candlesticks against a Spanish leather gilt wall-covering, with her back against the upright of the door, extremely blonde, talking with animation to Liszt, Bret Harte . . . and the author of the 'House of Gentlefolk.'. . . And I remember her, too, with her eyes red with tears as she read and re-read that book of the beautiful genius. . . . She knew it as 'Lisa,' in poor Ralston's translation.

So that from my earliest age I was aware that that book was the most beautiful book ever written, and I was, as it were, transfused with a sort of rapturous admiration for that Master that has never left me.

For me, when I read in that book 'The Singers,' or 'Tchertop Hanov and Nedopyushkin,' or that most beautiful of all pieces of writing, 'Byelshin Prairie,' I am conscious, as I have said, always of Turgenev's face looking up out of the pages—but also of a singular odour, sharp and rather pinching to the nostrils. It is that of smelling-salts. The phenomenon had always puzzled me until the

other day the explanation came to me when reading one
of the innumerable, not too sympathetic Russian bio-
graphies of Turgenev. I was conscious, that is to say,
when I had sat on the knee of my Bird Man and he had
told me something about the grouse that he had come to
England to shoot, that he had seemed to have about him
that particular odour. I had always thought that that had
been an illusion of my olfactory nerves. It seemed in-
credible that so male a giant should carry about with him
a specific so feminine. Or I would put it down to the fact
that so inveterate a sportsman who at an advanced age
came all the way to England to shoot grouse must have
been wearing Harris tweeds, which are impregnated with
the queer musty odour of the peat reek of the cottages in
which the fabric is woven. . . . But yesterday I had my
explanation. It would appear that Madame Pauline Viardot
had, in the first place, prohibited for him the use of cigars,
to which he was much attached . . . and then that of snuff-
taking, which he had adopted as a substitute. So to titillate
his poor nose he had taken to sniffing smelling-salts. . . .
And it was typical of him that, unlike me or you or the
milkman, even when rolling seas divided him from that
sister of the divine Malibran, he did not indulge surrepti-
tiously in tobacco but carried about with him his smelling-
bottle and, when the longing for nicotine came over him,
took, rather sadly, a long whiff. . . . Perhaps, even, the
singular aroma may have served to keep off from him the
attentions of the predatory charmers to whom his suscept-
ible heart fell always so easily a victim.

I find faintly adumbrated in the same volume an anec-
dote that my mother used to relate with much more spirit
in, I dare say, some approximation to the words Tur-
genev must have used when telling her the story. It was
told amongst other items of affectionate making fun of
poor Ralston at Spasskoye. It appeared that Ralston's
singular physical approximation to Turgenev had caused
amazement, and even concern, to the Master's serfs. They
saw something supernatural about the whole affair, for it

is to be remembered that they had never seen a foreigner, so remote were Turgenev's ancestral acres from the tides of outside humanity. So they imagined that this singular and fantastic double of their Master must have been introduced, incomprehensible language and all, with some sinister and even malign purpose. They were aware that as serfs they were extremely unsatisfactory, for Turgenev was utterly incapable of controlling anything but bird-dogs, and his very house-serfs when driving him in his landau on urgent errands would interrupt the journey in order to play cards on the box-seat—Turgenev being too shy to remonstrate with them. And even after the Emancipation—which he had brought about—they erected barriers across his only access to his only spring of drinking water. But now, they considered, the day of reckoning had come. The Master had imported a sorcerer to deal with them.

They saw the mysterious being enter all their huts, paper and pencil in hand, making copious notes. Actually, having his translation of the *Sportsman's Sketches* in mind Ralston was set on getting the Russian for every utensil and household article that their houses contained. Turgenev said that it was really extraordinary to see him run about, in and out of houses and barns and stable-yards, his white paper, hair and beard all fluttering together—searching for things he had not already observed. . . .

So, when he had gone, the peasants packed all their belongings on their poor carts and, sending a deputation into the Master's house, waited in a long file in the dusty road. The deputation wanted to know at what hour they were to start for England. . . . They had come to the conclusion that the Master was going to send them all into exile in that country . . . and to fill their places with a more obedient population. . . .

About Turgenev at that date there was no mistake. Standing . . . or rather, reclining on one elbow on a divan, he was a Deity all of himself. He had at that moment reached the height of his illustrious, world-wide fame . . .

and, for the first time in many years, he was feeling physically fit. He was quite complacent on the subject of his health in the letters he wrote Madame Viardot; he had no fear of cholera in London; he had for the first time in his life succeeded in pushing aside the fear of death ... and, although he complained that in Cambridgeshire he had missed a number of partridges, yet he could boast that he had hit a great many. So he seemed to radiate happiness and, leaning on his elbow, resembled one of those riverine deities who, in Italy, with torrents of hair and beards, recline in marble above the sources of streams, and let their waters render fertile the smiling valleys before them.

I prefer so to consider him. And always, except in the act of reading one or other of his lugubrious Russian biographers my image of him swings back to that picture. His Russian biographers prefer, for as it were political reasons, to show always the reverse of that medal. They have to present him as a miserable expatriate from Russia, bound to the girdle of a tyrannous French harpy, groaning for ever that he was not in Russia, detesting his French literary colleagues, detesting France where he was forced to live ... and groaning, groaning, groaning.

Turgenev of course groaned ... in a groaning world which was in the backwash of the Byronic-Romantic movement. Everybody in fact groaned, particularly in their letters. Reading the correspondence of the middle two-thirds of the nineteenth century is like sitting on a broken column by some grave beneath a weeping willow. Carlyle groaned, Flaubert howled groans, George Sand groaned, Sainte-Beuve was perpetually depressed. Tolstoy, Maupassant, Dostoievsky, Queen Victoria, Schopenhauer, Bielinsky.... But every one that Turgenev knew or ever heard of ... they all lamented their miserable lots; the injustices to which they were subject; the unpicturesque figures that they imagined themselves to cut; the world, and they with it, that was going to the dogs!

Nevertheless, George Sand's apartment in Paris roared and rocked with the laughter of Flaubert, Turgenev, the

Goncourts, Zola, Daudet and Pauline Viardot when the depressed Sainte-Beuve on a Sunday would turn himself into a whitened sepulchre in the attempt with his lips to pick a wedding-ring off a pyramid of flour. One Paris restaurant after another asked the five Hissed Authors—Flaubert, Daudet, Turgenev, Goncourt and Zola and now and then the youthful James—to take their weekly dinners elsewhere because their Gargantuan laughter and Titantic howls of derision at the style of their contemporaries disturbed the other diners. Yasnya Polyana—or whatever Tolstoy's lugubrious abode comes out when it is correctly translated—that hermitage then rocked to its foundations with scandalous mirth when Turgenev, aged sixty and declaring himself crippled with the gout, danced the *cancan* vis-à-vis to a girl of twelve. . . . Tolstoy notes in his diary: 'Turgenev; *cancan*. . . . Oh *shame*!'

Similarly in *her* diary, the German Empress Victoria—*Die Engländerin*—makes after the private first night of an operetta that Turgenev had written for the music of Madame Viardot and for performance by himself and the Viardot children, the note that the operetta was charming but Turgenev himself not quite *dignified*. . . . And Turgenev himself, lying on the floor, in the costume of a Turkish Sultan, and crawled over by adorable odalisques, was aware that there was passing over the great lady's face that singular English expression that we put on when we ask, 'Isn't he being rather a Bounder, my dear?' But Turgenev just says, 'Bedamn to that!'. . . And the Empress sends down two or three times every week to the Turgenev-Viardot villa to ask them to give another performance soon or that Turgenev should write another operetta for her at once.

It is a good thing that no one ever did know what was the exact relationship between Turgenev and the great Pauline and that for the world at large and Russia in particular it must remain in Turgenev's own enigmatic phrase an 'unofficial marriage.' That he was absolutely chained to the lady's apron-strings is obviously not true,

or even that he was in the technical sense of the word to-day an unhappy expatriate. His contacts with Russia—the as it were strings of interests that went from him to her—were innumerable and for ever undissolved. His interest in her fate was as constant as his interest in his own estate . . . and that was really unceasing if the results were never very satisfactory. He once told one member of my family—I forget which, either my father or my grand-father—that they must not think him merely frivolous if at his age he came as far as England merely to shoot partridges. Actually he could have shot partridges any-where—except perhaps round Paris where the *chasse* was very expensive. But he came to England to study on the spot the English management of great estates and agricul-tural methods, which he declared to be by far the best in the world. The immediate results of the emancipation of the serfs in Russia had been an almost boundless con-fusion, and the only pattern of which he could conceive as being a fitting or even a possible solution for the Russian situation was something like that practised on the semi-feudal, semilibertarian great estates in the English Dukeries and their purlieus. Today that seems like irony; but for a liberal thinker of that epoch it was something very like common sense. . . . And it is to be remembered that Turgenev had practical reasons, apart from his own necessities, for trying to evolve some sort of possible working scheme for the Russian agricultural system. Dur-ing the earliest eighties, whilst Alexander II was planning his Constitution for Russia, the German Ambassador in Petersburg wrote several times to the Empress Victoria—who passed it on to Turgenev—that it was a settled thing that Turgenev was to be the first Russian Prime Minister. And with all his real modesty there was no reason why Turgenev should not take that piece of diplomatic gossip with some seriousness . . . at any rate to the extent of considering with some practical attention the question of what was the best Constitution for his country's great landed estates, then in the possession of an extraordinarily

unpractical, frivolous and absolute aristocracy. He had at least unrivalled reasons for knowing how difficult the task was; for within his heart all possible benevolence, he had only succeeded in making of Spasskoye one of the worst-managed estates that even Holy Russia could show. . . . At any rate he never went back from England without carrying with him in baggage and brain some specimen of agricultural machinery or some detail of the estate-management of the Dukes of Norfolk or Northumberland. . . . I remember—I must have been told it by my mother —poor Ralston's agitation at not being able to find the manufacturers of some miraculous new plough of which Turgenev had heard in Russia and which he imagined might go far to solve the agricultural difficulties of his country.

In any case, if thinking of the interests and problems of one's native land suffice to prevent one's being an expatriate, Turgenev was none . . . and it is interesting to think of what would have happened to Russia if the Court Party had not let Alexander II be assassinated, if he had promulgated his Constitution, and if Turgenev had indeed occupied a high place in his first Constitutional ministry. That, as I have said, would not have been so astonishing. It is to be remembered that Alexander ordered the emancipation of the serfs three days after he had finished reading the *Sportsman's Sketches* and that twice at least the Empress had ordered the censor to refrain from interfering with Turgenev's books.

Turgenev carried the rendering of the human soul one stage further than any writer who preceded or has followed him simply because he had supremely the gift of identifying himself with—of absolutely feeling—the passions of the characters with whom he found himself. . . . And then he had the gift of retiring and looking at his passion—the passion that he had made his . . . the gift of looking at it with calmed eyes. It was not insincerity that made him say to the French *jeune fille bien élevée* that her convent and home influences had made her the most exquisite

flower of tranquillity and purity and refinement and devo-
tion . . . and of course, that as a corollary, the Russian
jeune fille was by comparison gross, awkward, ignorant
and sensual. That was his passionate belief in the presence
of the daughters of his Pauline . . . who certainly were not
his own daughters. . . . And yet it was equally his pas-
sionate belief, three weeks after in Spasskoye, that the
Russian young girl was limpidly pure, pious, devoted,
resigned—was all that he had projected in his Lisa—
whilst, in contradistinction to her the *jeunes filles bien
élevées* of Bougival were artificial products, *fades*, hyper-
civilised, full of queer knowledges that they had picked
up behind the convent walls . . . sophisticated, in short.
. . . No, he was not insincere. It was perhaps his extreme
misfortune . . . but it was certainly his supreme and beauti-
ful gift—that he had the seeing eye to such an extent that
he could see that two opposing truths were equally true.

It was a misfortune for his biographers and for those
who believe that biographies can ever illuminate anything.
For the biographer and the consumer of biographies, look-
ing only for what they seek, find what they want and play
all the gamut of their sympathies or hatreds. But Turgenev
was by turns and all at once, Slavophile and Westerner,
Tsarist and Nihilist, Germanophile and Francophobe,
Francophile and Hun-hater, insupportably homesick for
Spasskoye and the Nevsky Prospekt and wracked with
nostalgia for the Seine bank at Bougival and the Rue de
Rivoli. All proper men are that to some degree—certainly
all proper novelists. But Turgenev carried his vicarious
passions further than did anyone of whom one has ever
heard. He would meet during a railway journey some sort
of strong-passioned veterinary surgeon or some sort of
decayed country gentleman. . . . And for the space of the
journey he would be them. . . . And so we have Bazarov—
whom he loved—and the Hamlet of the Tschigri district
—whom perhaps he loved too.

It is because of that faculty that he made the one step
forward. Flaubert—whom he also loved and who perhaps

was the only man whom he really and permanently loved since they were both mighty hunters before the Lord of one thing or another—Flaubert, then, evolved the maxim that the creative artist as Creator must be indifferently impartial between all his characters. That Turgenev was by nature ... because of his own very selflessness. Like Flaubert he hated the manifestations and effects of cruelty produced by want of imagination. ... But he could get back from even that passion and perceive that unimaginative cruelty is in itself a quality ... a necessary ingredient of a movemented world. To noble natures like those of Flaubert and Turgenev the mankind that surrounded them is insupportable ... if only for its want of intelligence. That is why the great poet is invariably an expatriate, if not invariably in climate, then at least in the regions of the mind. If he cannot get away from his fellows he must shut himself up from them. But if he is to be great he must also be continually making his visits to his own particular Spasskoye. He must live always both in and out of his time, his ancestral home and the hearts of his countrymen.

So having lived he must render. And so having lived the supremely great artist who was Turgenev so rendered that not merely—as was the case with Shakespeare—did he transfuse himself into all his characters, so that Iago was Shakespeare and Cordelia Shakespeare and Bottom Shakespeare and Hamlet. ... Not only then are Lavretsky and Bazarov and Lisa and the Tschigri Hamlet and the Lear of the Steppes all Turgenev but—and that is the forward step—they are all us.

That is the supreme art and that the supreme service that art can render to humanity ... because, to carry a good enough saying the one step further that we have got to go if our civilisation is not to disappear, *tout savoir* is not only *tout pardonner*, it has got to be *tout aimer*.

Of Turgenev's techniques one can say with assurance no more than one can say with certainty of his personality or of his relations with Madame Viardot. The most you can say is that he was that fabulous monster, a natural

genius; when you have said his name and those of Bach and Cézanne—and one other that you can suit yourself about—you have exhausted the catalogue, since the Crucifixion. As with Hudson, as stylist, the dear God made Turgenev's words to come, as He made the grass grow. It is there and there is no more to say about it.

For myself I prefer my own undepressed version of the beautiful genius's personality... the giant, indulging in night-long verbal pillow-fights at Croisset, with the gigantic Flaubert... Flaubert's patient niece told me that when Turgenev came to Croisset Flaubert always surrendered his own bed to Turgenev and had one made up for himself in the attic.... But fortunately they never went to bed, preferring to talk all night about the assonances in Prosper Mérimée. Fortunately, because Turgenev's feet would have stuck far out over the end of Flaubert's bed and her uncle would never have slept on the shake-down under the tiles.

Talking all night with Flaubert then; next morning taking a walk with a true-Russian visitor and telling him that Goncourt was a bore, and Zola ill-mannered at table, and all French writers hard materialists and little Henry James too soft and the Terrorists heroes and the Tsarists fiends... or the Tsarists God-given if ineffectual statesmen and the Terrorists the spawn of the Devil; and taking a day's rest missing hundreds of partridges but killing hundreds too, and spending the night copying out Pauline Viardot's music for his operettas whilst sitting by the bedside of her sick grandchild who certainly wasn't his. And going to a tea-fight in some studio—and wallowing in adoration and adoration and adoration. And groaning that Life had no purpose and writing less. And telling some child about grouse to the acrid accompaniment of the odour of smelling-salts. And calming Ralston, in hysterics because the new steam-plough was undiscoverable. And swearing to a pretty lady that he would never write another line... never... never... never.... And writing, somewhere, anyhow, on any old piece of furniture

with the dregs at the bottom of any old inkpot ... any old
thing ... *Fathers and Children* or *The Lear of the Steppes*
or *The Death of Tchertop Hanov.*

THE SPIRIT OF AN AGE:
THE NINETIES

Let us consider for a moment more the surrounding period. It was a warlike era. There were Boer wars, China-Japanese, Russo-Japanese wars. There had been very nearly a war between this country and Great Britain. Mr Kruger, President of the Transvaal, and Mr Chamberlain between them manoeuvred Great Britain and the Transvaal into what Lord Salisbury called 'a sort of war.' It occupied the whole strength of the British Army for several years. Mr Chamberlain, on the other hand, had the credit of having, together with Mr Olney, extricated Lord Salisbury and President Cleveland from the disagreeable positions into which their obstinate characters had forced their respective countries over Venezuela. Then came the Spanish-American War.

It was a period of riots and reactions, and these clamours were not without their reactions on the tribe of writers. Mr Kipling, the matchless short-story writer, began to come out as the jingo lyrist. Crane made his appearance in Limpsfield fresh from Cuba. I first saw him when he was delivering a lecture on flag-wagging at the house of the Secretary of the Fabian Society, up the hill. Mr Cunninghame-Graham, born, like Hudson, in South America, and, like him, bearded à la Henri IV and romantic—oh, but infinitely romantic when you saw him sombreroed and with negligent reins, riding in the Row—Mr Graham, the magnificent prose-writer, rightful King of Scotland, head of the Clan Graham, Socialist member of Parliament, gaolbird and all, came out violently in favour of Spain and, in consequence, with a rare hatred for the inhabitants of this country.

He took it out by, in various ways, infuriating the

Master. He called for instance at Lamb House, Rye, and must tell Mr James that he had had extreme difficulty in getting directed to that stately residence. He said he had asked of various citizens and several policemen. 'It would take Mr Graham,' Mr James said, 'to find in Rye a policeman who did not know where *I* lived.' And we all felt that Mr Graham had carried his Hispanic sympathies too far.

Once, driving with Mr Graham to Roslyn Castle from Edinburgh, I heard a politically minded lady say to him:

'You ought, Mr Graham, to be the first President of a British Republic.'

'I ought, Madam, if I had my rights,' he answered sardonically, 'to be the King of this country. And what a three weeks that would be!'

Robert I of Scotland married two ladies without being through the ceremony of divorcing the first, something like that! The Stuarts were the offspring of the second marriage, the Grahams of the first and Mr Graham was the head of the Grahams. He was, all in all, the most brilliant writer of that or of our present day. But he was aristocratically negligent of the fate of the products of his muse and he has remained fittingly little known. Nevertheless, such things as *Beattock for Moffat* or the figure of the Spanish officer, sitting a skeleton in an arm-chair on the Cuban shore long after the battle of Guantanamo, are pieces of writing that can never die. Thomas Hardy at Dorchester was at that time resenting the outcry against *Tess of the D'Urbervilles* and getting ready with *Jude the Obscure* to abandon novel-writing. George Meredith at Box Hill was immensely eminent and writing *Lord Ormont and His Aminta* and *The Amazing Marriage*. Mr Swinburne was living at Putney with Mr Watts-Dunton. The Poet Laureate was—I think—Mr Alfred Austin. But all these Great Ones, like Mr Kipling, sat apart on their little hills. The English Great Writer is seldom intercommunicative, living in the company, usually, of several devoted females,

a lawyer, some scientists and a few parasitic beings, and mingling very little with his kind.

There had been—I am talking of 1898 or thereabouts—a brief moment when England had been a nest of singing birds, and in that moment Mr James and his attendant Americans had played their part. There had been, that is to say, the Henley gang and the *Yellow Book* group. Henley was a great, rough, tortured figure but a considerable and fine Influence. Without him Stevenson would hardly have bulked as he did; and such writers as Whibley, Wedmore, George Warrington Steevens and Marriott Watson made up with Henley a formidable group.

The 'note' of Henley and his gang was on the whole one of physical force and Tory reaction. They revelled in the good brown earth, the linotype machine, motor cars as promotive of thought, and such things. The *Yellow Book* movement had—as became a largely American movement—much more really a technically literary impulse. The periodical was founded by Henry Harland, the author of *The Cardinal's Snuff-box*. Its principal backer was Henry James. It fell with the trial of the miserable Oscar Wilde....

In the nineties in England—as indeed in the United States, France, Germany, Spain and Italy, and subterraneously in Russia—advanced politicians fell into sharply graded divisions. There were Anarchists, Socialists, Radicals, Labour politicians, Liberals and Whigs. In addition, the Irish had Fenians, and the Russians Nihilists. These last were by that date mostly Terrorists. All the major divisions hated the other with extraordinary violence. They in turn were divided up. There were philosophic Anarchists like Prince Kropotkin or Mr Bernard Shaw, physical-force Anarchists who were mostly men crazed by witnessing the sufferings of their fellows—like Ravachol, Vaillant or the imbecile boy whom the Tsarist *agents provocateurs* persuaded to attempt to blow up Greenwich Observatory. Of course there were also actual criminals and criminal lunatics.

The philosophic Anarchists were strongest in London, where the police left them unlisted. There was also a small group round Reclus, the mathematician, in Paris. I think there were few in Chicago or New York and in Russia, Italy or Spain.

The physical-force Anarchists were mostly active in Chicago, Paris, Rome, Naples and Barcelona. Their presence in London was usually transitory. They found refuge there when the pursuit of their native police-forces grew too hot. The London police left them alone. They committed practically no outrages in that city. The outrages in London and the North of England were mostly committed by Fenians. Their idea was to terrorise England into granting freedom to Ireland. They dynamited, successfully or unsuccessfully, underground railways, theatres, the Houses of Parliament and docks. They murdered officials, landlord's agents, tenants who paid their rents or refused to subscribe to the *Clan-na-Gael* in Ireland. They had many sympathisers in the United States. They not infrequently crossed the American border to commit outrages or foment insurrections in Canada.

The physical-force Nihilists were, like the Fenians, political terrorists. They assassinated Tsars, members of the Imperial Family, generals, superior officials. They hoped thus to terrorise their rulers into granting concessions or into abdication. They were mostly members of the middle classes, highly educated and of great physical energy. They included many women of the heroic type. The Constitutional Nihilists took in the great majority of the Russian educated classes, nearly all professional men and a great many officials and army officers and a great majority of university students. Poverty in Russia of that day was at its most horrible. There were a great many of both Terrorists and Constitutional Nihilists in London then, some in Paris, a good many in Geneva and some even in New York, Boston and Chicago. In each city the Imperial detectives, spies, secret police and *agents provocateurs* much outnumbered the revolutionists. The

police of every country except England worked hand in glove with the Tsarist organisations. A large proportion of the Tsarist agents took wages from both sides.

The Socialists of those days divided themselves in the purely sentimental groups like those headed by William Morris, the poet at Hammersmith or Charles Rowley's Ancoats Brotherhood. Their economic ideas were vague, but they desired to see people happy, dancing around may-poles and reaping plentiful wheat harvests with sickles. The Socialist movement in America was largely produced by Henry George's book, *Progress and Poverty*. This had its economic themes based on State ownership of the land, but practical or sentimental communion had long been a favourite exercise of the American intelligentsia from the earliest days of the Brook Farm Experiment to Shaker and other religious Communistic brotherhoods.

Towards the nineties the Socialist movement took an energetic spring forward in the direction of economics. This was principally the work of the disciples of Karl Marx. In the United States Marxism speedily swallowed up the movement that had grounded itself in Henry George's doctrine. In France it gained little or no ground. In England it made a little stir. A Marxian group founded itself around Dr Aveling, who had married Elinor Marx. Her suicide rather broke up the group. But, all out, in those days Socialism was a middle-class, sentimental movement. Its exponents were mostly rich men or those, either by inheritance or marriage, who were in easy circumstances. It received support from young intelligentsia and persons not quite of the ruling classes who were dissatisfied with the way the actual ruling classes managed affairs. Later in the nineties the Fabian Society—the exponents of what they called 'gas-and-water Socialism' —took the hegemony out of the hands of the William Morris, or Aesthetic, group. They are extraordinarily doctrinaire and rather grotesque personally. But they have made remarkably good. In Germany, where Socialism was not politically powerful, the movement had a terrorist

Left Wing. Cohen, the half-brother of my grandparents' adopted daughter, Mathilde Blind, attempted to murder Bismarck, and this attempt and other activities of the German Reds seems to have made a powerful impression in the minds of the German ruling classes.

Labour divided itself into Revolutionists, Trade Unionists, the Parliamentary Labour Party and Labour leaders with some economic doctrines. The Revolutionists desired any kind of Social Revolution, with lots of fun, looting, the burning of Government buildings and the paralysis of all authority. Trade Unionists aimed at the raising of wages by means of strikes, the Parliamentary Wing hoped to better the conditions of Industrialism by legislative action.

The world in turning towards universal industrialism was undergoing immense growing pains. The distress which goes with developments, as with stagnations of trade, is accompanied by wide-spread and atrocious suffering. The hideousness of the poverty in the early nineties the world over would now be incredible were it not that some of it is only too visible to-day. And it is not merely that hunger, cold and squalour beset the actually destitute. It was the terrible anxiety that for ever harassed the minds of those who were just above the starvation line. You were in work one day; you were out the next. Thus even whilst you were in work you had no rest at the thought of the morrow. Worklessness meant the gradual disintegration of your home, the wearing out of the shoes of your children, if your children had shoes; it meant thus slow starvation, your moral decay, your slowly sinking away from all the light. I remember Charles Booth saying fiercely in 1892: 'Do you realise that there are now in London two hundred and fifty thousand people—and in Lancashire God knows how many—who in this December weather have no fire in the grate, no meal on the table, no stick of furniture on the floor, no door in the doorway, no hand-rails to the stairs and no candle to go to bed by?' Mr

Booth was a great ship-owner but he was also a statistician. His statistics affected him at that time almost to madness.

If that could happen to a very rich man with great powers of alleviating suffering, what would take place in the minds of those who, just not starving themselves, lived as if buried beneath the foodless, the unclothed, the unwarmed, who dwelt in darkness? And it is to be remembered that if things were that bad in London they were infinitely worse in every other country in the world. It was a day of nightmares universal and showing no signs of coming to an end. Nothing could happen but what did —a world-wide flood of disorder ending in Anarchism. That was inevitable.

The state of affairs in some of the Continental cities was incredible. I remember Paris in 1892 as being absolutely paralysed. I was stopping with American relatives who belonged to the rich Anglo-American Catholic circle that solidly ornamented in those days the French capital. That colony and the rich and solid French families with whom they mingled and intermarried lived again as if in the days of the siege. They dared not go to theatres, to restaurants, to the fashionable shops in the rue de la Paix, to ride in the Bois where there were Anarchists behind every tree. The most terrible rumours ran around every morning: the Anarchists had undermined the churches of Paris; they had been caught pouring prussic acid into the city reservoirs; the New York *Herald* came out one day with a terrifying story of Anarchists having been hidden beneath the seats of the tiny black and yellow fiacres and coming out and robbing and murdering rich American ladies in the Champs-Elysées.

The Anarchists did not of course hide beneath the seats of fiacres because those little vehicles had no spaces beneath the seats. The axles of the wheels were there. Nevertheless to-day the catalogue of their outrages reads like an improbable nightmare. They bombed the cafés where the rich took their apéritifs and the more costly restaurants; then they bombed poor restaurants where

their comrades had been arrested; they bombed theatres, railway stations, the Chamber of Deputies, the President of the Republic himself. Merely to consider how they could have done it in the face of the most skilful and remorseless police force in the world is an amazing speculation.

'Paris,' says a contemporary journalist, Fernand Evrard, writing in 1892, 'offers the spectacle of a besieged city: the streets are deserted, the shops closed, the omnibuses without passengers, the museums and the theatres barricaded. The police are invisible but ubiquitous; the troops assembled in the suburbs are ready to march at the first command. The rich foreign families take flight, the hotels are empty, the takings of shops dwindle. After some weeks of relative quiet the populace takes hope again and the red sequence seems at an end. Then the terrible bomb in the police station of the Rue des Bons Enfants, followed immediately by the discovery of the dynamite cartridge in the Prefecture of Police causes new panic and despair. . . . There is cholera in the outskirts of the city, the Panama scandal within the walls . . . one hundred and four deputies are suspected of complicity. The year 1892 may well bear on its brow the words "Death to Society," and "Corruption to Politics." '

The passion that inspired these paralysers of a whole society was probably nothing else but pity. Ravachol, who committed the outrage in the Rue de Clichy, was arrested because he could not restrain himself from saying to a waiter in a *bistrot*: 'How can you call that an outrage when there is so much suffering in the world?' The queerly paradoxical and reckless speech might well stand for the philosophical basis of the whole movement, more especially when you consider that neither Ravachol nor Vaillant nor yet the assassin of President Carnot had suffered much themselves from poverty. And indeed the relative prosperity of England and possibly the more considerable voice that the poorer classes had in the government of the country may have been as much accountable

for the absence of Anarchist activities in London as the fact that, the police letting them alone, the Anarchists were determined not to close to themselves their only safe refuge.

Kropotkin's was the only name of the movement that is likely to remain in the annals of those times. A Prince and officer of the Imperial body-guard, he was in addition a very distinguished scientist. His investigations led him irresistibly towards the frame of mind that is called non-resistance and he was one of the most determined opponents of the theory of evolution as one upholding conquests. Eventually, like Tolstoy and so many of the Russian aristocracy, he abandoned his career and his vast properties and lived the life of a poor man among the poor.

From that to the bombing of the commissariat in the Rue des Bons Enfants may well seem a far cry but the workings of the human mind are always mysterious and when they take place under conditions of great stress there is no saying whither they may not tend. Kropotkin's great sympathy for the very poor and the very oppressed made him seek their company and they his. That he never counselled violence or excused it when it had taken place is certain enough, but the essence of his philosophy being that laws by their very existence incite to crime, it was not a great progression for a hunger-weakened brain to imagine that the destruction of those who benefit by or enforce laws will bring about a reign of peace upon earth.

I will not undertake to say that I ever heard him deprecating violence to Ravachol or Vaillant, though I certainly was in the same room with Vaillant if not with Ravachol on more than one occasion at a Socialist club, but I do remember Kropotkin speaking with great emphasis against physical force and even against revolution brought about by violence, the occasion coming back to me very vividly.

It was during the great coal strike of 1893 and Charles

Rowley had invited me to dine with some other Labour leaders with the idea of converting me to advanced opinions, such as they were in those days. The meal took place in the Holborn Restaurant, a haunt of everything that was middle-class and Free Masonic. There were present Mr Ben Tillet, Mr Tom Mann, Charles Rowley, the Manchester Socialist, and Prince Kropotkin, and since the restaurant was so very middle-class the presence of those notorious promoters of disorder created a sufficient agitation so that the management tucked us away into a quiet alcove where the waiters hovered about us with scared faces.

As long as the discussion remained on general lines of the relief of suffering or even of strikes these leaders of advanced thought got on very well together, and that stage lasted for the greater part of the meal. But the moment it came to the discussion of remedies Kropotkin's quietism acted like a bomb at the table, the Labour representatives being all for strong measures against authority. Kropotkin was all for non-resistance, meditation and propaganda so that eventually we broke up in disorder after a deadlock in which Mr Mann, who was dark and of Celtic animation with an immense harsh voice, had gone on for a long time striking the palms of his left hand with the clenched fist of his right and exclaiming over and over again, 'We must destroy! We must pull down! We must be rid of tyrants!'

Mr Tillet, little, blond and virulent, echoing in a soft but even more destructive voice:

'Yes, we must tear down! We must make a clear space!' And Charles Rowley with his red beard and Lancashire brogue, trying uselessly to quiet the noises. But always in the pauses came the quiet, foreign accents of the Prince, who, with the eyes of a German scientist behind his gleaming spectacles fixed intently on his interlocutors, exclaimed gently and unceasingly:

'No, there must be no destruction. We must build. We

must build the hearts of men. We must establish a king-
dom of God.'

That seemed to drive the others mad.

When the party broke up, I stood for a long time with
the Prince under the portico of the restaurant whilst the
rain poured down. He asked me what I was doing and I
told him that I was just publishing a fairy-tale. He said
that that was an admirable sort of thing to do. Then he
said that he hoped the fairy-tale was not about Princes
and Princesses—or at least that I would write one that
would be about ordinary people. I have been trying to do
so ever since. Indeed I tried to do so at once with the
singular result that although my first invention had a great
—indeed a prodigious—sale I could not even find a pub-
lisher for the second. My subsequent difficulties have been
technical. I always want to write about ordinary people.
But it seems to be almost impossible to decide who are
ordinary people—and then to meet them. All men's lives
and characteristics are so singular.

I do not think I saw much of Kropotkin after that in
political gatherings though I must have seen him once at
the office of *The Torch* in Goodge Street. But I did not
much frequent that establishment. Until my aunt's death,
the Rossettis' house being her property, my juvenile rela-
tives carried on their activities at home. Why my aunt
permitted them to run in her basement a printing press
that produced militant Anarchist propaganda I never
quite knew. She no doubt would have approved of any
activities of her children, so long as they were active in a
spirited and precocious way. But I imagine she would
have preferred their energies to continue to be devoted to
the productions of the Greek plays which caused me so
much suffering. In any case the world was presented with
the extraordinary spectacle of the abode of Her Majesty's
Secretary to the Inland Revenue, so beset with English
detectives, French police spies and Russian *agents provo-
cateurs* that to go along the side-walk of that respectable

terrace was to feel that one ran the gauntlet of innumerable gimlets. That came to an end.

My uncle William was a man of the strongest—if slightly eccentric—ethical rectitude and, as soon as my aunt was dead and the house become his property, he descended into its basement and ordered the press and all its belongings to be removed from his house. He said that although his views of the duties of parenthood did not allow of his coercing his children, his sense of the fitness of things would not permit him to sanction the printing of subversive literature in the basement of a prominent servant of the Crown. *The Torch* then had to go.

It removed itself to Goodge Street, Tottenham Court Road—a locality as grim as its name. There it became a sort of club where the hangers-on of the extreme Left idled away an immense amount of time whilst their infant hosts and hostesses were extremely active over their forms. I did not myself like it much and only went there I think twice—to see about the printing of my first poem. This was not very Anarchist in colouration. It ran:

> 'Oh, where shall I find rest?'
> Wailed the wind from the West,
> 'I've sought in vain on dale and down,
> In tangled woodland, tarn and town
> But found no rest.'

> 'Rest thou ne'er shalt find,'
> Answered Love to the wind.
> 'For thou and I and the great, grey sea
> May never rest till Eternity
> Its end shall find.'

It seems to be a fairly orthodox piece of verse to find publication in a Red journal.

The other piece of imaginative literature to which *The Torch* committed itself was Mr George Bernard Shaw's pamphlet entitled *Why I Am an Anarchist*. That had an amusing sequel.

When Mr Shaw first came to London he was a true-red Anarchist. A little later he changed his coat and became a Socialist, at first of the William Morris and then of the Marxian school. In the early days of the nineties the quarrels between Socialist and Anarchist were far more bitter than those between either and constituted Society. These quarrels as often as not ended in free fights. I have said that I remember seeing several meetings in Hyde Park break up in disorder, the Socialists being always the aggressors and usually the victors. One meeting at Kelmscott House was brought to an end by someone—I presume an Anarchist—putting red pepper on the stove. Poor William Morris, with his enormous mop of white hair, luxuriant white beard and nautical pea-jacket, used to preside at these meetings of his group. I never heard him speak. But he walked up and down in the aisle between the rows of chairs, his hands in his jacket-pockets, with the air of a rather melancholy sea-captain on the quarter-deck. He disliked the violence that was creeping into his beloved meetings. He had founded them solely with the idea of promoting human kindness and peopling the earth with large-bosomed women dressed in Walter Crane gowns and bearing great sheaves of full-eared corn. On this occasion his air was most extraordinary as he fled uttering passionate sneezes that jerked his white hairs backwards and forwards like the waves of the sea.

Mr Shaw imprudently addressed a meeting of Socialists in Hyde Park. It was perhaps his one mistake in tactics. As soon as he announced the title of his address, which was 'The Foolishness of Anarchism,' childish voices arose on the silence. They repeated and repeated: 'Buy *Why I Am an Anarchist* by the lecturer. *Why I Am an Anarchist* by the lecturer. One penny.' The high skies towered above the trees of the Park; in the branches birds sang. Those fresh young voices mounted to heaven. Mr Shaw's did not. Every time he opened his mouth that anthem: '*Why I Am an Anarchist* by the lecturer. One penny,'

began again. Every now and then they added: 'And worth it!' I suppose it would be worth ten thousand pence to-day. And then some!

Those young people shortly afterwards arrived at the conclusion that they were being victimized, and *The Torch* was discontinued.

It had one other curious literary offshoot. That was *The Secret Agent* by Joseph Conrad. In one of my visits to *The Torch* office I heard the inner story of the Greenwich Observatory outrage. It was subsequently confirmed and supplemented to me by Inspector French of Scotland Yard after first my mother's and then my own house had been burgled by a professional cracksman employed by the Russian Embassy. I happened to tell the story to Conrad shortly after my burglary and, since he detested all Russians, and the Russian Secret Police in particular, he made his novel out of it. In his attribution to me of the plot which will be found in the Preface to the book he says he is sure that the highly superior person who told him the tale could never have come into contact with Anarchists. I have recounted above how I did.

A short time after that dinner at the Holborn Restaurant, I forsook London and took to agriculture.

THE HEART
OF THE COUNTRY

In the ten years from 1894 to 1903 I was hardly at all in London. I had buried myself in the country and for three or four years hardly saw anyone but field-workers. These years were passed firstly at Bonnington, a lonely village in the Romney Marsh, and then at the Pent, a lonelier farmhouse at the foot of the North Downs. It was in 1897 that Mr Edward Garnett persuaded me to come to Limpsfield but I returned to the Pent. There Conrad came along.

I suppose that for seven or eight years we hardly passed a day and certainly not a month without meeting and discussing our joint and several works. For a number of years longer we remained on terms of the closest intimacy and community of interest. That was only interrupted by my frequent visits to the Continent of Europe or to the United States. In Belgium we spent some time together, when we were working on *Romance*. On the publication of that book we went to London where I occupied a house on the top of Campden Hill. Conrad had lodgings round the corner....

The people that I saw daily until the advent of Conrad and for long after that were all working farmers or farm-labourers. There were Meary Walker and Meary Spratt and Ragged Arse Wilson and Farmer Finn of Bonnington Court Lodge and Parson Cameron and Muss Rayner of the Corner and Muss Diamond, who still wore a smock-frock and a white beaver top-hat, and Shaking Ben who had been ruined by the bad gels of Rye.

Those brown, battered men and women of an obscure Kentish countryside come back to me as the best English people I ever knew. I do not think that, except for the

parson and the grocer, anyone of them could read or
write, but I do not believe that one of them ever betrayed
me or even each other. If, as I undoubtedly do, I love
England with a deep love, though I grow daily more alien
to the Englishman it is because of them. Here are some
of them.

About twenty-five years ago I wanted some mushroom
ketchup. Bonnington was in a scattered, little-populated
village of the South of England. The village stood on
what had formerly been common land, running all down
the side of a range of hills. But this common land had
been long since squatted on, so that it was a maze of little
hawthorn-hedges surrounding little closes. Each close had
a few old apple or cherry-trees, a patch of potato ground,
a cabbage-patch, a few rows of scarlet runners, a few
plants of monthly roses, a few plants of marjoram, fennel,
borage or thyme. And in each little patch there stood a
small dwelling. Mostly these were the original squatters'
huts built of mud, whitewashed outside and crowned
with old thatched roofs on which there grew grasses,
house-leeks or even irises. There were a great many of
these little houses beneath the September sunshine, and
it was all a maze of the small green hedges.

I had been up to the shop in search of my ketchup, but
though they sold everything from boots and straw hats
to darning-needles, bacon, haricot-beans, oatmeal and
British wines they had no ketchup. I was wandering
desultorily homewards among the small hedges downhill,
looking at the distant sea, seven miles away over the
marsh. Just beyond a little hedge I saw a woman digging
potatoes in the dry hot ground. She looked up as I passed
and said:

'Hullo, Measter!'

I answered: 'Hullo, Missus!' and I was passing on
when it occurred to me to ask her whether she knew any-
one who sold ketchup. She answered:

'Naw! Aw doan't knaw no one.'

I walked on a little farther and then sat down on a stile

for half an hour or so, enjoying the pleasant weather and taking a read in the country paper which I had bought in the shop. Then I saw the large, stalwart old woman coming along the stony path, carrying two great trugs of the potatoes that she had dug up. I had to get down from the stile to let her pass. And then seeing that she was going my way, that she was evidently oldish and was probably tired, I took the potato-trugs from her and carried them. She strode along in front of me between the hedges. She wore an immense pair of men's hobnailed boots that dragged along the stones of the causeway with metallic sounds, an immense shawl of wool that had been beaten by the weather until it was of a dull liver colour, an immense skirt that had once been of lilac cotton print, but was now a rusty brown, and an immense straw hat that had been given her by some one as being worn out and that had cost twopence when it was new. Her face was as large, as round and much the same colour as a copper warming-pan. Her mouth was immense and quite toothless except for one large fang and, as she smiled cheerfully all the time, her great gums were always to be seen. Her shoulders were immense and moved with the roll and heave of those of a great bullock. This was the wisest and upon the whole the most estimable human being that I ever knew at all well. Her hands were enormous and stained a deep blackish green over their original copper colour by the hops that it was her profession to tie.

As we walked along she told me that she was exactly the same age as our Queen, who was then just seventy. She told me also that she wasn't of those parts but was a Paddock Wood woman by birth, which meant that she came from the true hop country. She told me also that her husband had died fifteen years before of the sting of a viper, that his poor old leg went all like green jelly up to his thigh before he died and that he had been the best basket-maker in all Kent. She also told me that we can't have everything and that the only thing to do is to 'keep all on gooing.'

I delivered up her trugs to her at her garden gate and she said to me with a cheerful nod:

'Well, I'll do the same for you, mate, when you come to be my age.' She shambled over the rough stone of her garden path and into her dark door beneath the low thatch, that was two yards thick. Her cottage was more dilapidated than any that I have ever seen in my life. It stood in a very long narrow triangle of ground, so that the hedge that I walked along must have been at least eighty yards in length, while at its broadest part of the potato-patch could not have measured twenty spade-breadths. But before I was come to the end of the hedge, her voice was calling out after me:

'Measter! Dun yo really want ketchup?'

I replied that I really did.

She said:

'Old Meary Spratt up by Hungry Hall wheer ye see me diggin'—she makes ketchup.'

I asked her why she had not told me before and she answered:

'Well, ye see the Quality do be asking foolish questions, I thought ye didn't really want to know.'

I learnt afterwards it wasn't only the dislike of being asked foolish questions. In Meary Walker's long, wise life she had experienced one thing—that no man with a collar and a tie is to be trusted. She had had it vaguely in her mind that, when I asked the question, I might be some sort of excise officer trying to find out where illicit distilling was carried on. She didn't know that the making of ketchup was not illegal. She had heard that many of her poor neighbours had been fined heavily for selling bottles of home-made sloe-gin or mead. She had refused to answer, out of sense of automatic caution, for fear she should get poor old Meary Spratt into trouble.

But next morning she turned up at my cottage carrying two bottles of Meary Spratt's ketchup in an old basket covered with a cloth. And after that, seeing her rather often at the shop on Saturday nights when all the

world came to buy its Sunday provisions, and, because she came in to heat the bake-oven with faggots once a week, and to do the washing—in that isolated neighbourhood, among the deep woods of the weald, I got to know her as well as I ever knew anybody. This is her biography:

She was the daughter of a day-labourer amongst the hop-fields of Paddock Wood. When she had been born, the youngest of five, her own mother had died. Her father had brought a stepmother into the house. I never discovered that the stepmother was notably cruel to Meary. But those were the Hungry Forties. The children never had enough to eat. Once Meary cut off one of her big toes. She had jumped down into a ditch after a piece of turnip-peel. She had, of course, had no shoes or stockings and there had been a broken bottle in the ditch.

So her childhood had been a matter of thirst, hunger and frequent chastisements with the end of a leather strap that her father wore round his waist. When she was fourteen she was sent to service in a great house where all the maids slept together under the roof. Here they told each other legends at night—odd legends that exactly resembled the fairy-tales of Grimm—legends of Princes and Princesses, of castles, or of travelling companions on the road. A great many of these stories seemed to hinge upon the price of salt, which at one time was extravagantly dear in the popular memory, so that one Princess offered to have her heart cut out in order to purchase a pound of salt that should restore her father to health.

From this house Meary Walker ran away with a gipsy —or at least he was what in that part of the world was called a 'pikey,' a user of the turnpike road. So, for many years they led a wandering existence, until at last they settled down in this village. Until the date of that settlement, Meary had not troubled to marry her Walker. Then a parson insisted on it, but it did not trouble her much either way.

Walker had always been a man of weak health. He had what is called the artistic temperament—a small, dark,

delicate man whose one enthusiasm was his art of making baskets. In that he certainly excelled. But he was lazy and all the work of their support fell on Meary. She tied hops—and this is rather skilled work; she picked them in the autumn; she helped the neighbours with baking and brewing. She cleaned up the church once a week. She planted the potatoes and cropped them. She was the first cottager in East Kent to keep poultry for profit. In her biography, which I have related at greater length in another book,* you could find traces of great benevolence and of considerable heroism. Thus, one hard winter, she supported not only herself and her husband, but her old friend Meary Spratt, at that time a widow with six children. Meary Spratt was in bed with pneumonia and its after-effects, from December to March. Meary Walker nursed her, washed and tended the children and made the livings for all of them.

Then there came the time when she broke her leg and had to be taken against her will to the hospital, which was seven miles away. She did not want to be in the hospital; she was anxious to be with Walker, who was then dying of gangrene of the leg. She was anxious, too, about a sitting hen; one of her neighbours had promised her half a crown for a clutch of chickens. She used to lie in hospital, patting her broken knee under the bed-clothes and exclaiming:

'Get well, get well, oh, do get well quickly!' And even twenty years afterwards when she rehearsed these scenes and these words there would remain in the repetition a whole world of passionate wistfulness. But indeed, she translated her passion into words. One night, driven beyond endurance by the want of news of Walker and of her sitting hen, she escaped from the hospital window and crawled on her hands and knees the whole seven miles from the hospital to her home. She found when she arrived in the dawn that Walker was in his coffin. The chickens, however, were a healthy brood. Her admiration

* *The Heart of the Country*, London, 1906.

for Walker, the weak and lazy artist in basket-making, never decreased. She treasured his best baskets to the end of her life as you and I might treasure Rembrandts. Once, ten years after, she sat for a whole day on his grave. The old sexton, growing confused with years, had made a mistake and was going to inter another man's wife on top of Walker. Meary stopped that.

For the last twenty-six years or so of her life she lived in the mud hut which I had first seen her enter. She went on as before, tying hops, heating ovens, picking up stones, keeping a hen or two. She looked after, fed and nursed— for the love of God—a particularly disagreeable old man called Purdey who had been a London cab-driver. He sat all day in a grandfather's chair, grumbling and swearing at Meary whenever she came in. He was eighty-two. He had no claim whatever upon her and he never paid her a penny of money.

So she kept on going all through life. She was always cheerful; she had always on her tongue some fragment of peasant wisdom. Once, coming back from market, she sat down outside a public-house and a soldier treated her to a pot of beer. Presently there rode up the Duke of Cambridge in his Field-Marshal's uniform and beside him there was the Shah of Persia. They were watching a sham fight in the neighbourhood. Meary raised her pot of beer towards these royal personages and wished them health. They nodded in return.

'Well,' Meary called out to the Duke, 'you're only your mother's son like the rest of us.' Once, when Batalaha Reis* amiably told her that, in his language, bread was 'pom,' she expressed surprise but then she added:

'Oh, well, poor dear, when you're hungry you've got to eat it, like the rest of us, whatever you call it.'

She was sorry for him because he had to call bread by such an outlandish name. She could not think he remembered the word. Yet she knew that *Brot* was the German for bread and *Apfel* for apples, because during the

* Portuguese Consul-General and a friend of Ford's.

Napoleonic Wars the Hanoverian Legion had garrisoned that part of the country and there remained till the accession of Queen Victoria. One of what she called the jarman legions had murdered a friend of her mother's who had been his sweetheart, and when he was hung for it at Canterbury he asked for *Brot* and *Apfel* on the scaffold. She saw him hung, a pleasant fair boy, and when she looked down at her hands they were white as lard.

So she worked on until she was seventy-eight. One day she discovered a swelling under her left breast. It gave her no pain but she wanted to know what it was. So she put a hot brick to it. She knew that if it was cancer that was a bad thing to do, but she wanted to get it settled. The swelling became worse. So she walked to the hospital, the same hospital that she had crawled away from. They operated on her next morning—and she was dead by noon. Her last words were:

'Who's going to look after old Purdey?'

She was buried in the workhouse cemetery. The number of her grave is 1642. Mr Purdey was taken to the Union that night. And there, the last time I heard of him, he still was, a disagreeable old man.

Meary Spratt was much more like the average woman of fiction. She was decidedly emotional; she was certainly not truthful; she begged, and when she begged she would scream and howl and yell in the highest of keys, pulling her gnarled, rheumatic fingers into repulsive shapes and screaming like a locomotive to show how much they pained her, or sobbing with the most dramatic emphasis when she related how Meary Walker had saved her six little children from starvation. On the other hand, she would relate with a proper female virtue the fact—I fancy it may have been true—that, at some portion of her career Meary Walker had a daughter by somebody who was not Walker and that the daughter was in service in Folkstone. She would also say that Meary Walker was an arrant miser who had saved up a large fortune in bank-

notes which were quilted into her stays. She said she had
heard the stays crackle.

Meary Spratt had never had a child by anyone but her
husband. But then she had four husbands as well as
nineteen children, all of whom had lived. She was quite
a small woman with an appallingly shrill voice and her
tongue never stopped. In the early morning among the
dews you would hear her voice. She would be picking
what she called mushrooms for her ketchup. You would
hear her all the while like this screaming quite loudly
while you listened from your bedroom window, she being
in the field beyond the hedge and it being four o'clock
of a very dewy morning.

'He! He! He!' she would scream, 'here is a nice little
one, a little pinky one! Now I'm going to pick you! Up
you come, my little darling! Ah, doesn't it hurt!' And
then she would give a shrill yell to show the pain that the
mushroom felt when it was being picked. And then she
would continue: 'Oh, oh, oh, Lord! Oh my poor
shoulders! Oh! my poor legs! They do fairly terrify me
with rhumatiz! Oh, oh, Lord!'

And you would hear her voice seeming to get shriller
as it got fainter and she went over the marshy grass, into
the mist, until she came on another little pink one. She
was seventy-six and it was cold out on the marshes in
that October weather.

Yes, she was decidedly feminine. She had only been
married three years to Mr Spratford. Mr Spratford was
eighty-two when they married. Between them they had
thirty-one children. And they lived in a little brick cot-
tage not much larger than a dog-kennel. When you asked
Mr Spratford why he married—Mr Spratford was a most
venerable-looking peasant, like a Biblical patriarch, with
very white hair curling round a fine bald head and with
noble faded blue eyes; and when he spoke he always
gesticulated nobly with one hand and uttered the most
edifying moral sentiments. He was extremely dishonest
and had three times been to prison for robbing poor old

women. Indeed, when I first made his acquaintance, he did a week's work for me, charged me double prices and begged me not to tell anyone that I had paid him at all because he was on his club—and this is about the meanest crime any peasant can commit. It was an offence so mean that even Meary Spratford—who, you will observe, was a woman and who would have had no scruple at all about pilfering from any member of the quality—even Meary Spratford was outraged and made him pay back his club money for that week. She could not bear to think of the members of the club being defrauded, because they were quite poor people. It is true that she came to me afterwards and, groaning and sobbing, she tried to get the money out of me to make up for her noble act—but when you asked Mr Spratford why he married he answered:

'Well you see, sir, in a manner of speaking us do be very poor people and us bean't able to afford more than one blanket apiece, and one small fire for each of us, coals do be so dear.' (He got all his coal for nothing from the poor old parson and so did Mrs Spratt.) 'So if we do marry we do have two blankets atop of us at night and we have one big fire and sit on either side of it.'

So said Mr Spratford. But when it came to his wife she would scream out:

'Why did us marry? Why I, I like to have a man about the house and a woman looks better like among her neebours if she do have a husband.' So that no doubt Mrs Spratt was feminine enough, just as Mr Spratford was undoubtedly masculine. He died raving on the mud floor of his hut. His wife had not the strength to lift him into bed and the four men who had held him down during the night had had to go to work in the morning. He tore his head to ribbons with his nails and Mrs Spratt for years afterwards could make anybody sick with her dramatic rehearsals of how he died. When she was really worked up over this narration she would even scratch her own forehead until it bled. So perhaps she was really a more womanly woman than Mrs Walker. She kept on going just

the same. But she made much more noise about it. That, I believe, is what is demanded of man's weaker vessels.

But even in the village Meary Spratt was regarded as unusually loquacious, whereas Meary Walker attracted, as I have said, no attention at all. It was as if Meary Walker was just a woman, whereas Meary Spratt was at least a superwoman, or as if she were a woman endowed with the lungs of a locomotive-whistle. Indeed, I am certain that anyone there would have told you that Meary Walker was just an average woman.

The most faithful soul I have ever known was Ragged Arse Wilson. His nickname was given him because of the frailty of his nether garments. His Christian name I never knew. He was singularly handsome, dark, with a little beard like Shakespeare's and that poet's eyes. He was slow, soft-spoken, very gentle. In years I never knew him to run or lose his temper. And, for sure, he kept on going.

I never knew that man not working. Even after supper in his great stuffed chair, between fire and lamp, with his pipe going he would be netting onion-bags, making rabbit-snares, fashioning axe-helves. Twenty years after— in 1917—I got a singular shock. I had been taken to the Opéra-Comique by a staff officer, the French Foreign Ministry shewing me the attention because of some work I had done for them. Major B. was then doing staff work for the French Territorials and was very enthusiastic about them. He shewed me a photograph of an old Territorial in the parodos of a trench. The old man had been cutting the entrance to a dug-out in the chalk of the parodos. He had fallen asleep, sitting spread-eagled—his hands and arms raised above his head, the right holding a great cold-chisel, the left a hammer, the legs stretched out before him. At the time in the crowded foyer, I felt the singular emotion that we all know—of having seen that scene before. Now it occurs to me that that must have been a sudden remembrance of good Ragged Arse.

I had taken him over to the Pent.

All my life I have had a singular complexity of

possessions or have been singularly occupied in getting them shipshape. I seem to have leased, bought, inhabited, mended, extended, patched up, cleaned out more houses, households of furniture, carts, harness, waggon-sheds, plots of ground than there are years to my life or than would have sufficed for the lifetimes of ten other men. One of these properties was the Pent—the old farmhouse to which I went after living at Bonnington. This old place I pulled about for years, restoring it on the most approved lines to its original antique condition of great rafters and huge ingles with rackets and crocks. In all these activities poor Wilson was my abettor. There was nothing he could not do, patiently and to perfection. He was a wonderful gardener; he could make a stake-and-binder hedge better than any other man; he could get out of the underwood more of the fourteen kinds of woodcraft produce than any other man in the weald of Kent, or Sussex too. . . . Hop-poles, uset-poles, stakes, binders, teenet, faggots, wattle-gates, field-gates, clothes-props, clothes-pegs, gate-posts, kindling—there was nothing he could not work up out of your underwood and brush. He was an admirable thatcher, a careful waggoner, a wonderfully good shepherd. He could lay bricks, cut out rafters, plaster, hang paper, paint, make chairs, corner-cupboards, fish, poach, snare, brew, gather simples, care for poultry, stop foxes' earths. He could keep tallies and the most complicated accounts on notched sticks, cutting with a bill hook I II III IV V VI VII VIII IX X as fast as you could write them with a pen and adding up quite as fast. There was nothing he could not do but write, and late in life he taught himself to read—after he discovered that with the aid of a pair of old spectacles he could tell a great A from a bull's foot.

I had taken him over to the Pent then. He did all the odd jobs, attendant upon settling into that old place that had allowed to run to rack and ruin. His capacity for work was amazing. All daylight he worked in the orchard and gardens; when the lamps were lit he came into the

house and did carpentering. He had his meals with me; where he slept I never knew—I suppose on some straw and sacks in the corner of a cow-house. One evening, after supper, he started to disinter an old ingle-nook that had been bricked by previous farmers. I went to bed.

In the morning I came down and there was Wilson asleep on an old coffin-stool in the opened-up ingle. His arms were above his head, one hand holding a great hammer, another a cold-chisel, his legs were extended before him. It was of that that I was reminded in the foyer of the Opéra-Comique in 1917.

I think he was happy. In fact I think all those people were as happy as they were wise and unlettered. They made good money; thirteen and sixpence—say three and half dollars—a week with a cottage and garden for eighteenpence—say thirty-six cents! They would have a pig in the pen, a chicken or two, a poached rabbit, a hare when they were in luck, hopping money to pay the bills at Michaelmas, a cant of underwood to work on for their own profit in winter when farm work was at a standstill. And American beef was fourpence—eight cents—a pound in Ashford Market and fresh butter five pence at Grists on the Marsh. And you did not want for junketings; there were Fair-day and Wood Saledinners and excursions got up by Parson for the whole parish. Every year a party went from Bonnington to Boulogne in France. You could see it from Aldington Knoll on a clear day. One and threepence return to Folkestone Harbour, five shillings return Folkestone Harbour to Boulogne and twelve hours among the Frenchies. You could take yourself, the mistress and a daughter there and back for a pound and have fivepence apiece left to buy shell-boxes with views of the sea for the three other children.

No; it was not a bad life. I daresay it was as good a life as the world had to show—in the nineties in the English countryside when food was so cheap that even Shaking Ben got his bellyful twice a day from one cottage or another on his beat.

The village was full of sociability; you chattered over
the hedgerows or from orchard to orchard. There was
always plenty to talk about and plenty to do. You are not
to think that Ragged Arse Wilson bemoaned his lot. He
worked all daylight and all candlelight hours. But it was
merely turning from one handicraft to another. Every-
thing that he did interested him and everything that he
saw—from the ice breaking up on the dykes to the green
of Lenten wheat and the chaffinches nesting, the bees
swarming, the apples ripening, the hopping, the October
brewing, the wood sales, the work in the wood and so
round to Christmas and the New Year frosts again. I dare-
say Wilson, fashioning his axe-helve by the firelight, was
happier than any Wall Street operator in his box at the
Metropolitan Opera or than I, with such cares as I have,
sitting writing here. He was singularly carefree.

You would have believed that if you could have heard
them up at T'Shop at Aldington Corner on a Saturday
night. T'Shop was the village Club, the Emporium, the
news centre, the employment agency, the bank. It ran away,
back, back, from the mellow oil lamps in its two nar-
rower windows, back into sheds, stables, cellars, From its
rafters and the rafters of all the out-buildings hung a
mysterious inverted forest of unassorted objects—boots,
buckets, ploughshares, strings of onions, flasks of olive
oil, red herrings, corduroy trousers, baggin-hooks, bill-
hooks, tool-baskets, cradles, hams. There was no imagin-
able thing that you could not buy there—even to books.
I once bought off the counter Dostoievsky's *Poor Folk*.

And when Saturday's dusk had settled down on the
fallows and ridges and the dykes and the great marsh and
the high downs, then tongues wagged in T'Shop. Every-
one stood there, an immense market-basket or a potato-
trug on the arms—stood and stood and stood and talked
and talked or, into deaf ears, shouted. Farmer Borden had
had a stroke: a judgement on him! Fifty years ago he had
taken advantage of Dan Hogbin's gel an' tried to palm
the chil' onto his waggoner's mate to make the illegiti-

macy 'lowance less. A judgement on him! Dan Rangsley, down to Coppin's, he was the follow. Keeper Finn and Policeman Hogbin they bursteses into his place when the smoke was coming out of the chimney. There set Mistress Rangsley rocking the baby to and fro an' the crock babble-babbling from the hook on the fire. Powerful keen eyes they has Keeper Finn and Peeler Hogbin. Sees a pheasant's feather on the floor by Mistress Rangsley's foot and a hare's foot on the gun-rack. They pounces on the pot and what does they find boiling? Tater-peelings! You see? Tater-peelings for the peeler.... They had thought to find a pheasant or a hare of Earl Sonde's. Powerful ashamed they were. Show a tater to Policeman Hogbin and he'll clout you over the head or slope away round the corner according to the mood that is on him. How did Rangsley contrive that?—Picked up the feathers and the foot in game-dealer Vidler's shop up to Ashford Market when he'd bin to sell his mistress's duck eggs. Heard the Quality had it in mind to git him out of his cottage. You Know Who wants it for his doxy—her with the painted cheeks and don't-you-dare-look-at-me manner. But they won't catch Dan Rangsley. So in the warmth and scent of sugar, spices, leather, onions, coffee and woollens the talk goes on and on, list after list of weekly supplies being filled by the grocer's men.

Outside, silhouetted against the lights that gleam away, away for miles over the low country round Smith Paddocks, stands Shaking Ben. He holds the stump of his pipe to his toothless jaws, shrugs his shoulders incessantly, his straw basket dangling from his wrist. Sometimes he gives an eldritch shriek, sometimes a low chuckle. As you come out to go away down into the marsh you say: 'There Ben, you hain't no call to shriek. There's for you.' And you give him a couple of onions, or a handful of apple-rings, or a bit of pork, or a screw of 'baccy, according to your means or generosity.

There being no Squire for many miles round, the community centred on the parson. An old man with a long,

light, white beard that blew away over his shoulders, you would see him striding over the fields in black shiny leggings, his black Inverness cape streaming out behind him. He had a way when he talked to you, holding the side of his spectacles and pushing forward his face, which you might have called poking his nose into things. But nothing was further from Parson's habits. He let his flock alone—and was continuously consulted by them. His charities in the winter were very considerable. How he got along I could never understand; he had three large marshland parishes at a stipend of less than £250 a year —say $1,250. And he had several children and a parsonage that was falling to pieces. He was a most extraordinary preacher on occasion, though usually his sermons were above the heads of his congregation. But the country people would consult his children at T'Shop on a Saturday night and when the word went round that Parson was going to preach a stinger next day his tiny church would be packed with people listening in at all the windows. I sat under him once or twice on these occasions. I have seldom been more uncomfortably moved. He had a low voice, hardly more than a whisper. He held the side of his spectacles and uttered intimacies of everyday life that made the farmers and their wives around him groan spasmodically. On special occasions he would be invited to Canterbury to preach 'before the Archbishop and Sir Edward and the Lords,' his parishioners said. But he never got promotion. On the death of his first wife, he had married his cook, the only recompense he could make her for devoted nursing during an illness lasting for years. But you must not marry your cook—not though you be St Chrysostom of the golden words—if you want a house in a Cathedral Close among deans and minor canons.

A feature outside the country-communal life of the village was Grocer Rayner of T'Shop. Though he organized and ran that complicated place with a hand of iron, he was stone deaf. So he read. He read Henry James, Joseph Conrad, Stephen Crane. He had had no outside

guidance to these authors. He read them with the passionate engrossment of a man in deep isolation. When I once went into his parlour I saw that he had complete sets of the first editions of those authors. He had bought them as they came out. They would have driven New York auction rooms mad a year or so ago. When Crane and Conrad came into his shop one day Rayner's emotion was so great that he was ill for some time—a dour, bearded, Scotch-looking grocer.

It is a great pleasure of the literary life to come thus right out of the blue on figures like that of the Aldington grocer. Writing books, so far as the great public is concerned, is rather like throwing them into a well. You write and publish—and nothing happens. That literary, or literarily inclined, people should here and there salute you is all in the day's journey. You think cynically that the salutation is interested in one way or another—because of hope of return, or boredom, or desire of social advancement. But one day to come across a village grocer, or a bank president, or a railway porter or a doctor, accidentally to find that they support what you stand for—your friends, your point of view, your Movement—that is a great encouragement.

I wonder if that country group was happier for being unable to read. I fancy not. Imagination must be served or it feeds on itself; then superstitions come creeping in. And superstitions run like underground rootstocks throughout most countrysides—queer superstitions that the Quality neither hears of nor suspects. I had glimpses of them now and then. Once I was digging at Aldington in a bed near the corner of my cottage. Wilson and I were getting out a tree that was undermining the foundations. I dug up a small china doll and was about to throw it away. Wilson said with a queer dry manner:

'I wouldn't throw that away, Master. You'll be throwing away your luck. Us chaps buried that there when you bought this place.'

I asked him if they always did that. He blushed shyly

and at last said:

'Us allus does it if us likes the governor—Buries a maiden or a doll or a horse's skull if us can get it.'

That of course was an unsuspected survival of the human sacrifice when men buried a slave or a captive beneath the corner-stone of a new house. 'Maiden' is the Kentish for the mell doll of other counties—the last sheaf home of the harvest, tricked out with ribbons and given the place of honour at the thanksgiving dinner.

Once on the face of the cliff we dug up two very large skeletons in a burial niche. They faded away as the air got at them—all except the bright white teeth. Whilst they were crumbling Wilson looked at them pensively and said:

'Those be Denes—the gentry that jumps on your back like boo-boys and strangles you to death. In Aldington Knoll woods after dark.'

The Denes were the unforgotten and still dreaded Danes. The skeletons were those of men who had on that spot fallen in a tenth-century battle between the sea-robbers and the Anglo-Saxons. In much the same way the inhabitants of the hinterland of the Riviera and the Cam-argue dread the *Revenants* of the Saracens. As the Danes ravaged the south shores of England, so the Saracens landed on those of the Mediterranean and burnt and slew and led away captives. And just as the South Wind which brought the Algerines is still endowed with mysterious evil qualities on the shore of the one sea, so the East Wind in Essex and Kent is accounted the root of all evil. It is best not to be born with those winds blowing. You *may* have the evil eye. And it is worse at night.

Indeed the night sheds terrors over some countrysides and many, many were the woodland paths and roads that Wilson and Meary Walker, and Meary Spratt and Duss Diamond and the others absolutely refused to take after sundown. Still more singular were the taboos that existed —the things that for indefinite and unstatable reasons you must not do—and the mascots! But these do not come into this book. . . .

BEFORE
ARMAGEDDON

BEFORE ARMAGEDDON

A RING OF FOREIGN CONSPIRATORS

WINCHELSEA stands on a long bluff, in shape like that of Gibraltar. Two miles of marsh separate it from Rye. Once it was sea where the marsh now is; one day it will be so again. When it was sea all the navies of England would ride in that harbour. And the Five Ports and the two Ancient Towns provided all the navies of the King of England, as against certain privileges. A Baron of the Cinque Ports can still drive through all toll-gates without payment and sell in all markets toll-free.

In the face of the cliff that Winchelsea turns to Rye there is a spring forming a dip—St Leonard's Well, or the Wishing Well. The saying is that once you have drunk of those dark waters you will never rest until you drink again. I have seen—indeed I have induced them to it—three Americans, Henry James, Stephen Crane and W. H. Hudson, drink there from the hollows of their hands. So did Conrad. They are all dead now.

It was perhaps those waters that induced their frequentations of those two towns. But indeed there were sufficient other inducements. An historic patina covers their buildings more deeply than any others, in England at least. Indeed, I know of no place save for Paris, where memories seem so thick on every stone. The climate, too, is very mild. There is practically no day throughout the year on which a proper man cannot eat his meals under a south wall out of doors. Then, it is near France. On most days you can see the French cliffs. Once, by an

effect of mirage, the city of Boulogne was brought so near to Hastings, which is next door to Rye, that the promenaders on the parade of the English town could discern the faces of the tourists inspecting the column of Napoleon on the Boulogne sward over the sea which Napoleon erected to celebrate his invasion of England. That was as near as anything of his which ever got to the coasts of the Five Ports.

At any rate, it is an infectious and holding neighbourhood. Once you go there you are apt there to stay. Or you will see in memory, the old walled towns, the red roofs, the grey stones, the country sweeping back in steps from the Channel to the North Downs, the great stretch of the Romney Marsh running out to Dungeness. In the Middle Ages they used to say: 'These be the four quarters of the world: Europe, Asia, Africa and the Romney Marsh.' But that was before Columbus committed his indiscretion. Hendrik Hudson drew many of his sailors from the Rye Town. A Rye man was the first European to lose his life by an arrow in Manhattan—on the shores of the Hudson, I should imagine, beneath where Grant's grave is.

Some years ago my friend Mr H. G. Wells wrote to the papers to say that for many years he was conscious of a ring of foreign conspirators plotting against British letters at no great distance from his residence, Spade House, Sandgate. For indeed, those four men—three Americans and one Pole—lit in those days in England a beacon that posterity shall not easily let die. You have only got to consider how empty, how lacking a nucleus, English literature would to-day be if they had never lived, to see how discerning were Mr Wells's views of that foreign penetration at the most vulnerable point of England's shores.

At that date Henry James was clean-shaven. As clean-shavenness was then comparatively rare he had in his relatively quiet moments the air of a divine; when, which was more frequent, he was animated, he was nearly always

humorous and screwed his sensitive lips into amused or sardonic lines. Then he was like a comedian. His skin was dark, his face very clear-cut, his brow domed and bare. His eyes were singularly penetrating, dark and a little prominent. On their account he was regarded by the neighbourhood poor as having the qualities of a Wise Man—a sorcerer. My servants used to say: 'It always gives me a turn to open the door for Mr James. His eyes seem to look you through to the very backbone.'

His vitality was amazing. You might put it that he was very seldom still and almost never silent. Occasionally when he desired information and you were giving him what he wanted he would sit gazing at you with his head leaning back against his grandfather's chair. But almost immediately he would be off with comment and elucidation—or with more questions accompanied by gestures, raising of the eyebrows and the humorous twisting of his lips. His peculiarities were carefully thought out by himself. A distinguished man in the fifties must have peculiarities if he has a strong personality. His conversation used to contain a great many compliments to his interlocutor, male or female. They were the current coin of his conversation, learned in France and having no real significance but the fact that they were agreeable. Every woman from the Lady Maud Warrender on the hill to Meary Walker in the meshes was 'dear lady'; every man, 'my dear fellow.' If you did or produced anything it was always admirable: 'Your admirable verses, your admirable still lifes, tea-cakes, knowledge of stock-exchange operations, market-gardening.' It was agreeable when you were used to it but many people—and most Americans—it bewildered or repelled because of a supposed insincerity. Until you know a person well, it is perhaps not ethically better to say to him or to her '*Muy Hermosa Señora beso los manos de Usted,*' than to employ a universal 'buddy' for social contacts. But it is not insincere.

On the other hand, if he liked or were intimate with

you, his manners changed at once. You would not lack for censure, criticism or exhortations along with exactly calculated praise. He liked to live with people of leisure who were intellectually no wasters of time. At times he was unreasonably cruel—and that to the point of vindictiveness when his nerves were set on edge. I remember him at a tea-party given by one of his most gentle and modest admirers. He was talking to the young man's equally gentle, modest and adoring wife. The young man interrupted him by several times offering him sugar, tea-cakes, cigars. The things that he at last spat out to that young man I will not repeat. He indicted his manners, his hospitality, his dwelling, his work, with a cold fury in voice and eyes.

I was once walking with him and Mr John Galsworthy along the Rye Road to Winchelsea. His dachshund, Maximilian, ran sheep; so, not to curtail the animal's exercise, the master had provided it with a leash at least ten yards long. Mr Galsworthy and I walked on each side of James, listening obediently whilst he talked. In order to round off an immense sentence, the great man halted, just under Winchelsea Hill beneath the windows of acquaintances of us all. He planted his stick firmly into the ground and went on and on and on. Maximilian passed between our six legs again and again, threading his leash behind him. Mr Galsworthy and I stood silent. In any case we must have resembled the Laocoön, but when Maximilian had finished the resemblance must have been overwhelming. The Master finished his reflections, attempted to hurry on, found that impossible. Then we liberated ourselves with difficulty. He turned on me, his eyes fairly blazing, lifting his cane on high and slamming it into the ground:

'H . . . !' he exclaimed. 'You are painfully young, but at no more than the age to which you have attained, the playing of such tricks is an imbecility! An im . . . be . . . cility!'

The politeness of Conrad to James and of James to Conrad was one of the most impressive kind. Even if they

had been addressing each other from the tribune of the
Académie Française their phrases could not have been
more elaborate or delivered more *ore rotundo*. James
always addressed Conrad as '*Mon cher confrère*,' Conrad
almost bleated with the peculiar tones that the Marseillais
get into their compliments '*Mon cher maître*.'... Every
thirty seconds! When James spoke of me to Conrad, he
always said: '*Votre ami, le jeune homme modeste!*' They
always spoke French together, James using an admirably
pronounced, correct and rather stilted idiom such as pre-
vailed in Paris of the seventies. Conrad spoke with extra-
ordinary speed, fluency and some incomprehensibility, a
meridional French with a strong southern accent as that
of garlic in *aïoli*.... I speak French with a strong British
accent and much too correctly. When I was a boy my
grandfather, who was French by birth and had a strong
French tinge to his English, used to say to me: 'Fordie,
you must speak French with absolute correctness and
without slang, which would be an affectation, but with
the strongest possible English accent, to show that you
are an English gentleman.' We talked in those days, with
those distinctions of language, for many hours on end.
Or, rather, I listened whilst they talked.

Conrad had the most unbounded, the most generous
and the most understanding admiration for the Master's
work but he did not much like James personally. I im-
agine that was because at bottom James was a New
Englander *pur sang*, though he was actually born in the
city where I am writing.* James, on the other hand, liked
neither Conrad nor his work very much, mostly, I imagine,
because at bottom Conrad was a Pole, a Roman Catholic
and romantic and Slav pessimist. It was hardly to be
expected that James should like, say, *Lord Jim*, for,
though that may less appear to-day, the technique of
Conrad's work was then singularly revolutionary. James,
on the other hand, never made fun of Conrad in private.
Conrad was never for him 'poor dear old' as were

* New York.

Flaubert, Mrs Humphry Ward, Meredith, Hardy or Sir Edmund Gosse. He once expressed to me, as regards Conrad, something like an immense respect for his character and achievements. I cannot remember his exact words, but they were something to the effect that Conrad's works impressed him very disagreeably, but he could find no technical fault or awkwardness about them. So that, since so many men whose judgement he affected regarded Conrad even then as a great master, he must not be taken as uttering any literary censure....

The Conrad of those days was Romance. He was dark, black-bearded, passionate in the extreme and at every minute; rather small but very broad-shouldered and long in the arm. Speaking English he had so strong a French accent that few who did not know him well could understand him at first. His gestures were profuse and continuous, his politenesses oriental and at times almost servile. Like James he would address a society lady, if he ever met one, or an old woman in the lane, or his own servants, or the hostler at an inn, or myself, who was for many years little more than his cook, slut and butler in literary matters, or Sir Sidney Colvin, or Sir Edmund Gosse, all with the same profusion of endearing adjectives. On the other hand, his furies would be sudden. violent, blasting and incomprehensible to his victims. At one of my afternoon parties in London, he objurgated the unfortunate Charles Lewis Hind—a thin, slightly stuttering, nervous, dark fellow who was noted as a critic, mostly of paintings. Hind in a perfectly sincere mood had congratulated him because his name was on all the hoardings in London. Conrad's *Nostromo* was then being serialized in a journal that gave the fact unusual prominence in its advertisements.

Conrad, on the other hand, despised the journal and himself for letting his work appear in it. His hatred of the publicity was as real as if it were an outrage on the honour of his family. From the windows of my house his name was visible on a hoarding that some house-

breakers had erected—visible in letters three feet long.
This had driven him nearly mad and he had really taken
the congratulations of Mr Hind as gloating over his bitter
poverty. Mr Hind had a sardonic manner and spoke with
a rictus; bitter and dreadfully harassing poverty alone
had driven Conrad, mercilessly, to consent to that de-
gradation of his art.

In the event, next day Conrad was very ill with
mortification and I had to write the part of a serial that
remained to make up the weekly instalment. Our life
was like that. That manuscript of mine is in the hands
of a collector in this city.*

Otherwise he was the most marvellous *raconteur* in
the world. There was no country he could not make
you see when he talked, from Poland to the palms of
Palembang. He suffered at that time and till towards the
end of his life from agonies of poverty. He was terribly
concerned for the material future of his family to whom
he was almost unbelievably attached. Crane and Hudson
he really loved personally. His admiration for their works
was unbounded. When their books came it was as if he
bounded into them like a schoolboy running from the
school-door. I do not think he took much real stock in
other writers of English. He would utter elaborate polite-
nesses to them if he met them.

But you could always tell when he really admired work.
It would manifest itself in two ways. You would be read-
ing at one end of the room and he at the other. It would
be a new book he was reading—or perhaps a Flaubert,
a Turgenev or a Maupassant. He would begin to groan
and roll about on the couch where he was extended.
After a time he would say: 'What is the use? I ask you
what is the use of writing? When this fellow can write
like this. There's no room for us.' He would go on groan-
ing. Then he would, after a time, spring up, holding his
book. 'Listen to this!' he would exclaim in sheer joy,

* A long instalment in Ford's hand, it is now in Yale University
Library.

laughing with it as if with his whole body. 'By God,' he would cry out, 'there was never anything like this.' And he would read out a phrase of Crane's: 'The waves were barbarous and abrupt'; or a short passage of Hudson in which he shows you dandelion globes, when you are lying on your back on Lewes Downs, globes illuminated by the sun against the blue sky, in millions, for miles up into the blue. Or he would close a book by Henry James, sigh deeply and say: 'I don't know how the Old Man does it. There's nothing he does not know; there's nothing he can't do. That's what it is when you have been privileged to go about with Turgenev.'

Hudson immensely admired Conrad personally. He was very lean, *very* tall, big-boned, long-limbed, grey. He was slow in his motions. You have to be if you are a field naturalist. His head was smallish for his great frame, but as if chiseled by the wind, as rocks are; his cheeks weather-beaten. His eyes were small and keen, usually a little closed as if he were looking up along a strong wind. His voice was very gentle, soft as a rule, sometimes a little high and reedy, his accent neither English nor American, but very scrupulous. He had a little, short, pointed grey hidalgo's beard and a heavy grey moustache. He was all gentleness and infinite patience. I have been with him in circumstances of ill-natured companionship and querulousness in which his patience was unending. He would stroll along, swinging his shoulders, stooping a little, mostly silent, occasionally putting in a word of dissent, to shew that he was paying attention. He suggested, the immensely long fellow, a man holding in his hand a frightened bird, but making his examination with such gentleness that the bird's little heart would soon cease to beat fast. If he stood against the old grey wall in a field, he was so grey that he would be almost invisible from a few yards away unless you looked specifically for him.

He knew on the surface little about books. He would say again and again, indignantly: 'I am no writer. I am a naturalist.' He looked at books from afar. It was perhaps

long-sightedness but it gave the idea that he was mentally
aloof. He would stand up, holding *Heart of Darkness*, and
say: 'Yes, the river's all right. The trees are all right. Yes,
not so bad. No doubt he's a master.' James personally
a little alarmed him. Hudson was used to high society,
moving in aloof realms that are usually closed to imagina-
tive writers. They were then open to almost all Ameri-
cans, because they committed you to nothing socially.
The Greys of Falloden loved Hudson because he loved
birds. So he would look at James enigmatically, breath-
ing rather uncertainly through his nose. James was a
society figure all right—but a little too flamboyant. Like
an unusual species of a familiar genus. The early works of
James, in their first versions, Hudson liked and he was
ready to acknowledge that the Old Man was the master
of us all. Old Man means captain on a ship, a colonel in
a regiment, a head foreman in a gang of stevedores, a
master shepherd on a farm.

Crane was the most beautiful spirit I have ever known.
He was small, frail, energetic, at times virulent. He was
full of fantasies and fantasticisms. He would fly at and
deny every statement before it was out of your mouth.
He wore breeches, riding leggings, spurs, a cowboy's
shirt, and there was always a gun near him in the medieval
building that he inhabited seven miles from Winchelsea.
In that ancient edifice he would swat flies with precision
and satisfaction with the bead-sight of his gun. He pro-
claimed all day long that he had no use for corner lots
nor battlefields, but he got his death in a corner, on the most
momentous of all battlefields for Anglo-Saxons. Brede
Manor saw the encampment of Harold before Hastings.

He was an American, pure-blooded, and of ostentatious
manners when he wanted to be. He used to declare at one
time that he was the son of an uptown New York Bishop;
at another, that he had been born in the Bowery and
there dragged up. At one moment his voice would be
harsh, like a raven's, uttering phrases like: 'I'm a fly-guy
that's wise to the all-night push,' if he wanted to be taken

for a Bowery tough; or 'He was a mangy, sheep-stealing coyote,' if he desired to be thought of cowboy ancestry. At other times, he would talk rather low in very selected English. That was all boyishness.

But he was honourable, physically brave, infinitely hopeful, generous, charitable to excess, observant beyond belief, morally courageous, of unswerving loyalty, a beautiful poet—and of untiring industry. With his physical frailty, his idealism, his love of freedom and of truth he seemed to me to be like Shelley. His eyes with their long fringes of lashes were almost incredibly beautiful—and as if vengeful. Of his infinite industry he had need.

It was delightful to go to Brede Place because Steevie was there, but nothing was more depressing than to drive down into the hollow. In the Middle Ages they built in bottoms to be near the water, and Brede, though mostly an Elizabethan building, in the form of an E out of compliment to Great Eliza, was twelfth-century in site. The sunlight penetrated, pale, like a blight into that damp depression. The great house was haunted. It had stood empty for half a century, the rendez-vous of smugglers. On the green banks played fatherless children—and numberless parasites.

Crane never forgot a friend, even if it were merely a fellow who had passed a wet night with him under an arch. His wife was minded to be a medieval châtelaine. A barrel of beer and a baron of beef stood waiting in the rear hall for every hobo that might pass that way. The house was a nightmare of misplaced hospitality, of lugubrious dissipation in which Crane himself had no part. Grub Street and Greenwich Village did.

The effect on James of poor Steevie was devastating. Crane rode about the countryside on one of two immense coach-horses that he possessed. On their raw-boned carcases his frail figure looked infinitely tiny and forlorn. At times he would rein up before the Old Man's door and going in would tell the master's titled guests that he was a fly-guy that was wise to all the all-night pushes of

the world. The master's titled guests liked it. It was, they thought, characteristic of Americans. If the movies had then existed they would have thought themselves confronted with someone from Hollywood. James winced and found it unbearable.

From Steevie he had stood and would have stood a great deal more. The boy for him was always: 'My young compatriot of genius.' But he would explain his wincings to English people by: 'It's as if ... oh dear lady ... it's as if you should find in a staid drawing-room on Beacon Hill or Washington Square or at an intimate reception at an Embassy at Washington a Cockney—oh, I admit of the greatest genius—but a Cockney, still, a costermonger from Whitechapel. And, oh heavens, received, surrounded and adulated ... by, ah, the choicest, the loveliest, the most sympathetic and, ah, the most ornamented....'

And the joke—or, for the Old Man the tragedy—was that Crane assumed his Bowery cloak for the sole purpose of teasing the Master. In much the same way, taking me for a Pre-Raphaelite poet, at the beginning of our friendship, he would be for ever harshly denouncing those who paid special prices for antiquities. To Conrad or to Hudson, on the other hand, he spoke and behaved as a reasoning and perceptive human being.

And indeed the native beauty of his nature penetrated sufficiently to the Old Man himself. I never heard James say anything intimately damaging of Crane, and I do not believe he ever said anything of that sort to other people. But what made the situation really excruciating to James was the raids made by Crane's parasites on Lamb House. No doors could keep them out, nor butler. They made hideous the still levels of the garden with their cachinnations, they poked the Old Man in the ribs before his servants, caricatured his speeches before his guests and extracted from him loans that were almost never refused. There were times when he would hang about in the country outside Rye Walls rather than make such an encounter.

The final tragedy of poor Steevie did not find him wanting. It was tragedy. The sunlight fell blighted into that hollow, the spectres waved their draped arms of mist, the parasites howled and belched on the banks of Brede. That was horrible. But much more horrible was the sight of Crane at his labours. They took place in a room in the centre bar of the E of the Place, over the arched entry. Here Crane would sit writing, hour after hour and day after day, racked with the anxiety that he would not be able to keep going with his pen alone all that fantastic crew. His writing was tiny; he used great sheets of paper. To see him begin at the top of the sheet with his tiny words was agonising; to see him finish a page filled you with concern. It meant the beginning of one more page, and so till death. Death came slowly but Brede was a sure death-trap to the tuberculous.

Then James's agonies began. He suffered infinitely for that dying boy. I would walk with him for hours over the marsh trying to divert his thoughts. But he would talk on and on. He was for ever considering devices for Crane's comfort. Once he telegraphed to Wanamaker's for a whole collection of New England delicacies from pumpkin-pie to apple-butter and sausage-meat and clams and soft-shell crabs and minced meat and . . . everything thinkable, so that the poor lad should know once more and finally those fierce joys. Then new perplexities devastated him. Perhaps the taste of those far-off eats might cause Steevie to be homesick and so hasten his end. James wavered backwards and forwards between the alternatives beneath the grey walls of Rye Town. He was not himself for many days after Crane's death.

So the first of those four men to die was the youngest. Taken altogether, they were, those four, all gods for me. They formed, when I was a boy, my sure hope in the eternity of good letters. They do still. Long ago the greatest pride of my life used to be that Crane once wrote of me to a friend (I had presumably upset him by some want of oriental deference):

'You must not mind Hueffer; that is his way. He patronizes me; he patronizes Mr Conrad; he patronizes Mr James. When he goes to Heaven he will patronize God Almighty. But God Almighty will get used to it, for Hueffer is all right!'

And the words are my greatest pride after so many years.

They are now all dead, a fact which seems to me incredible still. For me they were the greatest influence on the literature that has followed after them—that has yet been vouchsafed to that literature. Young writers from Seattle to the Golden Gate and from Maine to Jacksonville, Florida, write as they do because those four men once wrote—and so with old writers in old houses in Greenwich Village. That fourfold tradition will not soon part. To that tradition I will one day return. For the moment I have been trying to make them live again in your eyes. . . . 'It is, above all, to make you see.'

I MEET THE MASTER

I cannot now remember whether I met Henry James before Conrad, but I think I did. I remember, at any rate, that I felt much younger when I at last went to see him than I did when Conrad first came to see me. I was in those days of an extreme shyness and the aspect of the Master, bearded as he was then and wearing, as he habitually did in those days, a great ulster and a square felt hat, was not one to dissipate that youthful attribute. I must have been seeing him in the streets of Rye on and off for eighteen months after Mrs W. K. Clifford had asked me to go and see him. The final pressure put on to do so had by then become considerable.

The adoration for Henry James amongst his relatively few admirers of those days was wonderful—and deserved. And I imagine that his most fervent adorers were the

Garnett family, of whom the best-known member is today Mr Edward Garnett, the publisher's reader who first advised a publisher to publish Conrad. In those days it was Dr Richard Garnett whose reputation as Principal Librarian of the British Museum was world-wide. He had a number of sons and daughters and, for a long time, I was in and out of the Garnetts' house in the Museum courtyard every day and all day long. Their hospitality was as boundless as it was beneficent.

The public opinion, as it were, of the younger Garnetts must have had a great effect in shaping my young mind. In one form or other it made for virtue always—in some members for virtue of an advanced and unconventional type, in others for the virtues that are inseparable from, let us say, the Anglican communion. The elder Garnetts at any rate had a strong aversion from Catholicism.

Mrs W. K. Clifford, a by no means unskilled novelist of those days, had put pressure upon me to go and see James. She was, I think, his most intimate friend. He corrected the manuscripts of almost all the books of Mrs Humphry Ward, an act of great generosity. Of Mrs Ward he always spoke as 'poor dear Mary,' with a slightly sardonic intonation. But I remember his saying several times that he had respectful, if he might so call it, affection for Mrs Clifford. Therefore, when the Master, for reasons of a rather painful disillusionment, decided to leave London almost for good, Mrs Clifford was greatly concerned for his health and peace of mind. She urged me very frequently to go and see him, so that she might be posted as to his well- or ill-being. I remained too shy.

Then, hearing that James was almost permanently fixed at Rye, the young Garnetts, who knew that I paid frequent visits to the next-door town, began to press me in their turn to call on their cynosure. Their admiration for him was so great that merely to know someone who knew the Master would, it appeared, ease their yearnings. They admired him above all for his virtue. None of his books so much as adumbrated an unworthy senti-

ment in their composer; every line breathed of comprehension and love for virtue.

For myself, I disliked virtue, particularly when it was pressed between the leaves of a book. I doubt if, at the date, when I was twenty-three or -four, I had read anything of his and the admiration that was wildly showered from Bloomsbury in the direction of Rye made me rather stubbornly determined not to do so for some time. I daresay I was not a very agreeable young man. But unbounded admiration quite frequently renders its object disagreeable to outsiders. Boswell must have alienated quite a number of persons from Johnson, and I have known a great many distinguished figures who would have been better off without surroundings of awed disciples who hushed roomfuls when the genius gave signs of desiring to speak. James suffered a great deal from his surroundings.

My resistance broke down eventually with some suddenness. James, who was always mindful of his health, had written a distressing letter to Mrs Clifford—about his eyes, I think. Mrs Clifford had influenza. She sent me three telegrams the same day begging me to go see the Master and report to her. I sent him a note to ask if I could visit him, mentioning that Mrs Clifford desired it.

I do not imagine that Mr James had the least idea what I was, and I do not think that, till the end of his days, he regarded me as a serious writer. That in spite of the fact that subsequently during whole winters we met almost daily and he consulted me about his most intimate practical affairs with a touching trustfulness in my *savoir faire* and confidence in my discretion. He was, however, cognisant of my ancestry and of the members of my grandfather's and father's circles. These he much disliked. He thought them Bohemian. I, on the other hand, considered myself as belonging, by right of birth, to the governing classes of the literary and artistic worlds.

I do not mean to say that I talked about my distinguished relatives, connections or family intimates. But I

am now conscious that I acted and spoke to others as if my birth permitted me to meet them as equals. Except for the King and my colonel on parade, I do not know that I ever spoke to anyone except on that basis. On the other hand, I never spoke even to a charwoman on any other. I have, however, always had a great respect for age, if accompanied with exceptional powers.

I certainly felt not infrequently something like awe in the presence of James. To anyone not a fool his must be a commanding figure. He had great virility, energy, persistence, dignity and an astonishing keenness of observation. And upon the whole he was the most masterful man I have ever met.

On that first occasion he was bearded, composed and magisterial. He had taken the house of the vicar, furnished, and had brought down his staff of servants from de Vere Gardens. At lunch he was waited on by his fantastic butler. The fellow had a rubicund face, a bulbous red nose, a considerable paunch and a cutaway. Subsequently he was to become matter for very serious perturbations to his master.

His methods of service were startling. He seemed to produce silver entrée dishes from his coat-tails, wave them circularly in the air and arrest them within an inch of your top waist-coat button. At each such presentation James would exclaim with cold distaste: 'I have told you not to do that!' and the butler would retire to stand before the considerable array of plate that decorated the side-board. His method of service was purely automatic. If he thought hard about it he could serve you without flourishes. But if his thoughts were elsewhere, the flourishes would return. He had learnt so to serve at the table of Earl Somebody—Brownlow, I think.

At any rate, James seemed singularly at home where he was. He was well-off for a bachelor of those days, when four hundred pounds a year was sufficient for the luxurious support of a man about town. You might have thought that he was in his ancestral home, the home itself

one of some elegance in the Chippendale-Sheraton-Gainsborough fashion. He had the air of one of the bearded elder-brother statesmen of the court of Victoria; his speech was slow and deliberate; his sentences hardly at all involved. I did not then gather anything about the state of his eyes.

He was magisterial in the manner of a police-magistrate, civil but determined to receive true answers to his questions. The whole meal was one long questionnaire. He demanded particulars as to my age, means of support, establishment, occupations, tastes in books, food, music, painting, scenery, politics. He sat sideways to me across the corner of the dining table, letting drop question after question. The answers he received with no show at all of either satisfaction or reproof.

After a meal he let himself go in a singularly vivid display of dislike for the persons rather than the works of my family's circle. For my grandfather, Ford Madox Brown, and for my father he expressed a perhaps feigned deference. They were at least staid and sober men, much such as Mr James affected and believed himself to be. Then he let himself go as to D. G. Rossetti, William Morris, Swinburne, my uncle William Rossetti, Holman Hunt, the painter of the 'Light of the World,' Watts-Dunton and all the rest of the Pre-Raphaelite circle. D. G. Rossetti he regarded with a sort of shuddering indignation such as that he devoted, subsequently, to Flaubert—and for much the same reason. When he had called on Rossetti, the painter had received him in his studio, wearing the garment in which he painted, which James took to be a dressing-gown. It was a long coat, without revers, like a clergyman's and had extremely deep vertical pockets. These Rossetti used for the keeping of his paint-rags.

For Mr James the wearing of a dressing-gown implied a moral obloquy that might end—who knows where? And he deduced from the fact that Rossetti received him at tea-time in what he took to be such a garment that he

was disgusting in his habits, never took baths and was insupportably lecherous. He repeated George Meredith's account of the masses of greasy ham and bleeding eggs which Rossetti devoured at breakfast.

He mimicked the voice and movements of Swinburne with gusto. He let his voice soar to a real falsetto and jerked his body sideways on his chair extending his hands rigidly towards the floor below his hips. He declared that Swinburne's verse in its flood and noxiousness was only commensurate with the floods of bad chianti and gin that the poet consumed. He refused to believe that Swinburne in those days, under the surveillance of Watts-Dunton, drank no more than two half-pints of beer a day. And he particularly refused to believe that Swinburne could swim. Yet Swinburne was one of the strongest salt-water swimmers of his day. One of Maupassant's *contes* tells how Swinburne's head with its features and hair of a Greek god rose from the sea beside the French writer's boat three miles out in the Mediterranean and how it began glorious to converse. And so conversing, Swinburne had swum beside the boat to the shore. No doubt Maupassant had his share of a poet's imagination. But Swinburne certainly could swim. He was also a remarkably expert skater.

My uncle William Rossetti Mr James considered to be an unbelievable bore. He had once heard the Secretary to the Inland Revenue recount how he had seen George Eliot proposed to by Herbert Spencer on the leads of the terrace at Somerset House. . . . The Inland Revenue headquarters is housed in that building and the philosopher and the novelist were permitted by the authorities there to walk as a special privilege.

'You would think,' Mr James exclaimed with indignation, his dark eyes really flashing, 'that a man would make something out of a story like *that*. But the way he told it was like this,' and heightening and thinning his tones into a sort of querulous official organ, Mr James quoted: 'I have as a matter of fact frequently meditated

on the motives which induced the Lady's refusal of one
so distinguished; and after mature consideration I have
arrived at the conclusion that although Mr Spencer with
correctness went down upon one knee and grasped the
Lady's hand he completely omitted the ceremony of
removing his high hat, a proceeding which her sense of
the occasion might have demanded...." Is that,' Mr
James concluded, 'the way to tell *that* story?'

MR KIPLING'S MOTOR CAR

I was going up the narrow cobbled streets that led to the
Master's house at the top of the pyramidal town when I
met Mr and Mrs Kipling hurrying down. They appeared
to be perturbed.

Conrad and I had gone in from Winchelsea to Rye to
hire a motor car. We must have sold something. In those
days the automobile was a rapturous novelty, and when
we had any buckshee money at all it went in hiring cars.
It would cost about six pounds to go eighteen miles with
seventeen break-downs and ourselves pushing the car up
most inclines.

Conrad had a passion for engineering details that I did
not share, and he had gone in search of a car as to which
he had heard that it had some mechanical innovation
which he desired to inspect. I knocked, therefore, on the
door of Lamb House, alone.

Lamb House was a majestic Georgian building of the
type that Henry James had gone to England more
especially to seek. Its best front gave on the garden. The
garden had an immense smooth lawn and was shut in by
stone walls against which grew perennial flowers. It con-
tained also a massively built white-panelled pavilion.
In that, during the summer at least, the Master usually
sat and worked.

In Rye Church you could see the remains of a criminal

hung in chains. It is that of a murderer, a butcher, who set out to kill a Mr Lamb and killed a Mr Greville. Or it may have been the other way round. Rye Town was prouder of its murderer than of its two literary lights—Fletcher and Henry James—but the murderer always seemed to me to have been a clumsy fellow. Lamb House had belonged to the family of the gentleman who was—or wasn't—killed. But Henry James gloated most over the other legend, according to which the house had been occupied by a mistress of George IV. The king, sailing down channel on a battleship, was said to have been rowed ashore to visit the lady in the garden-pavilion. I always used to wonder at the prodigious number of caps, gloves, canes and hats that were arranged on a table—or it may have been a great chest—in the hall. How, I used to say to myself, can he need so prodigious a number of head-coverings? And I would wonder what thoughts revolved in his head whilst he selected the cap or the stick of the day. I never myself possessed more than one cloth cap at a time.

When I was admitted into his presence by the astonishingly ornate man-servant, he said:

'A writer who unites—if I may use the phrase—in his own person an enviable popularity to—as I am told—considerable literary gifts and whom I may say I like because he treats me—' and here Mr James laid his hand over his ear, made the slightest of bows and, rather cruelly rolling his dark and liquid eyes and moving his lower jaw as if he were revolving in his mouth a piquant tit-bit, Mr James continued, 'because he treats me—if again I may say any such thing—with proper respect'—and there would be an immense humorous gasp before the word 'respect'—'. . . I refer of course to Mr Kipling . . . has just been to see me. And—such are the rewards of an enviable popularity!—a popularity such as I—or indeed you, my young friend, if you have any ambitions, which I sometimes doubt—could ever dream of, far less imagine to ourselves—such are the rewards of an enviable

popularity that Mr Kipling is in the possession of a magnificent one-thousand-two-hundred-guinea motor car. And, in the course of conversation as to characteristics of motor cars in general and those of the particular one-thousand-two-hundred-guinea motor car in the possession of our friend. . . . But what do I say?. . . Of our cynosure! Mr Kipling uttered words which have for himself no doubt a particular significance but which to me at least convey almost literally nothing beyond their immediate sound . . . Mr Kipling said that the motor car was calculated to make the Englishman . . .' and again came the humorous gasp and the roll of the eyes . . . 'was calculated to make the Englishman . . . think.' And Mr James abandoned himself for part of a second to low chuckling. 'And,' he continued, 'the conversation dissolved itself, after digressions on the advantages attendant on the possession of such a vehicle, into what I believe are styled golden dreams—such as how the magnificent one-thousand-two-hundred-guinea motor car after having this evening conveyed its master and mistress to Batemans Burwash, of which the proper pronunciation is Burridge, would tomorrow devotedly return here and reaching here at twelve would convey me and my nephew William to Burridge in time to lunch, and having partaken of that repast to return here in time to give tea to my friend Lady Maud Warrender who is honouring that humble meal with her presence tomorrow under my roof. . . . And we were all indulging in—what is it?—delightful anticipations and dilating on the agreeableness of rapid—but not, for fear of the police and consideration for one's personal safety, *too* rapid—speed over country roads and all, if I may use the expression, was gas and gingerbread when. . . . There is a loud knocking on the door and—*avec des yeux effarés* . . .' and here Mr James really did make his prominent and noticeable eyes almost stick out of his head . . . 'in rushes the chauffeur. . . . And in short the chauffeur has omitted to lubricate the wheels of the magnificent one-thousand-two-hundred-guinea motor car

with the result that its axles have become one piece of molten metal. . . . The consequence is that its master and mistress will return to Burwash, which should be pronounced Burridge, by train and the magnificent one-thousand-two-hundred-guinea motor car will *not* devotedly return here at noon and will *not* in time for lunch convey me and my nephew William to Burwash and will *not* return here in time for me to give tea to my friend Lady Maud Warrender who is honouring that humble meal with her presence tomorrow beneath my roof or if the weather is fine in the garden. . . .'

'Which,' concluded the Master, after subdued ho, ho hos of merriment, 'is calculated to make Mr Kipling think.'

RABBITS AND STEAMED SOLE

One of the greatest pleasures of my life—and it was accorded me at Limpsfield—comes back to me with the remembrance of sunshine, open doors and windows, climbing roses—and Prince Kropotkin. Mild, blond, spectacled, gentle-spoken, the great scientist inspired me with singular affection. We wrangled by the hour together on the steps of the troglodyte cottage, the Princess being always watchfully near at hand. I cannot imagine about what we can have wrangled. It was rabbits, I think. Kropotkin immensely admired the rabbit. It was for him the symbol of perdurability—and mass production. It stood out against selection. Defenceless and adapted for nothing in particular, it had outlived the pterodactyl, the Hyrcanian tiger and the lion of Numidia. The coneys, in short, were a feeble people, yet had their homes in everlasting rocks.

I don't know what I had to say against that. I obviously found something or the arguments could not have taken place. What I did say must obviously have had *some* sense, or he would not have returned to argue with me. He did that very often. It was perhaps because he was

never allowed quite to finish an argument. His heart was weak; suddenly the Princess would descend upon him when he had just thought out something really crushing but before he had had time to formulate it. She would drape his plaid about him, he would be led off, spitting fiery sentences at me over his shoulder.

I knew nothing in those days about science. I know nothing now and it seems probable that I shall remain in a similar state of ignorance till I die. I have always entertained the most vivid distrust for the scientific mind. All the scientists I have known have seemed to me to be extraordinarily untrustworthy. I was once, at a public dinner in London, placed next to Professor Metchnikoff. He was at that time one of the most eminent scientists in the world. I was placed next to him because I was the only guest who could speak French. He was mild and gentle, his voice and accent resembled those of his compatriot, Kropotkin. His specialty was the great bowel. All the ills of life, all illnesses, poverties and distress were to be cured and life itself infinitely prolonged by proper attention to the great bowel. It was the rabbit of Kropotkin. You were to eat nothing but lettuce and milk. At any rate, you were to eat nothing that you would possibly want to eat.

On this occasion the beaming savant was reckless. He pointed to his plate and said:

'*Tiens: je vais faire la noce. . . .* I am going on the spree.'

His plate contained a steamed sole. Save for blotting-paper, there is nothing so without taste.

Having eaten it, he began to talk. He talked of the fowls of the air. As with Kropotkin, the coney of the rocks, so for Metchnikoff was the bird of heaven. Either because they have no great bowel or because, having it, they take great care of it, birds, according to Metchnikoff attain unheard-of ages. Ravens, he said, lived to be a thousand, vultures are practically immortal. And as for peacocks. . . . He was in ecstasies over the white peacocks he had just seen at Warwick Castle. Lady Warwick said they

had been given to her by Disraeli who had them through his grandfather who had them from Hamburg where they had already attained the age of two hundred. . . .

I suggested to my smiling and triumphant neighbour that Disraeli was one of the most romantic liars of his generation and Lady Warwick was one of the most romantic . . . oh, figures of the Court of Edward VII. But these facts conveyed nothing to the professor. In his subsequent volume on the great bowel, the white peacocks of Warwick occupied prominent positions.

POTATOES AND THISTLES

The land which I occupied at Limpsfield was stifled by thistles. I made several experiments in their quick eradication, more particularly by intensive plantations of potatoes, which has become the standard method. Whilst at Limpsfield, I wrote an article on this subject and submitted it to several literary journals. It was sent back.

Crane came to see me whilst I was doing these things in the troglodytic cottage that he mistook for a baronial ruin. He was brought there by Mr Edward Garnett, the son of the Keeper of Printed Books, who will be as immortal amongst publishers' advisers as was his father amongst cataloguers. I don't think Crane wanted to come and see me because he took me for a Pre-Raphaelite poet. But in Limpsfield there was a strong get-together movement in those days and poor Crane had to come and plant a rose-tree beside the lintel of the door which was formed of half a mill-wheel.

The rose-tree was there a few years ago. You may no doubt have souvenirs. I may add that Conrad and I once planted an orange-tree, grown from a pip, under a south wall at the Pent. That also was still growing when I visited the place after Conrad's death. It grew no higher than the rim of the wall, the North Wind cutting it back;

but the fact should to the incredulous be a testimony to the climatic mildness of that Gulf-Streamed part of the shores of England. For the matter of that, at this November moment of writing, I am looking at an avocado pear-tree grown from a pip in a Greenwich Village back-yard. May the omen be propitious to its orange-leaf-like foliage!

Crane could use a spade all right. He could, that is to say, lift a heavy, wrought steel, sharp implement and, bringing it down from the full extent of his uplifted arm, smash into the yellow clay between a couple of rocks with accuracy and all his small weight duly in operation. I watched him with the sardonic attention that the inhabitants of Kent and Sussex bestow on foreigners. One did not credit writers and particularly American journalists with much practical knowledge or skill.

But Crane was all right. He could use a spade or an axe; he rode well. And he had, as I have said, an enviable trick with a gun. He would put a piece of sugar on a table and sit still till a fly approached. He held in his hand a Smith and Wesson. When the fly was by the sugar, he would twist the gun round in his wrist. The fly would die, killed by the bead-sight of the revolver. That is much more difficult than it sounds. One may be able to use a gun pretty well, but I never managed to kill a fly with the barrel much less the bead-sight.

I don't know that physical gifts are necessary to the imaginative writer. But I think a certain delicacy in handiwork goes often with accuracy of observation, just as the patience of the field naturalist goes with good prose. Hudson, White of Selborne and Waterton were three of our best prose-writers—Hudson the best of all. For myself, I know that the writer whose cadences have most intimately influenced me were those of Thomas Edwardes, the Scottish cobbler-naturalist who could neither read nor write till long after middle life—and after following birds alongside the sea on the links of Banffshire for years and years.

In the Middle Ages they used to say that the proper

man was one who had written a book, built a house, planted a tree and begotten a child. I don't know that Crane ever built a house. He avoided having children because he was afraid of giving them the heritage of tuberculosis. But as a writer of books he was incomparable, and the Limpsfield tree that he planted is alive at this day to testify to his handiwork.

There are few men that I have liked—nay, indeed, revered—more than Crane. He was so frail and so courageous, so preyed upon and so generous, so weighted down by misfortunes and so erect in his carriage. And he was such a beautiful genius.

I saw him, as I have said, first at a lecture he was delivering up on the Chart at Limpsfield, and I was much attracted to him then. He was enormously belauded and, on account of the harshness of his voice and his precision of language as a lecturer, I had taken him to be arrogant. The subject of his discourse was flag-wagging, as he called it—Morse signalling by flags. It is not a very inspiring subject though I remember getting some amusement when, being examined for signalling at Cardiff in 1915, I transmitted to a classically minded fellow-officer the line of Sappho's:

Eramen men ego sethen athi palai pota

The recording colour-sergeant struck the message off his tablets. It was to have been inspected by the examining general and the good sergeant thought that anything in a foreign language must of necessity be obscene.

But I have not even that as a memory of Crane's lecture. I remember his standing on an improvised platform in a Fabian drawing-room and looking young, pained and dictatorial. I avoided being introduced to him.

It is curious that I should have at first rather disliked all three—Crane, Conrad and James. That must have been because of the nature of the adoration bestowed upon them by their respective groups. I was a young man of a little achievement of my own. I must at that date or

before have had larger sales for my books than James and certainly than Conrad, though Crane, of course, with the *Red Badge* was a best seller of fantastic proportions. So it may have been latent jealousy. But I think it was rather a form of dislike for being, as it were, taken by the elbow and thrust into the presence of personages before whom the thrusters orientally prostrated themselves.

And I was not much of a reader in those days. I do not think that I had read any of James or Crane before I met them. Conrad's second book—*An Outcast of the Islands* —I had read in typescript. Mr Garnett had brought it down to my cottage in Bonnington-in-the-Marsh along with a lot of other manuscripts, and I had read it with a great deal of admiration. But that was rather tempered by the fact that Mr Garnett laid almost more stress on the anti-colonising force of the book than on its literary qualities. I never took much interest in politics though from my earliest days I always hated the idea that any one man or set of men should have any temporal powers over any other men of different races and religions. So were I a politician, I should be an embittered anti-Imperialist. I have always called myself a Tory, much as Shelley called himself an atheist. It stops political discussions when I find myself amongst the Advanced and, as for the Right, no one of that complexion knew what a Tory was—at any rate then.

I daresay that irritated Mr Garnett into emphasizing the propagandist nature of the *Outcast*. But I disliked the idea that a man of the gifts shown in the manuscript should prostitute them by putting them to political purposes. Nevertheless, I was so shocked when Mr Garnett said that his employer was in some doubt as to publishing the book because it could not be expected to pay expenses —I was so shocked that I offered to guarantee the publisher against loss on the book. I had lately come into money left me by an uncle who had been a forty-niner. ... Yes, I too had my *oncle de l'Amérique*. Indeed I had two. Thus dollars might even in those early days

have played their part in Conrad's fortunes and the history of literature. They did not in the event. The book just paid its way. Conrad earned a minute sum by it.

He must have come to see me a year or so later, just after the visit of Crane, and I remained rather prejudiced against him. As in the case of Crane, it was Mr Garnett who brought him to my door. I don't know why. I was no very amiable character in those days and I was temporarily in no mood for meeting men of letters. I had my potatoes and my thistles.

AN OTHERWORLDLY BEING

I was destined to deepen my acquaintance with Crane before I saw Conrad. That, remembering back, comes to me rather as a queerness. I got to know Conrad so well that I seem to have known him all my life. That was because he represented to me Man—humanity as it should be. Crane, on the other hand, was like the angels. He did not seem to have the motives of common clay. Conrad produced with agony and you saw how it was done; Crane hovered over his foolscap sheets using a pen as a white moth uses its proboscis. His work had for me something of the supernatural. He comes back to me always as joyous.

That was perhaps due to his youth and his early death, for in those circumstances he was fortunate. But I daresay it was due to the fortuitous circumstances that on several times when I visited him, or he me, he had just had pieces of good fortune.

My first visit to him was at a villa called Ravensbrook at Limpsfield, a horrible place in a bottom, damp, and of the most sordidly pretentious type of suburban villa architecture. I was trepanned there.

There was in Limpsfield a very energetic, advanced lady, Scottish, indomitable and the wife of a Fabian official. You would see her boyish figure, in knee-breeches

and a bonnet with strings, dragging at the reins of a
donkey in a governess-cart, up the hill, in the mists of the
Common and the Chart. There would be two freckled
little boys in the cart. They would fight, fall out, scramble
in again somehow. They would disappear and come again
into view against the clumps of gorse, always with the in-
defatigable lady dragging at the unwilling donkey, bend-
ing forward, striding along.

She would be going on her ceaseless errand of getting
people together. She was in those days my terror, but she
comes back to me in a sudden warmth of affection—her
ingenuous face, Scottish brogue, her optimism, length of
limb and heather tramp with its springy gait. She was
like a daughter of a Duke of Argyle urging her father's
tenants to be friendly with the Macgregors.

She appeared one afternoon in my cottage and ordered
me to go at once to Ravensbrook and teach Mrs Crane
how to make medieval dresses. I was confused and un-
willing. She said that I ought to know how to make
medieval women's clothes because of my Pre-Raphaelite
origins. One of the members of my family wore what we
should now call a *robe de style*, a close-fitting bodice, a
very full skirt and a sort of yellow surcoat with dangling
pointed sleeves which got into the baby's milk. The lady
said that that proved that I knew how to make hennins,
cottes, surmantles and the rest. I was alone in the cottage
and she managed to convey to me that there was breath-
less need of my hurrying to Mrs Crane.

I reached Ravensbrook about seven. Mrs Crane, large,
fair and placid, with her attendant dark, thin and vivacious
Mrs Rudy, would no doubt have looked admirable in a
hennin. But she was puzzled by my appearance. She had
never had any idea of abandoning coats and skirts. We
worked out that Mrs Pease had determined that I should
get together with the Cranes. Mrs Pease wanted to see
the countryside covered with ladies in medieval attire.

Mrs Crane was almost as puzzled by my English-
English accent as by my errand and we finally did talk

about medieval dress. It was perhaps the beginning of poor Crane's undoing. For it was, I think, Mrs Crane's amiable romanticism which led her and poor Crane into various fantasies and ended with their lodging themselves in Brede Place. There, truly, Mrs Crane wore hanging sleeves, hennins and pointed shoes. Beneath the refectory tables were rushes where the dogs lay and fought for the bones that were dropped to them. I did, of course, know a little more of how the ladies of the Courts of Love garbed themselves than she did.

I remember as a detail that when I said she must cut the stuff for herself on the cross or they would not hang right, she did not understand the words 'on the cross' and finally worked out that I meant that she should cut 'cater' the material. It pleased me very much to find that fine old Kentish dialect word in common American use. Or perhaps it was merely southern? Mrs Crane came from Jacksonville, Florida.

Do you know the story of the truthful curate? He called on a family of his parishioners at tea and every time they said to him 'Must you *really* go now?' he replied that it was not absolutely necessary. So he stayed to dinner, and the master of the house had to sleep on the billiard-table because the curate was in his bed; and he breakfasted there and sent for his sermon-paper and composed his sermon in the master's study and so on for ever. I must have been like that at Ravensbrook.

At any rate I was there at half past twelve when Crane came down from Town by the last train and I went to bed in the drawing-room, with the dog on top of me at four in the morning, and began again arguing with Crane about writing at a seven o'clock breakfast. Our views on life and letters were not really divergent but Crane would ascribe to me sets of theories and then demolish them with the manner and voice of a Bowery tough hammering an Irish scavenger. He was immensely happy.

Mrs Crane's alleged reason for making me stay till after midnight had been that Crane, coming down from

a momentous interview, would need to talk. Presumably he would want to talk in such Gargantuan gusts that she and Mrs Rudy would be insufficient to sustain his assaults of language.

On that Oxted night—for Ravensbrook is just outside Limpsfield and just inside Oxted—Crane was coming down from having seen Pinker.*

It had been a crucial moment in his career and I imagine that Mrs Crane had been anxious that I should stay with her and her friend simply because they could not bear themselves in the suspense. Crane was then—was, as you might say, still—the immensely successful author of the *Red Badge*. But it is the second and third books that have anxious passages. And Crane had not been very successful with them as far as the public were concerned. His adventure as a journalist in the Spanish-American War had not been a great success journalistically. Out of his sheer imagination he had created the most wonderful, real and vivid book about war that had ever been written. It was argued that, if then he saw a real war, with the shells flying and the flags wagging and the troops advancing at the double, he must do something superhuman in the way of journalism. He didn't.

He wrote as always beautifully and such by-products of the war as the stories in *The Open Boat* are among the masterpieces of all literature. But he had not been good at getting his dispatches through; he had not been in at the best deaths. He had endured great hardships, some dangers, some sicknesses; he had worn himself to a thread-paper, without gaining much success as a journalist. What was almost worse, he had acquired a thirst for the sort of thing. When the Turco-Greek War came he beat about London from office to office, like a butterfly against a window-pane. He was trying to get sent to Greece. The desire seemed to burn him up.

But at the moment of which I am speaking, his troubles had been mainly financial. The Cranes had run seriously

* J. B. Pinker, the literary agent. See p. 204.

into debt at Oxted. They were at the moment almost short of food. The meal of which I had partaken with Mrs Crane had certainly been exiguous. When Crane did arrive his arms were full of parcels containing mostly delicatessen with a bottle or two of claret. The local tradesmen had cut off supplies. In any case Ravensbrook was an unreasonably expensive establishment to run. Poor Steevie was certainly not fortunate in those who chose his English residences for him. Ravensbrook would well have suited a rich stock-broker.

What was almost worse, poor Crane's conscience and artistic imagination made him take his creditor's case against himself. Most people see dunning tradesmen as fiends. Crane saw them as starving fathers of families. He would say: 'Do you suppose Simpson, the butcher, will be bankrupted if I don't pay him?' Or: 'Oving, the saddle-maker's children are said to be going without shoes. Damn it! I owe him £50 for harness.' So, as two of my visits—on one of which I was with difficulty admitted because I was taken for a bailiff—as, then, two of my visits coincided with the arrival of considerable relief, he associated me with pleasant things.

He came back, nervous, distracted, loaded—and elf-like. Before he spoke to me, he had to have a whispered colloquy with Mrs Crane in the doorway. They leaned one against each door-post. He had his hat tilted over his eyes. I was holding the parcels in the dark hallway. He said a low phrase. Then there were explosions of joy.

Pinker had guaranteed him £20 per thousand words. For everything that he wrote: £20 per thousand, is $10 per hundred, is ten cents per one, words. You just sat down and wrote anything. But it is not merely dollars and cents. It is miles travelled. You could go to Ispahan, to Yokohama. You wrote for ten hours at fifteen words a minute and there was £180—$900. And in those days dollars were dollars, not nickels. You could go to Australia and back the other way for ten hours' writing! . . . And writing without tears. Without a crease of the brow.

Without anxiety at the back of the mind. He had brought a new collar for Flannel. Flannel was the unimaginable dog. Conrad had been given its brother called Sponge. It had, however, been re-christened Escamillo after the character in *Carmen*. How romantic Conrad was! Crane, in the doorway, drew the new collar from his pocket.

I have never seen such gladness as there was on that Oxted night. They were very simple people really. All great authors are. If you are not simple, you are not observant. If you are not observant, you can not write. But you must observe simply. The first characteristic of great writing is a certain humility.

For me, Crane came nearer the otherworldly than any other human being I have encountered. He was what Trelawney made us believe Shelley to have been. But he observed the littler things of life. He was the poet.

He kept it exaggeratedly beneath the surface. Outwardly he was harsh and defiant; his small, tense figure and his professional speech were those of the Man of Action of dime drama. He loved to suggest that he could draw his gun quicker than your brain could telegraph to your hand to approach your hip. He meant by that to shew that he was not a poet.

But he was. I will venture to say that no more poetic vision of humanity in our late Armageddon was ever written than *The Red Badge of Courage*—and that was written twenty years before our Armageddon burst upon us. And it was written about a war that ended sixty-five years ago. Yet it was amazingly vivid even in 1917. I am not at the moment writing about Literature; I am trying to re-constitute for you men that I loved . . . long since in ages past. Still Literature will come creeping in. I wish I could re-read *The Open Boat* but I have no copy and it appears to be out of print. It is astonishing that any book of Stephen Crane's should be out of print and that one should not be able to find a copy.* It is lamentable!

He was astonishingly glad that night at Oxted. Oxted

* Written in 1930.

is an exceptionally banal suburb of London; but the night
was dark and it was hidden. In the darkness the joy shone
out of him as heat glows sometimes through opaque sub-
stances. He could get away from Oxted! Crane hated his
villa.

With the falling from his shoulders of that intolerable
burden he desired, as Mrs Crane had foreseen, to talk. He
talked. He kept me there, listening, half through the night,
nearly until breakfast-time. He had the most amazing
eyes. They were large, like a horse's. They frowned
usually with the gaze of one looking very intently. But
they shone astonishingly at times. When he became ex-
cited the studied New York argot disappeared or nearly
so. He then talked a rather classical English. That night
he planned his glorious future.

It was not merely that he planned to travel. He planned
to travel the world over, flinging coins from the purse of
Fortunatus that bespectacled and benevolent Pinker had
put into his hands. But he was to render that world when
he had roamed all over it. He talked therefore about his
technique. That was unusual with him.

I do not flatter myself that it was to me that he talked.
That night he would have talked in the same way to
Conrad's dog, Escamillo. I had for him the aspect of a
Pre-Raphaelite or Aesthetic poet and he seemed to make
me responsible for the poems of D. G. Rossetti and the
gilded prose of Mr Richard Le Gallienne. He began by
telling me that I could not write and never should know
how to write. Then he went on to tell me how writing
should be done, pausing to denounce me and my family
only when his mind paused for context. Then he told me
what he was going to do.

He was going to write a great series of heroic poems in
vers libre. He wrote only one, *The Black Riders*. He hated
both formal metre and rhyme. He had never seen a word
of my poetry, but at one time he shouted at me: 'You
ruin ... ruin ... ruin all your work by the extra words

you drag in to fill up metres and the digressions in sense
you make to get in rhymes.'

The dawn came up on these harangues. Then, as I have
said, I slept on the sofa with either Soap, Flannel, or pos-
sibly Sponge on top of me. I eventually went back up the
long steep hill to the Chart rather sadly. Actually the
domestic troubles of the neighbourhood made me leave
Limpsfield that day and I did not see the place again for
more than twenty years. Then I went to see Crane's rose.
It was flourishing, being a monthly rose, though there
was actually snow on the cropped turf between the clumps
of gorse.

ON OBSOLETE WORDS

I remember once hearing Stephen Crane, with his won-
derful eyes flashing and his extreme vigor and intona-
tion, comment upon a sentence of Robert Louis Stevenson
that he was reading. The sentence was: 'With interjected
finger he delayed the motion of the timepiece.' 'By God,
poor dear!' Crane exclaimed. 'That man put back the
clock of English fiction fifty years.' I do not know that
this is exactly what Stevenson did do. I should say my-
self that the art of writing in English received the numb-
ing blow of a sandbag when Rossetti wrote at the age of
eighteen *The Blessed Damozel*. From that time forward
and until today—and for how many years to come!—the
idea has been inherent in the mind of the English writer
that writing was a matter of digging for obsolete words
with which to express ideas forever dead and gone.
Stevenson did this, of course, as carefully as any Pre-
Raphaelite, though instead of going to medieval books he
ransacked the seventeenth century. But this tendency is
unfortunately not limited to authors misusing our very
excellent tongue. The other day I was listening to an ex-
cellent Italian *conférencier* who assured an impressed
audience that Signor d'Annunzio is the greatest Italian

stylist there has ever been, since in his last book he has used over 2,017 obsolete words which cannot be understood by a modern Italian without the help of a medieval glossary.

WALTER CRANE'S GLOVES

I moved back to the Pent which I had let to an artist, then of some fame. His name being also Crane, he had painted a bird of that species on the front door which gave on to the stock-yard beyond a narrow strip of terrace and lawn. He had also painted numbers on all the room doors. There were thirteen. His family used to take baths on the lawn, which worried and astonished the stockmen and shepherds in the yard below. When they left there remained behind them an extraordinary number of gloves. In every drawer of the bedrooms there were old, soiled and crumpled gloves. I have remained wondering to this day what they can have been wanting with so many. Is there a *maladie de gants*, as there is said to be of boots? At any rate, we used them all to manure the roots of a vine that covered the front of the house. Leather is the best of all manures for vines and also for figs. Indeed, if you want to plant a fig-tree, you should plant it with the roots in an old leather portmanteau. You will have wonderful figs.

AGENTS

Pinker certainly deserves a page to himself, for without him you could never have had Conrad, and poor Crane could hardly have lived. He smoothed out, too, furrows in the later paths of Henry James. I had mysterious and obscure rows with him myself. I never understood what they were about. I suppose he was sensitive and I patronizing. He lived in an outer suburb, so as to ride to hounds. This he did two or three days a week. He had none of

the airs of the stable but he certainly knew something about horses—which is unusual for Scotsmen. At any rate, he once bought for £5 a horse out of a bus-yard and immediately afterward took with it second prize for tandem leaders at Richmond Horse Show. That was no mean feat. The horse would not go in harness or under the saddle and had been kicking a bus to pieces when Pinker had passed the yard. He liked driving tandem and it occurred to him that the animal might stand the light traces and blinkers which are all that go on a leader. And so it did. He gained added satisfaction from the fact that he sold the animal immediately after the show and it ran the new owner's cart against a post and threw him out, breaking his arm.

There used to be a grim gleam in Mr Pinker's hard eyes, behind his benevolent spectacles, when he told that story. I think the first London agent was a man called A. P. Watt, who looked like something between a bishop and a butler. As far as England was concerned, he invented the practice of syndicating articles in newspapers that circulated at sufficient distances the one from the other. I remember that he sold articles on music by my father to twelve newspapers at once. But he was very high and mighty to editors and the like. I remember that when I edited *The English Review* I went to ask him for something by one of his clients and he was so patronizing that I still feel like a worm when I think of it. He was agent only for the enormously distinguished. Pinker, on the other hand, was little and vivid and had a singular accent. He must have taken the cream off Mr Watt's business.

I should say that on the whole an agent is of little use to the author who has any business faculties at all, but so many have not. The agent's function is to be a sort of bar-loafer who hangs around, finding what publisher, magazine or paper wants what. He may be of use. But few agents will handle the work of young authors, who have always been my particular preoccupation. And the

agent's interests are not always by any means always at
one with the individual author's. He will place a highly
paid author in preference to another on his list; he gets
more commission. He will place an author who is in-
debted to him rather than one who isn't. He is then sure
of getting his money back. It is not always to his interest
to press a dishonest or defaulting publisher to the point
of definitely offending them. He has other authors that he
will wish to place with that publisher.

All out then, you had better do without an agent un-
less you are a very big seller. But, to his favourite clients
—and they were not always the most prosperous—Pinker
was all gold. I never could quite know how I felt towards
him. He was so good and helpful and patient with Conrad
and Crane and James and so quarrelsome to myself. But
on the whole I felt kindly and I very much regretted his
death which took place in New York. I remember think-
ing that New York was no place to go to if it could kill
anyone so hard as Pinker.

I dwell thus on him because you could have little real
idea of what the literary world I am portraying for you
was like unless you imagine that Scotsman as looming
always somewhere in the background of lettered thoughts.
I remember James, when, as he sometimes did, he con-
sulted me as to his financial affairs, telling me that for
years he had sold all the rights of his books to one in-
dividual publisher—for two hundred pounds a time. So
he had long given up looking at writing as even a very
thin stick. And he had had financial misfortunes and the
future looked like a gloomy vista of pinched discomfort.
'And then suddenly,' said James, 'along came a little man
called ... Pinker.' And Pinker offered enormous prices for
this, and great sums for that, and to place things here,
and serialize them in *The Illustrated London News* and
syndicate them from Beersheba to Spokane. . . . And he
jumped about and kept his promises. And all was gas and
gingerbread! ... Pinker would allow him to build his
gazebo in the garden and take apartments in Chelsea and

buy 'bits' of China. Similarly he would let Conrad go to Bruges or Poland and Crane to Brede Place. For always when you proposed to buy or travel or have a new mare, you first interviewed the little man in spectacles at the bottom of Arundel Street. 'A rundel Street' you would say to the hansom cabman who took you to learn your fate. 'You mean Arundel Street,' he would answer contemptuously. And in a quarter of an hour or so you would know whether you could have the wish of your heart or must go back to your cottage and live on potatoes and cheese for another quarter. Pinker would take quite long odds in backing you. Conrad must have been many thousands of pounds in debt to him before *Chance* really brought him before the public eye. On the other hand, the little man could softly and inexorably turn down anyone in whom he did not believe.

THE OLD ATHENAEUM

It is good will that is needed if the Humaner Letters are to come into their own. No amount of praise from Academicians will make a bad book have a permanent life whilst ill-natured comment on a good one will delay its entry into its kingdom. Thus people die without having read it and the writer is discouraged. These are two of the worst things that can happen to humanity. You may die reconciled to your fate without having seen Carcasonne but what would it be like to leave the world without having read ... oh, *The Playboy of the Western World*? And what is the place in the hereafter reserved for the gentleman who checked the activities of Keats? For myself, I would rather see the worst popular writer roll in gold than a fraudulent pill-maker or a Wall-Street bear. He at least is only doing what Shakespeare tried to do.

The only human activity that has always been of extreme importance to the world is imaginative literature.

It is of supreme importance because it is the only means by which humanity can express at once emotions and ideas. To avoid controversy I am perfectly ready to concede that the other arts are of equal importance. But nothing that is not art is of any lasting importance at all, the meanest novel being humanly more valuable than the most pompous of factual works, the most formidable of material achievements or the most carefully thought out of legal codes. Samuel Butler wrote an immense number of wasted words in the attempt to avenge himself for some fancied slight at the hands of Darwin. But, in spite of these follies *The Way of All Flesh* is of vastly more use to us today than is *The Origin of Species*. Darwin as scientist is as superseded as the poor alchemist in the Spessart Inn*: so is Butler in the same department of human futility. But *The Way of All Flesh* cannot be superseded because it is a record of humanity. Science changes its aspect as every new investigator gains sufficient publicity to discredit his predecessors. The stuff of humanity is unchangeable. I do not expect the lay reader to agree with me in this pronouncement but it would be better for him if he did. The world would be a clearer place to him.

From that point of view the activities of the old *Athenaeum* under Maccoll were unmitigatedly harmful—and singularly adroit. Mr Maccoll was, to all appearances, a nearly imbecile, blond, bald, whispered individual. He wore black gloves on every occasion, indoors or out, and if you addressed him his eyes wandered round the cornice of the ceiling as if the mere fact of being spoken to had driven him into a panic. As far as I know he never wrote anything except perhaps the biography of some obscure theologian or diplomatist but his bulky figure with its black kid gloves and its hand, in addition, always in the pockets of his reefer-jacket as if he had doubly to hide some grotesque and shameful disease—his panic-stricken

* The eighteenth-century occupant of a room where Ford and his tutor stayed during Ford's German schooldays in the early 1890's.

and bulky figure comes back to me as containing one of the most potent and disastrous forces of his day.

He had got his job I think from having been the travelling tutor of Sir Charles Dilke, the politician and owner of the journal. But having made his singular and bemused apparition at a public or private function he would return to his office and with unerring and diabolical skill would send out books to the reviewers for whom they were exactly unsuited. The policy of his journal was to regard all novels as tawdry trifles to be dismissed in a few notes. It considered that no poetry had been written or could have been written by persons born after 1820, except when Mr Watts-Dunton got hold of a volume by D. G. Rossetti, whose solicitor he was, or by Swinburne, to whom he acted as keeper. The body of the paper was given up to tremendous and sesquipedalian reviews of works with titles like *The Walcheren Expedition and the Manoeuvres in the Low Countries* in three volumes, post quarto. If its reviewer could discover three misprints, the name of a Dutch village spelt wrong, two real inaccuracies and a nine which the writer had inverted in a date so that it looked like a six—then the joy of the journal was unmeasured. It pronounced in Olympian tones that this immense undertaking was completely worthless to the student of the subject, and nothing could better display its infallibility. It once reviewed a novel of mine with the words:

'From the fact that on page 276 Mr Hueffer misspells the word *herasia* the reader will be able to judge of the value of his piece of fiction.' And most novels received as summary treatment at its hands.

A FABIAN DEBATE

I remember being present later at a Fabian debate as to the attributes of the Deity. I forget what it was all about, but it lasted a very considerable time. Toward the end of

the meeting an energetic lady arose—it was, I think, her first attendance at a Fabian meeting—and remarked:

'All this talk is very fine, but what I want to know is, whether the Fabian Society does, or does not, believe in God?'

A timid gentleman rose and replied:

'If Mrs Y. will read Fabian Tract 312 she will discover what she ought to think upon this matter.'

DURING THE GREAT DOCK STRIKE

Mr M.'s distaste at the idea of the intrusion of the Deity into mundane affairs reminds me of a strikers' meeting on Tower Hill during the great dock strike. News came during the meeting that the Government had taken some step that materially aided the employers. Mr Ben Tillet—who was almost out of his mind at the news—raised his fist at the heavens and called on the meeting to curse God. Mr Cunninghame-Graham, who was on the platform, quieted things down by saying that it was wrong of Mr Tillet to throw imprecations at the Almighty. God was a man of the very best intentions who died young. The committee of the aristocratic Devonshire Club had put up with many of Mr Graham's political eccentricities because of his illustrious birth and connections, but that was too much for them. They asked him to resign from the club. Mr Graham answered that a committee nearly all of whose names ended in -schen, -baum, and -stein no doubt knew more about Jehovah than he did. But he had been speaking about the Son. He heard no more from that body.

POLITICAL PREDILECTIONS

I never took any stock in politics. But political movements have always interested me. I have only once voted.

It is one of my most passionate convictions that no one individual can be sufficiently intelligent to be entrusted with the fortune or life of any other individual. Far less can he be morally capable of influencing to the extent merely of a single vote the destinies of millions of his fellows. I, at any rate, never could feel myself so entitled. I don't believe a creative artist can have any intellect; he is an observer and a recorder. He may have passions but he must mistrust them.

My own predilections have always been towards the Right. I like pomp, banners, divine rights, unreasonable ceremonies and ceremoniousness. It seems to me that when the world was a matter of small communities each under an arbitrary but responsible head then the world was at its best. If your community did not prosper you decapitated your chief. Till then he was possessed of divine rights. Presumably you cannot better the feudal system.

So I was always a sentimental Tory. But inasmuch as the Tories stood in the way of Home Rule for Ireland, I never voted or wrote for that Party. The Liberals of the nineties, on the other hand, were mostly great employers of labour. Their aim was to have always fringes of pauperized and parasitic working people so that wages might be kept low. It was perhaps an unconscious aim. My Tory view was that every workman should first be assured of four hundred a year. Let the employer of labour assure that before he started his factory—or clear out. So, though the Liberals supported Irish Home Rule I could not support them.

The literary man in England is usually predestined to the Left. Ranking socially with the governess and the butler—a little above it if he prospers, a little below if he is poor—he cannot, *qua* writer, be a gentleman. In consequence he tries to achieve importance outside his art. The Tory Party was always the stupid party. And proud of it! In the nineties it let Henley starve and cold-shouldered Mallock. The Left, on the other hand, for ever

stretches out its arms towards intellect. In consequence the English intelligentsia are almost invariably of the Left —Liberals, Fabians, Communists, Nonconformists or worse. The Liberals once offered me myself a constituency.... Clackmannon and Kinross, a scattered and bleak district to work in politically!

It has from my earliest days been my fate to be regarded as a brand to be snatched from the burning by the Left. From my earliest days in darkest London! I never quite knew why. I suppose it was because as a boy I was of a family influential in the arts and letters. At any rate, whether it was the Rosettis or the Garnetts of the Left or straight Labour, Fabian, or Morris Socialist agitators, I was seldom, between the ages of twenty or thirty, without someone putting Left pressure upon me. I was for ever being shouldered off to meetings of Hammersmith Socialists at William Morris's house, to meetings of Marxists at the Avelings, of Anarchists in Hyde Park, of Parliamentary Labour leaders at the Holborn Restaurants or to those of Pro-Boer agitators in Piccadilly Circus. In that way I saw some pretty fights. I saw the Anarchists break up a Morris Socialist meeting at Kelmscott House, the Morris Socialists break up an Anarchist assembly in Hyde Park and a tremendous set-to between Morris Socialists and Fabians in a North Kent suburb—the Crays, I think, or Eltham. In addition, being profoundly impressed by the uselessness to England of the British Empire and with the savage nature of the Dopper Boers and wishing solely that South Africa might be returned to its real owners, the natives, and Kruger and Mr Chamberlain hung on the same gallows, I was once chased for three quarters of a mile along New Oxford Street by a howling mob of patriots. That was during the South African War. On the other hand, I once saw Mr George Bernard Shaw brought to a clean stop in the middle of a Socialist speech. Few people can have seen the like....

SUPERSTITIONS

I have always been superstitious myself and so remain—
impenitently. Each month at the turn of the moon I go
to great trouble not to see the new moon through glass
and I prefer to be in a house that does not face towards
the west. Nothing will make me go under a ladder. I can-
not bear to sit in a room with three candles or to bring
snowdrops, may or marigolds indoors.

That is not foolish. An ill omen will depress you. How-
ever little it may depress you, it will do so. It is bad to be
depressed. Nor can you stand absolutely unmoved against
the tides of human opinion. The most rationalist of human
beings does not pass his life without saying: 'I am in luck
today!' It is as irrational to believe in good luck as to be-
lieve in shrouds in a guttering candle. The doctrine of
chances will tell you that there is no greater chance—and
no less chance—of fortunate events following each other
in a sequence than of unfortunate events alternating with
others. Yet you *know* that fortunate and unfortunate ones
do follow one another in sequences. The doctrine of
chances is none the less not at fault. It is operating in an
atmosphere of loaded dice.

When you feel you are passing a lucky day you will be
resolute, keen, active, awake to proper courses to pursue.
You ensure luck. When you are depressed by ill omens
you are less resolute, you are despondent in the degree
however small the weight you attach to the beliefs of your
fellow-man. You give your dice a bias towards the lower
numbers. I have found this again and again. The longest
and most disastrous runs of ill luck in my life have fol-
lowed the one on the presentation of an immense opal to
a member of my household; the other to a lady who was
driving with me and others in a closed automobile ex-
claiming in an open space in Harlem: 'Look at that

immense crescent!' She was indicating the new moon which in consequence I saw through the front glass.

From that day for a long time—indeed until about a year ago—I experienced nothing but disaster: in finances, in health, in peace of mind, in ability to work. It was a run of ill luck similar to that, a quarter of a century ago, that attended on the acquisition of that large opal.

That was followed by every imaginable and unimaginable disaster. Improbable illnesses, unreasonable breakages of limbs, financial losses in affairs that seemed as stable as the Bank of England and a similar falling off in ability to work. At last it landed me in that improbably murderous house on Campden Hill.*

ALL THE OLD DEVILS

I was one night at the house of Mr Edward Clodd at Aldeburgh, in Sussex, on the sea-shore. There were present, besides Mr Clodd, Thomas Hardy, Mr Hilaire Belloc, Mrs Belloc Lowndes, some more novelists and Professor Gilbert Murray. Mr Clodd had been one of those who, with Huxley, Bradlaugh, Foote the atheist, Ingersoll and others, had, in the eighties of the last century, destroyed revealed religion. The night was airless. On the black squares that the windows made, the lights of solitary fishing-boats hung themselves out. As was natural the talk fell on religion.

Thomas Hardy avowed himself a believing communicant of the Established Church, Hilaire Belloc, his sister and other novelists were Papists. Professor Murray had some sort of patent faith of which all I can remember is that a black velvet coffin played some part in it. Some other form of spiritualism was also represented.

At last, valiant old Mr Clodd threw his hands up above his white hair.

* See 'Collaborating with Conrad', p. 269 ff.

'Was it for this?' he exclaimed tragically, 'that we fought and overcame the priests in the eighties? You would think we had never lived. Here is a collection of the representative thinkers of Great Britain. Every one of them has his form of mumbo-jumbo. The old devils have all come creeping back and brought worse with them!'

THE EDUCATION OF CHILDREN

I opened my front door with my latch-key one day and met my eldest daughter coming downstairs with her hair and clothing on fire. I put the flames out and, as they had been streaming behind her, she was not hurt. She said that, as she had done nothing to hurt the fire-fairies, she could not see why the fire-fairies should hurt her. So she had no mental disturbance.

The education of children is one of the few subjects on which I have no settled opinion whatever. I do not see how anybody can have.

Admirable theorists from Solomon downwards have from time to time convinced the public that various eccentricities in the upbringing of children will lead to the salvation of the republic. But, as these theories can only be arrived at in old age, the theorists never see the results of their tuitions. For myself I incline to think a child's education should follow *in petto* the history of the education of mankind. It should be taught to believe implicitly in fairies until it outgrows that belief naturally. Then it should be carefully instructed in one or other of the forms of revealed religion, the instruction being exact and absolutely orthodox to whatever the form may be. For the child's good, the form should be that of the majority of the inhabitants of the country in which the child is born. Or it should be in a form avowed by a minority sufficiently to be able to take care of itself. A sense of persecution is bad for a child's mental development as a rule.

After that, it simply remains a matter of whether a child does or does not jump off from revealed religion. If it does, the jump should be as clean as possible. That is why I should advocate all children being brought up as implicit Roman Catholics. If you disbelieve any article of the Roman form of faith your whole faith falls. That is a good thing if you are fated not to continue in a form of belief. Protestantism is a continual and gradual refining away of beliefs. You refuse to believe in the Immaculate Conception, but, for the time being, believe in the Virgin Birth. Then you find yourself no longer believing in the Virgin Birth but believing still in the Divine Origin and the Holy Trinity. Then you no longer believe in the Divine Origin but in Divine Inspiration. So you whittle away and your thought has a continued timidity. I am inclined to believe that the happiest—and even the best—members of a society are those who retain their religious beliefs intact. But I am certain that only harm can come from want of clarity in thought or of courage to face the issues. And I am equally certain that such religious instruction as a child has should be authorized by parents or the State. Otherwise the child will for certain come in contact with the most odious, ignorant and bigoted forms of revelation. I had a friend who—in the days when it was the fashion to bring up children in militant atheism—rigorously enacted that his children should have no religious instruction whatever. The servants, the elder members of his family, his friends were all forbidden so much as to mention the Deity. One day he stopped outside the open bedroom door of his night-nursery. He heard his eldest little girl say: 'They say God is everywhere.' All the children answered in chorus: 'Yes, God is everywhere.' The first child said: 'Is God in the cupboard?' The second answered: 'I don't know. But if you hold my hand I will see.' The servants had been attending to those children. Servants will, forbid how resolutely you may. Then your children will be estranged from you to the extent of having secrets.

A DEGREE OF INTIMACY

Good Friday before last I gave a lunch to four men at my London club. I passed the meat as a matter of habit, of good manners, of what you will. What was my astonishment to discover that each of my guests passed the meat. In short, each of us five was actually a Roman Catholic of a greater or less degree of earnestness. Yet, although we were all five fairly intimate, meeting frequently and talking of most of the things that men talk about, we were not any of us aware of the other's religious belief. This, I think, would be impossible anywhere but in London, and it is just for that reason that London of today is such a restful place to live in.*

KIND AND VALUABLE ADVICE

I once gave a waiter—but a head, head waiter—advice. He was the incredibly all-knowing, bearded, inscrutable *maître d'hôtel* of the Carlton Grill Room. He positively came to me one day when I was lunching and asked me if I could give him advice how to find the house in which Casanova lived in London. Even the bibliophile Jacob had not known where it was except that it was in Soho. He wanted the information for some American clients who were making a pilgrimage to all the places dwelt in by Casanova—and if possible to the very house. I happened to have the information, so he was saved further trouble. He was suavely grateful.

Later he came back to my table and leaning one hand on the cloth said:

'Why do you ever lunch anywhere else but here? This

* Written in 1910.

is the best grill-room in the most famous hotel in the world. It should be good enough for you.' I used the word 'expensive.'

He looked down sardonically at my *couvert*.

'Yes,' he said, 'but what do you want with a lunch like that? Half a dozen oysters, that alone is enough for a lunch for a young man like you. But you follow it by a paté de Périgord and quails stewed with grapes. And you drink a half *Berncastler* and a half *Pontet Canet* 1906. . . . What sort of lunch is that and can you grumble if it costs you the eyes out of your head?'

I said I was very busy and needed sustaining. He said:

'A lunch like that will not sustain you. After it you will be sleepy and your business will be a battle. Do you suppose I could do my work if I lunched like that? No, take my advice. Lunch here every day. We do not ask you to spend enormous sums but to have a good lunch. You will take a chump chop, or a steak, or some kidneys or any other thing of the grill. You will have some Stilton or Cheshire cheese, butter and the choice of twelve different sorts of bread and cheese biscuits. You will drink iced water or a half bottle of Perrier or, if you like, a half bottle of our *vin ordinaire rouge* which I drink myself. It costs one and ninepence. If you have mineral water you will save a shilling. So your lunch will cost you two or three and ninepence. The chop and the cheese cost two shillings. You will have the same seat and the same waiter whom I will choose for you myself. You will tip him fifteen shillings on the first of every month. You will be troubled by no tiresome suggestions to take more costly food and you will be under no sense of obligation. I have several of the richest and most distinguished men in London amongst my regular clients and they never spend or tip more.'

It was kind and valuable advice to give a younger man. I suppose I was thirty-three or -four then. But you have to be older before you can dispense with a *maître d'hôtel*'s

or even a waiter's advice. I should think you would have
to be a hundred.

PORTRAIT OF THE ARTIST AS A DANDY

You are to think of me then as rather a dandy. I was
going through that phase. It lasted perhaps eight years—
until Armageddon made one dress otherwise. Every morn-
ing about eleven you would see me issue from the door of
my apartment. I should be wearing a very long morning-
coat, a perfectly immaculate high hat, lavender trousers,
a near-Gladstone collar and a black satin stock. As often
as not, at one period, I should be followed by a Great
Dane. The dog actually belonged to Stephen Reynolds,
but he disliked exercising it in London because he was
nervous at crossings. But a policeman will always stop the
traffic for a Great Dane to cross. I carried a malacca cane
with a gold knob.

I would walk up Holland Park Avenue as far as the
entrance to Kensington Gardens, diagonally across them
to Rotten Row where I would chat with the riders, lean-
ing on the rails. I would cross to St James's Park and the
Green Park, cross them and reach one or other of my
clubs about half past twelve, read the papers and my
letters until one. Then I would lunch at the club or the
Carlton and take a hansom—later a taxi—back to my
apartment which I would reach about half past two. At
five I would go to or give a tea-party. Before dinner I
would take a bath and a barber would come in and shave
me. I dined out every day, but very occasionally, for
someone special, I would cook a dinner myself in my own
flat, putting a chef's coat over my evening things. I had
two boasts—one that no one had ever seen me work, the
other that I walked four miles every day on grass. That
was in crossing the parks. In Central Park, New York, I
had been apostrophized by a policeman who said:

'Get off the grass, same as you would in any other civilized country.' I used my second boast usually on New Yorkers, of whom I saw a good many.

My father used to say that he was the laziest man in the world, yet he had done more work than any man living. I could almost say as much of myself. I fancy that for ten years—say from 1904 to 1914—I never took a complete day's rest. I worked even on the trains in America at a time when that was less usual than it is to-day. My record in the British Museum Catalogue fills me with shame; it occupies page on page with the mere titles of my printed work. Even at that it is not a complete record; it omits several books published only in America. I do not imagine that any one not a daily journalist has written as much as I have and I imagine that few daily journalists have written more.

I am not proud of the record. If I had written less I should no doubt have written better. Of the fifty-two separate books there catalogued, probably forty are out of print. There is only one of those forty that I should care to re-publish and, of the remaining twelve, there are not more than six of which I should much regret the disappearance.

This great body of work was produced without any feeling of fatigue. At the time of which I am writing I used to work with great regularity from nine to eleven, when I went out to lunch, and from half past two to half past four, when I would go out to tea. After I was eighteen I never wrote at night and except for a week or so before the publication of the first number of *The English Review* I never did any work at all—even editing or proof-correcting—after dinner. In the four hours of work I turned out exactly 2,000 words. Of these I would condemn about half. This left about a thousand words for the day. A thousand words a day is 365,000 for the year—enough to make over four novels. Of course, I never published four novels in any one year. Only twice indeed have I published as many as two. The usual tale was one novel

and one book of the type called in England 'serious.'
There the novel cannot be heralded as 'serious.' It would
give the public cause to think the writer was in earnest,
which to the Englishman is insupportable. In the United
States books that are not novels are classed as 'non-
fiction.' The classification is perhaps not accurate but it is
more complimentary to the novelist. That I suppose is
why I have latterly published more books to the West
than to the East of the Atlantic. Earnestness *will* come
creeping into what I write.

STARTING A REVIEW

There entered then into me the itch of trying to meddle
in English literary affairs. The old literary gang of the
Athenaeum-Spectator-Heavy Artillery order was slowly
decaying. Younger lions were not only roaring but making
carnage of their predecessors. Mr Wells was growing a
formidable mane; Arnold Bennett if not widely known
was at least known to and admired by me. Mr Wells had
given me his first novel—*A Man From the North*. Ex-
perimenting in forms kept Conrad still young. Henry
James was still 'young James' for my uncle William
Rossetti and hardly known of by the general public;
George Meredith and Thomas Hardy had come into their
own only very little before. Mr George Moore was being
forgotten as he was always being forgotten; Mr Yeats
was known as having written the *Lake of Innisfree*. It
seemed to me that if that nucleus of writers could be got
together, with what of undiscovered talent the country
might hold, a movement might be started. I had one or
two things I wanted to say. They were about the tech-
nical side of novel-writing. But mostly I desired to give
the writers of whom I have spoken a rostrum as it were.
It was with that idea that I had returned from America.
England, I knew would always regard me—rather comic-
ally and a little suspiciously—as too damn in earnest.

The others it might listen to and I might slip a word in now and then.

The nature of the periodical to be started gave me a good deal of thought. To imagine that a magazine devoted to imaginative literature and technical criticism alone would find more than a hundred readers in the United Kingdom was a delusion that I in no way had. It must therefore of necessity be a hybrid, giving at least half its space to current affairs. Those I did not consider myself fit to deal with. I knew either nothing about them or I knew so much that I could not form any opinions. The only public matter as to which I was determined to take a line was that of female suffrage.

I dallied with the idea for some time. Then I came across the politician who had insisted on telling me his life history. I do not remember if he approached me or I him. At any rate, we quickly came to an agreement. He was a virulent Tory of the new school, and he wanted an organ of his own. He was to provide half of the capital necessary, which we agreed was to be £5000, I the other half. He was to edit half the magazine, which was to be a monthly, I, the other half. Being a business man as well as a politician, he was to manage the business affairs of the concern, I to see to its make up, proof-reading and other details of publication. It was a good arrangement. I liked him very much. He was too brilliant to like me extremely but he tolerated me more than he tolerated most people. He had an exaggerated idea of my omniscience and political influence.

I had arranged with the house of Duckworth to publish the review and had commissioned a number of stories, poems and critical articles. He came to me one day and said he could not supervise the business affairs of the concern. That was rather a heavy blow because I knew enough about business to know that I should make a muddle of that side of it. I sighed, cabled to Byles,* who

* R. B. Byles, a friend and one of Ford's more flamboyant publishers.

was then in Japan, to come back and take on the business of the *Review*, and consented to continue the enterprise. A little later my friend came to me and said that he could not undertake to do half the editing. A General Election was in the offing; he had neglected his constituency; he would have to go perpetually into the North to kick off footballs, open flower shows, subscribe to fox-hounds and utter verbal coruscations. He suggested that I might find someone else of his school of thought to direct the political policy of the review; I sighed again and consented. For that Marwood was indicated.* He was an old, rather than a New, Tory and he was incurably indolent. But he consented to suggest from Winchelsea the sort of article that should go into the review and in most cases to indicate the writers who should be invited to contribute. My political friend proposed in fairness that if so much of the labour was to fall on me, he should increase the amount of capital that he found, whilst I should retain my full half share of the control of the periodical. I was glad of that because I had lately had rather serious financial reverses.

The dummy of the first number approached completion; I had announced the name of the periodical, *The English Review*, in the press. It was Conrad who chose the title. He felt a certain sardonic pleasure in the choosing so national a name for a periodical that promised to be singularly international in tone, that was started mainly in his not very English interest and conducted by myself who was growing every day more and more alien to the normal English trend of thought, at any rate in matters of literary technique. And it was matters of literary technique that almost exclusively interested both him and me. That was very un-English.

A couple of presumably needy journalists,† both of very great ability, conceived the idea of making me, who was presumed to be rolling in wealth, pay for the use of

* Arthur Marwood, an intimate friend of Ford's.
† T. W. H. Crosland and Lord Alfred Douglas, who had in fact edited a review of that name in the winter of 1905–06.

that title. They registered it as soon as I had announced it in the press and then asked me to pay a prodigious sum for its use. I offered them half a sovereign apiece. They then published a single-sheet broadsheet under the title of *The English Review*. Its letter press consisted of virulent attacks on Lord Northcliffe and me, promising extraordinary revelations as to both of us in their next number. I fancy they imagined that Lord Northcliffe was financing the review. The main allegation against myself was that I was a 'multiple reviewer.' The charge was true enough but only as far as one book was concerned. That was Charles Doughty's *Dawn in Britain*—an epic poem in twelve books and four volumes. I had a great admiration for Doughty, who was the author also of *Arabia Deserta*, and I read his poem entirely through with a great deal of pleasure. No reviewer in London had leisure for that task. The book looked as if it might go unreviewed, so I asked a number of those gentlemen to let me review it for them. Others, hearing that I had volunteered to do it, also asked me to relieve them of the task, I do not remember how many reviews I wrote; it was a considerable number and some of them were quite long. I pleased myself by finding that I could do them all without once repeating a sentence or even an idea. At any rate I was quite unrepentant. I do not see why you should not write more than one review of a book for which you have a great admiration. I have written several times about *Ulysses*.

I continued to take no notice of the other *English Review*. My telephone became a constant worry because those two gentlemen rang me up at all hours of the night, asking me to buy the title for sums that gradually descended from a thousand pounds to five. Lord Northcliffe, on the other hand, applied for an injunction against my rivals in one of the courts—I forget which. The injunction was granted and the other *English Review* disappeared. The real joke was that I had lent one of those lively persons the money with which he paid for his

broadsheet. At any rate, just before he printed it, I had met him looking very destitute in Fleet Street and had lent him exactly the sum with which he paid his printer's and paper-maker's bill.

A little later I went to a Trench dinner. A Trench dinner was a Dutch treat presided over by Herbert Trench, the Irish poet. They were agreeable affairs and attended by most of the brilliant people in London. I was only asked to one. On this occasion I was set at a round table with Mr Hilaire Belloc, Mr Gilbert Chesterton, Mr Maurice Baring and Mr H. G. Wells. My politician was at another table with Mr Trench, the Marchioness of Londonderry and other notables.

Amongst all these celebrities I felt nervous. Celebrities are always rude to me. That has been the case from my tenderest years. I can hardly think of one that has not, at one time or another, said rude things to me. I ought to except politicians, I can hardly remember a politician who has not said nice things to me about my books—as soon as he heard that I was a writer. I suppose they learn that when canvassing for votes. Mr Balfour once asked me to send him my books as they came out. I did for years. He always wrote politely thanking me for the volume 'from the reading of which he anticipated much pleasure.' The letters were always marked: 'Not for publication.'

I knew I should not get through that dinner without discomfort. It came. Mr Belloc was late. I had written an article about him a day or two before. It had been published that morning. I had classed him among the brilliant *jeunes* of the day and had expressed the really great admiration I felt for his wit, sincerity and learning. He hurried in, saw me, stopped as if he had been shot, thrust his hand through his fore-lock, gave one more maledictory glance at me with his baleful, pebble-blue eyes and then sank wearily into his chair next to Mr Maurice Baring. He looked anywhere but at me and began an impassioned monologue about the misfortunes of historians. They wore themselves out searching for matter in

the British Museum Library and other stuffy places; they toiled till far into the night putting the results of their researches on paper. After infinite tribulation they published their books. Then along came the cold-eyed critic.

I forget what Mr Belloc said that the cold-eyed critic did to the historian but I realized that it was my eyes that were frigid in his. In my eulogy of him I had amiably found fault with some gigantic exaggeration in a book, I think, about the Cromwell family. What exactly Thomas Cromwell had done to our co-religionists or how Oliver had sinned against the Church of Rome I forget. Heaven forbid that I should set myself down as good a Papist as Mr Belloc, but I dislike to think of myself as a worse. I consider that there are only two human organizations that are nearly perfect for their disparate functions. They are the Church of Rome and His Britannic Majesty's Army. I would cheerfully offer my life for either if it would do them any good and supposing them not arrayed the one against the other. But I could not see that the cause of the Church was advantaged by gigantically exaggerating the confiscations from which she has suffered any more than it would help the Old Contemptibles to represent them as having been without exception teachers in Sunday Schools. I had said this mildly in my article. As a matter of fact I wished that Mr Belloc would write novels and leave propaganda to the less gifted.

The affair ended dramatically in nothing, for before ending his monologue Mr Belloc suddenly burst out to someone whom I could not see at the chairman's table beside us:

'Our Lord! What do you know about Our Lord? Our Lord was a gentleman.'

After that I escaped notice in the shadow of Mr Chesterton. Mr Chesterton and Mr Belloc were one on each side of Mr Baring. They occupied themselves for some time in trying in vain to balance glasses of Rhine wine on his skull. That gentleman comes back to me as

having been then only a little less bald than an egg. The floor and his shirt front received the wine in about equal quantities. But he did not seem to mind.

Suddenly Mr Belloc was at me again. He said that I would not dare to print in my review any article that he sent me just as it stood. I said I would. He repeated that I would not and I that I would. He was in those days almost as vigorous a muck-raker as S. S. McClure and hardly anyone had the courage to print him in his more coruscating moments. I may say that I did print his article. It contained the most amazing accusations against bishops, keepers of the Crown jewels, West Indian Governors and other apparently unoffending and unimportant beings. So I made the printer black out the names and functions of everybody concerned. Those pages of the review startlingly resembled newspapers in Russia after they had received the attention of the censor. They startled Mr St Loe Strachey, the editor of *The Spectator*, to some purpose. He confused my *English Review* with the broadsheet promoted by the two journalists and supposed that either I or Mr Belloc intended to threaten the owners of the blacked-out names with exposure in another number if we were not bought off, and solemnly and weightily he protested against this growing tendency in British journals. He seemed to me to be a mild and doting old gentleman, so I wrote to him amiably and told him that he had accused me of being a blackmailer and would he kindly refute himself in the next number of his journal. He did so and wrote me a very agitated letter saying that he had meant nothing of the sort. He did not say what he *had* meant.

That Trench dinner, different as it was from the Trench dinners that we afterwards ate, came also to an end. I was going towards the Piccadilly tube. It was pouring and Mr Belloc was begging me not to believe that he was in fact the light-hearted being that he appeared. Actually he was filled with the woes of all the world.

I was beginning to assure him that from then on I

would regard his as a figure of the deepest tragedy. We were just turning into the tube-station when my politician, ex-fellow-editor and business manager, came running up rather breathlessly and caught hold of the arm of mine that Mr Belloc was not imprisoning. He said:

'Fordie, I'm very sorry. I can't find my half share of the capital for the review.'

I said:

'That will be all right.' He disappeared and I went on assuring Mr Belloc of my appreciation of his pessimism.

It appeared subsequently that my friend was suffering from the same financial disaster that had hit hard not only myself but many other people. It was the case of a disappearance abroad—with an expensive young woman —of a man, the bearer of a very honoured name in whose faith too many had reposed their trust. He subsequently committed suicide.

There seemed to be nothing to do but to close down that periodical, pay off the contributors whom I had already commissioned and realize my dream of retiring to a little farm in Provence. I had of course to tell Marwood, who was by that time as enthusiastic about the review as he could be about anything.

He agreed with me. There was nothing to do but to shut it down. He made a good many caustic remarks about Young Tories in general and my friend in particular. I disagreed with him. That politician was no more guilty than I. Marwood, however, was certain that he had never intended to find the money.

I returned from Winchelsea to Aldington where I had by now bought a cottage. There remained, it seemed, nothing for it but to emigrate to Provence and there seemed to be nowhere else to emigrate to. As the world then appeared to me I could support living in London, if I had the review. Without it, I couldn't.

I was writing to a friend I had in Tarascon—a *notaire* —to ask about small farms that might be for sale in his neighbourhood. It was a Sunday. Marwood was suddenly

on the terrace. He was pale with indignation and brand-ished a crumpled newspaper. He panted:

'You've got to carry on that review.'

I had never seen him agitated before—and I never did again. He must have got up at four that morning to catch the train from Winchelsea to Aldington.

The newspaper announced that *The Cornhill Magazine* had refused to print, on the score of immorality, a poem of Thomas Hardy called *A Sunday Morning Tragedy*. All the other heavy and semi-heavy monthlies, all the weeklies, all the daily papers in England had similarly refused. Marwood said:

'You must print it. We can't have the country made a laughing-stock.' He was of opinion that the rest of the world must guffaw if it heard that Hardy could not find a printer in England. Marwood was accustomed to say nothing worth the attention of a grown man had been written in England since the eighteenth century. Claren-don's *History of the Great Rebellion* and the Jacobean poets were his reading. He made a great concession to modernity when he read Maine's *Ancient Law* and Doughty's *Arabia Deserta*. Yet there he was, made to spend several thousand pounds in order to publish one poem by a modern poet who as poet was hardly known at all. For of course he found the money that hadn't been found by my other friend.

That was *my* Sunday morning tragedy. But for that I should have been saved a great deal of labour, a number of enemies. I should have been, now, twenty years instead of only six months, a kitchen-gardener in Provence.

ENTER EZRA POUND

The English Review duly appeared. It was a source of a good deal of amusement and some profit to certain people and of a good many worries to myself. Our first two

numbers were made up, perforce of works of the then distinguished. After that we tried to let the distinguished drop out gradually, so as to publish the unpublished. We published contributions of one sort and another by Thomas Hardy, George Meredith, D. G. Rossetti (posthumously), Swinburne, Anatole France, Gerhart Hauptmann, Henry James, Joseph Conrad, W. H. Hudson, W. B. Yeats and even President Taft. Of the then youngish —speaking in terms of career—we published Mr Wells's *Tono-Bungay* serially in four numbers and a short serial of Mr Arnold Bennett in two, as well as Messrs. Galsworthy, Belloc, Chesterton and others of then similar standing.

Then came Ezra.... His Odyssey would take twelve books in itself. In a very short time he had taken charge of me, the review and finally of London. When I first knew him his Philadelphian accent was still comprehensible if disconcerting; his beard and flowing locks were auburn and luxuriant; he was astonishingly meagre and agile. He threw himself alarmingly into frail chairs, devoured enormous quantities of your pastry, fixed his pince-nez firmly on his nose, drew out a manuscript from his pocket, threw his head back, closed his eyes to the point of invisibility and looking down his nose would chuckle like Mephistopheles and read you a translation from Arnaut Daniel. The only part of that verse that you would understand would be the refrain:

'Ah me, the darn, the darn it comes toe sune!'

We published his 'Ballad of the Goodly Fere' which must have been his first appearance in a periodical except for contributions to the *Butte* (Montana) *Herald*. Ezra, though born in Butte in a caravan during the great blizzard of—but perhaps I ought not to reveal the year. At any rate, Ezra left Butte at the age of say two. The only one of his poems written and published there that I can remember had for refrain:

'Cheer up, Dad!'

As a reaction against a sentiment so American, he shortly afterwards became instructor in Romance Languages at the University of Pennsylvania. His history up to the date of his appearance in my office, which was also my drawing-room, comes back to me as follows: Born in the blizzard, his first meal consisted of kerosene. That was why he ate such enormous quantities of my tarts, the flavour of kerosene being very enduring. It accounted also for the glory of his hair. Where he studied the Romance Languages I could not gather. But his proficiency in them was considerable when you allowed for the slightly negroid accent that he adopted when he spoke Provençal or recited the works of Bertran de Born.

His grandfather I understood was an unsuccessful candidate for the Presidency in the time of Blaine, his father assayer to the Mint in Philadelphia, a function requiring almost incredible delicacy of touch. His grandfather, as was the habit of millionaires in the America of that day, made and lost fortunes with astonishing rapidity and completeness. He had promised to send Ezra to Europe. Ezra was just making his reservations when his grandfather failed more finally and more completely than usual.

Ezra therefore came over on a cattle-boat. Many poets have done that. But I doubt if any other ever made a living by shewing American tourists about Spain without previous knowledge of the country or language. It was, too, just after the Spanish-American War when the cattle-boat dropped him in that country.

It was with that aura of romance about him that he appeared to me in my office drawing-room. I guessed that he must be rather hard up, bought his poem at once and paid him more than it was usual to pay for a ballad. It was not a large sum but Ezra managed to live on it for a long time—six months, I think—in unknown London. Perhaps my pastry helped.

...AND ANOTHER CONSPIRATOR*

One day Marwood, Miss Thomas and I were lunching as we daily did in my dining-room which was above the office. I said to Marwood:

'The *Review* is rotten this month.' He said:

'You might call it putrid.'

So I asked Miss Thomas to be good enough to go down into the office and say a prayer to St Anthony. He was to find a good contribution for that month's number.

From downstairs we heard her give a little squeak. It could not have been fear, for Miss Thomas was so expert at jujitsu that she could throw both Marwood and myself through the office window. But she came up again, saying rather agitatedly that there was an extraordinary-looking man on the stairs.

He was extraordinary in appearance. It was just after Azev had tried to sell me the Tsar's diary and I was determined to have nothing to do with Russians. He seemed to be Russian. He was very dark in the shadows of the staircase. He wore an immense steeple-crowned hat. Long black locks fell from it. His coat was one of those Russian-looking coats that have no revers. He had also an ample black cape of the type that villains in transpontine melodrama throw over their shoulders when they say 'Ha-ha!' He said not a word.

I exclaimed:

'I don't want any Tsar's diaries. I don't want any Russian revelations. I don't want to see, hear or smell any Slavs.' All the while I was pushing him down the stairs. He said nothing. His dark eyes rolled. He established himself immoveably against the banisters and began fumbling in the pockets of his cape. He produced

* The painter and novelist Wyndham Lewis, here mysteriously referred to as 'Mr D. Z.'

crumpled papers in rolls. He fumbled in the pockets of
his strange coat. He produced crumpled papers in rolls.
He produced them from all over his person—from inside
his waist-coat, from against his skin beneath his brown
jersey. He had no collar or I am sure he would have taken
that off too and presented it too to me and it would have
been covered with hieroglyphs. All the time he said no
word. I have never known any one else whose silence
was a positive rather than a negative quality. At last he
went slowly down those stairs. I had the impression that
he was not any more Russian. He must be Guy Fawkes.

He had thrust all those rolls into my arms. I went up
again into the dining-room and dropped the rolls before
Marwood. He looked at one of them for no more than a
second and said:

'We are saved. St Anthony has answered our prayer.'

The article was called *Poles*. It was not about hop-poles
or rods, poles, or perches. It was about the indigent Slavs
or make-believe Slavs who victimize willing boarding-
house keepers in the French capital and Provinces. I be-
came then certain that Mr D. Z. was himself a Pole. But
he wasn't. He was actually born in the Western Con-
tinent and his costume was the usual uniform of the
Paris student of those days. His writing was of extra-
ordinary brilliance. He practised several arts.

I apparently conspired against him, so he threatened the
editor of an Academic journal. I did not for many years
—twenty at least—know how I had conspired. At last Ezra
told me.

I had said to D. Z. one day:

'I wish you would give up your other arts and con-
centrate on writing. The other arts can look after them-
selves but in England writers are desperately needed.'
That proved that I was conspiring with Academecians to
suppress his activities. There was nothing very singular
in Mr D. Z.'s suspecting me of willing his undoing. It
was merely the form that his vengeance took that seemed
to me singular. As far as I can remember, except for

Ezra, not one of the writers whose first manuscripts I printed or whose second efforts I tried to give lifts to—not one of them did not in the end kick me in the face, as the saying is. Indeed if you believed my record as set down by my so-called protégés I must be the spider of my grandfather's image. It fell into an inkwell and then sprawled all across the whole ten commandments. That is Nature asserting itself. In the end the young cockerels must bring down the father of their barn-yard. Without that the arts must stand still.

THE END OF MY TENURE

The work of the *Review* grew harder, money grew scarcer. I secured a business manager in the person of my brother-in-law, Dr Soskice, who put my accounts into some sort of order and found some fresh backers. As these were all of the moderate Left type, they did not like me much. I could always get on with the Extreme Right or the Extreme Left; moderates of any type I have always found insupportable.

It was not long before those gentlemen took over the *Review*, leaving me as the nominal editor. Marwood resigned his share in the *Review* to me; Conrad refused to continue serializing his reminiscences in it. My controllers established a committee of censorship over my editing. They knew how to make censorship irritating. They had suffered from censors.

I saw that the end was not far off and took a flying visit to Provence. When I came back I found Mr Galsworthy installed in my editorial chair. He had been nominated editor by the committee of censors. They had told him that I had gone for good. He resigned on my return. He had introduced one or two writers into my number which had gone to press before I left. I forget who they were but they gave the *Review* a distinctly

more Left aspect. Its sales diminished very considerably. There was a small public for imaginative literature plus more or less imaginative handling of public matters but they were frightened away by moderate Left propaganda. The supporters of the moderate Left could not bear imaginative literature in their houses.

I raised money in various disagreeable ways—by impignorating my furniture and paintings, by borrowing from my father's richer relatives and others, by writing extremely bad novels at a very great speed. Count Metternich, the German Ambassador, suggested amiably that his Government might like to hire the services of the *Review* and myself. He wanted to come and see me but hearing that I had lately had influenza he sent some Prince in a gorgeous carriage and pair. I think it was the hereditary Prince of Wied. I said that the German Government might if it liked buy the *Review* if it would pay off its creditors but it could not have my services. Prince Metternich then asked me to go and see him as soon as I could be quite certain that he would not catch influenza from me. He repeated his offer and paid me a number of compliments. He said that his Imperial master had sent me a personal message asking me to do my best to improve the relationships of the two countries. I said I had been doing it already but I could not carry it any further. I repeated that he could buy the *Review* but not my services.

As it was, I gave up and let the *Review* go to Sir Alfred Mond, who promptly installed a son of Frederick Harrison as its editor. I thought at the time that was much the same as selling it to Count Metternich. But I suppose it wasn't.

To some extent that undertaking had justified its existence for me. It had got together, at any rate between its covers, a great number—the majority—of the distinguished writers of imaginative literature in England of that day and a great many foreign writers of distinction. It had been quite impossible to get the distinguished

to come together in person. The attractions of their hill-
tops and attendant worshippers were too overpowering.
Conrad came and stayed for several days with me on
several occasions, but he always managed to be out at
tea-time, in case anyone literary should come in. James
always rang up on the telephone before coming to see
me, so as to make sure of meeting no writers—and so it
went down the list. I think that only one contributor to
my first two numbers did not tell me that the *Review* was
ruined by the inclusion of all the other contributors.
James said: 'Poor old Meredith, he writes these mysterious
nonsenses and heaven alone knows what they all mean.'
Meredith had contributed merely a very short account of
his dislike for Rossetti's breakfast manners. It was quite
as comprehensible as a seedsman's catalogue.

Meredith said on looking at James's *Jolly Corner*
which led off the prose of the review:

'Poor old James. He sets down on paper these
mysterious rumblings in his bowels—but who could be
expected to understand them?' So they went on.

With the younger writers it was different. They
crowded my office drawing-room, they quarrelled they
shouted. They attended on me like body-guards when I
took my walks abroad. I remember only one dull moment.

Most beautifully and incredibly wealthy ladies who
liked to look up to those spirited young creatures and ask
them to their dances used to crowd my office. It was
rather a handsome large drawing-room in an old house.
There were pictures by Pre-Raphaelites, old furniture, a
rather wonderful carpet. The room was lit from both
ends and L-shaped so that if you wanted a moment's
private conversation with anyone you could go round
the corner. Miss Thomas, large, very blonde and in-
variably good-tempered, presided over the tea-table. Ezra
looked after the cakes.

On the dull occasion nothing would go. I had a red-
purple velvet divan. It was the gift of my mother, so I
had to display it. But it was a startling object. On it sat

three young men as dumb as mile-stones. Thomas Hardy remained for the whole afternoon round the corner of that L talking in low tones to the wife of the Bishop of Edinburgh.

The rest of the room was occupied by beautiful creatures who had come specially to hear Thomas Hardy and those young men. The young men sat side by side on that egregious divan. Their legs were stretched out, their ankles were clothed, as to the one pair in emerald green socks, as to the next in vermilion and as to the next in electric blue. Merely to look in the direction of that divan was to have a pain in the eyes. The young men kept their hands deep in their trouser-pockets and appeared to meditate suicide. Ezra did not even eat any cakes.

He had the tooth-ache. Next to him was Gilbert Cannan: he had just been served with papers in a disagreeable action. Next to Cannan was Mr Hugh Walpole. He had just published a particularly admirable novel called *Mr Perrin and Mr Traill*. But he was suffering agonies of fear lest his charming mother, who was the wife of the Bishop of Edinburgh and hidden round the corner, might hear something that should shock her. I think myself that humorous lady, taking a swallow's flight into Bohemia, would have liked to be a little shocked.

FUND-RAISING

I had behind me other activities. I wrote a shadow play for Mme. Strindberg and had to act it myself in place of the lovely actress who should have done it. A too ardent admirer of Mme. Strindberg had stolen the manuscript because he could not bear to let my play be produced.

One night I came home rather earlier than usual and found Lady Gregory camped on my doorstep. She said:

'You have got to finance and manage the Irish Players.'

I said:

'Delighted! But why?'

Miss Maire O'Neill, the adorable Pegeen Mike of *The Playboy of the Western World*, had attended a public meeting of Suffragettes. Miss Horniman, the guarantor of the company in England, had telegraphed from Liverpool that she would withdraw the subsidy if she did not receive an unconditional apology from every member of the company. The company had refused.

Lady Gregory said: 'You will have to do it. You are responsible for the Suffragettes. It was reading you made Maire O'Neill go to that meeting.'

I said: 'How much do you want?' She said: 'Two thousand pounds.' I said: 'All right. I will get it for you,' and we drove to the theatre where W. B. Yeats was rehearsing *The Well of the Saints*.

Their publicity had not been very well managed and we put on the *Playboy* for the first time to a perfectly empty house. Very few of the critics had cared to come. The Irish Players played that play as if it had been the direst tragedy ever written. For the second performance I had bought all the reserved seats in the house and had sent them to all London. All London came. You never saw such a house. There was over half the Cabinet and more than half of the Opposition Front Bench. Mr Balfour and Mr Burns sat together in the middle of the front row of the stalls; there were ambassadors; shoals of titles. We just missed having royalty because there was something going on at the other Court. Ours was the Court Theatre.

The Players played the *Playboy* as if it had been a roaring farce. The night before it might have been *Oedipus Tyrannus*. It is susceptible of both treatments.

Ellen Terry said a pretty thing. At the supper that we gave on the stage she lost a great paste star that she had been wearing. When it was given back to her she held it over Maire O'Neill's head. She said:

'My dear, "a star danced and underneath it you were born." This is the star. Take it.' It had been said to her

before that. She meant that she was resigning her place to that young thing. She had the most graceful gestures and kindnesses of any woman that ever lived.

Four—or perhaps three—Christmas-days ago I saw those same Irish players playing *Juno and the Paycock* in New York to five people, including two that I had brought. They came home with me after the play and I gave them grilled sausages and Dublin stout. It must have been Mr Allen Tate, the beautiful poet, who found those not too easily found comestibles in New York on Christmas-day at one in the morning. They were as gay as on the second night of the *Playboy* at the Court.

The money for the subsidy did not at first seem difficult to obtain. But an unforeseen difficulty arose. I had organized one or two drawing-room meetings at the houses of people like Governors of the Bank of England, who lent them kindly enough. We needed a relatively small sum, for the company was doing pretty well. The *Playboy* at least played to bumper houses. There was by then a committee of which Mr Shaw was the president.

We organized a really swell meeting in the studio of Mr Jacob Epstein at Chelsea. There must have been an enormous sum of money represented in that room. I had to make an appeal for funds first because I was going on somewhere else. I made the silly sort of speech that you make on such occasions. I said that if you wanted to keep Ireland quiet the best thing you could do would be to give the Irish good theatres. Before I had finished speaking the Monds, Wertheimers, Speyers and the usual subscribers to things of the sort had sent me up notes saying that they would subscribe between them a good deal more than was needed. I hurried away rejoicing.

When I went home to dress, Lady Gregory was again occupying my door-step. She said:

'What are we to do now?' I asked about what? She said:

'To raise that money.'

Mr Bernard Shaw had spoken after me. He had said:

'You idle rich. You are the last sort of people who should come to a meeting like this. Catch you subscribing a penny. All you think of is ...' I don't remember what it was but his words were to that effect. All those subscribers had withdrawn their promises of subscriptions. We had to begin all over again.

FOR THE PRICE OF A PINT

We came back on top of a bus, Bennett and I.* In passing a trolley-car the bus ran into an electric-light standard. A girl sitting on one of the forward seats began to scream. I went to her and she said that her side had hit the side-rail of the bus and hurt her terribly. A crowd had collected below including a couple of policemen. I told one of them to take the girl to the nearest doctor. The policemen said:

'You don't know the lower classes, sir. Sharp as weasels they are to get damages out of the great companies.' I said:

'Take the girl to the doctor as I told you. I will pay his fee if she is not hurt.'

There was a doctor's house just across the way. We streamed across to it; the doctor examined the girl and found she had two of her short ribs fractured. The police then behaved like angels of kindness to her and conveyed her at their own expense to her home, since she refused to go to a hospital.

When I got back to the bus there was Arnold Bennett. He was standing on the top of it with his jaw hanging down. He said:

'You dare to talk to the police like that?'

I said: 'Why not? Aren't the police there to do what you tell them to do?'

* Arnold Bennett and Ford had been to visit a common friend in Ealing.

He said:

'In my walk of life as a boy and my father's as a grown workingman if we saw a policeman we got round the corner as quickly as we could. I still do. The idea of speaking to a policeman makes me shiver.'

He was exaggerating of course, so as to impress me. His father could hardly be described as a workingman. He was I believe a lawyer's clerk and lawyer's clerks can usually manage the police very nicely, being certainly their social superiors in that singular maze of social strata, where the bricklayer will not eat at the same table with the bricklayer's labourer and the plasterer will not let his wife go out with the bricklayer's. But no doubt he had once had something of the feeling. For myself I have always regarded the policeman at the corner as a man who would fetch cabs for you if it rained, or post letters, or do any little job for the price of a pint.

THEY

To myself I never seem to have grown up. This circumstance strikes me most forcibly when I go into my kitchen. I perceive sauce-pans, kitchen-spoons, tin canisters, chopping-boards, egg-beaters and objects whose very names I do not even know. I perceive these objects, and suddenly it comes into my mind—though I can hardly believe it—that these things actually belong to me. I can really do what I like with them if I want to. I might positively use the largest of the sauce-pans for making butterscotch, or I might fill the egg-beater with ink and churn it up. For such were the adventurous aspirations of my childhood when I peeped into the kitchen, which was a forbidden and glamorous place inhabited by a forbidding moral force known as *Cook*. And that glamour still persists, that feeling still remains. I do not really very often go into my kitchen, although it,

and all it contains, are my property. I do not go into it because, lurking at the back of my head, I have always the feeling that I am a little boy who will be either 'spoken to' or spanked by a mysterious *They*. In my childhood *They* represented a host of clearly perceived persons: my parents, my nurse, the housemaid, the hardly ever visible cook, a day-school master, several awful entities in blue who hung about in the streets and diminished seriously the enjoyment of life, and a large host of un-named adults who possessed apparently remarkable and terrorising powers. All these people were restraints. Now-a-days, as far as I know, I have no restraints. No one has a right, no one has any authority, to restrain me. I can go where I like; I can do what I like; I can think, say, eat, drink, touch, break, whatever I like that is with-in the range of my own small empire. And yet till the other day had constantly at the back of my mind the fear of a mysterious *They*—a feeling that has not changed in the least since the day when last I could not possibly resist it, and I threw from an upper window a large piece of whiting at the helmet of a policeman who was stand-ing in the road below. Yesterday I felt a quite strong desire to do the same thing when a bag of flour was brought to me for my inspection because it was said to be mouldy. There was the traffic going up and down under-neath my windows, there was the sunlight, and there, his buckles and his buttons shining, there positively, on the other side of the road, stalked the policeman. But I re-sisted the temptation. My mind travelled rapidly over the possibilities. I wondered whether I could hit the policeman at the distance, and presumed I could. I wondered whether the policeman would be able to identify the house from which the missile came, and presumed he would not. I wondered whether the servant could be trusted not to peach, and presumed she could. I con-sidered what it would cost me, and imagined that, at the worst, the price would be something less than that of a stall at a theatre, while I desired to throw the bag of flour

very much more than I have ever desired to go to a theatre. And yet, as I have said, I resisted the temptation. I was afraid of a mysterious *They*. Or, again, I could remember very distinctly as a small boy staring in at the window of a sweet-shop near Gower Street Station and perceiving that there brandy-balls might be had for the price of only fourpence a pound. And I remember thinking that I had discovered the secret of perpetual happiness. With a pound of brandy-balls I could be happy from one end of the day to the other. I was aware that grown-up people were sometimes unhappy, but no grown-up person I ever thought was possessed of less than fourpence a day. My doubts as to the distant future vanished altogether. I knew that whatever happened to others, I was safe. Alas! I do not think that I have tasted a brandy-ball for twenty years. When I have finished my day's work I shall send out for a pound of them, though I am informed that the price has risen to sixpence. But though I cannot imagine that their possession will make me happy even for the remaining hours of this day, yet I have not in the least changed, really. I know what will make me happy and perfectly contented when I get it— symbolically I still desire only my little pound of sweets. I have a vague, but very strong, feeling that every one else in the world around me, if the garments of formality and fashion that surround them could only be pierced through—that every one else who surrounds me equally has not grown up.

FINISHED! EXPLODED! BLAST!

I was tired out and my private affairs in literature were all arranged for me. I had 'made my effort,' as racing people say, during the last six months. I had always held two things. No man should write more than one novel. No man should write that novel before he is forty. I had

been forty six months before. On my birthday I had sat down to write that novel. It was done and I thought it would stand. There was to be no more writing for me— not even any dabbling in literary affairs.

The English Review seemed then profoundly to have done its work. Ezra and his gang of young lions raged through London. They were producing an organ of their own. It was to be called—prophetically—*Blast*.

One day Ezra and the young man I have called Mr D. Z. took me for a walk. In Holland Street D. Z. had grasped my arm as if he had been a police-constable. Those walks were slightly tormenting. Ezra talked incessantly on one side of me in his incomprehensible Philadelphian, which was already ageing. That made it all the more incomprehensible. Mr D. Z., dark, a little less hirsute but more and more like a conspirator went on and on in a vitriolic murmur. On this occasion he raised his voice for a little, so as to be heard by me but not by Ezra. Ezra would not have stood for it.

D. Z. said:

'*Tu sais, tu es foûtu! Foûtu!* Finished! Exploded! Done for! Blasted in fact. Your generation has gone. What is the sense of you and Conrad and Impressionism. You stand for Impressionism. It is finished, *foûtu*. Blasted too! This is the future. What does anyone want with your old-fashioned stuff? You try to make people believe that they are passing through an experience when they read you. You write these immense long stories, recounted by a doctor at table or a ship-captain in an inn. You take ages to get these fellows in. In order to make your stuff seem convincing. Who wants to be convinced? Get a move on. Get out or get under.

'This is the day of Cubism, Futurism, Vorticism. What people want is me, not you. They want to see me. A Vortex. To liven them up. You and Conrad had the idea of concealing yourself when you wrote. I display myself all over the page. In every word. I...I...I....'

He struck his chest dramatically and repeated: 'I...
I...I...The Vortex. Blast all the rest.' I was reminded
of a young lady I once went to call on and who came run-
ning exclaiming:

'Devil, devil, devil take them all but me.'

But Mr D. Z. was perfectly right. I don't mean that I
only thought then that he was right. I think it now. Im-
pressionism *was* dead. The day of all those explosive
sounds had come. Louder blasts soon drowned them out
and put back the hands of the clock to somewhere a good
deal the other side of mere Impressionism. But in that
moment they were undoubtedly all right. It was in a sense
another foreign invasion, like the one with which this
chapter opens. There was hardly a born Londoner in it.
D. Z., Ezra, H. D., the beautiful poetess, Epstein,
Fletcher, Robert Frost, Eliot were all transatlantically
born from the point of view of London. Henri Gaudier
was a Marseillais. They had all become Londoners be-
cause London was unrivalled in its powers of assimilation
—the great, easy-going, tolerant, loveable old dressing-
gown of a place that it was then. It was never more to be
so.

Those young people had done their best to make a man
of me. They had dragged me around to conspiracies,
night-clubs, lectures where Marinetti howled and made
noises like machine-guns. They had even tried to involve
me in their splits. Of course they split. The Ezra-D. Z.
contingent blasted another contingent led by Mr Nevin-
son the artist. Those continued I think to call themselves
Futurists. I was, I suppose, identified with the Vorticists.
At any rate for years after that every time that Mr Nevin-
son met me he would say: 'How fat you are!'—which was
supposed to be blasting. Ezra, on the other hand—out of
affection—used to call me 'the pink egg.' So they pranced
and roared and blew blasts on their bugles and round
them the monuments of London tottered.

I went home after that conversation and wrote my

farewell to literature—quite formally. It was printed in a shortlived periodical called *The Thrush*. Thrushes had no chance of making themselves heard in those days. The Vorticists kindly serialized my novel—my Great Auk's Egg, they called it. The Great Auk lays one egg and bursts. That bird was no louder than a thrush in the pages of *Blast*.*

So I was done with letters—and with the Left. Of what I was going to do I had little notion. But Provence still called. I had paid a prolonged visit to the neighbourhood of Tarascon just before and chosen my house. I had written a long poem about Heaven which I had placed in the Alpilles, tiny grey mountains just outside the town of Tartarin. That poem had produced remarkable reverberations in America. It was given prizes, crowned with gilt laurel-leaves. Leaders were written about it in many of the newspapers of the Eastern Sea-board. It was said to have put up the marriage-rate in New York. Elinor Wylie, the beautiful poetess and most beautiful woman, told me that she and her husband, William Benét, had become engaged whilst reading my poem to each other in Central Park.

In England its publication was stopped by the police. Mr Courtney proposed to publish it in *The Fortnightly Review* but was a little afraid. Masterman† took it to the Home Secretary. The Home Secretary said that if it were published he would have to authorize a prosecution. It gave a materialist picture of heaven. God appeared in it. It is against the law for God to appear in England. That poem was, during the War, published under the auspices of the Ministry of Information—as Government propaganda! It might encourage young men who were about to die if they thought they would go to a nice heaven.

* Ford's timid bird was called *The Saddest Story*, which, revised and completed, was published in book form as *The Good Soldier* in 1915.

† C. F. G. Masterman, Chancellor of the Duchy of Lancaster in Asquith's cabinet and a friend of Ford's.

THE END OF A WORLD

I went home to pack my things. Next morning I was on the high platform of Berwick Station. Berwick Town is in Berwickshire and Berwickshire in Scotland. But Berwick Town is neither English nor Scottish. It is 'juist Berwick.' The King's proclamations are ordered to be affixed to the church doors of England, Scotland, Wales and Ireland and the town of Berwick upon Tweed. I once had a cousin who was Mayoress of Berwick.

The air was very clear. The North Sea very blue. London was far away. I bought a newspaper—a Liberal sheet of the more grandmotherly kind. It told me that the Suffragettes were naughty, naughty girls and that they must be stopped. It was very angry with the King over several pages. The King was acting almost—oh but only just almost—unconstitutionally. He had asked all the leaders of all the Irish parties to meet in a Round Table conference at Buckingham Palace under his own Presidency. *The Daily News* said it was a really very naughty King.

I imagined I knew all about that. I had seen Masterman a month before really angry for the first time in my life. He said that the King was impossible to get on with. He was as determined that the Irish Question should be settled to the satisfaction of all his Irish subjects, as his father had been to have the Entente Cordiale with France. The Cabinet was unanimously against the Buckingham Palace conference. They wanted to do nothing that could enhance royal prestige. The matter had come to an absolute impasse.

Finally, according to Masterman—and I made a note of his words immediately afterwards. It was the only note I ever made, but the occasion seemed very extraordinary —the King had said:

'Very well gentlemen. I am the richest commoner in England. If you wish me to abdicate, I will abdicate, supposing that to be the wish of the country. But before

that we will have a general election and I have not much doubt as to the results as between you and me.' So he had his conference.*

I was immensely glad. All my life I had been a passionate Home Ruler. I hate, I hate, I hate—three times—the idea of people of one race and religion being ruled over by people of alien race and another religion. But the Irish Question was a nightmare—a worse nightmare than the case of the Suffragettes. Here was a majority of one island with a minority of another religion and an intense enmity one with the other. The thought of the Connaught Rangers or the King's Royal Rifles going through the Three Counties was unspeakable. And then ... inside the territory of the Protestant minority was a tiny Catholic minority, as inside the Catholic territory of the majority was a small Protestant minority. Not even an Abbey Theatre in every village in Ireland could stop bloodshed in that sorrowful country. So I was glad the King was determined to have that question settled to the satisfaction of all parties of his Irish subjects. There had been a mutiny of English officers in the camp at Curragh outside Dublin. . . .

I was putting down the paper with its large anti-Royal and anti-feminine headings. I had a sudden sinking at the heart—most sinister feeling. There was a three-line paragraph—such is editorial prescience—tucked away at the bottom of a page and headed minutely:

AUSTRIAN HEIR MURDERED IN SARAJEVO

It was London's news of the 28th June 1914, reaching me in a border town.

I said to myself:

'Oh, the Socialists and Labour will stop a war. They are the tail that wags the Liberal dog all the world over.' And I really believed it and got into the branch-train for Duns with a serene heart.

* This story of King George V's threatened abdication caused a furore in the London press and was officially denied. Ford, however, considered the denials unconvincing, and it is included here as an example of how he thought a king ought to behave.

PORTRAITS
AND
PERSONALITIES
II

PORTRAITS AND
PERSONALITIES II

THE OLD MAN

Henry James

I DARESAY, if we could only perceive it, life has a pattern. I don't mean that of birth, apogee and death, but a woven symbolism of its own. 'The Pattern in the Carpet,' Henry James called it—and that he saw something of the sort was no doubt the secret of his magic. But, though I walked with and listened to the Master day after day, I remember only one occasion on which he made a remark that was a revelation of his own aims and methods. That I will reserve until it falls in place in the pattern of my own immediate carpet. For the rest, our intercourse resolved itself into my listening silently and wondering unceasingly at his observation of the littlest things of life.

'Are you acquainted,' he would begin, as we strolled under the gateway down Winchelsea Hill towards Rye . . . Ellen Terry would wave a gracious hand from her garden above the old Tower, the leash of Maximilian would require several re-adjustments, and the dog himself a great many *sotto voce* admonitions as to his expensive habit of chasing sheep into dykes. 'Are you acquainted,' the Master would begin again, 'with the terrible words. . . .'

A higgler, driving a cart burdened with crates of live poultry, would pass us. The Master would drive the point of his cane into the road. 'Now *that* man!' he would exclaim. And he would break off to say what hideous, what

251

appalling, what bewildering, what engrossing affairs were going on all round us in the little white cottages and farms that we could see, dotting Playden Hill and the Marsh to the verge of the great horizon. 'Terrible things!' he would say. 'Appalling! ... Now that man who just passed us. ...' And then he would dig his stick into the road again and hurry forward, like the White Queen escaping from disaster, dropping over his shoulder the words: 'But that probably would not interest you. ...'

I don't know what he thought *would* interest me!

So he would finish his sentence before the door above the high steps of Lamb House:

'Are you acquainted with the terrible, the devastating words, if I may call them so, the fiat of Doom: "I don't know if you know, sir"? As when the housemaid comes into your bedroom in the morning and says: "I don't know if you know, sir, that the bath has fallen through the kitchen ceiling." '

It was held in Rye that he practised black magic behind the high walls of Lamb House. ...

Exactly what may have been his intimate conviction as to, say, what should be the proper relation of the sexes, I don't profess to know. That he demanded from the more fortunate characters in his books a certain urbanity of behaviour as long as that behaviour took place in the public eye, his books are there to prove. That either Mr Beale Farange or Mrs Beale committed in the circumambience of *What Maisie Knew* one or more adulteries must be obvious, since they obtained divorces in England. But the fact never came into the foreground of the book. And that he had a personal horror of letting his more august friends come into contact through him with anyone who might be even remotely suspected of marital irregularities, I know from the odd, seasonal nature of my relations with him. We met during the winters almost every day, but during the summers only by, usually telegraphed, appointment. This was because during the summer Mr James's garden overflowed with the titled, the

distinguished, the eminent in the diplomatic world...
with all his *milieu*.

Occasionally, even during the summer, he would send
from Rye to Winchelsea, a distance of two miles, tele-
grams such as the following which I transcribe:

> To Ford Madox Hueffer, Esq.,
> The Bungalow, Winchelsea, near Rye, Sussex.
> May I bring four American ladies, of whom
> one a priest, to tea to-day?
> Yours sincerely, Henry James.

And he would come.

But once he had got it well fixed into his head that I
was a journalist, he conceived the idea that all my friends
must be illegally united with members of the opposite sex.
So it was inconceivable that my summer friends should
have any chance to penetrate onto his wonderfully
kept lawns. I do not think that I knew any journalists at
all in those days, and I am perfectly certain that, with
one very eminent exception, I did not know anyone who
had been so much as a plaintiff in the shadow of the
divorce-courts. I was in the mood to be an English country
gentleman and, for the time being, I was.... It happened,
however, that the extraordinarily respectable wives of two
eminent editors were one week-end during a certain sum-
mer staying in Winchelsea—which was a well-known
tourist resort—and they took it into their heads to go and
call on James at Rye.

I had hardly so much as a bowing acquaintance with
them. But the next day, happening to go into Rye, I met
the Old Man down by the harbour. Just at the point
where we met was a coal-yard whose proprietor had the
same name as one of the husbands of one of those ladies.
James stopped short and with a face working with fury
pointed his stick at the coalman's name above the gate
and brought out the exasperated words:

'A couple of jaded... WANTONS!...' and, realizing
that I was fairly quick on the uptake, nothing whatever

more. . . . But, as soon as the leaves fell, there he was back on my door-step, asking innumerable advices—as to his investments, as to what would cure the parasites of a dog, as to brands of cigars, as to where to procure cordwood, as to the effects of the Corn Laws on the landed gentry of England. . . . And I would accompany him, after he had had a cup of tea, back to his Ancient Town; and next day I would go over and drink a cup of tea with him and wait whilst he finished dictating one of his sentences to his amanuensis and then he would walk back with me to Winchelsea. . . . In that way we each got a four-mile walk a day. . . .

But it was, as I have said, an almost purely non-literary intimacy. I could, I think, put down on one page all that he ever said to me of books—and, although I used, out of respect, to send him an occasional book of my own on publication, and he an occasional book of his to me, he never said a word to me about my writings, and I do not remember ever having done more than thank him in letters for his volume of the moment. I remember his saying of *Romance* that it was an immense English plum-cake which he kept at his bedside for a fortnight and of which he ate a nightly slice.

He would, if he never talked of books, frequently talk of the personalities of their writers—not infrequently in terms of shuddering at their social excess, much as he shuddered at contact with Crane. He expressed intense dislike for Flaubert, who 'opened his own door in his dressing-gown,' and he related, not infrequently, unrepeatable stories of the ménages of Maupassant—but he much preferred Maupassant to 'poor dear old Flaubert.' Of Turgenev's appearance, personality and habits, he would talk with great tenderness of expression; he called him nearly always 'the beautiful Russian genius,' and would tell stories of Turgenev's charming attention to his peasant mistresses. He liked, in fact, persons who were suave when you met them—and I daresay that his preference of that sort coloured his literary tastes. He

preferred Maupassant to Flaubert because Maupassant was
homme du monde—or at any rate had *femmes du monde*
for his mistresses—and he preferred Turgenev to either
because Turgenev was a quiet aristocrat and an invalid of
the German bathing towns to the finger-tips. And he
liked—he used to say so—people who treated him with
proper respect.

Flaubert he hated with a lasting, deep rancour. Flau-
bert had once abused him unmercifully—over a point in
the style of Prosper Mérimée, of all people in the world.
You may read about it in the *Correspondence* of Flau-
bert, and James himself referred to the occasion several
times. It seemed to make it all the worse that, just before
the outbreak, Flaubert should have opened the front door
of his flat to Turgenev and James, in his dressing-gown.

Flaubert was in short the sort of untidy colossus whom
I might, if I had the chance, receive at Winchelsea, but
who would never, never have been received on the sum-
mer lawns of Lamb House at Rye.

And suddenly Mr James exclaimed, just at the dog-leg
bend in the road between the two Ancient Towns:

'But Maupassant!!!! . . .' On the Rye Road, Maupas-
sant was for him the really prodigious, prodigal, munifi-
cent, magnificently rewarded Happy Prince of the
Kingdom of Letters. He had yachts, villas on the Medi-
terranean, 'affairs,' mistresses, wardrobes of the most gor-
geous, grooms, the entrée into the historic salons of Paris,
furnishings, overflowing bank-balances . . . everything that
the heart of man could require even to the perfectly
authentic *de* to ally him to the nobility and a public that
was commensurate with the ends of the earth. . . . And
then, as the topstone of that edifice, Mr James recounted
that once, when Mr James had been invited to lunch
with him, Maupassant had received him, not, to be as-
sured, in a dressing-gown, but in the society of a naked
lady wearing a mask. . . . And Maupassant assured the
author of *The Great Good Place* that the lady was a

femme du monde. And Mr James believed him.... Fortune could go no further than *that!* ...

Myself, I suppose he must have liked, because I treated him with deep respect, had a low voice—appeared, in short, a *jeune homme modeste.* Occasionally he would burst out at me with furious irritation, as if I had been a stupid nephew. This would be particularly the case if I ventured to have any opinions about the United States, which, at that date, I had visited much more lately than he had. I remember one occasion very vividly—the place, beside one of the patches of thorn on the Rye Road, and his aspect, the brown face with the dark eyes rolling in the whites, the compact, strong figure, the stick raised so as to be dug violently into the road. He had been talking two days before of the provincialism of Washington in the sixties. He said that when one descended the steps of the Capitol in those days *on trébuchait sur des vaches*— one stumbled over cows, as if on a village green. Two days later, I don't know why—I happened to return to the subject of the provincialism of Washington of the sixties. He stopped as if I had hit him and, with the coldly infuriated tone of a country squire whose patriotism had been outraged, exclaimed:

'Don't talk such *damnable* nonsense!' He really shouted these words with a male fury. And when, slightly outraged myself, I returned to the charge with his own *on trébuchait sur des vaches*, he exclaimed: 'I should not have thought you would have wanted to display such ignorance,' and hurried off along the road.

I do not suppose that this was as unreasonable a manifestation of patriotism as it appears. No doubt he imagined me incapable of distinguishing between material and cultural poverties and I am fairly sure that, at the bottom of his mind, lay the idea that in Washington of the sixties there had been some singularly good cosmopolitan and diplomatic conversation and society, whatever the cows might have done outside the Capitol. Indeed I know that towards the end of his life, he came to think that the

society of early, self-conscious New England, with its circumscribed horizon and want of exterior decoration or furnishings, was a spiritually finer thing than the mannered Europeanism that had so taken him to its bosom. As these years went on, more and more, with a sort of trepidation, he hovered round the idea of a return to the American scene. When I first knew him you could have imagined no oak more firmly planted in European soil. But, little by little, when he talked about America there would come into his tones a slight tremulousness that grew with the months. I remember once he went to see some friends—Mrs and Miss Lafarge, I think—off to New York from Tilbury Dock. He came back singularly excited, bringing out a great many unusually uncompleted sentences. He had gone over the liner: 'And once aboard the lugger . . . And if . . . Say a toothbrush . . . And circular notes . . . And something for the night. . . .' All this with a sort of diffident shamefacedness.

I fancy that his mannerisms, his involutions, whether in speech or in writing, were due to a settled conviction that, neither in his public nor in his acquaintance, would he ever find anyone who would not need talking down to. The desire of the artist, of the creative writer, is that his words and his 'scenes' shall suggest—of course with precision—far more than they actually express or project. But, having found that his limpidities, from *Daisy Miller* to *The Real Thing*, not only suggested less than he desired, but carried suggestions entirely unmeant, he gave up the attempt at Impressionism of that type—as if his audiences had tired him out. So he talked down to us, explaining and explaining, the ramifications of his mind. He was aiming at explicitness, never at obscurities—as if he were talking to children.

Because of that he could never let his phrases alone. . . . How often when waiting for him to go for a walk haven't I heard him say whilst dictating the finish of a phrase:

'No, no, Miss Dash . . . that is not clear. . . . Insert before "we all are" . . . Let me see. . . . Yes, insert "not so

much locally, though to be sure we're here; but temperamentally, in a manner of speaking." ' So that the phrase, blindingly clear to him by that time, when completed would run:

'So that here, not so much locally, though to be sure we're here, but at least temperamentally in a manner of speaking, we all are.'

No doubt the habit of dictating had something to do with these convolutions, and the truth of the matter is that during these later years he wrote far more for the ear of his amanuensis than for the eye of the eventual reader. So that, if you will try the experiment of reading him aloud and with expression, you will find his even latest pages relatively plain to understand. But, far more than that, the underlying factor in his later work was the endless determination to add more and more detail, so that the exact illusions and the exact facts of life may appear, and so that everything may be blindingly clear even to a little child.... For I have heard him explain with the same profusion of detail to Conrad's son of five why he wore a particular hat whose unusual shape had attracted the child's attention. He was determined to present to the world the real, right thing!

It has always seemed to me inscrutable that he should have been so frequently damned for his depicting only one phase of life; as if it were his fault that he was not also Conrad, to write of the sea, or Crane, to project the life of the New York slums. The Old Man knew consummately one form of life; to that he restricted himself. I have heard him talk with extreme exactness and insight of the life of the poor—at any rate of the agricultural poor, for I do not remember ever to have heard him discuss industrialism. But he knew that he did not know enough to treat of farm-labourers in his writing. So that, mostly, when he discoursed of these matters he put his observations in the form of questions: 'Didn't I agree to this?' 'Hadn't I found that?'

But indeed, although I have lived amongst agricultural

labourers a good deal at one time or another, I would cheerfully acknowledge that his knowledge—at any rate of their psychologies—had a great deal more insight than my own. He had such an extraordinary gift for observing minutiae—and a gift still more extraordinary for making people talk. I have heard the secretary of a golf club, a dour, silent man who never addressed five words to myself though I was one of his members, talk for twenty minutes to the Master about a new bunker that he was thinking of making at the fourteenth hole. And James had never touched a niblick in his life. It was the same with marketwomen, tram-conductors, ship-builders' labourers, auctioneers. I have stood by and heard them talk to him for hours. Indeed, I am fairly certain that he once had a murder confessed to him. And he needed to stand on extraordinarily firm ground before he would think that he knew a world. And what he knew he rendered, along with its amenities, its gentle-folkishness, its pettinesses, its hypocrisies, its make-believes. He gives you an immense —and an increasingly tragic—picture of a leisured society that is fairly unavailing, materialist, emasculated—and doomed. No one was more aware of all that than he.

Steevie used to rail at English literature, as being one immense, petty parlour game. Our books he used to say were written by men who never wanted to go out of drawing-rooms for people who wanted to live at perpetual tea-parties. Even our adventure-stories, colonial fictions and tales of the boundless prairie were conducted in that spirit. The criticism was just enough. It was possible that James never wanted to live outside tea-parties—but the tea-parties that he wanted were debating circles of a splendid aloofness, of an immense human sympathy, and of a beauty that you do not find in Putney—or in Passy!

It was his tragedy that no such five-o'clock ever sounded for him on the time-piece of this world. And that is no doubt the real tragedy of all of us—of all societies—that we never find in our Spanish Castle our ideal friends living in an assured and permanent Republic. Crane's

utopia, but not his literary method, was different. He gave
you the pattern in—and the reverse of—the carpet in
physical life, in wars, in slums, in western saloons, in a
world where the 'gun' was the final argument. The life
that Conrad gives you is somewhere half-way between
the two; it is dominated—but less dominated—by the
revolver than that of Stephen Crane, and dominated, but
less dominated, by the moral scruple than that of James.
But the approach to life is the same with all these three;
they show you that disillusionment is to be found alike
at the tea-table, in the slum and on the tented field. That
is of great service to our Republic.

It occurs to me that I have given a picture of Henry
James in which small personal unkindliness may appear to
sound too dominant a note. That is the misfortune of
wishing to point a particular moral. I will not say that
loveableness was the predominating feature of the Old
Man; he was too intent on his own particular aims to be
lavishly sentimental over surrounding humanity. And his
was not a character painted in the flat, in water-colour,
like the caricatures of Rowlandson. For some protective
reason or other, just as Shelley used to call himself the
atheist, he loved to appear in the character of a sort of
Mr Pickwick, with the rather superficial benevolences and
the mannerisms of which he was perfectly aware. But be-
low that protective mask was undoubtedly a plane of
nervous cruelty. I have heard him be—to simple and
quite unpretentious people—more diabolically blighting
than it was quite decent for a man to be, for he was
always an artist in expression. And it needed a certain
fortitude when, the studied benevolence and the chuck-
ling, savouring enjoyment of words, disappearing sud-
denly from his personality, his dark eyes rolled in their
whites and he spoke very brutal and direct English. He
chose in fact to appear as Henrietta Maria, but he could
be atrocious to those who behaved as if they took him at
that valuation.

And there was yet a third depth—a depth of religious,

of mystical, benevolence, such as you find just now and again in the stories that he 'wanted' to write—in *The Great Good Places*.... His practical benevolences were innumerable, astonishing—and indefatigable. To do a kindness when a sick cat or dog of the human race *had* 'got through' to his mind as needing assistance, he would exhibit all the extraordinary ingenuities that are displayed in his most involved sentences.

I have said that my relation with James was in no sense literary—and I never knew what it *was*. I am perfectly sure that I never in my life addressed to the Master one word of praise or of flattery and, as far as I know, he called me *le jeune homme modeste* and left it at that. He did indeed confess to having drawn my externals in Morton Densher of *The Wings of the Dove*—the longish, leanish, looseish, rather vague Englishman who, never seeming to have anything to do with his days, occupied in journalism his night hours.

I dare say he took me to be a journalist of a gentle disposition, too languid to interrupt him. Once, after I had sent him one of my volumes of poems, he just mentioned the name of the book, raised both hands over his head, let them slowly down again, made an extraordinary, quick grimace, and shook with an immense internal joke.... Shortly afterwards he began to poke fun at Swinburne.

In revenge, constantly and with every appearance of according weight to my opinions, though he seldom waited for an answer, he would consult me about practical matters—investments now and then, agreements once or twice—and, finally, unceasingly as to his fantastic domestic arrangements....

I was sitting one day in my study in Winchelsea when, from beside the window, on the little verandah, I heard a male voice, softened by the intervening wall, going on and on interminably ... with the effect of a long murmuring of bees. I had been lost in the search for one just word or other so that the gentle sound had only dreamily penetrated to my attention. When it did so penetrate and

after the monologue had gone on much, much longer, a
certain irritation took hold of me. Was I not the owner of
the establishment? Was I not supposed by long pondering
over just words and their subsequent transference to paper
to add at least to the credit, if not to the resources, of
that establishment? Was it not, therefore, understood that
chance visitors must *not* be entertained at the front door
which was just beside my window? . . . The sound, how-
ever, was not harsh or disagreeable and I stood it for
perhaps another ten minutes. But at last impatience over-
came me and I sprang to my door.

Silhouetted against the light at the end of the little pas-
sage were the figures of one of the housemaids and of Mr
Henry James. And Mr James was uttering the earth-
shaking question:

'Would you then advise me . . . for I know that such an
ornament decorates your master's establishment and you
will therefore from your particular level be able to illumi-
nate me as to the . . . ah . . . smooth functioning of such,
if I may use the expression, a wheel in the domestic time-
piece—always supposing that you will permit me the
image, meaning that, as I am sure in this household is the
case, the daily revolution of a really harmonious *chez soi*
is as smooth as the passing of shadows over a dial . . .
would you then advise me to have . . . in short to intro-
duce into *my* household and employ . . . a . . . that is to
say . . . a Lady Help?'

I advanced at that and, as the housemaid with a sigh of
relief disappeared amongst the rustling of her skirts, in
the strongest and firmest possible terms assured Mr James
that such an adornment of the household of an illustrious
and well-appointed bachelor was one that should very
certainly not be employed. He sighed. He appeared worn,
thin for him, dry-skinned, unspirited. His liquid and
marvellous dark eyes were dulled, the skin over his
aquiline nose was drawn tight. He was suffering from a
domestic upheaval—his household, that for a generation
had, indeed, revolved around him as quietly as the

shadows on a dial, with housekeeper, butler, upper house-maid, lower housemaid, tweeny maid, knife-boy, gar-dener, had suddenly erupted all round him so that for some time he had been forced to content himself with the services of the knife-boy.

That meant that he had to eat in the ancient hostelry, called The Mermaid, that stood beside his door. And, his housekeeper having for thirty years and more sent up, by the imposing if bottle-nosed butler who was her husband, all Mr James's meals without his ever having ordered a single one—being used to such a halcyon cuisine the Master had not the slightest idea of what foods agreed with him and which did not. So that everything disagreed with him and he had all the appearance of being really ill. . . . The cause of the bottle-nose had been also the oc-casion of the eruption, all the female servants having one day left in a body on account of the 'carryings-on' of the butler, and the butler himself, together, alas, with his ad-mirable wife, the housekeeper, having, twenty-four hours later, to be summarily and violently ejected by a sympa-thetic police-sergeant.

So the poor Master was not only infinitely worried about finding an appropriate asylum for the butler and his wife, but had had to spend long mornings and after-noons on what he called 'the benches of desolation in purgatorial, if I may allow myself the word, establish-ments, ill-named, since no one appeared there to register themselves . . . eminently ill-named: *registry-offices. . . .*' And there would be a sound like the hiss of a snake as he uttered the compound word. . . .

He would pass his time, he said, interviewing ladies all of a certain age, all of haughty—the French would say *renfrognée*—expressions, all of whom would unanimously assure him that, if they demeaned themselves merely by for an instant considering the idea of entering the house-hold of an untitled person like himself, in such a God-forsaken end of the world as the Ancient Town of Rye, they having passed their lives in the families of never

anyone less than a belted Earl in mansions on Constitution Hill in the shadow of Buckingham Palace ... if they for a fleeting moment toyed with the idea, it was merely, they begged to assure him ... 'forthegoodoftheirhealths'. Mr James having dallied with this sentence would utter the last words with extreme rapidity, raising his eyebrows and his cane in the air and digging the ferrule suddenly into the surface of the road....

How they come back to me after a quarter of a century ... the savoured, half-humorous, half-deprecatory words, the ironically exaggerated gestures, the workings of the closely shaved lips, the halting to emphasize a point, the sudden scurryings forward, for all the world like the White Rabbit hurrying to the Queen's tea-party ... along the Rye Road, through the marshes, from Winchelsea.... I walking beside him and hardly ever speaking, in the guise of God's strong, silent Englishman—which he took me really to be....

To give the romance, then, its happy ending.... One of the matrons of Rye had conceived the idea of lodging a dependent orphan niece in poor Mr James's house and so had recommended him to employ a Lady Help, offering to supply herself that domestic functionary. He had consulted as to the adviseability of this step all the doctors', lawyers', and parsons' wives of the neighbourhood, and in addition one of the local great ladies—I think it was Lady Maud Warrender. The commoners' ladies, loyal to the one who wanted to dispose of the dependent niece, had all said the idea was admirable. Her Ladyship was non-committal, going no further than to assure him that the great ladies of the neighbourhood would not refuse to come to tea with him in his garden—that being their, as well as his, favourite way of passing an afternoon— merely because he should shelter an unattached orphan beneath his roof. But she would go no further than that.

So, in his passion for getting, from every possible angle, light on every possible situation—including his own—he had walked over to Winchelsea to consult not only me,

but any female member of my household upon whom he should chance, and had kept the appalled and agitated housemaid for a full half hour on the doorstep whilst he consulted her as to the adviseability of the step he was contemplating.... But I soon put a stop to *that* idea. In practical matters Mr James did me the honour to pay exact attention to my opinions—I was for him the strong, silent man of affairs.

How long his agony lasted after that I cannot say. His perturbations were so agonizing to witness that it seemed to be a matter of years. And then, one day, he turned up with a faint adumbration of jauntiness. At last he had heard of a lady who gave some promise of being satisfactory.... The only shadow appeared to be the nature of her present employment.

'Guess,' he said, 'under whose august roof she is at the moment sheltering? ... *Je vous le donne en mille....*' He started back dramatically, rolling his fine eyes, and with great speed he exclaimed:

'The Poet Laureate ... no less a person!'

Now the Poet Laureate occupies in England a position that it is very difficult to explain on this side of the water. By his official situation he is something preposterous and eminent ... and at the same time he is something obsolescent, harmless and ridiculous. Southey, Tennyson and Doctor Bridges have commanded personally a certain respect, but I cannot think of anyone else who was anything else than ridiculous ... rendered ridiculous by his office. And at the time of which I am speaking the whole literary world felt outragedly that either Swinburne or Mr Kipling ought to have been the Laureate. As it was, the holder of the title was a Mr Alfred Austin, an obscure, amiable and harmless poetaster who wrote about manorhouses and gardens and lived in a very beautiful manorhouse in a very beautiful garden.

And, two days later Mr James turned up, radiant. He lifted both hands above his head and exclaimed:

'As the German Emperor is said to say about his

mostachio, '*it is accomplished*.' . . . Rejoice—as I am confident you will—with me, my young friend. All from now onwards shall, I am assured, be with me gas and gingerbread. . . . Halcyon, halcyon days. In short, ahem. . . .' And he tapped himself lightly on the breast and assumed the air of a traveller returned from the wintry seas. 'I went,' he continued, 'to the house of the Poet Laureate . . . to the back door of course . . . and interviewed a Lady who, except for one trifling—let us not say defect but let us express it "let or hindrance" to what I will permit myself to call the perfect union, the continuing *lune de miel* . . . except for that, then, she appeared the perfect, the incredible, the except for the pure-in-heart, unattainable She. . . . But upon delicate enquiry . . . oh, I assure you, enquiry of the *most* delicate . . . for the obstacle was no less than that on reckoning up the tale of her previous "situations". . . as twenty years with the Earl of Breadalbane, thirty years with Sir Ponsonby Peregrine Perowne, forty with the Right Honourable the Lord Bishop of Tintagel and Camelot . . . on reckoning up the incredible tale of years it appeared that she must be of the combined ages of Methuselah and the insupportable Mariner —not of your friend Conrad, but of the author of *Kubla Khan*. But upon investigation it appeared that this paragon and phoenix actually was and in consequence will, to the end of recorded time, remain, exactly the same age as'. . . and he took three precise, jaunty steps to the rear, laid his hand over his heart and made a quick bow . . .'*myself*. . . .'

'And,' he resumed, 'an upper housemaid and her sister, the under housemaid, who had left me in circumstances that I was unable to fathom but that to-day are only too woefully apparent to me, having offered to return and to provide a what they call twenty of their own choosing . . . all shall for the future be as I have already adumbrated, not only gas and gingerbread, but cloves and clothespegs and beatitude and bliss and beauty. . . .' And so it proved.

One day, going, as we seemed eternally in those days to be doing, down Winchelsea Hill under the Strand Gate, he said:

'H...you seem worried!' I said that I was worried. I don't know how he knew. But he knew everything.

Ellen Terry waved her gracious hand from the old garden above the tower; the collar of Maximilian the dachshund called for adjustment. He began another interminable, refining sentence—about housemaids and their locutions. It lasted us to the bridge at the western foot of Rye.

In Rye High Street he exclaimed—he was extraordinarily flustered:

'I perceive a compatriot. Let us go into this shop!' And he bolted into a fruiterer's. He came out holding an orange and, eventually, throwing it into the air in an ecstasy of nervousness and stuttering like a schoolboy:

'If it's money, H...' he brought out. '*Mon sac n'est pas grand.... Mais puisez dans mon sac!*'

I explained that it was not about money that I was worried, but about the 'form' of a book I was writing. His mute agony was a painful thing to see. He became much more appalled, but much less nervous. At last he made the great sacrifice:

'Well, then,' he said, 'I'm supposed to be.... Um, um.... There's Mary.... Mrs Ward.... Does me the honour.... I'm supposed to know.... In short, why not let me look at the manuscript!'

I had the decency not to take up his time with it.... *Les beaux jours quand on était bien modeste!* And how much I regret that I did not.

The last time I saw him was, accidentally, in August of 1915—on the fourteenth of that month, in St James's Park. He said:

'*Tu vas te battre pour le sol sacré de Mme. de Staël!*'

I suppose it was characteristic that he should say 'de Mme. de Staël'—and not of Stendhal, or even of George Sand. He added—and how sincerely and with what

passion—putting one hand on his chest and just bowing, that he loved and had loved France as he had never loved a woman!

I have said that I remember only one occasion on which Henry James spoke of his own work. That was like this: He had published *The Sacred Fount*, and was walking along beside the little shipyard at the foot of Rye Hill. Suddenly he said:

'You understand ... I *wanted* to write *The Great Good Place* and *The Altar of the Dead*.... These are things one wants to write all one's life, but one's artist's conscience prevents one.... And then ... perhaps one allows oneself...'.

I don't know what he meant.... Or I do! For there *are* things one wants to write all one's life—only one's artist's conscience prevents one. That is the first—or the final, bitter—lesson that the artist has to learn: that he is not a man to be swayed by the hopes, fears, consummations or despairs of a man. He is a sensitized instrument, recording to the measure of the light vouchsafed him what is—what *may* be—the truth.

COLLABORATING WITH
CONRAD

Conrad came round the corner of the house. I was doing something at the open fire-place in the house-end. He was in advance of Mr Garnett, who had gone inside, I suppose, to find me. Conrad stood looking at the view. His hands were in the pockets of his reefer-coat, the thumbs sticking out. His black torpedo beard pointed at the horizon. He placed a monocle in his eye. Then he caught sight of me.

I was very untidy in my working clothes. He started back a little. I said 'I'm Hueffer.' He had taken me for the gardener.

His whole being melted together in enormous politeness. His spine inclined forward; he extended both hands to take mine. He said:

'My dear faller. . . . Delighted. . . . *Ench . . . anté.*' He added: '*What* conditions to work in. . . . Your admirable cottage. . . . Your adorable view. . . .'

It was symbolic that the first remark he should make to me should be about conditions in which to work. Poor fellow! Work was at once his passion and his agony, and no one, till the very end of his life, had much worse conditions. On the last time I saw him, a few weeks before his death, he said to me:

'You see, I have at last now got a real study of my own. I can work here uninterrupted.' He was to do so little more!

He was staying at the moment of that visit up on the Chart, to be near Mr Garnett. He had been living in the rather lugubrious village of Stamford-le-Hope, on the estuary of the Thames, amongst the Essex marshes. His poverty was like a physical pain, but his reputation as a writer was already enormously high. A week after the

publication of his first book, he stood absolutely in the front rank of English authors, yet the great public was extraordinarily slow to hear of him. I suppose it did not really do so till the publication of *Chance*, fifteen years after that date. And they were fifteen years of agonized labours and the most fell anxieties, the most desperate expedients. The highest note of his life was his passion for his work, the most dominant one that of being assured of having provided for his family. His tastes were of the least expensive. He was as happy playing dominoes in a city Mecca—a coffee-house—over a cup of coffee as in any other situation in the world. He would place on the marble table-top the winning domino of a series, his whole face lighting up with animation and triumph. Yet, since I never won one of innumerable games that I played with him, the triumph could only in the beginning have had any novelty for him.

In those early days he still had a great deal of the master mariner about him. His characteristic attitude was that, with his hands in the pockets of his coat and his beard pointing at the horizon. There was something masterly about him. . . .

He was small rather than large in height; very broad in the shoulder and long in the arm; dark in complexion with black hair and a clipped black beard. He had the gestures of a Frenchman who shrugs his shoulders frequently. When you had really secured his attention he would insert a monocle into his right eye and scrutinize your face from very near as a watch-maker looks into the works of a watch. He entered a room with his head held high, rather stiffly and with a haughty manner, moving his head once semicircularly. In this one movement he had expressed to himself the room and its contents; his haughtiness was due to his determination to master that room, not to dominate its occupants, his chief passion being the realization of aspects to himself. . . .

It is to be remembered that he was Polish of very

aristocratic ancestry. That was what gave a particular agony to his anxieties for his family's welfare. He sat almost in rags and groaned with the fear that his pen would not be able to provide for his children and grand-children, great mansions to withstand the snow, elabo-rately ornamented sleighs, blood horses, innumerable retainers and halls opening out, the one into the other, beyond the eyesight. I never heard him lament the short-age of the present. He was happy with, and even proud of, the few poor things that he had. The old mare that he drove, Nancy, had such long ears that she had the air of a mule, but for him she was the most engaging of beasts with the most enlivening characteristics and the speed of a Rolls-Royce amongst quadrupeds. His old harness and his old cart were of the noblest pedigree of such things. He never knew that he was shabby. If he had two odd gloves they would have been manufactured by the best maker Bond Street could shew. But for his son the future must hold a Rolls-Royce all of silver and clothes all from Poole, who made for Edward VII.

But indeed he wore his old clothes with the air of a Prince and when he was behind Nancy you thought her the horse of the Cid; he so dominated all views. He had a singularly nice taste in cooking, and in that respect fate was good to him. In the direst times of his poverty, he yet had a table that was better than almost anybody's I have ever known. For with care, two eggs, a little butter, some pot-herbs and a few scraps you may eat as did Brillat-Savarin, and Conrad had a devoted family.

Except for his unexpected, queer, rather stiff appear-ance, his sudden melting into oriental mannerisms, and the fact that his first speech was about conditions of work, I do not remember much more of that first visit of a man with whom I was destined to become extremely intimate and whose memory remains the most treasured of my possessions. I remember mostly his smile of satis-faction and enchantment at his son and my daughter as they climbed determinedly on all fours and wrestled like

eighteenth-century cherubs on the sloping grass of Mr Garnett's property, which was called the *Cearne*. I must have told him that I was writing a novel about Cuban pirates. But I did not see him again during his visit to Limpsfield and he went away back to Stamford-le-Hope and its marshes.

That autumn I had a letter from Conrad asking that he might be allowed to collaborate with me in the novel about pirates. . . .

There descended across the dusty wall a curtain of moonlight thrown across by the black shadows of oak-trees. We were on a verandah that had a glass roof. Under the glass roof climbed passion-flowers, and vine-tendrils strangled them. We were sitting in deck-chairs. It was one o'clock in the morning. Conrad was standing in front of us, talking. Talking on and on, in the patches of moonlight and patches of shadow from the passion-flowers and vines! The little town in which we were dominated the English Channel from a low hill-top. He was wearing a dark reefer-coat and white trousers.

He was talking of Malaysia, palm-trees, the little wives of rajahs in coloured sarongs—or perhaps not sarongs?—crouched round him on the ground; he himself cross-legged on the ground teaching the little wives of rajahs to use sewing machines! Moored to a rotting quay—as it might have been Palembang, but of course it was not Palembang—was his schooner. His schooner had in its hold half a cargo of rifles under half a cargo of sewing machines. The rajahs, husbands of the little wives, did not like their Dutch suzerains and in that country the War had lasted not five but three hundred and fifty-five years. . . .

That then was Conrad on the occasions when he talked as he did on the first evening after dinner. His voice was then usually low, rather intimate and caressing. He began by speaking slowly, but later on he spoke very fast. His accent was precise, rather dusky, the accent of dark

rather than fair races. He impressed me at first as a pure Marseilles Frenchman; he spoke English with great fluency and distinction, with correctitude in his syntax, his words absolutely exact as to meaning but his accentuation so faulty that he was at times difficult to understand and his use of adverbs as often as not eccentric. He used 'shall' and 'will' very arbitrarily. He gesticulated with his hands and shoulders when he wished to be emphatic, but when he forgot himself in the excitement of talking he gesticulated with his whole body, throwing himself about in his chair, moving his chair nearer to yours. Finally he would spring up, go to a distance and walk back and forth across the end of the room. When I talked he was a very good listener, sitting rather curled up whilst I walked unceasingly back and forth along the patterned border of the carpet.

We talked like that from about ten, when the ladies had gone to bed, until half past two in the morning. We talked about Flaubert and Maupassant—sounding each other, really. Conrad was still then inclined to have a feeling for Daudet—for such books as *Jack*. This I contemned with the sort of air of the superior person who tells you that *Hermitage* is no longer a wine for a gentleman. We talked of Turgenev—the greatest of all poets; 'Byelshin Prairie' from the *Letters of a Sportsman*, the greatest of all pieces of writing; Turgenev wrapped in a cloak lying on the prairie at night, at a little distance from a great fire, beside which the boy horse-tenders talked desultorily about the roosalki of the forests with the green hair and water-nymphs that drag you down to drown in the river.

We agreed that a poem was not that which was written in verse but that, either prose or verse, that had constructive beauty. We agreed that the writing of novels was the one thing of importance that remained to the world and that what the novel needed was the New Form. We confessed that each of us desired one day to write Absolute Prose.... But that which really brought us

together was a devotion to Flaubert and Maupassant. We discovered that we both had *Félicité*, *St. Julien L'Hospitalier*, immense passages of *Madame Bovary*, *La Nuit*, *Ce Cochon de Morin* and immense passages of *Une Vie* by heart. Or so nearly by heart that what the one faltered over the other could take up. . . .

Before we went to bed Conrad confessed that previous to suggesting a collaboration he had consulted a number of men of letters as to its advisability. He said that he had put before them his difficulties with the language, the slowness with which he wrote and the increased fluency that he might acquire in the process of going minutely into words with an acknowledged master of English. The only one that Conrad mentioned was W. E. Henley. He stated succinctly and carefully that he had said to Henley—Henley had published *The Nigger of the Narcissus* in his *Review*—'Look here. I write with such difficulty; my intimate, automatic, less expressed thoughts are in Polish; when I express myself with care I do it in French. When I write I think in French and then translate the words of my thoughts into English. This is an impossible process for one desiring to make a living by writing in the English language. . . .' And Henley, according to Conrad on that evening, had said, 'Why don't you ask H—— to collaborate with you. He is the finest stylist in the English language of to-day. . . .' The writer, it should be remembered, though by ten or fifteen years the junior of Conrad was by some years his senior, at any rate as a published author, and was rather the more successful of the two as far as sales went.

Henley obviously had said nothing of the sort. Indeed, on the occasion of a verbal duel that I had later with Henley, that violent-mouthed personality remarked to me, 'Who the hell are you? I never even heard your name!' or words to that effect. It probably does not very much matter. What had no doubt happened was that Conrad had mentioned the writer's name to Henley and Henley had answered, 'I dare say he'll do as well as any

one else.' No, it probably does not matter, except as a light on the character and methods of Conrad, and as to his ability to get his own way.... Conrad liked to please as much as Henley liked to knock the nonsense out of you.

When we had finally decided on collaborating on *Romance*, he insisted on driving the seven miles that separated the Pent from Spade House in order to break the news to Mr H. G. Wells. I suppose he regarded Mr Wells as the doyen of the younger school of writers. Certainly Mr Wells had written of *Almayer's Folly* with extraordinary generosity. Anyhow, to my discomfort we drove in state in a hired fly from the Pent to pay a call on Mr Wells at Sandgate. There was a curious incident. As we stood on the door-step of Mr Wells's villa, in the hesitant mind of those paying a state call, behold, the electric bell-push, all of itself, went in and the bell sounded.... Conrad exclaimed, '*Tiens!* ... The Invisible Man!' and burst into incredible and incredulous laughter.[*] In the midst of it the door opened before grave faces.

We paid our call. Whether we were taken to be drunk or no only the owners of those grave faces can say. I suppose that we were. But the incident of the bell-push was of a nature that had a peculiar appeal to Conrad's humour. For years after, a translation of Mr Wells's book having appeared in Italian, you could never mention that author's name without Conrad saying, '*Tiens!* ... *L'Uomo Invisible!*'...

Conrad had odd, formal notions of how one should proceed in the life literary. As far as he was concerned the purpose of our call on Mr Wells was to announce to the world of letters that we were engaged in collaboration. To the writer this was just exactly a matter of indifference except for a not materially pronounced disinclination to pay calls anywhere or at any time. But Conrad liked proceedings of a State nature. He would have liked the

[*] H. G. Wells's novel of that title had appeared in 1897, the year before the formal announcement of the Ford-Conrad collaboration.

driving in a barouche to pay calls on Academicians such as is practised by candidates for membership of the French Academy. And exceedingly vivid in my mind is the feeling I had, as we drove down the sloping railway bridge above Sandling Junction. I was like a brown paper parcel on a seat beside a functionary in a green uniform, decorated with golden palm-leaves and a feathered cocked hat....

Of what happened at that villa in the lower Sandgate Road, except that the back garden had, descending to the sea-beach, a step-ladder up and down which several charming creatures were disporting themselves with the Channel as background, I carry in my memory now only the conversation of Bob Stevenson* and the remembrance of Conrad, talking to Mrs Wells with enormous animation about the great storm in which for the first time he came up the Channel, passing that point. I was engaged in remembering that great storm. I had been at school at Folkestone on the cliff almost perpendicularly above where we then sat. In the morning after the gale had blown itself out we looked down in sunlight from the edge of the Leas. The whole sickle of Dungeness Bay had a fleet ashore on its beaches—innumerable smacks and coasting vessels, large international sailing ships and two East Indiamen, the *Plassy* and the *Clive*, with their towering black and white sides, all heeling over, rigging and canvas hanging down like curtains right round the bay, unforgettable and helpless.... Bob Stevenson was engaged in telling me with animation almost equal to that of Conrad that Ford Madox Brown could not paint. I was wishing myself with the group round Conrad and Mrs Wells. The crossing of the voices of those two brilliant conversationalists remains still in my ears, and the odd mixture of feelings....

On the next day Mr Wells bicycled up to Aldington Knoll, where at about seven miles distant from the Pent

* R. A. M. Stevenson, the art critic, cousin of Robert Louis Stevenson.

I was once again leading an agricultural life of the severer type—in a cottage of the most minute, the Conrads occupying the Pent. I was, indeed, engaging myself on the invention of a new species of potato.... Mr Wells came to persuade me not to collaborate with Conrad. With an extreme earnestness he pleaded with me not to spoil Conrad's style. 'The wonderful oriental style.... It's as delicate as clockwork and you'll only ruin it by sticking your fingers in it.' I answered that Conrad wanted a collaboration and as far as I was concerned Conrad was going to get what he wanted. I can still see the dispirited action of Mr Wells as he mounted his bicycle by the rear step and rode away along that ridge of little hills.... Not more than those two speeches had been exchanged.

I may as well dispose, once and for all, of the legend that I had any part in teaching Conrad English, though, on the face of it, it may well look plausible enough since he was a foreigner who never till the end of his life spoke English other than as a foreigner. But when it came to writing, it was at once quite a different matter. As I said elsewhere a little time ago, the moment he got a pen in his hand and had no eye to publication, Conrad could write English with a speed, a volubility and a banal correctness that used to amaze me. So you have his immense volume of letters. On the other hand, when, as it were, he was going before the public, a species of stage-fright would almost completely paralyse him so that his constructions were frequently very un-English.

In his letters, that is to say, he just let himself go without precision of phrase as without *arrière-pensée*, pouring out supplications, abuse of third parties, eternal and unvarying complaints, so that in the end the impression is left of a weak, rather whining personality. But no impression could be more false. Conrad was a man, a He-man if you like, who fought against enormous odds with undying—with almost unfaltering—courage. And his courage was all the more impressive in that by birth,

race and temperament he was an unshakable pessimist. Life for him was predestined to end tragically, or, if not, in banality; literature was foredoomed to failure. These were his *choses données*, his only certain truths. In face of that creed, his struggles were unceasing.

And it was astonishing what small things could call down to his underlying buoyancy. I remember once we had been struggling with *Romance* for hours and hours, and he had been in complete despair and everything that I had suggested had called forth his bitterest gibes, and he was sick, and over ears in debt, and penniless. And we had come to a blank full-stop—one of those intervals when the soul *must* pause to breathe, and love itself have rest. And Mrs Conrad came in and said that the mare had trotted from Postling Vents to Sandling in five minutes—say, twelve miles an hour! At once, there in the room was Conrad-Jack-ashore! The world was splendid; hope nodded from every rosebud that looked over the window-sill of the low room. We were going to get a car and go to Canterbury; the mare should have a brand new breeching strap. And in an incredibly short space of time—say, three hours—at least half a page of *Romance* got itself written.

That was how it went, day in day out, for years—the despair, the lamentations continuing for hours and then the sudden desperate attack on the work—the attack that would become the fabulous engrossment. We would write for whole days, for half nights, for half the day, or all the night. We would jot down passages on scraps of paper or on the margins of books, handing them one to the other or exchanging them. We would roar with laughter over passages that would have struck no other soul as humorous; Conrad would howl with rage and I would almost sigh over others that no other soul perhaps would have found as bad as we considered them. We would recoil one from the other and go each to our own cottage—our cottages at that period never being further the one from the other than an old mare could take us in

an afternoon. In those cottages we would prepare other drafts and so drive backwards and forwards with packages of manuscript under the dog-cart seats. We drove in the heat of summer, through the deluges of autumn, with the winter snows blinding our eyes—always, always with manuscripts. Heavens, don't my fingers still tingle with the feeling of undoing the stiff buckles, long past midnight, of a horse streaming with rain—and the rubbing down in the stable and the backing the cart into the coach-house. And with always at the back of the mind, the consideration of some unfinished passage, the puzzledom to avoid some too-used phrase that yet seemed hypnotically inevitable.

There was an occasion when the whole of the manuscript of the last instalment of *The End of the Tether* for *Blackwood's* was burnt shortly before it was due for publication. That sounds a small thing. But the instalments of *Blackwood's* are pretty long and the idea of letting *Maga* miss an instalment appalled: it was the almost unthinkable crime.... The manuscript had been lying on the round, Madox Brown table, under a paraffin-lamp with a glass reservoir, no doubt also an 1840 contrivance; the reservoir had burst.... For a day or so it was like a funeral; then for moral support or because his writing-room was burnt out, Conrad drove over to Winchelsea, to which Ancient Town the writer had removed. Then you should have seen Romance! It became a matter of days; then of hours. Conrad wrote; I corrected the manuscript behind him or wrote in a sentence—I in my study on the street, Conrad in a two-roomed cottage that we had hired immediately opposite. The household sat up all night keeping soups warm. In the middle of the night Conrad would open his window and shout. 'For heaven's sake give me something for *sale pochard*; it's been holding me up for an hour.' I called back, 'Confounded swilling pig!' across the dead-still, grass-grown street.

Telegrams went back and forth between ancient

Winchelsea and the ancient house of Blackwood in Edinburgh. So ancient was that house that it was said to send its proofs from London to Edinburgh and back by horse-messenger. We started the manuscript like that. Our telegrams would ask what was the latest day, the latest hour, the latest half minute that would do if *The End of the Tether* was to catch the presses. *Blackwood's* answered, at first Wednesday morning, then Thursday. Then Friday night would be just possible.... At two in the morning the mare—another mare by then—was saddled by the writer and the stable-boy. The stable-boy was to ride to the junction with the manuscript and catch the six-in-the-morning mail-train. The soup kept hot; the writers wrote. By three I had done all that I could in my room. I went across the road to where Conrad was still at it. Conrad said, 'For God's sake.... Another half-hour; just finishing....' At four I looked over Conrad's shoulder. He was writing, 'The blow had come, softened by the spaces of the earth, by the years of absence,' I said, 'You must finish now.' To Ashford Junction was eighteen miles. Conrad muttered, 'Just two paragraphs more.' He wrote, 'There had been whole days when she had not thought of him at all—had no time.' I said, 'You absolutely must stop!' Conrad wrote on, 'But she loved him, she felt that she loved him after all,' and muttered, 'Two paragraphs....' I shouted—it had come to me as an inspiration—'In the name of God, don't you know you can write those two paragraphs into the proofs when you get them back?...'

The occupation of writing to such a nature as Conrad's is terrible engrossing. To be suddenly disturbed is apt to cause a second's real madness.... We were once going up to town in order to take some proofs to a publisher, and half-way between Sandling and Charing Cross Conrad remembered some phrase that he had forgotten to attend to in the proofs. He tried to correct them with a pencil, but the train jolted so badly that writing, sitting on a seat, was impossible. Conrad got down on the floor

of the carriage and lying on his stomach went on writing. Naturally when the one phrase was corrected twenty other necessities for correction stuck out of the page. We were alone in the carriage. The train passed Paddock Wood, passed Orpington, rushed through the suburbs. I said, 'We're getting into town!' Conrad never moved except to write. The house-roofs of London whirled in perspective round us; the shadow of Cannon Street Station was over us. Conrad wrote. The final shadow of Charing Cross was over us. It must have been very difficult to see down there. He never moved. . . . Mildly shocked at the idea that a porter might open the carriage door and think us peculiar, I touched Conrad on the shoulder and said, 'We're there!' Conrad's face was most extraordinary— suffused and madly vicious. He sprang to his feet and straight at my throat. . . .

Romance was published in 1903, and shortly afterwards Conrad and I determined to 'shew ourselves'—that was Conrad's phrase—in London. The move to London was for me the beginning of a series of disasters. That was perhaps because the year was 1903. Those digits added up to thirteen. No one should have done anything in that year. Or it was perhaps because the house I than took was accursed. It was a monstrous sepulchre—and not even whitened. It was grey with the greyness of withered bones. It was triangular in ground plan; the face formed the nose of a blunted sedan, the body tapered to a wedge in which there was a staircase like the corkscrew staircases of the Middle Ages. The façade was thus monstrous, the tail ignoble. It was seven stories in height and in those days elevators in private houses were unknown. It was what housemaids call 'a murderer.'

The happenings in that house come back to me as gruesome and bizarre. I daresay they were mere episodes in the chain of disasters, suicides, bankruptcies and despairs that visited its successive tenants and owners. My first party was distinguished by Conrad's attack on

the unfortunate Mr Charles Lewis Hind. This violent encounter took place in a circle of half-gay, half-morose celebrities. Mr James had brought Mrs Humphry Ward; Mrs Clifford, who could be as awful as Mrs Ward, had brought some mild and decorous young American—I should think it was Mr Owen Wister. Mr Watts-Dunton had brought a message from Swinburne, blessing me because he had known me as a baby. This Mr Watts-Dunton repeated *à tort et à travers* at the oddest and most inconvenient moments. He was deaf and accustomed to speaking to Swinburne, who was deafer. I found myself again and again distracted by his rather snuffling, elevated voice exclaiming:

'Swinburne said in excusing himself for not attending this party of our gifted young host. . . .'

He was a little dark man with an immense waterfall of grey moustache. Finally he settled himself—I think on the always patient Mr Galsworthy—and repeated over and over again the message with which he was charged. Then I was aware that Conrad had hold of Lewis Hind's tie and was dragging him towards the door that gave onto the corkscrew staircase. If he had thrown Hind down it, the poor man would have been killed. I managed to separate them but I haven't forgotten and don't suppose I ever shall forget the look of polite incredulity of the more august guests. Mrs Humphry Ward looked like a disgusted sheep. Mrs Clifford, who loved the society of reviewers, was openly distressed at the disappearance of Mr Hind. Mr Hind was the editor of the *Academy*. The *Academy* was a rather livelier *Athenaeum*. A great lady of the Court of His Majesty put her lorgnettes up to her proud nose and weary eyes and exclaimed to me afterwards:

'Haw! Very interesting. But awkward for you. I suppose all literary parties are like that.'

She added:

'I wonder you give 'em. I shouldn't. I once gave one

but it did not work. Yet one tries to encourage ... ah ... these things!'

The Court in those days had to be interested in literature because Edward VII wanted to be told about books. I know this because I had at that date a secretary who was very highly connected. Her name was Smith and she was the daughter of a very famous soldier. She was one day sitting with the beautiful Lady Londonderry, who was her cousin. Lady Londonderry was dying of a painful disease, but lay on a sofa. The King came in. Miss Smith was the shyest human being I have ever known. She desired to sink into the ground and made for the door. Lady Londonderry told her to stay and pour tea for them and presented her as

'Miss Smith, the daughter of the famous soldier.' The King said:

'Smith ... ah, we all know *that* name.' Royal politenesses must exact a certain lack of the sense of humour.

I was once presented to the President of a Great Republic. He said he was delighted to see me and would never forget a certain passage in one of my books. He recited the passage. But the book was lying on the table behind him; with, in it, a slip inscribed in the handwriting of the friend who had introduced me: 'Try here!' They manage these things better in France. At any rate, during the War I was sent for from the line by M. Delcassé, then Minister for Foreign Affairs. He showed a remarkable knowledge of a book of propaganda I had written for his Government. He even suggested alterations in certain passages. And the book was not to be seen even in his bookshelves. ...

Well, the King asked Lady Londonderry if he might touch the bell and ask the footman for some very dry toast, as he was banting. Miss Smith poured tea. As she was finally escaping, the King said:

'Miss Smith, Lady Londonderry tells me you are interested in literature. I like books. I like boys' books. ... Captain Marryat now. I have read all Captain Marryat. But I find it very difficult to get books like that.'

He said that he had asked all the Court but no one could tell him of books like that. He added:

'If in the course of your researches at the British Museum, Miss Smith, you should come across any such books, I should be very much obliged if you would jot their names down on a postcard and send it to me, at Buckingham Palace.'

Miss Smith said it seemed to her curious that he should think she did not know his address.

Alas: she found no books like Marryat's. All the horses and all the men of all the dozen sovereigns between the days of Shakespeare and our Roi Bonhomme had not sufficed to produce a second—nor all the wishes of Edward VII. It put him in the good books of Conrad at least, for Conrad considered Marryat to be the greatest English novelist since Shakespeare and always declared that it was reading *Peter Simple* and *Midshipman Easy* that made him wish to go to sea.

It is curious—and sad!—to think that but for his altercation in my drawing-room Conrad might possibly have become Edward VII's favourite writer. I was quite seriously given to understand later that he was then under the observation of the wife of the King's mentor. But apparently the works of a writer so inconsiderate as to make a fuss in a drawing-room might be considered to be bad for a King who was thinking out an Entente Cordiale. It would have made all the difference in the world to the poor fellow. He might have had fifteen years or so of comparative ease. For the literary examples of royalty in England are followed with extraordinary keenness by the King's lieges and they have a contagious effect on the United States. As it was, a little before his death, Conrad wrote to me that he had not made any money by his pen for nearly two years. He lived on royalties from his earlier books. . . .

It was one of those years when influenza—it was then called the Russian influenza—struck London as if with an immense hailstorm. That house, as if because it stood

on a hill-top looking over a great part of the city, it struck as if with iron bullets. Member after member of my family went down, then the children's governess, then one by one of the servants except the cook, then the temporary servants and charwomen. No one was left on his feet except the hospital nurse I got in—she was an added flail!—the cook and myself. The cook, the nurse and I ran the family meals. There was fortunately a sort of dumb-waiter hoisted by ropes that ran up several stories of the house. It made a rumbling like intoxicated thunder but would carry several trays of food at a time. Conrad came in to lunch every day because he was trying to work very hard in his lodgings round the corner.

He used to come in in the mornings and, having climbed the many stairs to my small, dreadful, study, would sit for hours motionless and numb with a completely expressionless face. Every now and then he would say:

'I can't do it. It can't be done. *Je suis foûtu!*' Then he would launch out into a frightful diatribe against the English language. It was a language for dogs and horses. It was incapable of conveying human thoughts. He had given up the attempt. For good. The damn paper must go without its damn serial. Who would care? No one.

I would stand in the window, looking right over London: a grey expanse with sparkling points. From there—in the middle west—one could see Greenwich Observatory in the extreme east. It was looking over that view that I first told Conrad the story that he turned into *The Secret Agent*.

But in those moments I would have a perfectly vacant mind. It just stopped. There was really nothing to say. English is not a good language for prose. You cannot make a direct statement in literary English. At any rate in those days you could not and I doubt if you can now—in English English. In American English you almost can, but you shock elegant ears. Conrad's English, however, was literary. I had nothing with which to console him.

He would declare that he had written the last word of that serial. I would manoeuvre him towards writing as the drake manoeuvres the sitting duck back to the nest when she has abandoned her eggs. I would read over his last sentence to him. If it provoked no beginnings on his part I would displace him at the desk and write a sentence or two. There are five words that seem horrible to me. They are 'the silver of the mine.' That was the title of the part of *Nostromo* over which we then wrestled.

He would groan:

'No, it's no use. I'm going to France. I tell you I am going to set up as a French writer. French is a language; it is not a collection of grunted sounds.'

I would say:

'*Nostromo* would go admirably in French. Let us get it blocked out. Then you could re-write it very easily in French.'

The hospital nurse would come in:

'Now, Mr Ford it is time you got back to bed again.' I would have been up an hour.

Conrad liked the society of that nurse. Inscrutably. She was a flail. She had a face like a Cockney camel. There poured out of it incessantly words that I hardly understood. Conrad however did. He had served before the mast with Cockney deck-hands. He would ask her how the other patients were. That would give her an excuse to get going.

'Last peetient I 'ad wus Lord Northcliffe. Hoperishun on 'is leg! Lie in bed e' would wiv the telephone on 'is chess. Sweer into the telephone 'e would. Sweer ... somethin' awful.... Sweer w'en hi chinged im ... oh terrible! Sweer at the pines an' then onto the telephone. At the *Dily Mile*.... Sech lengwidge. Houtrageous. Then wen hi was going: "Nurse," 'e sez to me, "Nurse.... Whenever you 'ear men speak against me you will say: 'He bore his illness like a Christian and a gentleman.'"... Peetient bifor that was an old maid ... bifor er they 'ad

swingin doors. Between the quality staircase and the servants.... Green b'ize....'

She had been standing on the top landing of the house. A servant let the green baize door swing against her. It had precipitated her down several flights of stone stairs. She lay at the bottom with her skull smashed and her brains protruding. The servants put sheets of newspaper under her head. They wanted to protect their mistress's stair-carpets. When the surgeon came he could read the imprint of the paper on her brain—an account of the dispersal of the works of art from the collection of the Hon. Matthew L. Oldroyd.

That was her story—one of hundreds. Of thousands, perhaps. Her appearance used to drive me frantic. It meant that Conrad would not get to work for hours. Neither could I. I need a certain period of quiet before words will come.

I would slip away downstairs and dust the dining-room against lunch. When I returned, Conrad would be writing contentedly at my desk. The nurse with her lack-lustre eyes and untidy strands of hair hanging from beneath her cap was detrimental to all her patients. Conrad she seemed to stimulate. He would listen to her singular tarradiddles for hours with an expression of the utmost interest and deference. Perhaps *Nostromo* would never have got itself written but for her. Or perhaps Conrad's next book would have borne a Parisian imprint.

His dislike of England acted as a powerful depressant on me. I took the view that, for good or ill, we must write English and in England. If then the public and the critics were as dense as he declared in his passionate outbursts, what chance was there for us? I certainly shared his view, but it was as if I could not bear to hear my own view confirmed. We were once at a music-hall. I used to like music-halls myself. They took for me the place of the cafés one for ever misses when one is out of Paris or the French provinces. You can sometimes see there remarkable pieces of juggling which I very much enjoy.

Occasionally there will be a good singer. When there is nothing to claim your attention on the stage you can talk to your neighbour, read a newspaper or even correct proofs. Conrad did not much share my tastes, but he went with me now and then. On this occasion the visit was not a success. The principal turn was by a lion comique of considerable notoriety. He was dressed as a miserable charwoman with a red nose, weeping eyes and straggling red locks. He described how when young he had been seduced by a lodger, had several children by him; was deserted, went on the streets, took to gin and now did charing.

The house rocked and roared with laughter—an immense house: the old Empire, I think. It was almost impossible to hear the mincing comedian for the laughter. Between two verses, Conrad turned to me and said:

'Doesn't one in spite of everything feel a stranger in this beastly country?' That was just what I had been thinking. But, as I have said, it depressed me to have my thoughts so exactly confirmed.

So it went on for years—seven, ten, eleven—I don't remember how many. At any rate, it was after *Romance* itself was finished that Conrad wrote that 'Ford had become a habit,' rather wondering at it because, he said, no one liked me.

My early job was to get Conrad's work over. I do not believe that any other person could have tackled it then, though later on Marwood was quite as indispensable—quite as much of a habit. Given that you acknowledge that Conrad's professional career was fortunate from the date of our association, the conjunction must have been materially fortunate for him whether or no his work deteriorated. That it was fortunate for me I am sure, for if I know anything of how to write, almost the whole of that knowledge was acquired then. It was acquired at the cost of an infinite mental patience, for the process of digging out words in the same room with Conrad was exhausting. On the other hand, the pleasure derived from his society was inexhaustible; his love, his passion for his art did not,

I believe, exceed mine, but his power of expressing that passion was delicious, winning, sweet, incredible. When —but how rarely!—a passage went right or the final phrase of a long-tinkered episode suggested itself, his happiness was overwhelming, his whole being lit up, his face became serenely radiant, his shoulders squared, his monocle gleamed like rock crystal. It was extraordinary.

And his delight was just as great if the *trouvaille* had been mine as if it had been his own. Indeed, the high-water mark of our discoveries was reached with a phrase of mine—'Excellency, a few goats!'—which so impressed him that twenty years later he was still chuckling over it. It was that generosity that atoned for, say, his abusive letters written about myself to his friends. After all, you cannot—nobody could—live with another man practically as a room-mate for years without occasional periods of exasperation, and if you have the habit of volubly expressing yourself, in unstudied letters, your exasperations will work through into print.

But in spite of these rubs of the game—and what a game for rubs it was!—our friendship remained unbroken and only interrupted by the exigencies of time, space and public events. It is in the end better if the public will believe that version—for nearly ideal literary friendships are rare, and the literary world is ennobled by them. It was that that Conrad meant when, looking up from the play of *King John* at which he had been glancing for a little while, he quoted to me, who was writing and had to turn my head over my shoulder to listen:

> Oh, two such silver currents when they join
> Do glorify the banks that bound them in—

and he added: '*C'est pas mal, ça; pour qualifier nous deux!*'

And by that he meant not that we were producers of great books but writers without envy, jealousy or any of the petty feeling that writers not unusually cherish, the one towards the other. That gave him lifelong satisfaction.

A NATURALIST FROM
LA PLATA

W. H. Hudson

Almost the most vivid emotion that I can remember in my life was caused by the first visit one of the greatest of writers paid to the Pent. We were sitting on a quiet sunlit day in the parlour of the Pent. Conrad was at the round table in the middle of the room, writing, his face to the window; his collaborator was reading some pages of corrected manuscript, facing into the room. A shadow went over those pages from the window. Conrad exclaimed, 'Good God!' in an accent of such agony and terror that my heart actually stopped as I swung round to the window to follow the direction of my companion's appalled glance. It went through my mind, 'This must be the bailiff.... He has debts of which I do not know.... What's to be done? ... Are all the doors bolted? ... What does one do?'

An extremely tall man with a disproportionately small, grave head was stalking past the window, examining the house front with suspicion.... The family were all out driving. How could they be got in if all the doors had to be bolted? Through the window? But if a window is used as a place of ingress surely a bailiff can use it too.... One imagines that immense, grave fellow, in a pepper-and-salt gamekeeper's coat with tails, putting one knee over the window-sill as a small boy is handed in.... Surely an execution for debt cannot take place after sunset? ... Then they will have to remain out till then. Or perhaps that is obsolete law.... They could go into the great barn.... It is always warm and still there, with the scent of hay: like an immense church.

The house was perfectly still. The tall figure with the

aspect of a Spanish alcalde disappeared from above the monthly roses. He had been stalking, very slowly, like a man in a grave pageant—a stork. Suddenly Conrad exclaimed in a voice that was like a shout of joy, 'By Jove! ... It's the man come about the mare!' Conrad was almost always going through some complicated horse-dealings with that mare of his. He was going to exchange her for a pair of Shetland ponies and a chaff-cutting machine; he was going to sell her in Ashford Market as against a part of the price of a stout Irish cob, the remainder to be paid by the loaning of her during hay-making to the farmer who hired the lands of the Pent; she was to be exchanged with a horse-dealer who was shortly going out of business and had a most admirable roll-top desk and a really good typewriter. Traps could be hired from the Drum Inn at Stamford. ...

Conrad's conviction restored life to the fainting Pent; it breathed once more; the cat jumped off the window-sill; the clock struck four. ... I hurried, a little tremulous still, to open the front door. ... The tall, thin, grave man looked gravely at me. I exclaimed hurriedly, 'The mare's out driving. ...' I added, 'With the ladies!' It's a great thing to be able to prove to a horse-dealer that your mare can really be driven by a lady. The man—he resembled a sundial—said in the slow voice a sundial must have, 'I'm Hudson!' I said, 'Yes, yes. The mare's out with the ladies.' Getting into his voice the resonance of a great bell, the tall man with the Spanish sort of beard said, 'I'm ...W. ...H. ...Hud ...son. I want to see Conrad. You are not Conrad, are you? You are Hueffer. ...'

I may very well have psychologized Conrad wrongly, though I remain strongly under the impression that after that king of men had gone Conrad said, 'By Jove, I thought he was a bailiff!' Hudson was at that date making a regular tour of the literary world, as he at other times for sedulous and immobile days would watch the nests of cuckoos or the colonies of rooks in bare trees. I remember once, near Broad Chalke in the great bare downs where

he had his hide-hole, standing with him for half an hour at least watching a rookery. It was all alone in the valley that formed a broad bowl in the chalk downs. Its peculiarity was that it stood alone: rooks always affect the society of men and practically never build in the open but in the shadow of great manor-houses. Whilst we stood there he told in his slow, low, keen tones the story of a family who, having left one manor, moved to another. At the second there were no rooks. Within a day there were rooks building in the great elms round the house and the rooks had deserted their nests in the old habitation to follow that family. He told that story as if he believed it. In the case of the rooks we were watching, the manor-house had fallen down half a century before. He was interested to observe whether the inhabitants of houseless rookeries behaved exactly like those—in their parliaments, conclaves, penalties and executions—whose nests were near the stables of great, red brick houses. He spent hours watching the rookery at Wilton, then returned to the one at Broad Chalke, and so on for weeks.

He was very tall, with the immense, lean frame of an old giant who has for long stooped to hear men talk. The muscles of his arms stood out like knotted cords. He had the Spanish face and peaked grey beard of a Don Desperado of the Spanish Main; his features seemed always slightly screwed together like the faces of men looking to windward in a gale. He paused always for an appreciable moment before he spoke, and when he spoke he looked at you with a sort of humorous anticipation, as if you were a nice cockatoo whom he expected to perform amusing tricks. He was the gentlest of giants, although occasionally he would go astonishingly off the deep end, as when he would exclaim violently, 'I'm not one of you damned writers: I'm a naturalist from La Plata.' This he would put over with a laugh, for of course he did not lastingly resent being called the greatest prose-writer of

his day. But he had a deep, dark, permanent rage at the thought of any cruelty to birds.

Hudson was born of American parentage in a place called Quilmes in the Argentine, about 1840, and coming to London in the eighties of the last century, he was accustomed to declare—in order to account for his almost impassioned love for the English countryside—that no member of his family had been in England for over 250 years. After his death his industrious and devoted biographer, Mr Morley Roberts, ferreted out that Hudson's father had been born in the State of Maine about 1814, his paternal grandfather having gone there from the West of England a little before the Declaration of Independence. On his mother's side he was, however, of very old United States descent. In any case his youth and young manhood had been passed in Spanish-American countries and that no doubt gave him his gravity of behaviour ... and of prose. For he remained always an extraordinarily closed-up person and the legends that grew up about him could hardly be distinguished from the little biographical truths that one knew. The truths always came in asides. You would be talking about pumas. For this beast he had a great affection, calling it the friend of man. He would declare that the puma would follow a traveller for days over the pampas or through the forest, watch over him and his horse while he slept, and drive away the jaguar ... who was the enemy of man. He said that this had happened to him many times. Once he had been riding for two months on the pampas, sleeping beneath the *ombu* trees that seem to cover half a county, and three times a puma had driven off a jaguar. It had been a period of drought. For a whole week he had not been able to wash his face. One asked what it was like not to wash one's face for a week and he would reply: 'Disagreeable.... Not so bad ... as if cobwebs touched you here and there.' You would say that must have been a disagreeable week all the same and he would slip out: 'Not so bad as a week I've known ... when Mrs Hudson and I passed a

whole ten days in a garret with nothing but a couple of tins of cocoa and some oatmeal to eat.'

And gradually it would reach your consciousness, by means of a lot of such asides, that, after he first came to England, there had been a long, dragging series of years in which he had passed through periods of near starvation, trying to make a career. It was almost impossible to realize; he seemed so remote from the usual vicissitudes, with his hidalgo aloofness and his mind set on birds. And there was no one—no writer—who did not acknowledge without question that this composed giant was the greatest living writer of English. It seemed to be implicit in every one of his long, slow movements.

He shared with Turgenev the quality that makes you unable to find out how he got his effects. Like Turgenev he was utterly undramatic in his methods, and his books have the same quality that have those of the author of *Fathers and Children*. When you read them you forget the lines and the print. It is as if a remotely smiling face looked up at you out of the page and told you things. And those things become part of your own experience. It is years and years since I first read *Nature in Downland*. Yet, as I have already said somewhere or other, the first words that I there read have become a part of my own life. They describe how, lying on the turf of the high sunlit downs above Lewes in Sussex, Hudson looked up into the perfect, limpid blue of the sky and saw, going to infinite distances one behind the other, the eye picking up one, then another beyond it, and another and another, until the whole sky was populated . . . little shining globes, like soap-bubbles. They were thistledown floating in an almost windless heaven.

Now that is part of my life. I have never had the patience—the contemplative tranquillity—to lie looking up into the heavens. I have never in my life done it. Yet that is I, not Hudson, looking up into the heavens, the eye discovering more and more tiny, shining globes until

the whole sky is filled with them, and those thistle-seed globes seem to be my globes.

For that is the quality of great art—and its use. It is you, not another, who at night with the stars shining have leaned over a Venice balcony and talked about patines of bright gold; you, not anyone else, saw the parents of Bazarov realize that their wonderful son was dead. And you yourself heard the voice cry *'Eli, Eli lamma sabac-thani!'* ... because of the quality of the art with which those scenes were projected....

'It's the simplicity of your prose,' I would protest. 'It's as if a child wrote with the mind of one extraordinary erudite.'

He would answer: 'You've hit it. I've got the mind of a child. Anyone can write simply. I just sit down and write. No doubt what I write about is important. I try to make it so. It's important that the chough should not be exterminated by those Cornish brutes. The chough is a beautiful and rare bird and it's important that beauty and rareness should not be driven from the world. But it's simple enough to write that down.'

'You know it isn't,' I would protest. 'Look how you sweat over correcting and recorrecting your own writing. Look how you went all through *Green Mansions* before it was published again. You took out every cliché....'

'Why, I was a very young man when I wrote the book. It was full of sham genteel words. I took them out. That isn't difficult.'

'It is,' I said, 'so difficult that if you can do it, you become an artist in words.'

He exclaimed still violently, but weakening a little: 'That's not reasonable. I'm not an artist. It's the last thing I should call myself. I'm a field naturalist who writes down what he sees. *You're a* stylist. You write these complicated things that no one else could. But it's perfectly simple to write down what one has seen. You could do it if you wanted to. With your eyes shut.'

I answered: 'I can do it for an hour. An hour and a

half. Then simplicity bores me. I want to write long, complicated cadences. . . .'

'Well, that's art,' Hudson brought out triumphantly. 'I told you so long ago.'

I said: 'It isn't. Art is clarity; art is economy; art is surprise. Hang it, suppose you want to drive an ox. You tickle his hide with a sharpened stick; you don't stand away off from him and flick a fly off him with a twenty-yard sjambok.'

He would reply: 'I should have thought that that was what art is . . . showing off in some sort of way. But I never want to show off. That's why I'm not an artist. . . .' And I would throw up my hands in despair and begin all over again.

The longest and most voluminous correspondence I had with Hudson was about caged birds. I was then emerging from a nervous break-down and, acting on the advice of the nerve specialist in Butler's *The Way of All Flesh*, I had had the glass taken out of my bedroom window and replaced by small meshed wire netting and I had let loose in the room a half-dozen African wax-billed finches and parakeets. They seemed to flourish and to be quite happy, and my nerves were immensely soothed by lying in bed and watching them fly about. I won't go into the argument. It was the usual one between bird-lovers and those who find solace from keeping birds in captivity. And finally I brought it to an end by saying that I should keep the birds and go on keeping them. Besides: what would be the sense of turning African wax-bills and parakeets loose in London? . . . At that he came to see me and stumped up the stairs to inspect my bedroom. He looked for a long time at the birds, which were perfectly lively. Then he recommended me to have some large mirrors set into the walls with perches in front of them. And to hang about bright silvered balls from Christmas-trees, and scarlet ribbons. Birds, he said, loved all bright objects, and the mirrors gave them the illusion, with their reflected images, that they were in great crowds of birds.

Then he said, 'Humph,' and stumped down the stairs and never to me mentioned the subject of birds in captivity again.

A day or two later you would go and spend a night or two under the thatched roof of his hide-hole on Salisbury Plain in that curious long village of thatched cottages where, on one side of the street, all the women were dark as Spaniards and beautiful and blue of eye, and on the other they were all blonde Anglo-Saxons, buxom and high-coloured and slow. And there he was, as legendary and as much at home as on Carlton House Terrace and Gerrard Street, Soho, where the imitation French restaurants swarm.... There he was a gipsyish man who had been in foreign parts, but knew the pedigree of every shepherd's dog on the Plain and the head of game that every coppice carried and the hole of every vixen and the way every dog fox took when at night he went ravaging at a distance... for the fox never takes poultry near his home. Not he! For fear of retribution. And you may see the fox cubs play in the sunlight with the young rabbits from the next burrow.... Hudson had told the villagers that and they recognized how true it was. And he knew all about the dead and gone folk of the Plain, and all the living good-looking women, and he was a healer who brought you good luck merely by looking at you....

And there that great tall man would sit by the shepherd's table, drinking the terribly strong tea out of the thick cups and eating the fleed-cake and the poached rabbits. And the tiny little black-haired, blue-eyed girls caressing their insteps with their shoe-soles and visiting his great gamekeeper's pockets for the candies they were confident of finding there... as confident as the tame squirrel of finding nuts... and there were always orange flowers in an earthenware mug on the table, the flower that is just a weed in English gardens, but is cherished above all others in the winter flower-beds above the Mediterranean.

And then the great, long figure would arise, brushing
the beams of the cottage ceiling with his hair, and stroll
down the broad valley. And stay for many minutes watch-
ing the colony of rooks in the trees that still stood a hun-
dred years after the manor-house that they had sheltered
had fallen to the ground. And so to the station and back
to the strangest home of all those that sheltered him.

His wife then—in her day she had been a celebrated
singer—kept a boarding-house. She was twenty years
older than Hudson and did not come up to his elbow.
After her marriage to him she sang very little, because
her voice was leaving her. But otherwise she was very
normal and quick-witted, if a little quick-tempered and
not a good businesswoman. For all the great money she
had earned in her day had gone and shortly after their
marriage her boarding-house went bankrupt too. It was
then that they had known days of real starvation and it
is not the least romantic part of Hudson's career, the
desperate and courageous efforts he made to keep them
going. He was a stranger in London with nothing to earn
a living by but his pen; and it is curious to think that one
of the ways by which he did earn money was by ferreting
out genealogical tables for Americans of English origins.
Then he also did hack-work descriptions of South Ameri-
can birds for scientific ornithologists who had never seen
a bird. And then magazines began to commission him for
articles about birds; his wife inherited a fantastically
gloomy house in the most sooty neighbourhood of London
and a small sum of money with which she set up a board-
ing-house that this time did not fail. It was touching to
see how Hudson made another gentle legend for himself
amongst Shetland-shawled old maids and broken-down
Indian colonels. And then he was granted a pension on
the King's Civil List, and then fame came to him in
London and money from New York. And he and his
wife lived together until she died, a little before him, at
the great age of a hundred years.... That, too, was
Romance.

I am ashamed to say that I did not see it at the time, and I disliked the atmosphere of the boarding-house so much that whenever I could I used to insist on Hudson's coming out with me to Kensington Gardens. He was not a good walker in those days in spite of the fact that he had spent the greater part of his life on his feet, watching birds. We used to pace very slowly up and down beneath the tall elms of the Broad Walk and in front of the little palace, amongst the children of the wealthy. We would watch the grey squirrels that had come from New York and that were monstrously at home in the Gardens, having bitten off the tails of all the aboriginal red squirrels. And he would talk of how the Liberator carried his whip and reviewed his troops; and of the birds and herds and great trees of the pampas, far away and long ago. And *Far Away and Long Ago* is the most self-revelatory of all his books.

I do not think that I would much like to recapture many of the atmospheres of my own past. The present days are better. But I would be glad, indeed, if once again I could walk slowly along the dingy streets that led from that Bayswater boarding-house to Paddington Station ... slowly beside Hudson and his wife, who would be going away towards English greennesses, through the most lugubrious streets the world could imagine, let alone know. And Huddie would be expressing theories as to the English rain and far below him his tiny wife would be incessantly telling him that he was going the wrong way.

Hudson had lived in that district for forty years, continuing to stay there after fortune had a little smiled on him—because it was near the great terminus of Paddington and they could slip away from there to the country without attracting attention by their singular disproportion in size. In spite of this they never could go to that exit from London without her telling him that he was going the wrong way ... I suppose because she had lived there for nearly a century. And she would keep on and on at it, bickering like a tiny wren threatening some great

beast approaching her nest in the gorse. Her great age only affected her colouration so that she seemed to recede further and further into the mists of Saint Luke's Road until she was almost invisible. But her vivacity was unconquerable, and appropriate. It was as if, having framed that romantic giant, the force of nature could go no further, and to frame a fitting mate must compound for him that singular and elfish humming-bird.

THE GLACIAL GAZE OF
THE SERPENT

George Moore

I did not ever know Mr Moore at all well. I must first
have been in the same room with him in the gloomy house
of Mr—afterwards Sir Edmund—Gosse. It was on the
banks of the Regent's Canal and my father lived opposite
across the canal. Mr Gosse had at one time a subordinate
position on a review that my father owned. I was brought
up among admirers of Mr Moore. My grandfather thought
very highly of his writings on the French Impressionists;
my father was one of the earliest to praise *Esther Waters*
and later nearly all my young friends patriotically cham-
pioned Mr Moore in his claim to be the master of Guy
de Maupassant. I did not go as far as that but I did be-
lieve—as I do now—that Mr Moore was the only novelist
of English blood who had produced a novel that was a
masterpiece at once of writing and of form. So in one
house or London club or the other when I found that
Mr Moore was there I always effaced myself as much as
I could. If I had not had so great an admiration for his
greatness, his clarity of mind and the chilliness of his
temperament I might have got to know him well for I
saw him often enough. . . .

At a later stage I was writing a preface to a volume
of translations from Maupassant. Mr Henry James had
told me some singular details about the life and habits of
the author of *La Maison Tellier*. Conrad had said that
these stories were all nonsense. I was not writing about
the life or personality of Maupassant—only about his
methods of writing. But I thought it might clarify my
thoughts if I could get myself posted as to the matter
upon which James and Conrad disagreed. Moore had

lived in Paris in the great age of impressionist painters and had known all the naturalistic writers of the last decades of the last century. It was a question of French manners and I do not intend to say what it was for a reason that will appear.

I wrote to Mr Moore and asked him for information as to two succinct points so that he need take no more trouble than to answer 'Yes' or 'No.' . . . He ordered me to go and see him. . . .

He was in a dressing-gown, recovering from influenza in a darkish rather rich room that I found overheated. Before we had even sat down he said:

'So you want to steal my thunder!'

I was then young and that annoyed me. I denied that I had any intention of using anything that he said but he paid no attention. The interview continued disagreeably for me.

There is an early American folk song:

> So I sez to Maria, sez I:
> 'Praise to the face
> Is open disgrace.'

And I have never been able in the presence of the Great to express to them the admiration that I usually feel. I try to bide my time until I can slip into the conversation something like: 'Your admirable *Nets to Catch the Wind*' or whatever I judge to be the great one's favourite work. But Mr George Moore never gave me the time to manoeuvre for position. He said at once that Maupassant had pilfered his ideas in *Une Vie* and *Bel Ami* and hinted that he had made a very poor job of it as compared with *Esther Waters* and *A Modern Lover*. . . . If you put it to me to-day that *Esther Waters* is a greater novel than *Une Vie* I do not suppose that I should deny it, for Maupassant, great as he may have been as a short-story writer, was not a novelist *pur sang*. To state that is to deny the gods of my youth but I was then in the full heat of the Maupassant faith. . . . And Mr Moore,

if he was unobservant as to material details, was a perfect
demon for detecting hesitancies of the voice.

It became worse later for I distinctly chilled him by
obstinately stating that I preferred *A Drama in Muslin*,
he, quite properly thinking that *Esther Waters* was his
masterpiece. But at the moment I had just finished read-
ing the other and I had read it with a personal enthusiasm
for its relative humanity whereas all the rest of the
Master's novels left me—personally—cold. Intensely ad-
miring—but repelled!

So I have that early image of him, standing rather rigid
and grim, chilled and monachal in his long dressing-
gown. He was dismissing me with one hand on the door-
knob of his dim, overheated room. I had at the moment
for the first time the impression of his extreme pallor.
That was owing, possibly, to a shaft of light coming from
the passage. And he seemed as aloof as if he had been a
denizen of another world, where there was neither sun
nor wind. The impression was so strong that I was re-
lieved that he did not remove his hand from the door-
knob and offer it to me. . . . I gathered that he took me
for an interviewer. I had told him again and again that
I had no intention of printing anywhere anything that he
might say but it had not seemed to make any impression
on him. Before I came he had made up his mind that he
was going to receive a reporter who would pick his brains
and he was a man who had great difficulty in changing
his ideas. In those days an interviewer was regarded in
England at once with a sort of fearful fascination and at
the same time as a being some degrees lower than the man
who comes to check your gas-meter.

So I remained with the impression of something at
once querulous and etiolated. Etiolation is what happens
to plants if you grow them in the dark. I felt as if a minor
James had called on a blotted Flaubert. . . . I called on
him once more at his request and the visit was even more
of a failure. As I have said I had asked him to give me
something for *The English Review*. That had been before

Marwood and I had actually started that periodical. His first words were:

'Gosse says I should certainly have nothing to do with you.... What do you want of me?'

I never knew what I had done to Mr—afterwards Sir Edmund—Gosse, and I never enquired. It is natural to dislike the sons of one's early patrons even more than one dislikes in the end the patrons themselves. That seems to be a law of humanity and I left it at that. So I answered Mr Moore's question. I explained that Marwood and I wanted the review to contain the best writing in the world so that naturally one came to Mr Moore at a very early date. We had secured promises of work from Mr James, Mr Conrad, Mr Meredith, Mr Swinburne, M. France. ...

Mr Moore said:

'Not of old Gosse?'

I said we were prepared to pay any price an author asked, leaving it to his conscience not to ask much more than his usual prices so as to leave something for the others. That had worked very well so far.

He said:

'You must be in possession of gold like the floods of Pactolus!'

I said: 'No. Some authors asked preposterous prices but some quite distinguished ones asked nothing at all, so it worked very well.'

Then he asked me what sort of writing we wanted from him and we got once more to something like icy bickering. It was of course my fault. I had just been reading his reminiscences—*Ave Atque Vale*, I think—and I had felt such admiration for their beauty of expression and poetry that I said that I liked them infinitely better than anything else he had ever done.

You should never say to a novelist that you prefer his 'serious' writings to his fiction though I find that such few novelist friends as I have always say that to me. But novel-writing is a sport infinitely more exciting than the

other form so that almost all writers would prefer to be remembered by their imagination rather than by their records. . . .

I made it all the worse by telling that great man that his *Ave Atque Vale* was infinitely more imaginative than *Evelyn Innes*. As imaginative even as *Esther Waters*! . . .

I was by then worked into a state of nervous inanity by his mere nearness to me. He was living then in Ebury Street, a neighbourhood that I have always disliked. And I kept looking aside at his pictures and missing what he said.

In the end he said that he was engaged in revising one of his novels but that if I would ask him again in a month or two he might do something for me. I think he really liked the idea . . . but to my lasting shame I forgot to write to him and I never saw him alone again.

I suppose it was his aloofness from life that made one always forget George Moore. I have never met a critic with any pretensions to knowledge of letters who would not acknowledge when challenged that Moore was infinitely the most skilful man of letters of his day. The most skilful in the whole world. . . . Yet in an infinite number of reviews and *comptes rendus* of the literature of the world that I have read—and written—George Moore was almost invariably forgotten. That was due perhaps to the fact that he belonged to no school in England; perhaps to his want of personal geniality, perhaps to something more subtle.

I was walking last night along a cold dark boulevard with a critic possessing a delicate discrimination in letters. He said, talking naturally of Galsworthy:

'He wasn't at least wicked like George Moore. . . .' Then he checked and exclaimed almost in mental distress: 'I don't know why I say that George Moore was wicked. I know nothing against him personally. I have never heard anything against him and *The Brook Kerith* is one of the most beautiful books in the world. But you know what I mean. . . .'

I knew what he meant. It was that something wicked seemed to distil itself from the pages of Moore's books so that whilst you read them you felt, precisely, mental distress. You felt even mentally distressed at merely remembering the writings of George Moore—as if you were making acquaintance with what goes on in the mind behind the glacial gaze of the serpent that is the Enemy of Man. . . .

CHANGES

CHANGES

AFTER THE ARMISTICE

NAKED came I from my mother's womb. On the day of my release from service in His Britannic Majesty's army —in early 1919—I was nearly as denuded of possessions. My heavier chattels were in a green, bolster-shaped sack. All the rest I had on me—a worn uniform with gilt dragons on the revers of the tunic.... All that I had once had had been conveyed in one direction or the other. That was the lot of man in those days—of man who had been actively making the world fit for ... financial disaster. For me, as writer I was completely forgotten and as completely I had forgotten all that the world had before then drummed into me of the art of conveying illusion to others. I had no illusions myself.

During my Xmas leave in a strange London I had gone to a party given at the French Embassy by M. Philippe Berthelot, since Ambassador himself and for long Principal Secretary to the French Foreign Office. I swam, as it were, up the Embassy steps. Then I was indeed a duck out of water.... The party was given for the English writers who with the implements of their craft had furthered the French cause. And there they all were, my unknown confrères. It was seven years since I had written a word: it was almost as many since I had spoken to a man of letters. Unknown faces filled the considerable halls that were misty under the huge chandeliers. There was a fog outside.... Unknown and queer!

I cannot believe that the faces of my British brothers

of the pen are really more pallid and misshapenly elongated than those of any other country or of any other sedentary pursuit. But there, they seemed all unusually long, pale and screwed to one side or the other. All save the ruddy face of Mr Arnold Bennett, to which war and the years had added. He appeared like a round red sun rising from amongst vertical shapes of cloud. . . .

But I was not on speaking terms with Mr Bennett and I drifted as far from him as I could.

Just before the Armistice I had been summoned from my battalion to the Ministry of Information in London. There I had found Mr Bennett in a Presidential chair. In my astonishment at finding him in such a place I stuttered out:

'How fat you've got!'

He said:

'You have to write about terms of peace. The Ministry has changed. France is not going. . . .'

We immediately disagreed very violently. *Very* violently! It was a question of how much the Allies ought to secure for France. That meeting became a brawl. Sir W. Tyrrell got introduced into it at first on the telephone and then personally. He was then Secretary to the Foreign Office and is now British Ambassador in Paris.* I have never seen any look so irritated. The chief image of that interview comes back to me as a furnace-hot flush mounting on a dark-bearded cheek. And Mr Bennett lolling back augustly in his official seat like a marble Zeus on a Greek frieze. I suppose I can be very irritating, particularly when it is a matter of anyone who wants, as the saying was, to do France in the eye. That responsible diplomat uttered language about our Ally! I should think that now, when in his pocked hat he passes the sentry at the door of the Elysée, he would have little chills if he thought of what he then said. I on the other hand had come straight from a company of several million men who were offering their lives so that France might be saved for the world.

* Written in 1933.

When he had stormed out I asked Mr Bennett if he still wanted my article about the terms of peace. A Chinese smile went over his face. Enigmatic. That was what it was.

He said:

'Yes. Write it. It's an order. I'll have it confirmed as such by the Horse Guards if you like.'

I went back to my regiment where, Heaven knows, the work was already overwhelming. I wrote that article on the top of a bully-beef case in between frantic periods of compiling orders as to every conceivable matter domestic to the well-being of a battalion on active service. The article advocated giving to France a great deal more than Mr Lloyd George's Government desired to give her. A great deal more! That article was lost in the post—a fate that must be rare for official documents addressed to a great Government department. A week later I received through my Orderly Room an intimation that, as an officer of His Britannic Majesty's Army, I was prohibited from writing for the press. And I was reminded that, even when I was released from active service, I would still be an officer of the Special Reserve and a paragraph of the Official Secrets Act was quoted to me. I could not think that I was in the possession of a sufficiency of Official Secrets to make that intimation worth while but at that point I had understood Mr Bennett's queer smile.

I like what the Boers call slimness and usually regard with pleasure acts of guilt practised against myself. I fancy it must make me feel more real—more worth while! —if a Confidence Trick man attempts to practise on me. But at that party at the Embassy I felt disinclined to talk to Mr Bennett. Dog should not, by rights, eat dog.

But patriotism and the desire of Dai Bach's Government to down the French covered in those days hundreds of sins in London town. *Dai Bach*—David darling! —was the nickname given to the then Prime Minister in the Welch Regiment for which in those days I had the honour to look after many intimate details. It pleases me

still to read the 'character' that decorated my Soldier's Small Book on my resigning those duties:

> Possesses great powers of organization and has solved many knotty problems. A lecturer of the first water on military subjects. Has managed with great ability the musketry training of this unit.

I stood then alone and feeling conspicuous—a heavy blond man in a faded uniform in those halls of France. Pale faces swam, inspectantly, towards me. But, as you may see fishes do round a bait in dim water, each one checked suddenly and swam away with a face expressing piscine distaste. I imagined that the barb of a hook must protrude somewhere from my person and set myself to study the names and romantic years of the wines that M. Berthelot had provided for us.

Their juice had been born on vines, beneath suns of years before these troubles and their names made fifty sweet symphonies. . . . It had been long, long indeed, since I had so much as thought of even such minor glories as *Châteauneuf-du-Pape* or *Tavel* or *Hermitage*—though I think White Hermitage of a really good vintage year the best of all white wines. . . . I had almost forgotten that there were any potable liquids but *vins du pays* and a horrible fluid that we called Hooch. The nine of diamonds used to be called the curse of Scotland, but surely *usquebaugh*—which tastes like the sound of its name—is Scotland's curse to the world . . . and to Scotland. That is why Glasgow on a Saturday night is Hell. . . .

A long black figure detached itself from Mr Bennett's side and approached me. It had the aspect of an undertaker coming to measure a corpse. . . . The eyes behind enormous lenses were like black pennies and appeared to weep dimly; the dank hair was plastered in flattened curls all over the head. . . . I decided that I did not know the gentleman. His spectacles swam almost against my face. His hollow tones were those of a funeral mute:

'You used to write,' it intoned, 'didn't you?'

I made the noise that the French render by '!?!?'

He continued—and it was as if his voice came from the vaults of Elsinore. . . .

'You used to consider yourself a literary dictator of London. You are so no longer. *I* represent Posterity. What I say to-day about books Posterity will say for ever.' He rejoined Mr Bennett. I was told later that that gentleman was drunk. He had found Truth at the bottom of a well. Of *usquebaugh*! That was at the other, crowded end of the room.

That reception more nearly resembled scenes to be witnessed in New York in Prohibition days than anything else I ever saw in London. It must have given M. Berthelot what he could call *une fière idée de la Muse*, at any rate on Thames bank.

A month or so later I might, had it not been too dark, have been seen with my sack upon my shoulder, approaching Red Ford.

That was a leaky-roofed, tile-healed, rat-ridden, seventeenth-century, five-shilling-a-week, moribund labourer's cottage. It stood beneath an enormous oak beside a running spring in a green dingle through which meandered a scarlet and orange runlet that in winter was a river to be forded. A low bank came down to the north. At the moment it loomed, black, against the bank and showers of stars shone through the naked branches of the oak. I had burned my poor old boats.

THE RETURN OF THE NATIVE

You may say that everyone who had taken physical part in the war was then mad. No one could have come through that shattering experience and still view life and mankind with any normal vision. In those days you saw objects that the earlier mind labelled as *houses*. They had been used to seem cubic and solid permanences. But we

had seen Ploegsteert, where it had been revealed that men's dwellings were thin shells that could be crushed as walnuts are crushed. Man and even Beast . . . all things that lived and moved and had volition and life might at any moment be resolved into a scarlet viscosity seeping into the earth of torn fields. . . . Even omnibuses had picked their lumbering ways, crowded with obfusc humanity, dulled steel and bronze, between pits and hillocks of the tortured earth until they found the final pit into which they wearily subsided. It would be long before you regarded an omnibus as something which should carry you smoothly along the streets of an ordered life. Nay, it had been revealed to you that beneath Ordered Life itself was stretched, the merest film with, beneath it, the abysses of Chaos. One had come from the frail shelters of the Line to a world that was more frail than any canvas hut.

And, more formidable than the frailness of the habitations was . . . the attitude of the natives. We who returned —and more particularly those of us who had gone voluntarily and with enthusiasms—were like wanderers coming back to our own shores to find our settlements occupied by a vindictive and savage tribe. We had no chance. The world of men was changed and our places were taken by strangers.

As to my own fate I was relatively unmoved. Very early in life I had arrived at the settled conviction: *Homo homini lupus*—man is a wolf to his fellow-men. And I have always believed that, given a digging fork and a few seeds and tubers, with a quarter's start, I could at any time wrest from the earth enough to keep body and soul together.

THE PEASANT FRAME OF MIND

I have been accustomed to regard myself as of the family of the dung-beetle. This stoical creature I came across on

the mountain that is topped by the Genoese castle above
Gatti di Vivario in South Corsica. I was stopping with
a retired bandit whose wife had once been engaged to
Ruskin. Their baked earth hut—for it was little more—
was therefore adorned with products of the firm of
Morris & Co. and relics of my Pre-Raphaelite past whilst
it stood deep in the *macchia*—the trackless forest of white
heather that is the resort of bandits.

On the first day—at my first meal of kid and white
haricots—I committed an unpardonable offence. I was a
great salt-lover and, before even tasting the ragoût, I
sprinkled a great deal of salt on it.... I have never re-
peated that offence. The ex-fiancée of Ruskin behaved as
if I had questioned her virtue. One must *never* add con-
diments to hospitable dishes in France, Italy, or the Isles
of the Mediterranean. It is to suggest that the lady of the
house does not know how her meats should be prepared.
... Even the aged brigand with his one eye and black
skull-cap became almost as agitated as Mr Ruskin when
he discovered traces of immorality in the brushwork of
Millais.... And that septuagenarian was said still to be
very handy with his knife!

To escape from the thunder-clouded atmosphere I
went to take my siesta on a goat path of the mountain.
And there, reclining on one elbow, I looked down and
saw the dung-beetle.

Henry James used to say that the best goods are not
done up in the most fashionable-looking parcels and
certainly for a paladin of industry and benefactor to the
world, the dung-beetle wore no very shining armour. He
was an obfusc, brownish, bullet-shaped mortal and he
pushed before him up the mountain another bullet of
obfusc, brownish matter—dung rolled and patted into
form and pushed so far up what sun-dried precipices and
grasses beaten to steel by the hoofs of the goats! Even as
I looked at him—and perhaps but for that my eye would
not have been attracted to him—gripping his load of
dung he rolled backwards and over and over until he was

level with my foot, say. . . . Without as much pause as
would have given him time to spit on his hands or say:
'What a hope!' he was at his dung-bullet again. He
pushed and strained and the bullet wavered and jolted
upwards until he was on a level with my forehead. Then
with the suddenness of catastrophe, so that one started,
he slipped again and rolled and rolled till he was a foot
below my shoes. And then . . . at it again at once.

I do not suppose that Providence who had prescribed
adaptation, or the survival of the fittest for all mortal
beings, was here at fault. The normal dung-beetle lives
on level ground: a rounded fragment of dung is there
more easily pushed. But this beetle had chosen the moun-
tain-top for his abode and thus the normal packing of his
material told heavily against him. It is not enough to
choose exalted mansions:—I am addressing this apologue
to poets!—you must then adapt your material to your
situation. . . .

I watched that poor beast for the whole of a dreamy
afternoon, on the baked hill-side, looking over the
Mediterranean, whose liquid cord of horizon was indis-
tinguishable from the vivid edge of the sky, and in the
soft odours of white heather, of rosemary, of lavender
. . . oh, intoxicating land! And, at the end of my siesta and
the afternoon that poor beast was not more than a foot
above the level of my head.

A certain Puritanism—inculcated into me, I suppose,
by Mr W. H. Hudson—prevented my taking up that
beetle and setting him down some yards further up the
hill. I fancy I have always had an instinctive dislike for
playing Providence. I have never taken ants out of spiders'
webs though contests between ants and spiders must be
more cruel than anything since there were combats be-
tween *hastiarii* and *retiarii* in the Roman arenas. I fancy
that without the influence of Hudson I should have tried
to bring up orphaned wild rabbits—or fledgelings that
had fallen from nests. But, with his Spanish gravity and
power of making me feel like a worm when it was a

question of thoughtfulness to dumb animals, Huddie had
long since proved to me that nothing was less desirable
than an interfering Providence in the realm of feather,
fur and claw. A fledgeling fallen from the nest is the
weakest of its batch: to hand-rear with chosen food a
young animal with an inherent weakness was to give
to a world of fear and cruelty a being that, after a short
span of dreads and pains, must incur a fearful death in
the talons of a hawk or the jaws of a fox, whereas young
animals die quietly and without fear passing gently back
into the First Principle that supplied their feeble lives.

I daresay he was right. All the same on my first evening
in Red Ford, leaning on my elbow on my camp-bed and
watching the death of my first fire of twigs and driftwood
in a completely empty house I wished that I had played
Providence to that beetle, I wished it very intensely in-
deed. I could not see how, without the intervention of
an immense and august finger and thumb that should take
me up and transport me through the dark air—how,
without that, I should ever reach the top of ... say,
Parnassus! Or even effect a lodgement in a kitchen-
garden on the slopes of the little Alps above the *Plateau
des Antiquités* by St Rémy in Provence.

I don't mean to say that I was unaware of the romance
of the situation ... but I wanted to get to Provence. Not
to Italy where the lemons glare in dark foliage; nor to the
Hesperides where you may find apples of gold. Not even
to the land of Cockaigne where little roasted pigs run
about and beg to be eaten. ... Just to Provence, with the
arid hill-sides and the tufts of aromatic herbs and the
skeleton-white castles and the great Rhône and, beyond
the skyline, the Mediterranean! ...

There I lay, the ruined author in a bare room that
shadows were beginning to invade from every corner.
The fire was a mere glimmer that just gleamed in the
jet irregularities of the small, leaded window-panes. I lay
on one elbow in my old bed of fitted rods with for sole
furniture a canvas bucket with a rope handle and a green

canvas table with a defective leg that was propped against the bare plaster of the wall. . . . The floor of tiles was covered with dead leaves that must last autumn have drifted in through spaces in the windows from which the panes had fallen. With the last light of day I had raked out of an outhouse a cast-iron crock that I had washed and filled at the spring under the oak-tree and there, near the fire, from a pot-rack it hung and was half-filled with a stew.

The rest of the stew was giving me courage. . . . I had said to myself: 'I will never look back. . . . From now on I will never look back . . .' and I do not believe that I have!

I have always been, not so much a believer in, as subject to omens. Indeed, as I have already said, I think any man who is impervious to them is either a fool or something more than a man. I had, then, that night come through Pulborough in a farm-waggon and had brought some haphazard eatables—a leg of mutton, some shallots, bread, salt and a bottle of port. I had had to lug these along with my impedimenta—the green canvas army-sacks—across a stretch of ploughed field in the dusk, the waggoner not having dared to take me and my load further than his master's farm. The farmer—who was also my landlord—was a tartar!

I had come round the corner, heavy with my swag, upon Red Ford in its hollow and I had felt dismay. I like old, mouldering houses and I like solitude. But Red Ford was almost too old and too mouldering and its solitude— between dog and wolf—had a peculiar quality. I had never seen the house before. It had been taken for me by a friend who knew my tastes—and my means. I had no knowledge of the countryside: West Sussex to a Kent-minded man is as foreign in speech and habits as is China. I knew not a soul for miles and miles and I was even ignorant of how far away the nearest house might be. I had never been so alone and with my heavy sack to represent his burden I was indeed the dung-beetle. I had rolled clean down to the bottom of the hill.

I have said that the word despair is not to be found in my vocabulary. . . . The immense rusty key grated in the lock of the door of an unknown room. It was a space filled with shadows. The house had been unoccupied for many years: if one had spoken one would have whispered. The floor was ankle-deep in dry leaves; on the hearth were bushels of twigs dropped by the starlings who had nested in the chimney. I lit a candle and used the last daylight outside in, as I have said, finding more wood and the cast-iron crock. Fortunately the house was bone-dry.

I had my bed and my canvas table up very quickly and then had to face my mutton-neck and shallots. Here there came in the ridiculous omen. It was when I confronted my shallots. A shallot is perhaps the best of all the onion tribe; but shallots are very small things; scores of them lay under my nose. I touched the frontiers of dismay where it borders on the slough of despair. I was at the lowest ebb of my life. It would take me hours and the last of my strength to skin those bulbs. I could not tackle that job.

That really shamed me. One may be poor, friendless, fallen in estate, infinitely alone. But if one goes back on one's arts one loses self-respect and once one loses that —so I have been told—one is lost indeed. And I knew I should never skin those dwarf-onions. I sat on the edge of my bed and faced facts and the fire.

On it, in the crock, the neck of mutton was already browning in butter. Cooking is an art the first of whose canons is that all stewed meats must first be braised in butter or olive oil according as your cooking is *au beurre* or *à l'huile*. (The French call the process *rissoler*.) The second canon is that a portion at least of your onion matter—onions, garlic, shallots, chives even—must be browned too.

I said to destiny:

'Look here, I will skin and brown nine shallots. . . . But not a single other one.'

So far I had not lost self-respect. The shallots browned.

But then I did a thing that I have never done before or since. When the mutton and the rest were nicely *rissoléd* and I had added the quota of water and the water had come to a boil, I closed my eyes so that I might not see the deed and tipped all the rest of the shallots into that crock—skins and all (I *had* washed them).

I said to destiny:

'Now I have lost my self-respect!'. . . The crock began again to boil.

I added that, nevertheless I would make a pact with myself. I would try once more to push that dung up the long hill if those onions came unstuck in the course of boiling. I was not of course trying to tempt Providence. The pact I made was simply with myself. I had no reason to believe that destiny cared whether I made further efforts or not. It seemed reasonable to imagine that that august force took no interest in the matter. . . . So I sat on my bed and gazed at the viands.

But the hour and the nature of the place made it impossible not to think of the supernatural. The half-ruined cottage creaked unceasingly. There was no wind. The fire had ceased fluttering. There was no sound save the creak of the old stairs and the ancient rafters working in their sockets in the walls. Whilst there had been anything to do I had had no need to think. Now there was nothing. I am one of those fortunate—or unfortunate—beings who can think of only one thing at once. Whilst I am building a fire I cannot think out a letter I want to write nor, whilst tree-felling, can I make myself think about the developments of the plot of a novel. I live in my moment.

That type of temperament is fortunate in that, if you have worries you have only to, say, set to work to clean your shoes or rearrange your books to be immune from depressions. Perhaps, too, if you are of the single-minded type you do your material jobs better. Possibly even you think better. . . .

But it is unfortunate in that, if you are of that type,

whilst you are doing anything concrete your powers of observation desert you. I found that to be eminently the case when I was in the line or in support. As long as I had any job to do—and Heaven knows I did three men's jobs and sometimes five—from the 14th August 1914 to the 11th November 1918—as long then as I had any duty to perform I would be almost completely dead to my surroundings. I remember very distinctly having to go from our headquarters behind Bécourt-Bécourdel Wood —to give some instructions to an officer in charge of a detachment by an artillery observation post on the ridge facing Martinpuich. The orders were rather intricate, their being properly carried out depended on careful synchronisation and observation of a trench-map. I had had the orders from Battalion Headquarters by telephone and had committed them to writing myself. But I was not satisfied that my wording was plain: that was why I went myself instead of merely sending an orderly.

All the way I was thinking of how I could have worded these orders to make them plainer. Finally I satisfied myself and, over the ridge saw the valley of the Somme beneath the August sun—for all the world like the down-lands behind the Pent. And when I had done my job and chatted a little with the gunners I remembered I had nothing at all to do till dinner. I needed exercise, for the battalion had just come out, so I gave my horse to my orderly and told him to take it back to camp while I walked.

I found myself on an extraordinarily bright, thistle-covered hillside without the least idea of where I was or how to get back to camp.... In coming up I had had the orderly to guide me and I had noticed nothing—not the brilliant sunlight, not the thistles, not the bullet-stripped trees nor even the contours of the landscape. So perhaps the engrossed temperament is unfortunate. I might otherwise have written better about the war.

But now, in Red Ford, there was nothing to do and there would not have been light enough to do anything.

I had in my bag the adaptation of one of my books to French that I had begun on the Somme and was minded to finish there. But, on account of paper shortage it had been written in a hand so minute that in the light of my one candle I could not read it.... The crock went on boiling and fatalistically its contents swayed my destiny....

A single candle, some pot-herbs, a neck of mutton, the shallots, a meat-chopper, a tin plate, a washing-up bowl, a loaf of bread, a bottle of port.... In a store in the market-town I had grabbed these things hastily—and it is characteristic that after the candle the first thing I had thought of had been the pot-herbs ... thyme, sage, bay leaves, chives and garlic. For light is your first necessity and then flavour for whatever food you have.... I might have brought more than one candle. But when one is in a hurry the mind works queerly. They say there is no knowing what you will not snatch up when escaping from a house on fire.... And whilst I had been buying those things the waggoner with the farm-cart outside was all on edge to be going. He went in dread of his master the farmer. He was a tartar. So I had only a single candle and could not read. And the crock was boiling. A good stew takes hours and hours to make—three, four, seven, simmering slowly. I had decided to give it an hour ... and as much longer as I could stick it!

It is in such circumstances that the supernatural becomes clamant for your thoughts....

I had given little thought to the supernatural but I have a sense of it as usually accompanying me in the shape of luck at cards, or in finance and the little imps of doubts and fears. I suppose most men have that sense. ... When I was a boy I had an orthodox Roman Catholic training. But when I was between seventeen and eighteen I went to my Confessor and said:

'Father, I find it very difficult to believe in—to conceive of—the Third Person of the Trinity. The rest of the Creed does not trouble me but that is too difficult.'

He was a very old, old Passionist who had been on a mission in Australia and, a native having speared him through the lattice of the Confessional, he had been sent to Paris to recover from the effects of his wound in the monastery attached to the American Church in the Avenue Hoche. He said:

'Calm yourself, my son; that is a matter for theologians. Believe as much as you can and be a good boy.' And I do not believe I have ever given a thought to what may be called the supernatural-major from that day to this. Prayer for personal ends I have almost never permitted myself. One's personal ends usually imply that what one desires will have to be taken from someone else and one can hardly contemplate asking the Heavenly Powers' arbitraments in one's favour against others.— These I take it are the sentiments of most proper men.— During the worst phase of the first battle of the Somme —on the 13th July 1916—at night, when one had a long period of waiting, with nothing to do, in pitch-blackness, in the midst of gunfire that shook the earth I did once pray to the major Heavenly Powers that my reason might be preserved. In the end, if one is a writer one is a writer and if one was in that hell it was a major motive that one should be able to write of it, if only for the benefit—to the extent of the light vouchsafed one!—of one's fellow men. So what reason I had was preserved to me, and I eventually placed my candle in front of the image of Our Lady of Good Help to the left of the entrance door in Notre Dame.

That apart, I do not think that I have much troubled the major powers with supplications. . . . But in Red Ford, whilst the crock boiled over the sinking fire the cottage was filled with a horde of minor malices and doubts. The stairs creaked; the rafters stirred; in the chimney the starlings, distressed by my fire, kept up a continuous rustling. The rest of that empty house I had only dimly seen by the light of one candle. It was unknown ground. I had a sense that the shadows were alive with winged

malices and maladies and that the dark, gleaming panes of the windows hid other, whispering beings that jeered behind my back, hanging from the rose stems in the outer night. And the crock went on boiling out destiny. If the skins came off the shallots I was to make a further effort. If not I was to let go.

To where?... To where the dung-beetle finally slid? I don't know. But by that time I was already in the peasant frame of mind. All over that countryside and all over the world; on the Alpilles of Provence as in Kent; on the Roman Campagna as in the islands of the South Seas and the lands flooded by the Yellow River the peasant has the final gift of the really Happy Dispatch. Perhaps Providence who prescribes for him a life of endless monotonies, unending toils, exposures, heats, frosts, blights, murrains and pestilences, gives to him a mean of departure from life more merciful than the sword of the daimio. He can say: 'Enough' and fade—and fade further, and lie down in the shadow of a rick, under a date-palm or in his bed and so pass away.

My mind ran on tired people.... There had been an old butler in Albert in 1916. The shells were falling on the town desultorily; one here one there. He sat asleep in the sunlight, with his black alpaca béret, his striped waistcoat and his green baize apron and his horn-rimmed spectacles. The *Matin* was on the table before him; above his head the canary spattered from its cage the seed over his skull-cap.... He was worn out with the effort of keeping the officers and orderlies of Headquarters from walking with muddy boots on the bright, waxed tiles of the *salon* of his absent master—and worn out with all the obscure toil that had gone before.

And my thoughts went back to my grandfather who had slaved all his life with his brush and then laid it down and went up to bed and died in the night. And to my father who had slaved with his pen and died worn out and to my mother who at the end of her life was so tired that she would not even go to see the exhibition of

her own work that someone had got together—and to poor Stephen Crane in his porch-room on Brede Place, covering with his tiny handwriting, laboriously, the immense sheets of white paper. . . . Alas, in my valise I had sheets of faded paper covered with minute handwriting. . . .

But the skins came off those shallots and floated in the bubbling on the top of the crock. So, after an hour and three-quarters of waiting I skimmed them off and ate a fair-to-middling stew and drank half a bottle of port.

AT RED FORD

Before next nightfall I had a dog and a man-servant. This caused amusement to my friends, I do not know why. They said it was typical of me. I can't again see why. The dog was just dog, of no particular race and no particular intelligence—white with black patches. The man-servant was a nasty boy of fourteen of no particular gifts and of no apparent intelligence though in later years it grew evident that he possessed extraordinary gifts of foul language and had most of the human vices in a marked degree. . . . For the moment I employed him in drawing water from the spring, clearing roots, doing a little digging and looking after the dog. I had acquired the dog from a wandering man by the roadside—for half a crown, say sixty cents. In consequence he had little homing sense and a great part of the man-servant's time was taken up in running after the dog and retrieving him from other cottages or farms. The dog's name was Beau, that of the boy, Jo. . . . Later I acquired a goat, called Penny because it had a certain facial resemblance to Mr Pound, and a drake that someone called Fordie because it lived at Red Ford and was good to look at. These beasts had a great dislike of being left alone so that when I went out I was followed by dog, drake and goat—sometimes for great distances. A little later I acquired a

black pig. This animal was also companionate but I thought my procession would look too noticeable if she were added to it. I built her a sty in part of a sort of natural cave in the bank at the back of the house.

In those halcyon days—just before peace was declared —everyone was filled with public spirit. That was the era of reconstruction and each human being had his own plan for the salvation of humanity. My own contributions were to be two. Leaning on my spade-handle I would dream long dreams about them.

The sun, as I look back upon it, seemed always to shine —though I remember coming out of my cottage door one morning and seeing all my beautiful beans cut down and blackened—by frost. But sunshine and stillness seemed to brood over the land, awaiting the sound of the guns from Portsmouth. And in that stillness I dreamed—of evolving a disease-proof potato! The second dream was so audacious that I hardly dared acknowledge it to myself.

The final arcanum—the philosopher's stone—of agriculture is to discover a method of wastelessly administering nutriment to plants. An incredible dream. For, as manure is at present employed an immense percentage of it is wasted in the ground or on the nourishment of weeds —and a vast amount of labour is wasted in the distribution. If then a method could be discovered by which each plant planted—or each seed sown—could be directly supplied with the nutriment it is to require the addition to human wealth would be almost unmeasurable. As against that the transmutation of base metals into gold would be a mere flea-bite. . . . And then, presumably, you would throw men out of work. . . .

I have had these dreams ever since I can remember— certainly ever since the nineties when in Paris I studied kitchen-gardening. I tried to introduce wine—and tobacco-growing—into Kent, but was stopped by the Excise authorities: I experimented along the lines of the discoveries of the great Professor Bottomley, but stopped

them in order to write a book. Literature kept creeping in.

Now literature seemed to be done for as far as I was concerned and I began with enthusiasm and indefatigable industry on the evolution of my potato. I had scraped together somehow a little furniture. The first thing I bought was a brass candle-snuffer tray, an eighteenth-century gadget which my friends declared to be a characteristic extravagance. But it looked consoling, lying with a goose-quill pen in it on my broken-legged green canvas table, and round it I could conjure up a whole *décor* of eighteenth-century rooms. Then Mr Clifford Bax lent me a chest of drawers and a bedstead—an act of kindness from a poet who must have cordially disliked my work if he had ever heard of it!... Then I bought five knives and some spoons and forks at the sale of a lieutenant of the East Sussex Regiment. He had committed suicide.

Growing potatoes from seed is quite different from the usual propagation. Instead of cutting a potato in half and committing the halves to the ground you have to take the seeds that are contained in the green, apple-like fruits of the plant in the autumn. These you sow in pots from which finally arise tiny potato-plants. You then set out these plants and in due course obtain a few tubers. These will be your future seed-potatoes.

Theoretically each separate plant should differ from every other one. Each should be the progenitor of a new race, and, the race being new, should for a time be immune from disease.... Actually a great proportion—say six out of ten—seem to inherit ancestral diseases. But three out of ten will be markedly different from their ancestor and from each other, and the tenth will be a sport —with black, scarlet or five-fingered tubers or with blossoms of unusual blues and pinks.

Of, say, fifty different plants by the end of 1922 I had succeeded in selecting nine that seemed to be reasonably new varieties and two that apparently resisted all the diseases they were likely to meet. They were not

however very attractive in appearance and, presumably on that account, received no commendation at the Pulborough Flower Show. I daresay I could have bred them to be smooth and oblong. I had planted them, on purpose to test them, in very bad ground so that, though very large and heavy-cropping, they were lumpy, one quite white and the other peculiarly purple. If, next year, I had planted them in fine, friable, carefully sifted soil they might have turned out to be smooth enough to please the market-gardeners and to have established a race as famous as the Beauties of Hebron or the great Scottish varieties. Then I might have known fame as a benefactor to my kind—and near wealth. . . .

I have always had luck when gardening. I imagine it is because I observe the rules of the game of gardening life. I propitiate the little winged devils of doubt and destiny. I always seed whilst the moon is waxing; I never begin a planting on a Friday or a 13th but always on a 9th, an 18th or a 27th. I attach superstitious reverence to certain favourite plants or beds. If there is a wishing well in the neighbourhood I fetch a bottleful of it to start my first watering of the spring. . . . So I attached names of friends to each of my potato-plants.

In consequence Joseph, when he woke me in the mornings, would dash in with startling pieces of literary information:

'Mr 'Enry James have picked up proper in the night, but Mr Conrad do peek and pine and is yallowin'. Mr Galsworthy's beetles 'ave spread all over Miss Austin. . . .'

He was exceedingly enthusiastic about those plants. . . .

Those little imbecilities of a jocular kind are maybe necessary to the proper conduct of an innocent and agricultural existence. They cause a little merriment by the juxtaposition of the improbable; they enhance the zeal of one's finds; perhaps they are palliatives against the imps and little devils of doubts; perhaps they induce the contemplative and bovine frame of mind that is conducive to good gardening. . . .

I had at Red Ford a rook called: 'O Sapientia!' We found him with a broken wing, in the paddock on the 17th December.... The collects of the octave of Christmas are the collects of the Great O's.... They begin: 'O Sapientia....' 'O Innocentia' and so on.... My birthday happens to fall on the 17th, so my collect begins: 'Oh Sapience....' That should make me be listened to with more respect.

Certainly 'O Sapientia' was remarkably propitious to one's boots. He hung in a wicker cage by the kitchen door and showed a prodigious appetite for cheese. If Joseph was allowed to give that rook a couple of chunks of cheese he would clean and grease, not only one's boots, but the donkey's hooves, dreamily whilst he gazed at 'O Sapientia,' but in the most masterly fashion.... And there are ways and ways of greasing boots and hooves.... I cannot remember the donkey's name but Joseph never looked after his hooves properly till he could do it looking up from time to time at that wicker cage....

Mr Galsworthy—the novelist, not the potato—once nearly jumped over my verandah at Winchelsea because I said:

'Here's Hall Caine coming.'

I always thought that Poor Jack suspected me of keeping queer literary company and on that occasion he ejaculated:

'My *God*!' though usually the least profane of mortals.

But the Hall Caine who was walking with a disdainful nonchalance down the middle of Winchelsea High Street was only the Blue Angora cat of the House.

That cat was the most contemptuous being that I have ever even imagined. Once Conrad threw the match from his cigarette at the fire-place. It fell short, onto the magnificent tail of Hall Caine, who was gazing at the coals. The tail caught fire. But did that cat move? No. ... It simply gazed contemptuously down and the master of adorned English had to spring like a lamp-lighter to extinguish the flames....

And the hilarity that cat's expression caused in Conrad
was so great that—this is the point of the story—he
immediately wrote three pages of the 'End of the Tether'
right off the reel....

I do not think I had many contacts with the outer
world, being hidden in a green—a far too green—corner
of England, on a hill-top that was almost inaccessible to
motor traffic, under an immense screen of giant beeches.
But I must have had some contacts. Fabians, as has
always been the case on hill-tops, drifted about and
seemed to regard me as a brand to be snatched from the
fires of militarism and Teutophobia and to be turned into
a whitened finger-post on the road towards Guild Social-
ism.... And Mr Pound appeared, aloft on the seat of my
immensely high dog-cart, like a bewildered Stewart pre-
tender visiting a repellent portion of his realms. For Mr
Pound hated the country, though I will put it on record
that he can carve a suckling pig as few others can. With
him I quarrelled about *vers libres* and he shortly after-
wards left England and acquired his mastery of the more
resounding rhythms. About the same time I had a visit
from Mr F. S. Flint, the beautiful imagiste poet who,
unfortunately, had had a difference with Mr Pound about
French poetry and declared that he had given up writing
poetry of his own.... That gang, which had given Lon-
don its chance to become an Art Centre of the world,
had, to my great mournfulness, disappeared as the Rhine
separates at its mouth and sinks into Dutch sands.
Gaudier Brzeska had been killed; I had lost touch with
H. D. and Mr Percy Wyndham Lewis.... Conrad wrote
to say that he had not earned a penny for over two years.
... And we had ninety days of drought!

Then my book was published.... It met with no atten-
tion whatever. The gentleman who had approached me
at the French Embassy wrote that it appeared to have
been written in my dressing-gown and slippers. A gentle-
man on *The Times*—which was still the property of Lord
Northcliffe and on which I was blacklisted—declared that

I seemed to think myself a literary personage, but I wasn't. Both statements were true. I nearly always write in my dressing-gown and slippers. I am doing it at this moment—in a room that looks over the Mediterranean. . . . I tumble out of bed soon after it is dawn, put on those offending garments and start to write. I do my thinking for the day, in bed, looking at the sea as it dimly appears and, with my thoughts fresh in my mind, go straight to my writing. In that way I have finished work by ten or thereabouts, for the rest of the day I can garden. It seems as good a way as any other. I cannot understand why that gentleman was so offended. . . .

VISITORS FROM THE WEST

And then America came creeping in. *Poetry,* under the editorship of Miss Harriet Monroe, suddenly, out of the blue awarded me a prize for the best poem of the year. I was making a stake-and-binder hedge on the top of the twelve-acre field with the glorious view when the letter was brought me. . . . My gigantic sows were forever breaking out. Their gentleman-friend lived at Fittleworth, two miles down the hill, and they were a great nuisance for nothing in the world could stop them. Normally, when you live on a common, you have to fence out, not fence in. My beasts had grazing rights and if the neighbours' fences did not keep them out I had no responsibility for any damage they did. But that dread plague, the foot-and-mouth disease, appeared in that part of Sussex and there was a penalty of £50 for every beast of yours that was found on a road. That did not apply as far as the Common was concerned. Unfortunately Fittleworth was off the Common and that attractive boar lived next to the rose-covered, thatched cottage that was the police-station.

And it was really agony to two stout gentlemen like myself and Mr. Standing to have to chase those enamoured

and monstrous quadrupeds up and down those roof-like, beech-grown declivities, assisted by the red-headed hind and Joseph, the stable-boy and the kitchen-maid and the carpenter and his wife all yelling and beating tins—and all to almost no purpose. That county was Sussex and the emblem of Sussex is a hog and its motto "Wunt be druv," and those were Sussex sows, impervious to blows, deaf to objurgations, indifferent, when love filled their bosoms, to the choicest porcine condiments. . . . Yet there was one thing they feared!

On one dreadful afternoon we had been completely worsted. We wiped our dripping brows and lumbered, Standing and I, to the shed where the cider-barrels were. The red-headed Irishman went back to his digging of the potatoes, Joseph to his more uncongenial boots, the kitchen-maid who dearly loved scampering over the hill-side to her novelette in the scullery; Hunt, the carpenter to his boards, and his wife to her washing, and their son who was in the Royal Artillery to his damnable bugle. And the great sow, Anna, was over the hills and away down to her beau.

And Standing interspersed his reminiscences of the hard old cider that the local earl used to give his workmen with the rueful words:

'Fifty pounds. It do seem a lot of money to lose over a sow. . . . It do seem a lot of money to lose over a sow. . . . Fifty pounds. . . .'

And I was, equally ruefully, thinking about overdrafts and interviews with a sympathetic but obdurate bank manager. . . .

A voice called from above the hedge—a lady's voice:

'Hullo, Standing: Hi, Standing. . . . Here's your pig. . . . Here's the sow, Anna . . .' and there she was, trembling with eagerness to be let into her sty. . . .

That heroic lady, wheeling a perambulator with a baby in it had been coming up Fittleworth Hill. She had met Anna and had driven the perambulator right against that monstrosity. . . . That had been too much for the sow,

who dreaded perambulators as she feared no fiends. The sow had tried to make a break through a turnip-field but everywhere she met the perambulator, the lady occupying a strategic position on the road. So the sow had given in. . . . And we locked and bolted her in her sty, and we went to make up the gap in the hedge the sow had made . . . and Miss Monroe's amazing cheque came from the Middle West—from Porcopolis itself. . . .

The first queer thought that came into my head was:

'Now I will get a *chien de berger alsacien*, a police dog. And call him Chicago! . . .'

I don't know why that came to me. I had never been conscious of wanting a police dog. I do not like dogs much unless they can be made to be useful and I don't believe you could train a police dog to herd pigs. . . .

Then there came a letter and an article about my work from a real Professor in a great Western University. That Don had pursued me through life with the persistency of a sleuth in a moving picture. No word of mine had he left unread: there seemed to be no phase of my life to which he had not applied the microscope. He provided me moreover with a full-fledged philosophy, religious views and a disbelief in the Infallibility of the Pope. It appeared that, years before, he had gone up the Rhine as far as Heidelberg on the same boat as myself. 'But,' he wrote modestly, 'although I have read over a thousand anecdotes by this writer in not one of them does he mention myself. So I can only imagine that my personality made no impression at all upon him.'

One should not meet one's life heroes. The poor professor came to stay with me on that farm and he was dismayed. He was on his way to Strasbourg for his Sabbatical year and he expected to find me looking like a poet. I looked like a tramp dressed in military clothes that I had rescued from a scarecrow and talking of hogs. And after dinner—it was midsummer and the days were long—we made him ted hay—in evening-dress.—I have always dressed for dinner when I was farming.—And it was

warm and American evening-dress is not made for tedding hay! And my house having been built before the discovery of the United States contained nothing in the way of what the French call *conforts modernes*. . . . I have said that I am indifferent to comfort! . . . And after a long summer day of farming I am usually indifferent to literary conversation. . . .

Next came—not by letter but in person—an intense and very energetic journalist from one of Mr Hearst's papers. He professed a knowledge of my work and career, at least equal to those of the Professor of English, but I think he must have acquired it not by hard reading but, as it were, by the grace of God. He stayed with me for some time but if I ever, as must be the case with even quite retiring writers, mentioned one of my books it always happened to be one that, by accident, he had not read. I was none the less flattered that one with such varied attainments should even give himself the trouble to imagine he had read me.

There was nothing that fellow had not done. He had fought and farmed and camped in virgin forests and shot grizzlies and tracked down murderers and felled giant oaks and fought desperadoes. Unfortunately my tools did not suit him. He volunteered to drive the mare to the mill for middlings. He came back leading that amiable beast, having overturned the cart into a stream and broken off one of the wheels whilst the middlings melted in the water. I should have thought it impossible to make that mare do anything wrong. You could let off a fire-cracker under her tail and she would do no more than wag her ears. My friend however said he was unused to that sort of harness. In the Far West they drive with the reins crossed. . . . He professed to share my passion for garlic and pulled up and devoured a large part of my plantation—raw. He told the doctor who administered the stomach-pump that the garlic you bought in Avenue A was different. . . .

But his great achievement was in felling trees. He described with enormous animation to Standing—who re-

garded him as a fabulous monster!—how he had cut
down a hundred of the giant California redwood pines in
—I think, an afternoon. Standing said:

''Is Lordship would pay him a pretty penny to be 'is
woodreeve!' and we went to cut some of my oak-saplings,
about as big as my thigh. Standing and I, when we used
an axe, would take it near the end of the helve with the
left hand and then, sliding our rights up to the axe-head,
would use the left for strength in the down-stroke and the
right for guidance and weight. In that way we usually with
little fatigue could go on for most of an afternoon. They
must have used different axes in California. . . . My young
friend grasped his firmly with both hands at the lowest
extremity of the helve. He whirled it round and round
his head as if he were giving a display with Indian clubs.
Then he let go at the tree. The axe-head glanced off and
cut off the heel of his shoe.

Standing screamed! . . . That elderly, tough, bristling
giant of a man gave a high scream like a horse that has
broken its back. He went chalk-pale under his week's
bristles and said:

'I could do with a gill of 'is Lordship's brandy!'

Then he turned on that young man like one of the
grizzly bears he had shot. He described how Jim Selby
had cut his leg clean through at the shin and how Jack
Wilmot had killed his little daughter standing near him.

'I've seen fools!' he said. 'But never a fool like you!
Do you think a haxe is the tea-spoon your mother fed pap
to you with. . . .' And on and on and on. . . . When it
came to carrying these logs up the hill he selected—he
was the master of the team—the heaviest and longest of
all for that hero to stagger under.

'No, Cahpt'n' he said, when I remonstrated. 'Yon one's
felled in Caliyifornyer. . . . Let'm carry in Old Eng-
land. . . .'

So Mr Hearst's star provided infinite amazement in
Sussex. In the end he took down by shorthand my best
story and sold it to a London magazine for sixteen pounds

that I could well have done with myself. . . . I don't know why people do things like that to me. I suppose they think I don't notice. . . .

Then came several agreeable young men and then a letter from Mr Cunninghame-Graham introducing other young men from the Middle West. That immense region appeared to hear of that incomparable writer of English and noble horseman at about the same moment as it heard of myself. The letter giving the name and address of one of these young men I immediately lost and although I remembered the young man's name I could not for the life of me remember the address except that it was near either's Earl's Court or Gloucester Road Station on the underground. Mr Graham's letter had been so generous in praise of the young poet that I addressed two letters to him in that neighbourhood, the one being addressed simply 'Near Earl's Court Station' and the other 'Near Gloucester Road.' His Majesty's intelligent Post-office promptly delivered the first into the hands of Mr Glenway Wescott and returned the second to me.

So destiny and the mail service conspired to make me write. For if Mr Wescott had not paid me a visit of some duration I do not think that I should have taken seriously again to writing.

JUST BEFORE . . .

Two years ago I happened to find in New York my engagement book for 1914. It was tied up with the soiled, soaked translation into French of my one novel. I had begun to make it in Bécourt-Bécourdel Wood in July 1916.

The engagement book was an amazing, packed affair. From the middle of May to the end of June, except for the week-ends which I had spent either at Selsey, where I lived next to Masterman and the editor of the *Outlook,* or

at other people's country-houses—there were only six days on which I did not have at least three dinner and after-dinner dates. There would be a dinner, a theatre or a party, a dance. Usually a breakfast at four after that. Or Ezra and his gang carried me off to their night-club which was kept by Madame Strindberg, decorated by Epstein and situated underground.

London was adorable then at four in the morning after a good dance. You walked along the south side of the park in the lovely pearl-grey coolness of the dawn. A sparrow would chirp with a great volume of distinct sound in the silence. Another sparrow, another—a dozen, a hundred, ten thousand. They would be like the violins of an orchestra. Then the blackbirds awakened, then the thrushes, then the chaffinches. It became the sound of an immense choir with the fuller notes of the merle family making obligatos over the chattering counterpoint of the sparrows. Then, as like as not, you turned into the house of someone who had gone before you from the dance to grill sausages and make coffee. Then you breakfasted—usually on the lead roof above a smoking-room, giving onto a deep garden. There would be birds there too. Those who cannot remember London then do not know what life could hold. Alas. . . .

. . . AND JUST AFTER

Once, just after the declaration of war, when Holland Park was picketed because anti-air guns were posted there, a policeman startled me as I was going home by jumping out of the shadows and exclaiming:

'Halt. Who goes there?' I said: 'God damn and blast your something eyes what do you mean by startling me?' He said: 'Beg pardon, sir, I did not know that you were a gentleman.'

NOT REALLY ENGLISH

Years and years ago I was talking to Mr E. V. Lucas.
We were lying on the grass at Kent Hatch, looking out
over the great view that goes away into West Kent. . . .
Mr Lucas was then publishing his edition of Charles Lamb
and I was abusing Lamb and De Quincey and Hazlitt and
all the tribe of English essayists. I was saying that it was
with their works—and particularly with those of Charles
Lamb—that the English people anodyned what passed for
their brains so that Pure Thought was a thing unknown
in all that green country. It comes to me suddenly and for
the first time after thirty years that I was not tactful!

But Mr Lucas seemed most amiable. Like all English
humorists he was of a mournful and taciturn cast. On the
very finest days he carried an umbrella. He listened for a
long time to me, slim, dark, puffing at his pipe and looking
out over the view.

I said:

'Damn it all, Lucas, you are an intelligent fellow. How
can you read this buttered-toast-clean-fire-clear-hearth-
spirit-of-the-game-beery-gin-sodden-sentimentalism? What
can you see in it? For Heaven's sake tell me what you
see in it!'

Mr Lucas let ten puffs of his pipe eddy away towards
the great, green-grey vale below us. . . . I kept on with
invectives, asking him to tell me. Why wouldn't he at least
tell me?

Between the tenth and eleventh of his next set of puffs
he said:

'Because you wouldn't understand.'

I said:

'Damn it all, why wouldn't I understand? Has not
your servant eyes? Has not your servant ears? A tongue
to savour meats? A belly for their digestion?'

Mr Lucas gave four puffs at his pipe. He said:

'"Belly" is not a very nice word.'

I said fiercely:

'But why can't I stomach Lamb and Hazlitt and the whole boiling? Why?'

He removed his pipe from his lips to say:

'Because you use words that are not quite nice. Charles Lamb would never have used them. You remember that Thackeray, speaking of Lamb, removed his hat and whispered "Saint Charles."'

I said:

'Lamb was a drunkard. His sister committed a murder. Wainwright, another English essayist, committed a murder and was hung. I never was drunk in my life. I never attempted to murder anybody. I was never hung. I detest buttered toast. Is that why I do not appreciate Elia? Or is there another reason?'

Mr Lucas did something with his pipe. Perhaps he put it back in his mouth. At any rate his pipe like that of later British Prime Ministers was an integral and active part of the landscape. I said insistently:

'Why-cannot-I-appreciate-Charles-Lamb?'

Mr Lucas, always the gentlest of human beings, said more gently than usual:

'Because you are not really English.'

That hit me in the face like a discharge from a fireman's hose.

I said:

'Why am I not English? I play cricket not quite as well as you do but with as much pleasure. I play golf more often if not so well. I went to as great a public school as yours. I take a cold bath every morning. I know as much about flower-gardening and more about kitchen-gardening, sheep, the rotation of crops, hops, roots and permanent pasture. I drop my aitches before words derived from the French. My clothes are made by a Sackville Street tailor who made for my great-grandfather and has never fitted me too well. I never let anybody see me writing and deprecate as far as possible the fact that I

follow an art. I shave every morning and have my hair cut
every fortnight at the proper shop in Bond Street. Why
then, am I not English?'

Mr Lucas said with dejection:

'Because you do not appreciate. . . .' He paused; I
supplied:

'Charles Lamb?'

He said:

'No, I am thinking.' He added: '*Punch.*'

I exclaimed heatedly that I was the sole owner of the
recipe for the world-famous Prince Regent's brew. It had
been all that my great-uncle Tristram Madox had had to
leave my grandfather.

Mr Lucas said that he did not mean the beverage. He
meant the journal. A number of Englishmen had not read
or heard of Lamb but no one who was not English could
appreciate him. Equally no one who could not appreciate
him after they had read him could be English. But every
Englishman read, appreciated and quoted the journal un-
ceasingly.

I daresay the diagnosis was correct. . . .

Till that day in 1898 I had never given the matter of my
own nationality a thought. I gave it very little after that.
There remained in my subconsciousness a conviction that
must have grown stronger—that I was not English. Not
English at all, not merely 'not really English.' I never had
much sense of nationality. Wherever there were creative
thinkers was my country. A country without artists in
words, in colours, in stone, in instrumental sounds—such
a country would be forever an Enemy Nation. On the
other hand every artist of whatever race was my fellow-
countryman—and the compatriot of every other artist.
The world divided itself for me into those who were
artists and those who were merely the stuff to fill grave-
yards. And I used to feel in the company of those who
were not artists the same sort of almost physical, slight
aversion that one used, during the war, to feel for
civilians. . . .

DUELS

I fought a duel in Bonn with a student who trod on the tail of my dog. It was not a *Mensur*—one of those affairs at which the *corps studenten* hack each others' faces to pieces and incur the scars of glory. No, it was a duel with rapiers such as soothes outraged honour. For, if in student Bonn of those days another student trod with intention on the tail of your dog, your honour was tarnished until blood had cleansed it. But to my astonishment—for I had regarded the contest as a necessary action—my young friends of the Intelligentsia regarded the proceeding with the greatest disfavour. In those days already the State universities—and particularly their customs—were regarded with great disfavour by the children of the professional classes. So I got no glory.

A little later I fought another with a young man in Paris over a celebrated professional beauty. I do not mean for a moment to assert that either of us had enjoyed the lady's favours. She was meat for our masters and is still a leader in the society of another capital. But I had actually spoken to the lady and my young friend thought he was better with the sword. So we went to the Bois de Meudon.

In each event the result was the same. I wounded my adversary in the forearm. I was so long in the reach that few men of my own class or near it ever got by me. But I was always so wanting in enterprise or ferocity that I never made much show in competitions, though I once won a pair of gilt-headed foils at London University. They were promptly pawned by a necessitous relative; so I got little good out of them.

I all but got into a duel later with a Polish enemy of Conrad's. That would have been a much more serious affair. But Conrad's unfortunate opponent committed suicide in the train coming to the meeting. I think I was rather glad that that meeting did not come off. The poor

man was too miserable to have been fought. But last spring I tried to fight one with a French man of letters who had said injurious things about Henry James—and that that did not come off I still regret. I wrote the most injurious things I could think of to that French gentleman —to the effect generally that dog does not eat dog if he is a gentlemanly dog and that one constructive imaginative writer should not write things against another. But the French gentleman told the friend of mine who went to see him that: firstly, the letter had not reached him; secondly, that he was too old to fight and that, thirdly, he should imagine that I was too. So I suppose he really had the laugh on me. For, alas, when I come to think of it, almost all the people I could now want to meet in mortal combat must be nearly past standing up!

I ought, I suppose, to be ashamed of myself. There are innumerable reasons against the duel. Yet there are certain things which the duel alone can satisfactorily remedy, though it is perhaps only a foreigner who can see that. For instance, against libel. If a man libels me I would rather have his life than his money. . . . Or if anyone libels a dead friend of yours what better can *you* do than pink the fellow in the forearm—as a gesture to indicate that you spare his life or that you have offered your life to the shade of your dead friend? I can't expect Anglo-Saxons to agree with me. . . .

IN THE ABSENCE OF MR JOYCE

I had to settle the question of my return to England. I remember the exact hour of my coming to that decision —though the exact date does not come back to me. But I had a date with Mr Joyce at the old Lavenue's, which used to be one of the best restaurants in Paris. As I stood outside it the clock on the Gare Montparnasse marked five and twenty past seven. I can see the spidery black

hands on the pallid, opaline face of the dial! I had asked
Joyce for seven-thirty; so I bought an English newspaper
and sat down to an apéritif outside the restaurant in an
evening of golden haze. . . . So it was perhaps in August
1923.

The English newspaper was yelling with triumph. All
across the front page it yelled the words: 'Big Axe's First
Chop!' The British Government had abolished the post of
Historical Adviser to the Foreign Office. It was then that
I said:

'Perhaps I had better never go back to England!'

A country whose Foreign Office lacks Historical Advice
is no country for poets—or for anybody else! . . . It was
then 19.h.27.30. . . . The clock had moved on two and
a half minutes. . . .

A peculiar incident had, even before my leaving Eng-
land, pre-disposed me towards expatriation. This was the
call of an election agent—a Tory, I think. He asked for
my name on his rolls, I said he could have it because I
never refused anybody anything that was mine to give and
the Liberal agent had never called on me. . . .

When he had taken down my name he said oilily: 'And
what profession shall I put, sir?'

I said: 'Writer?'

He exclaimed:

'*What?*' . . . and only after a second remembered to
add: 'Sir!'

I said:

'I'm a writer! I write books for a living!'

He was appalled and became almost lachrymose. He
said:

'Oh, *don't* say that, sir. Say: "Gentlemen." '

I explained that I was not a gentleman. I was a poet.

He became almost frantic at that. He said:

'Oh, I *can't* say that, sir. It would make my roll look
ludicrous. I should be laughed out of my job if you made
me say "poet." . . . Make it "gentleman," sir. . . .'

And, sitting there, outside Lavenue's, I was reminded

of something else. When I was employed in demobilising
my battalion after the armistice I had to sort men into
categories. There were eighteen categories. They regu-
lated the rate of priority of discharge according to the use
of the individual to the community. In the first category
you had Administrators—Bankers, Manufacturers, Em-
ployers of manual labour. After that you had classes
labelled: 'Productive'—skilled artisans, coal-miners, black-
smiths, whitesmiths, breeders of animals. . . . When I
came in my inspection of the Army Order making these
regulations, on the XVIIIth and last category, which was
labelled 'Totally unproductive,' I found huddled together
and not even in alphabetical order those who were to be
last discharged. They were utterly useless to the com-
munity. They included:

'Travelling showmen, circus performers, all writers not
regularly employed on newspapers, tramps, pedlars, all
painters not employed as house, factory, industrial, car-
riage, or sign-painters; all musicians, all unemployable
persons . . .' and, oh irony! 'Gentlemen independent.'

I pondered over those things whilst I waited for Mr
Joyce. . . . It was by then 8.10. . . . Indignation took com-
plete possession of me. That artists should be lowly rated
was supportable. But that they should be labelled un-
productive, being the creatures of God who produce en-
tirely out of themselves, with no material aids and no hope
of help! I could imagine, even with sympathy, the honest
Army Officer who composed that document in his White-
hall Office. . . . But that the State should, to its eternal
shame, let pass such a compilation—that appeared to me
intolerable.

And on top of that that Election Agent! It appeared
that for me and my brothers there was no escape. One
way or other—either as Artists or Gentlemen we had to
be in the XVIIIth Category. . . . And more than anything
I resented being forced to be a Gentleman. An Artist
cannot be a Gentleman, for, if he is a Gentleman he is
no artist. The best Gentleman is he who, with the pink

cheeks of urban health, inhabits a glass showcase. He at least will never commit a solecism. His clothes at least are for ever perfectly pressed. He at least will never express despair, intelligence, fear, animation or passion! And I on an electioneer's sheet must write myself down—that!

I pondered like that as the hands of the station clock reached 8.15!

And now Mr Baldwin's Government had moved. They were no Gentlemen, they had allowed themselves to be badgered by the cheap press, into action. With an axe! The cheap press with the voices of jackals demanded Economy. To them Mr Baldwin's Ministry had, like the Russian mother, thrown to the wolves the Foreign Office Adviser in History. No British diplomat from henceforth was to know what was the Pragmatic Sanction, or what was enacted by the Congress of Rastatt, the Convention of Cintra, the Venezuelan Arbitration award—or the very treaty of Versailles which by then was historic. . . .

Two ladies passed and bowed to me—Miss Sylvia Beach and Miss Nina Hamnett.

They said:

'We shall see you at Joyce's dinner at nine. Opposite!'

I said:

'No: he's dining with me here at 7.30. . . .' It was 8.37.

They said:

'Joyce never dines with anybody, anywhere but opposite and never at seven-thirty.'

I said:

'He is dining with me to-night to try the *Château-Pavie*, 1914.'

They said:

'He never drinks anything but white wine.'

I said:

'Anyhow I am never going back to England.'

They said:

'How nice!' and passed on.

So it will appear to the reader that I have nothing to say against my country which any Englishman would

resent. For all that I have said amounts to that the English State and the English social hierarchy believe in keeping the imaginative artist in his place—his place being the XVIIIth Category. The admirable Staff wallah who compiled that schedule would merely shake his head in bewilderment at reading my reasons for living outside his shadow. He would say:

'This seems to be rather tosh. Does Mr F. really think that banks are not more useful to—er—the Community than . . . er, novels? . . . Surely not *novels*! . . . Or that coals are not more necessary to England than pictures. . . . Even hand-painted oil ones! . . .' And he will shake his scarlet hat-band in perplexity and add: 'The johnny must mean something. But what?'

And the tragedy is that that man is an admirable personality inspired by the very best sense of duty. The very best! If you could get him to see that a training in the Arts was as salutary to mankind as Army physical training, he would spend a month of slow arranging and re-arranging his schedules so that every Tommy would get at least as many hours a week of Aesthetic and Literary training and exercise as he spends on P.T. And that Staff Officer would see to it that the instruction was the best to be got and that the regimental officers saw to it that there was no shirking.

But the tragedy is that you could never get him to see what every peasant here in Provence knows—that to the properly circumstanced man frescoed rooms are infinitely more salutary than artificial heating—or than anything that is the product of steam-driven machinery. . . . So they fresco their rooms with those admirably primitive local paintings that have had so great an influence on modern art and make no provision whatever for heating. And, on occasion, it can be cold here.

From that day I began to feel that I had no country and I have gone on feeling more and more convinced that I have none—or that my only country is that invisible one that is known as the kingdom of letters. So that, since that

day I live in France where the Arts are held in great
honour and as often as I can I go to the United States
where the greatest curiosity as to the Arts is displayed. I
go there, that is to say, when I can afford it and stay until
my money is spent. Then I come back to the shores of the
Mediterranean where one can live on a few herbs and for
the greater part of the year, in a soft climate, pass the
day and night entirely out of doors! . . .

BEFORE THE CRISIS . . .

It was before the crisis. . . . I was at Villeneuve-lès-
Avignon with crowds of charming American friends settled
around the immediate landscape. . . . There came down
a lady almost *too* generous and almost *too* beautiful from
the countryside where the Studebakers grow.

Nothing would content her but that she must take out
and treat the whole crowd. . . . That was all right. . . . I
led them to the Avignon tavern where you can get the
best wine in all Provence. Then the disaster occurred.
That lady who was beautiful enough to hold the eyes of
everyone in that place of entertainment would have it that
we must drink champagne. We must have champagne: she
had never heard of anyone dining without champagne.
Champagne it must be. . . .

You should have seen the incredulous faces of my
Avignonnais friends sitting round. . . . Champagne may
be all very well in its place—but I do not know what may
be its place. . . . Perhaps at a very young child's birthday-
party with an iced cake or after two, at a dance, as a
before-supper cocktail. . . .

But on the next day came the tragedy. . . . Wanting to
be quiet after that whirlwind I lunched at the same place.
It was a special occasion and I ordered—there were two
of us—a famous Bordeaux, bottled at the Château in the
year 1914. . . . I had eaten at that place often enough to

know its wine-card and the proprietor very well. The sommelier however was new.

Now mark. . . . That fellow brought the wine in its wicker carrier, already uncorked. He shewed me the cork which had the brand of the Château all right. He made to pour out the wine but as we were still eating an exquisite *soupe de poisson*—which is one of the specialties of Avignon—and drinking one of the little local white wines which goes very agreeably with fish and saffron, I told him I would pour the wine myself later.

Now listen very attentively. . . . When with reverential hand I tried to pour out that wine . . . *it would not pour.* . . . In the neck of the bottle was part of a perfectly new cork.

I called the proprietor, who, as I have said, was a very old friend of mine and signed to him to pour out the wine, shewing him at the same time the Château cork and the date on the label of the bottle. . . . I did not say a word. . . . He peeped into the neck of the bottle.

I have never seen a man become so suddenly distracted or pallid. He caught at his throat. . . . He really caught at his throat. . . . When he was a little recovered he shouted at that sommelier in a voice of shaky thunder to fetch the cellarman.

That procession of two threaded its way between the tables of the appalled diners. And M. le Patron shouted:

'Take off your aprons. . . . There is the door!'

Then, as their crest-fallen shades obscured the doorway, he went himself to his deep cellar and came back, bearing with his own hands a bottle of *Château-Pavie* 1914.

I don't know if you see the point. Americans are said never to be able to see an Englishman's point and the English never to see the point of any story at all for a week, when they telegraph to the teller the two vocables 'Ha! Ha!'

The point isn't merely that that sommelier, taking me for an ignorant Briton, had, with the connivance of the cellarman, poured a bottle of local wine at f. 1.90 into

an empty *Château-Pavie* bottle which he had re-corked
with a *bouchon* so new that, unknown to him, half of it
had remained, when he re-uncorked it, in the neck of the
bottle. . . . *Château-Pavie* is a very expensive wine when
it is of the year 1914 so he and the cellarman would have
made a handsome profit. . . . They would of course have
reserved several authentic corks from real bottles previ-
ously opened. . . .

But you had seen that already. . . . There is of course
the other point that the sommelier had never seen me
before, being new, and had observed me the day before
to drink champagne—but positively *champagne*!—with
a titianesque Bacchante from Studebakerville. So naturally
he had taken me for one of those other Anglo-Saxon
'brutes.'

But even *that* is not the point. . . . *Je vous donne en
mille*! . . . The real point is that, if that bottle *had* poured
I might have gone through all the ceremonies of turning
the wine under my nose, swirling it round in the glass,
regarding the light through and finally sipping and re-
spiring it. . . . And might quite possibly have been taken
in and have lectured my unfortunate—for once Antipo-
dean!—disciple as to its colour, bouquet, body and the
rest. Do not think that that would have been the result
merely of snobbishness. . . . I do really know something
of Bordeaux and Mosel wines. I am not one of the great
writers on wines, like Mr William Bird or Mr Shand or
M. Monot. . . . But *Château-Pavie* is my favourite wine
and I ought to know something about it. And you have
to consider that I was in a restaurant that I had known
for years; that I was entirely convinced of the probity of
the proprietor and the excellence of his kitchen and cellar.
And who can really pledge his personal taste against such
overwhelming things as the cork and bottle of the
Château? Not I!

... AND DURING THE WAR

We had lived like gentlemen in that Red Cross Hotel on Cap-Martin. A peeress of untellable wealth and of inexhaustible benevolence had taken, for us chest sufferers of H. M. Army . . . for us alone all the Hôtel Cap-Martin . . . one of those great, gilded caravanserais that of my own motion I should never have entered. We had at our disposal staff, kitchens, chef—and a great chef of before the days when Anglo-Saxondom had ruined these shores —wine-cellars, riding horses, golf-course, automobiles. . . .

We had sat at little tables in fantastically palmed and flowering rooms and looked from the shadows of marble walls over a Mediterranean that blazed in the winter sunlight. We ate *Tournedos Meyerbeer* and drank *Château-Pavie* 1906 . . . *1906*, think of that.

We slept in royal suites; the most lovely ladies and the most nobly titled, elderly seigneurs walked with us on the terraces over the sea. . . . Sometimes one looked round and remembered for a second that we were all being fattened for slaughter. . . . But we had endless automobiles at our disposal and Monte Carlo was just round the corner. . . .

One day I was put in charge of a detail of my comrades at that Hotel. . . . An incredibly inaccessible and distant town in the hinterland of high mountains that there press down on the sea had asked me to be allowed to receive a deputation of British officers. We were told that the town would send conveyances. I was to make a speech in Provençal. It sounded very nice and for a day or two having got hold of a copy of the *Trésor des Félibriges* I worked at my speech. . . .

Before the marble steps and the scarlet carpet of the Royal entrance of that hotel—it is only used for ambassadors or for those going to state functions—waited six very small donkeys; behind each, a meagre and dishevelled

peasant woman. They were our Rolls-Royces and there
was no avoiding them. . . . It was a military order. All the
six of us were portly and too weak to walk much more
than a mile on the level.

We climbed the shuddering inaccessibilities on those
valiant microcosms. On the hand-breadth paths we shut
our eyes so as not to see the precipices below. The in-
defatigable, lean women ran behind our valiant mounts,
brandishing immense cudgels. Every few steps my attend-
ant brought hers down on the flanks of my poor donkey.
Each time she cried:

'*Courage,* Montebello.'

It was an allegory, as if poor Montebello, the micro-
scopic donkey, were poor humanity with Destiny at its
back, climbing the inaccessible peaks with the whole load
of the stupidity of its rulers in its saddle. . . .

That mountain fastness was a madhouse of militarism.
Our arrival was beflagged; the miserable cow-byres that
served for houses had bedspreads from every window-hole.
Before our donkeys' feet they threw lavender and rose-
mary. . . . Little boys and girls whilst they threw those
herbs ran beside us and shouted to us exhortations to kill
each one thousands and thousands more Huns. . . . Their
ancestors had no doubt done the same for Hannibal with
his elephants, for Caesar, for Napoleon, all of whom with
how many conquerors more, had passed that way. They
cheered my twenty-word speech to the echo. They gave
us the flesh of new-born kids, the miserable 'greens' from
their miserable patches of soil carried up from the plains
to the pockets they scrape out of the rocks in the eternal
glooms of the high mountains. . . . They gave us wine
that they swore was of the days of the Greeks. It was
hundreds of years old—of the days of Hannibal. It was
thick, golden, glutinous and perfumed—like an enchanted
hair-oil. . . . One understood why Horace diluted his
wine with sea-water. . . .

And they invited us into their houses. Regarding them
through the doorways, gingerly, we saw that they slept on

mud floors beside their miserable cattle and their starved goats, the meagre hens roosting overhead and covering them with their droppings. . . .

Those patriots lived a life of an incredible squalor—and of infinite passion for their locality. . . . On our return down the dizzy precipices we had to be medically examined. The Military Authority had heard that every inhabitant of that city suffered from a disease that was to them innocuous but that was extraordinarily malignant to anyone else. . . . I do not know if that is true. But they were said to be proud of it as an inheritance from Napoleon—or maybe Hannibal. . . .

THE TRANSATLANTIC REVIEW

The *Transatlantic Review* was born amidst turmoil and had a tumultuous if sometimes gay career. Foreseeing this, we took for its crest the ship that forms the arms of the city of Paris and, for its motto, the first words of that city's device: 'Fluctuat. . . .' 'It is borne up and down on the waves.' Had its career been prolonged we had intended to add the rest of the device: 'Nec mergitur'—'and does not sink.' . . . It was not to be.

It seemed to me that it would be a good thing if someone would start a centre for the more modern and youthful of the art movements with which in 1923 the city, like an immense seething cauldron, bubbled and overflowed. I hadn't thought that the task was meant for me. But a dozen times I was stopped on the boulevards and told that what was needed was another *English Review*. Then one day, crossing the Boulevard St Michel up near the Luxembourg Gardens, I met my brother. I had not seen him for a great number of years. The last time had been in 1916 when I had passed his rather bulky form, in uniform, in New Oxford Street. He had been wounded and I failed to recognize him, khaki making everyone look

alike. My companion on that day said that I exclaimed—
it was during the period when my memory was still very
weak:

'Good God: that was my brother Oliver. I have cut my
brother Oliver. . . . One should not cut one's brother. . . .
Certainly one should not cut one's brother! It isn't *done*.'

I do not remember to have uttered those words but I
can still hear the ringing laughter that saluted whatever
I did say. I ran back along the street after him but he had
gone down the tube-lift before I caught him up.

Now I met him on a road refuge half-way across the
Boulevard. He said that he wanted me to edit a review
owned by friends of his in Paris!

The startling nature of that coincidence with the actual
train of my thoughts at that moment made me accept the
idea even whilst we stood in the middle of the street.
He mentioned names which were dazzling in the Paris of
that day and sums the disposal of which would have made
the durability of any journal absolutely certain. So we
parted with the matter more than half settled, he going
to the eastern side-walk, I to the west.

Ten minutes after I emerged from the Rue de la
Grande Chaumière on to the Boulevard Montparnasse.
Ezra with his balancing step approached me as if he had
been awaiting my approach.—He can't have been.— He
said:

'I've got a wonderful contribution for your new review'
and he led me to M. Fernand Léger who, wearing an old-
fashioned cricketers' cap like that of Maître Montagner of
Tarascon, was sitting on a bench ten yards away. M.
Léger produced an immense manuscript, left it in my
hands and walked away. . . . Without a word. I think he
regarded me with aversion as being both English and a
publisher.

Ezra led me to the Dôme—a resort I much disliked—
and provided me with a sub-editor and a private secretary.
The sub-editor was a White Russian, exiled Colonel, an
aristocrat to his fingertips, knowing not a word of English

and more nervous than you would imagine that anyone could be. He saw Communist conspiracies everywhere and, within five minutes, was convinced that I was a Soviet agent. He was a beautiful specimen of his type but he was starving.

The private secretary was also a beautiful specimen of his type. He was an English Conscientious Objector, an apparently mild, bespectacled student. He too was starving. . . . Everyone in the Dôme was starving. . . . I would have preferred not to have a Conscientious Objector for my private secretary or a White Russian aristocrat for a sub-editor. Indeed I was not quite certain that I needed at the moment the services of either functionary.

The Russian produced a contract with a printer and several manuscripts by friends—White Russians who recounted their martyrdoms under the Soviet; the Conscientious Objector gave me the manuscript of a work of his on German lyric poetry and another on neo-German metaphysics. Ezra beckoned to a slim, apparently diffident young man and to a large-boned undiffident young man. They told Ezra that they had not brought the manuscripts he had told them to bring. They had thought I should not like them. I did not catch their names because the avalanche began.

The beings that bore down on me, all feeling in their pockets, were of the most unimaginable colours, races and tongues. There were at least two Japanese, two Negroes—one of whom had a real literary talent—a Mexican vaquero in costume, Finns, Swedes, French, Rumanians. They produced manuscripts in rolls, in wads, on skewers. They produced photographs of pictures, pictures themselves, music in sheets. Americans expressed admiration for my work; gloomy Englishmen said that they did not suppose I was the sort of person to like their stuff. I was, as a matter of fact, extremely anxious to read the manuscripts. I am always anxious to, and the more battered and unpresentable the manuscript the more hope it excites in me. But I was not to read many of them.

I shared the small sum I had in my pocket between the Conscientious Objector and the White Russian and ran away. With that small sum the Colonel bought perfumes and roses for the Princess his wife. The Conscientious Objector embarked on a career of martial adventure. I had told him to collect the manuscripts and bring them round to me next morning, Alas!

When I got home, there were manuscripts—nearly a wash-basketful—already there. And awaiting me were a very vocal lady from Chicago and an elegant but bewildered husband. It was then ten o'clock at night. They stayed till two o'clock in the morning, the husband completely silent, the lady—who was very tall and frightening —threatening me with all sorts of supernatural ills if I did not make my new magazine a vehicle—of course, for virtue, but also for some form of dogma connected, I think, with psychiatry. She offered to subscribe for herself and her husband, then and there.

So there I was with all the machinery of a magazine —sub-editor, secretary, contributions, printers, subscribers. . . .

It had been just before dinner-time that I had met my brother. I had conversed with him in absolute isolation. You could not have greater isolation than a refuge in the centre of the traffic of the Boulevard St Michel. Yet here was an organization.

It seemed however to be nothing for me. And it was nothing for Ezra, who at that moment had become both sculptor and musician. Thus all his thoughts were needed for those arts. He had living above his studio in the Rue Notre-Dame des Champs a gentleman whom he suspected of being an ex-Enemy, a person obnoxious in himself. He had therefore persuaded Mr George Antheil, who, besides being a great composer, must be the heaviest living piano-player—he had persuaded Mr Antheil to practise his latest symphony for piano and orchestra in Mr Pound's studio. This lasted all day for several weeks. When Mr Antheil was fatigued, his orchestra played unceasingly

Mr Antheil's own arrangement of the *Wacht am Rhein*. In the meanwhile, turning sculptor, Mr Pound fiercely struck blocks of granite with sledge-hammers.

The rest of his day—his evenings that is to say—would thus be given up in the court of the local justice of the peace, rebutting the complaints of the gentleman who lived overhead. He had some difficulty, but eventually succeeded in convincing that magistrate that he and Mr Antheil were two pure young Americans engaged in earning their livings to the greater glory of France whereas the gentleman upstairs was no more nor less than the worst type produced by a lately enemy nation. So that fellow had to leave Paris.

It was not to be imagined that, with all this on his hands, Mr Pound could be expected to give time to the conducting of a *Review* and there the matter had rested. Or I supposed it to have rested. But I knew that Mr Pound was passionate to have that *Review* and that he was industriously searching for a cat to get those chestnuts out of the fire. He wanted a mild, gentle young man who should provide all the money and do all the work. He in the meantime was to extend his length in the office arm-chairs and see that that *Review* printed nothing but the contributions of his friends for the time being. . . .

Next day we proceeded—my brother, I, the White Russian, Mr Pound and others, to see fair play, to an office in the Quartier de l'Etoile. There was no doubt that that office represented High Finance. High Financiers passed in and out all the time we were kept waiting in the ante-room. I had even a glimpse of the enormously wealthy man, who was said to—and I believe did—own the *Review* it was proposed to entrust to me. He was the principal winning owner of the French turf that year. I didn't much like his looks—I mean as owner of a *Review* —and I gather that he didn't much like mine or those of the helpers who accompanied me. . . .

We were all shewn into the office of a gentleman well-known in Paris. He was the head of a firm of solicitors

though I believe he was not actually a solicitor himself. But he employed English lawyers in that office. That is, I believe, a perfectly proper proceeding and the gentleman himself seemed a very ordinary city man. He certainly knew very little about running reviews and agreed to every condition that I made with such readiness that I made them as stiff as I could. I then gave Mr P. an outline of my proposed editorial policy. It seemed to astonish him mildly but not in the least to antagonize him. He had never heard of Picasso, Matisse, Brancusi, Mr Joyce, Miss Stein nor Mr Pound. Not even of Conrad or Thomas Hardy. But he said:

'That's all right. You go ahead. It's in your hands. You get going as soon as you please. We have every confidence in you.'

I went to a reception at Mr Pound's studio that afternoon and there met Mr John Quinn*—who pretended to mistake me for Mr George Moore. Mr Joyce was also there and a photographer from *The New York Times*. So we were all photographed together. Then there came in, bearded, thin and as nervous as ever, Mr William Bird IV. With him was the large-framed young man I had seen at the Dôme. I had played lawn-tennis one early morning against him and Ezra, with M. Latapie, the painter, for partner. M. Latapie's studio was next door to mine and the tennis-court was on the further side of the wall. Latapie and I used to get straight out of bed towards seven in the morning, get over the wall, play a set or two, have a shower in the club-house and then go back to breakfast. If anyone else turned up we would play against them. As those who turned up at so matutinal an hour had usually been up all night we beat them as a rule. I don't remember how it had been with Ezra and that young man, nor had I caught his name.

I didn't catch it then, in the studio. I was engaged in avoiding Mr Quinn whom I disliked because he had pretended to mistake me for George Moore. I was also

* The American lawyer, financier, bibliophile and art collector.

engaged in trying not to be near Mr Joyce. For Mr Joyce's work I had the greatest admiration and for his person the greatest esteem. I also liked his private society very much. He made then little jokes, told rather simple stories and talked about his work very enlighteningly. But to be anywhere near Mr Joyce at any sort of reception or public event was embarrassing. I should be at once seized on by the hostess, two stiff chairs would be placed side by side and, surrounded by a ring of Mr Joyce's faithful, we should be expected to talk. To Mr Joyce this was by no means embarrassing. He was used to it. But to me as a young man from the country it was very trying. Mr Joyce would maintain an easy but absolute silence, the faithful hanging on his lips. I would try to find topics of conversation to which the author of *Ulysses* would reply with a sharp 'Yes' or a 'No.' . . . At last I found a formula. I used to beseech Mr Joyce to drink red, not white, wine.

I was really very much in earnest and not quite without official warrant. I have always held a brief against white wine. Its whiteness is caused by the absence of tartaric acid that renders red wine assimilable. I never drink white wine except when politeness demands it and then, if I take only a small glass, I find myself troubled with depression of a gouty nature. And it happened that, on Joyce's own recommendation I had gone to a great oculist in Nice. The oculist had operated on Joyce. He told me that there was nothing the matter with my eyes. He added: 'And never drink white wine. It is ruinous to the eyesight. . . .'

On the occasion of the Pounds' reception—it was in honour of Mr Quinn—the Faithful were not present and I found myself at last beside Mr Joyce. I took the occasion to tell him that I would like to print in my *Review* some pages of the book he was writing. I was going to devote a section of my magazine to Work in Progress of persons like himself and Picasso so as to make it a real chronicle of the world's activities. He said it was a pity that I had not been in time to ask that of Proust. He had been told

that a single sentence of Proust would fill a whole magazine. Not that he had read any Proust to speak of. His eyes would not let him read any work of other people. He could just see to correct his own proofs.

The stalwart young man had retired to a distance in the vast dim studio and was threatening with his fist a relic of Ezra's Chinese stage—the rendering in silk of a fat and blinking bonze.

'That young man,' I said to Ezra, 'appears to have sinophobia. Why does he so dislike that. . . .'

'He's only getting rid of his superfluous energy,' Ezra said.

It appeared like it. The young man was dancing on his toe-points. Shadow-boxing was what it seemed to be. Ezra said:

'You ought to have had him for your sub-editor. He's an experienced journalist. He writes very good verse and he's the finest prose-stylist in the world. . . . He's disciplined too.'

I answered:

'He has to be if he's a prose-stylist. It isn't like verse. You can turn that out in your sleep. . . . But you told Mrs Levoir Suarez yesterday that I was the finest prose-stylist in the world. . . .'

'You!' Ezra exclaimed. 'You're like all English swine. . . .'

Ezra a few years before had been called the greatest bore in Philadelphia, so ceaselessly had he raved about London and Yeats and myself to uninterested Pennsylvanians. Now he was Anglo-phobe.

'It's just like you to miss the chance of a sub-editor like that,' Ezra fulminated. 'Disciplined. Energetic! Trained!'

I said that yesterday he had insisted on my engaging the Russian Colonel. I had engaged him. Ezra said:

'Isn't that like you! . . . Of course I was only recommending him. How could you think I wanted you to engage him. . . . Engage Kokulof! . . . You must be mad.

He's a Russian Colonel—a *Colonel*. Com*pletely* illiterate. . . .'

I said I would engage the young man too. I could easily do with two sub-editors. The young man certainly looked disciplined in a Herculean way. Ezra confirmed my suspicion that he must have been in the Army. I took him to be one of those Harrow–Cambridge–General Staff young Englishmen who make such admirable secretaries until they let you down.

I asked where Ezra's Conscientious Objector was. He ought to have brought those manuscripts round to me that morning. Ezra said:

'Oh he. . . . That'll be all right. . . . You mustn't keep his nose too close to the grindstone. . . . He's not used to discipline. But he'll be invaluable. . . . That's what he'll be. . . . Only your excremental *Review* will be in the gutter tomorrow. . . .'

Mr Quinn, who had been looking at me over Ezra's shoulder, said:

'Poor fellow. . . . Poor fellow. . . . I'm sorry for you. . . .'

Mr Quinn, tall, lean, perpetually indignant, had, as Maecenas, conversational licence.

Ezra said:

'I'd never think of letting Ernest engage himself under those English diarrheas. . . . Why couldn't you have found *French* backers? The French are the only people who have any guts. . . . Look at Tristan Tsara! . . . Why didn't you go to him? . . .'

I said that M. Tsara was a Rumanian and, as far as I knew, was no Croesus.

Mr Quinn said:

'Poor fellow. . . . You're an honest man. . . . I hate to see you in that position. . . .'

Ezra said:

'The damfool deserves it. . . . He can't see the difference in merit between Arnaut Daniel and Guillem de Cabestann. . . . He *prefers* Guillem. . . . What could you expect? . . .'

Mr Quinn's resentful eyes fixed me for a long time. He repeated:

'I just *hate* to see you in that position.'

I said it was not as uncomfortable as it looked. The chair I was in had been made by Mr Pound during his cabinet-making stage. It was enormous, compounded of balks of white pine, and had a slung canvas seat so large that, once you sat down, there you lay until someone pulled you out.

Mr Quinn said:

'I'll send Mrs Foster to you. . . . Have a cigar. . . .'

I struggled on that chair-bottom like a horse that had fallen down on a slippery seat. Mrs Foster gave me a hand. I avoided Mr Quinn's cigar. It was as large as a crowbar, black and minatory. It had cost a dollar. I was not man enough for that. I smoked Alsatians that cost forty centimes—one and three-fifths cents.

I said I should just love to have Mrs Foster come and see me. . . . But I had no pictures to sell. I wasn't, I explained, a painter. When I had nothing else to do I wrote a book. . . .

'And fall among thieves,' Mr Quinn said. 'I hate to see it. You're an honest man. . . . I'll send Mrs Foster to see you.'

Mrs Foster was the ravishingly beautiful lady who bought Mr Quinn's pictures for him.

Mr Quinn said:

'Hang it, you mustn't swear at me. . . . I only mean your good. . . . Conrad told me what a violent fellow you are. . . . But I've done nothing to be sworn at for.'

I had sworn actually at a piece of Ezra's sculpture. As sculptor Ezra was of the school of Brancusi. He acquired pieces of stone as nearly egg-shaped as possible, hit them with hammers and then laid them about on the floor. The particular piece that had distressed me had, to be appreciated, to be seen from a reclining position in the chair from which Mrs Foster had just extracted me. In my

struggles I had forgotten that piece of work. One should never forget works of Art.

I limped away with the assistance of Mr Bird. The Mr Bird of those days was everybody's uncle. He knew everything and could get you everything that you wanted. He was what the *Assistance Publique* would be if it were worthy of its name. In public he was a stern and incorruptible head of a news agency with the aspect of a peak-bearded banker. In private he had a passion for a hand-printing-press that he owned and his hands and even his hair would be decorated with printer's ink.

On that occasion I asked him if he could find me a private office. That seemed impossible. Paris in those days was as crowded as a swallow's nest that expands and contracts as the young brood breathes inside. You advertised that you would pay thousands of francs to anyone who would find you an apartment. No young couples could get married. Middle-class people slept under the arches of bridges over the Seine. Six artists slept in the kitchen of the Rotonde—by courtesy of the chef.

Bird said:

'Certainly. I am taking a second office tomorrow. There will be plenty of room for you.'

The next day was Saturday. I sent the White Russian down to the office of the Review Company for the first week's salary of himself and the Conscientious Objector. The Conscientious Objector's spectacles had not yet again beamed on me but I thought he might like a little salary.

The Colonel came back from that office raving like a lunatic and unable to speak any language but Russian. I gathered that he had not received his salary and that he was afraid that the Princess would have to go without caviare for another week-end. When he could again speak French he asserted that Mr P. the financier had confessed himself a Communist and had threatened to have General —— murdered.

He remembered at last that he had a note from Mr P. Mr P. said that the articles of the Company not having

been signed he was not really empowered to pay out any-
thing and the banks were closed. He would however send
me a small sum for salaries and petty cash by my brother
on Monday morning. . . .

That seemed good enough. I engaged that evening an
advertising manager. . . .

It seemed to me then that everything would turn on the
amount of money that my brother would bring from Mr
P.'s office for the salaries and petty cash. If it was a fair
sum I might be satisfied that those business men intended
to behave according to the generous letter of the agree-
ment. If it were derisively small, I determined, I would at
once look for new capitalists.

In spite of vigorous telephoning my brother did not
arrive till past seven in the evening. He had been away
for the week-end. The cheque that he brought was in-
sufficient to cover the cost of the postage-stamps I had
used. He said that he had had great difficulty in getting it.
Mr P. was exceedingly irritated by the commotion that
the White Russian had made in his office on the Saturday.
He was convinced that the Russian was Communist of a
violent and dangerous kind. The company absolutely re-
fused to subsidise agents of the Soviet Republic.

'Besides,' my brother said, 'Mr P. is not too pleased
with you either. He says you did not treat him with the
respect to which he is entitled. He's very rich as I've told
you. He says he went out of his way to be complimentary
to you and you did not shew the least *empressement*. In
fact he said he almost believed. . . .'

I asked if Mr P. believed that I too was a Com-
munist. . . .

My brother's embarrassment increased. He said he
must say that I had treated Mr P. very much *de haut en
bas*. . . . As if he had been the dirt beneath my feet.

I said that when it came to the Arts he probably was.
But did that matter? I need never see him again. He was
not coming near my private office and I certainly should

not go near his. There was he, my brother, to act as buffer. And well-padded.

His distress increased. He said that they had decided that I could not have a private office. I must work in their building. They thought they must keep an eye on me. The race-horse owner, passing through the room, had not liked my looks much. As for Mr Pound. . . . Look at his slouch hat, his forked beard, his spectacles. And his extraordinary tie. His malacca cane certainly contained a sword-stick. What else could make you carry anything so out of date as a malacca cane? . . . And his pockets! Why did they bulge? Probably because they contained bombs. . . . And he mumbled. Incomprehensible words! To himself.

That is how the Left Bank looks to the Right.

In short, my brother said, they thought that I might be a worthy person. I dressed passably. My hat of course was a last-year's model. Brims were not so wide that year. They had suggested that Oliver should hint that to me. They thought that I was weak. Worthy but easily led astray. . . . I was in the hands of the red-bearded Anarchist and the sham Russian General. . . .

I said: 'Get it out. . . .'

'In short,' Oliver said, 'Mr X.'—the race-horse owner —'insists that he shall censor the *Review* himself. You must give an undertaking not to print a word that he has not O.K.'d. . . . That seems reasonable. He's finding the money. But fine pie he'll make of Joyce and Pound and Conrad. . . . Not to mention you!'

I felt like cold steel. I said:

'I suppose Mr X. wants to insert an article a month. On racing form?'

My brother said:

'Two! He wants to have space for two articles every month. One by himself: on racing form. The other by Mr P. That will be on finance. . . . Be reasonable. They're finding the money. They've surely a right to some say about how it's spent. After all they're as keen on their subjects as you are on what you call the Arts. . . .'

Half an hour afterwards Mrs Foster came in. She said Mr Quinn wanted me to go to him. He was rather sick. In a hotel on the Champs-Elysées. I said:

'No. Let's all go and have dinner somewhere. I've shut the *Review* down.'

She said that that was why Mr Quinn wanted to see me. He had known I should shut the *Review* down. He didn't want me to. . . . Mr Quinn proposed to finance a different *Review* for me. And I was convinced that at that juncture some such review was a necessity. It is the greatest blot on the face of Anglo-Saxondom that it has never been able to support a review devoted entirely to the Arts. Anglo-Saxondom consists of four hundred million subjects, citizens and variously coloured dependents, yet it cannot find ten thousand to display a glimmering of interest in what differentiates man from the brute creation. It seemed therefore my duty, if there was any chance of the existence of such a periodical, to do all I could to bring it into being. . . .

We came to an arrangement. I stipulated that I was to find 51% of the capital and should hold 51% of the shares. Mr Quinn stipulated the *Review* should be turned into a limited company according to French law. It was this that really proved the undoing of the *Review*. The charges for founding and registering that company exhausted nearly half our original capital and the exasperation and minute formalities caused me more labours and loss of time than all the rest of the *Review* together. . . . The prospectus occupied forty pages in the *Journal Officiel* and we had to pay for them. Mr Bird printed the most beautiful share-certificates that can ever have been printed and we didn't have to pay for them. They were on vellum in the most beautiful and most minute type to be imagined. The whole forty pages had to go on them. I even sold four at a thousand francs apiece—to Miss Barney, Miss Gertrude Stein, a lady whose name I cannot call to mind and the Duchesse de Clermont Tonnerre. I thus

became a financier and those ladies had the right to be protected from me by all the rigour of French Law.

On the face of it the *Review* should have prospered. The costs of production in Paris were ludicrously small; contributors aware that the proprietors were not to make any profits worked at the tiniest of rates; even distribution was very cheap and office expenses were almost nothing as compared with those of any journal in London or New York. All out, a copy cost between two and three cents, and was sold to the public for fifty! . . . You would have thought that there must be a fortune in it. . . . Alas, I have not yet succeeded in liquidating the debts it caused me to incur. I do not suppose I ever shall.

For a time it was fun. Mr Bird's 'office' turned out to be exactly what I craved for—a great wine-vault on the banks of the Seine in the Ile St Louis. The ground floor was occupied by his great iron seventeenth-century hand-press and his forms. In a sort of kitchen he kept the books he printed and the spare copies of the *Review*. The *Review* office was in a gallery that covered half the vault. It was sufficiently large as to floor-space but it was not much more than five feet high and Miss Reid and I had permanently contused skulls. Every time anybody who looked like a purchaser rang the door-bell we would spring up from our tables. Miss Reid—who is very tall—had then become the *Review*'s admirably efficient secretary. . . . And it was fine, sitting there in our swallow's nest looking over the Seine to the grey houses on the other bank. The stove below made our gallery sufficiently hot even for a New Yorker like Miss Reid and far too hot for me who had most times to sit in my shirt-sleeves. And, across the space occupied by the press with its gilt eagle atop, we could watch the plane-leaves drifting down into the river; and then the thin sifting of snow; and then the young plane-leaves growing green again. And then dusty!

And the excitement when somebody bought a copy of a *Review*! . . . I never sold anything in my life, but my emotions when I actually received f. 7·50 for a wad of

paper that existed because of the labours of Miss Reid
and myself made me think that to be a shopkeeper must
be the most glorious of fates. And there was an old,
broken London printer to make and bring me up cups of
tea and Mr Bird bending over his types below. . . . And
the wonderful manuscripts! . . . In the case of Mr Hem-
ingway I did not read more than six words of his before
I decided to publish everything that he sent me. Of
course he had been recommended to me. He was the
young man who had been shadow-dancing in Ezra's studio.
. . . In the case of Mr E. E. Cummings I had decided
after reading ten lines of his that I would open *The Trans-
atlantic Review* with the poems he sent me.

There then was *the transatlantic review*—without capi-
tals. I had no motive in printing the title without capitals.
I had seen the name of a shop somewhere on the Boule-
vard without capital letters and had rather liked the
effect. Then, by a mere coincidence, Mr Cummings's
poems had no capitals. The conjunction made a great
sensation. It was of course taken to be a display of Com-
munism. We were suspected of beheading initial letters
as if they had been kings. The American Women's Club
in Paris solemnly burned the second number of the
Review in their hall-fire, thus giving a lead to Mr Hitler.
Their accusation was that we were not only Communists
but indecent—that, on account of a really quite innocent
story in French by my extraordinarily staid friend M.
Georges Pillement. But one of the scenes took place in
a . . . bathroom. It seemed to me that it would be better
if some American ladies did not read French. It might
cause international complications if they set up a censor-
ship in Paris. After I had written that, the Club cut off its
subscription.

Bringing out the first number was rather hectic. The
misprints made by the Russian printers were natural, but
their corrections made the pages look like a Soviet battle-
field and their procrastination was without parallel. The
White Russian Colonel almost went out of his mind

because he read Communism into every incomprehensible English sentence. Finally everything was ready except for the proof of my editorial which conveyed a slight *aperçu* of the Arts in Paris at that moment. It had cost me a good deal of work. There seemed to be no way of getting this proof from the printers.

The White Russian Colonel now resigned. He said with a great deal of dignity that he would probably starve. But it was inconsistent with his honour to go on taking money from an organ that was now definitely proved to be an agency of the U.S.S.R. I didn't argue with or even question him. The Soviet Republic loomed enormously large in the Paris of those days for Paris is an excitable city and the finger of Lenin was traced to the most unlikely things. Even the mark of a newly invented rubber boot-heel! It was taken to print a trail by means of which Soviet agents could follow each other's movements. . . .

I had nevertheless, within a week, offers of every kind of service from every kind of White Russian noble or army officer or their wives. I refused them.

I was in rather a hole. The only person at the printer's who spoke comprehensible French or seemed reasonably sane was the manager. He had taken the opportunity to go sick. The rest of the staff, who appeared to be mad, flew into frenzies whenever I entered their office. My Russian is very limited and Miss Reid was afraid to go near that madhouse. As far as we could make out that firm was run by near relatives of Grand Dukes. As soon as Miss Reid or I appeared one of them would insinuate that another was an Israelite. A free fight would ensue.

About that time Mr Pound strolled into my studio and said that my secretary was next door and would like to see me. I was a little confused because I thought that Miss Reid was at the office in the wine-vault of the Quai d'Anjou. I had quite forgotten the Conscientious Objector. 'Next door' was the Santé prison.

The ten shillings or so that I had given that studious

and bespectacled young man as earnest money had proved
his undoing. He had been really near starvation, having
been earning what living he did earn as an artist's model.
So, instead of spending the money on a square meal he
laid it out on the normal products of the Dôme. That is
not a good thing to do.

When he got home he found that his concierge's lodge
had been moved to the other side of the passage; its
furniture was quite different and the concierge was a
new man. In his own room an aged gentleman was sitting
on the bed. The aged gentleman threw him down the
stairs. The kindly *agent* to whom he told this unusual
story patted him on the back and recommended him to go
home as a good, spectacled student should.

The young man walked round a block and tried again.
Things were worse. The strange concierge blocked the
way. The young man knocked him down. . . . The aged
gentleman was still on the bed. This time he held a gun.
Outraged by their offences against the laws of hospitality
the young man smashed some windows, defiled the stair-
case, yelled at the top of his voice and got into bed with
the concierge's wife.

When the *agents* arrived in great numbers the young
man made a spirited attempt to bite off the nose of the
sergeant in charge of them. He was carried, spread-eagled,
to the Santé. Next morning a kindly magistrate told him
he had acted very wrongly. Poets have a certain licence
but his deeds were not covered by that indulgence. The
concierge pleaded for him; the old gentleman pleaded
for him; the sergeant, who was a poet too, if a Corsican,
asserted his conviction that the prisoner was an excellent
young man. He had indulged too freely in the juice of the
grape—but to indulge freely in wine was in France an
act of patriotism.

He was ordered to pay f. 15 for injuries to the aged
gentleman; f. 12 for the broken window; f. 5 for the
cleaning of the staircase and f. 9 to the wife of the

concierge, all these with *sursis*—the benefit of the First Offender's Act. He expected to go free and unmulcted.

Alas, a much more dire offence was alleged against him. He had been found to be in possession of a prohibited arm! The weapon was a pen-knife, three inches long. But the blade could be fixed. It was one of those Scandinavian, barrel-shaped affairs that some gentlemen use for cleaning their finger-nails. The unfortunate young man was remanded in custody.

The kindly sergeant did his best to lighten the irksomeness of the young man's captivity. He visited him in his cell, declaimed to him his own *vocéros* and other poems to the glory of the vendetta. He listened with attention to the poems of the young man and to the music of Mr Pound, who had brought his bassoon and rendered on it the airs to which the poems of Arnaut Daniel had been sung. That sergeant even brought half bottles of thin wine and slices of the sausage called *mortadella*. With this he fed the captive. It is good to be a poet in France.

The Higher Court before whom the case was tried was less placable. The poor young man had just, when Ezra visited me, been sentenced to a fine of f. 4 with f. 66 for costs and, it having been discovered that as Conscientious Objector he had been in prison in England, he was sentenced to expulsion from France—Ezra's proposition now was that I should pay the fine and approach the authorities with assurance of the excellence of the young man's poetry and of my conviction that he would no further offend.... I had never read the young man's poetry and had only seen him for ten minutes at the Dôme, so I knew little about his character. But I perjured myself all right. I did it rather reluctantly for I dislike the militant sides of the characters of Conscientious Objectors and, having once seen a man's ear bitten off by an American trooper, I felt some distaste at the idea that my own nose might leave my face between the teeth of an English

poet.... Eventually, on the assurance that the young man was in my service, the authorities decided that as long as he kept that job he might stay in Paris.

I was glad, for I did not like the idea of France expelling poets. So that young man became sub-editor. He assisted me to get out the first number. He made the discovery that what was delaying the printers was the fact that that White Russian Colonel had carried off the manuscript of my article and had never returned it. He had taken it to the General who was the Chief Organiser of the Counter-revolution in Paris and, between them I suppose, they had puzzled out that my account of the Dadaists, Surrealists, Fauves, Cubists and supporters of M. Gide was really a Soviet guide to the houses of White Russian organizers in Paris.... The idea does not really seem so mad when you consider that that General was, actually, a year or so later, 'taken for a ride' in the streets of Paris in full day-light—and murdered.

As soon as the first number was out the social life began. It came like an avalanche. I had arranged to give a modest Thursday tea to contributors after the time-honoured fashion of editors in Paris. The broken-down London printer was to make the tea and there would be biscuits whilst we sat on benches round the press and talked of the future policy of the *Review*. It is a useful function as it is arranged in France.

But you never saw such teas as mine were at first. They would begin at nine in the morning and last for twelve hours. They began again on Friday and lasted till Saturday. On Sunday disappointed tea-drinkers hammered all day on the locked doors. They were all would-be contributors, all American and nearly all Middle Westerners. If each of them had bought a copy of the *Review* we should have made a fortune. Not one did. They all considered that as would-be contributors they were entitled to free copies.

I had to shut these teas down and to admit no one except contributors to the current numbers and instead

of a Thursday tea I gave a Friday dance. I do not mind giving dances. I can think my private thoughts while they go on nearly as well as in the Underground during rush hours—and if any one is present that I like and there is a shortage of men I dance. I would rather dance than do anything else.

It was during one of these festivals that I had my first experience of Prohibition. I was dancing with a girl of seventeen who appeared to be enthusiastic and modest. And suddenly—amazingly—she dropped right through my arms and lay on the floor like a corpse. I was, as it were, shattered. I thought she had died of a heart disease.

No one in the room stopped dancing. They were all Americans and nearly all from the Middle West. The girl's mother came from another room and, helped by her brother, carried the girl away. She expressed no particular concern and hardly any vexation. I had never seen a girl—I don't believe I had ever seen a woman or even a man—in such a condition before.

...Prohibition made these Friday dances noisy and sometimes troublesome affairs. I didn't much mind. I have a large presence and can overawe trouble-makers as a rule. And I like to see people enjoy themselves and Heaven knows some of these poor devils needed to enjoy themselves. There was one poor nice boy without the beginnings of any talent who had come to France on a cattle-boat—to paint. He committed suicide when he found that he would never paint even passably and I learnt that the sandwiches and things at those Fridays had, for several months, been his only regular and certain food. To some devotees the Arts can be very cruel goddesses.

The dances gradually became burdensome and then overwhelming. In the beginning I had asked about thirty couples, all writers or painters with one or two composers. On the second occasion there were perhaps forty-five, on the third, sixty.... So they increased. By May

as the tourist season commenced they became over-
whelming. I had to shut them down.

I did it with reluctance. It seemed to me that the
Review and everything connected with it was—I venture
the statement—a burden of public duty laid on me. And
the dances, burdensome as they were, gave the *Review* a
certain publicity. I do not mean that I was so naïf as to
imagine that any of those who danced would afterwards
subscribe and as a matter of fact not a soul amongst all
those that came did subscribe to the *Review*. Not one.
... But a very large proportion of those who have real
merits as artists are painfully shy. They are shy of sub-
mitting their work and still more shy of personal con-
tacts. So it seemed to me that if for such shy persons there
could be a little, intimate function they might be drawn
from their shells and establish contacts not merely with
those responsible for the *Review* itself but also with
each other. Thus one might evolve an atmosphere of
artistic friendliness and intimacy such as is extremely bene-
ficial to the population of an art centre on its aesthetic side.

In that way the *Review* and its social side-shows did
its work. The dances had changed their character almost
too soon and the greater number of those who crashed
them being not only not artists but having no connection
or concern with any Art. Indeed towards the end the
dancers were in the majority people like State Senators
and up-state bankers and publishers who, passing through
Paris, came as it were to a dance straight from a boat-
train, made themselves offensive, and caught the next
morning's train for Monte Carlo, Berlin or Vienna. That
of course froze out all my French friends and nearly all
the practitioners of the Arts.

The work however had been done and I do not think
that there could ever have been an artistic atmosphere
younger or more pleasurable or more cordial than that
which surrounded the *Review* offices and the Thursday
teas when they were again instituted. It was now possible
to keep them intimate. They were not festivities for

State Senators or up-state bankers and the purely derogatory bringers of manuscripts had by then made the discovery that neither my assistants nor I myself were pigeons easy to pluck. There came to these frugal feasts regularly Mr Bird and Mr Pound before he set up as a musician and, discovering with startling rapidity that all Frenchmen were swine and all French art the product of scoundrels, shook the dust of Paris from his feet. On most Thursdays Mr Hemingway shadow boxed at Mr Bird's press, at the files of unsold reviews and at my nose; shot tree-leopards that twined through the rails of the editorial gallery and told magnificent tales of the boundless prairies of his birth. I actually preferred his stories of his Italian campaign. They were less familiar. But the one and the other being supposed by Ezra, Mr Robert McAlmon and others of the Faithful to assist me by making a man of me, Mr Hemingway soon became my assistant editor. As such he assisted me by trying to insert as a serial the complete works of Baroness Elsa von Freytag Loringhofen. I generally turned round in time to take them out of the contents table. But when I paid my month's visit to New York he took charge and accomplished his purpose at the expense of cutting a short story of Mrs H. G. Wells down to forty lines—and the London Letter of an esteemed correspondent down to three.

The baroness too was a fairly frequent visitor to the office, where she invariably behaved like a rather severe member of any non-Prussian reigning family. So I thought the stories of her eccentricities were exaggerated. Her *permis de séjour* which she had somehow obtained from the British Consulate General in Berlin expired and she asked me to try to get the Paris Consulate General to extend it. The Consulate General in Paris is made up of the most obliging people and I made a date with her to meet me there. I waited for her for two hours and then went home. I found the telephone-bell ringing and a furious friend at the British Embassy at the end of it. He wanted to know what the hell I meant by sending

them a Prussian lady simply dressed in a brassière of
milk-tins connected by dog-chains and wearing on her
head a plum-cake! So attired, she that afternoon repaired
from the Embassy to a café where she laid out an
amiable and quite inoffensive lady and so became the
second poet of my acquaintance to be expelled from
France. The Embassy discontinued its subscription to
the *Review*.

A bewildering succession of sub-editors then helped
me and Mr Hemingway. They had all been cowboys so
that the office took on an aspect and still more the
sound of a Chicago speak-easy, invaded by young men
from a Wild West show. The only one whose identity
comes back to me is Mr Ivan Bede, who wore large,
myopic spectacles in front of immense dark eyes, wrote
very good short stories about farming in the Middle
West and boasted of his Indian blood and the severe
vastnesses that had enveloped his childhood. I take that to
be much the same thing as being a cowboy.

Mr Hemingway had, I think, been a cowboy before he
became a tauromachic expert: Mr Robert McAlmon the
printer-author certainly had; so had poor Dunning, the
gentle poet; even Mr Bird had been a rancher in his day
and Mr Pound had come over to Europe as a cattle-hand!

In Paris, in 1924, the *Review* staggered on its way
towards death. The attendants rushed in and out looking
for the nostrum or the leech. . . . Someone—Hemingway
I should think—brought in the usual young financier
who was to run the *Review* for ever. But the young
financier, as is usually the case, turned out to have no
money—or only so much as was allowed him by his
female relatives. So we got to the twelfth number and I
called a meeting of the four shareholders in Miss Gertrude
Stein's studio and there, surrounded by the Picassos and
Matisses and the pictures of whoever was the latest white
hope of modern painting—I think it was then M 'Baby'
Bérard—I told that valiant four that they had lost their
money.

A NOVELIST'S CREDO

The first thing the novelist has to learn is self-effacement
—that first and that always. Not for him flowing locks,
sombreros, flaming ties, eccentric pants. If he gets himself
up like a poet, humanity will act towards him as if he
were a poet ... disagreeably. That would not matter
were it not that he will see humanity under a false aspect.
Then his books will be wrong.

His effort should be to be at one with his material.
Without that he will not understand its emotions and
reactions. Superstitions, belief in luck, premonitions, play
a great part in human motives. A novelist who does not
to some extent enter into those feelings can hardly under-
stand and will certainly be unable to render to perfection
most human affairs. Yes, you must sacrifice yourself. You
must deny yourself the pleasure of saying to your weaker
brothers and sisters: 'Haw! No superstitions about me.'
Indeed you must deny yourself the pleasure of high-
hatting anybody about anything. You must live merrily
and trust to good letters.

PORTRAITS
AND
PERSONALITIES
III

PORTRAITS AND PERSONALITIES III

THE FOX

D. H. Lawrence

In the year when my eyes first fell on words written by Norman Douglas, G. H. Tomlinson, Wyndham Lewis, Ezra Pound and others, amongst whom was Stephen Reynolds, who died too young and is much too forgotten —upon a day I received a letter from a young school-teacher in Nottingham. I can still see the handwriting— as if drawn with sepia rather than written in ink, on grey-blue notepaper. It said that the writer knew a young man who wrote, as she thought, admirably but was too shy to send his work to editors. Would I care to see some of his writing?

In that way I came to read the first words of a new author:

The small locomotive engine, Number 4, came clanking, stumbling down from Selston with seven full waggons. It appeared round the corner with loud threats of speed but the colt that it startled from among the gorse which still flickered indistinctly in the raw afternoon, outdistanced it in a canter. A woman walking up the railway line to Underwood, held her basket aside and watched the footplate of the engine advancing.

I was reading in the twilight in the long eighteenth-century room that was at once the office of *The English*

Review and my drawing-room. My eyes were tired; I had been reading all day so I did not go any further with the story. It was called *Odour of Chrysanthemums*. I laid it in the basket for accepted manuscripts. My secretary looked up and said:

'You've got another genius?'

I answered: 'It's a big one this time,' and went upstairs to dress. . . .

The lady who had sent the story to me chooses to be known as 'E. T.' and she had not even told Lawrence that she was sending the manuscripts.

So next morning I sent Miss E. T. a letter, a little cautious in tenor, saying that I certainly liked the work she had sent me and asking her to ask her friend to call on me when he had the opportunity. I appear to have said I thought Lawrence had great gifts, but that a literary career depended enormously on chance, and that if Lawrence had a good job in a school he had better stick to it for the present. It was probably a stupid thing to do and I have regretted it since for I was certain that that writer had great gifts and the sooner a writer who has great gifts takes his chance at writing, the better.

Miss E. T. in her little book on the youth of Lawrence* —and a very charming and serviceable little book it is— seems to be under the impression that she sent me as a first instalment only poems by Lawrence. Actually she first asked me if I would care to see anything—and then should it be poetry or prose. And I had replied asking her to send both, so that she had sent me three poems about a schoolmaster's life . . . and *Odour of Chrysanthemums*. I only mention this because I found the poems, afterwards, to be nice enough but not immensely striking. If I had read them first I should certainly have printed them—as indeed I did; but I think the impact of Lawrence's personality would have been much less vivid.

* *D. H. Lawrence, a Personal Record*, by Jessie Chambers Wood ('E. T.'), London, 1935.

...Let us examine, then, the first paragraph of *Odour of Chrysanthemums*.

The very title makes an impact on the mind. You get at once the knowledge that this is not, whatever else it may turn out, either a frivolous or even a gay, spring-time story. Chrysanthemums are not only flowers of the autumn: they are the autumn itself. And the presumption is that the author is observant. The majority of people do not even know that chrysanthemums have an odour. I have had it flatly denied to me that they have, just as, as a boy, I used to be mortified by being told that I was affected when I said that my favourite scent was that of primroses, for most people cannot discern that primroses have a delicate and, as if muted, scent.

Titles as a rule do not matter much. Very good authors break down when it comes to the effort of choosing a title. But one like *Odour of Chrysanthemums* is at once a challenge and an indication. The author seems to say: Take it or leave it. You know at once that you are not going to read a comic story about someone's butler's omniscience. The man who sent you this has, then, character, the courage of his convictions, a power of observation. All these presumptions flit through your mind. At once you read:

'The small locomotive engine, Number 4, came clanking, stumbling down from Selston,' and at once you know that this fellow with the power of observation is going to write of whatever he writes about from the inside. The 'Number 4' shows that. He will be the sort of fellow who knows that for the sort of people who work about engines, engines have a sort of individuality. He had to give the engine the personality of a number.... 'With seven full waggons.'... The 'seven' is good. The ordinary careless writer would say 'some small waggons.' This man knows what he wants. He sees the scene of his story exactly. He has an authoritative mind.

'It appeared round the corner with loud threats of speed.'... Good writing; slightly, but not *too* arresting.

... 'But the colt that it startled from among the gorse ... outdistanced it at a canter.' Good again. This fellow does not 'state.' He doesn't say: 'It was coming slowly,' or—what would have been a little better—'at seven miles an hour.' Because even 'seven miles an hour' means nothing definite for the untrained mind. It might mean something for a trainer of pedestrian racers. The imaginative writer writes for all humanity; he does not limit his desired readers to specialists. . . . But anyone knows that an engine that makes a great deal of noise and yet cannot overtake a colt at a canter must be a ludicrously ineffective machine. We know then that this fellow knows his job.

'The gorse still flickered indistinctly in the raw afternoon.'. . . Good too, distinctly good. This is the just-sufficient observation of Nature that gives you, in a single phrase, landscape, time of day, weather, season. It is a raw afternoon in autumn in a rather accented countryside. The engine would not come round a bend if there were not some obstacle to a straight course—a watercourse, a chain of hills. Hills, probably, because gorse grows on dry, broken-up waste country. They won't also be mountains or anything spectacular or the writer would have mentioned them. It is, then, just 'country.'

Your mind does all this for you without any ratiocination on your part. You are not, I mean, purposely sleuthing. The engine and the trucks are there, with the white smoke blowing away over hummocks of gorse. Yet there has been practically none of the tiresome thing called descriptive nature, of which the English writer is as a rule so lugubriously lavish. . . . And then the woman comes in, carrying her basket. That indicates her status in life. She does not belong to the comfortable classes. Nor, since the engine is small, with trucks on a dud line, will the story be one of the Kipling-engineering type, with gleaming rails, and gadgets, and the smell of oil warmed by the bearings, and all the other tiresomenesses.

You are, then, for as long as the story lasts, to be in one of those untidy, unfinished landscapes where locomotives wander innocuously amongst women with baskets. That is to say, you are going to learn how what we used to call 'the other half'—though we might as well have said the other ninety-nine hundredths—lives. And if you are an editor and that is what you are after, you know that you have got what you want and you can pitch the story straight away into your wicker tray with the few accepted manuscripts and go on to some other occupation. . . . Because this man knows. He knows how to open a story with a sentence of the right cadence for holding the attention. He knows how to construct a paragraph. He knows the life he is writing about in a landscape just sufficiently constructed with a casual word here and there. You can trust him for the rest.

And it is to be remembered that, in the early decades of this century, we enormously wanted authentic projections of that type of life which hitherto had gone quite unvoiced. We had had Gissing, and to a certain degree Messrs. H. G. Wells and Arnold Bennett, and still more a writer called Mark Rutherford who by now, I should imagine, is quite forgotten. But they all wrote—with more or less seriousness—of the 'lower middle' classes. The completely different race of the artisan—and it was a race as sharply divided from the ruling or even the mere white-collar classes as was the Negro from the gentry of Virginia—the completely different class of the artisan, the industrialist and the unskilled labourer was completely unvoiced and unknown. Central Africa and its tribes were better known and the tombs of the Pharaohs more explored than our own Potteries and Black Country.

It was therefore with a certain trepidation that I awaited the visit of Lawrence. If he was really the son of a working coal-miner, how exactly was I to approach him in conversation? Might he not, for instance, call me 'Sir'—and wouldn't it cause pain and confusion to stop him doing so? For myself I have always automatically

regarded every human being as my equal—and myself, by corollary, as the equal of every other human being— except of course the King and my colonel on—not off— parade. But a working-man was so unfamiliar as a pro- position that I really did not know how to bring it off.

Indeed, E. T. in her account of the first lunch that I ever gave Lawrence and herself, relates that Ezra Pound —who has a genius for inappropriate interpolations— asked me how I should talk to a 'working-man.' And she relates how she held her breath until, after a moment's hesitation, I answered that I should speak to him exactly as I spoke to anybody else.

Before that I had had some little time to wait for Lawrence's visit. I found him disturbing enough. It hap- pened in this way:

It would appear that he was on his holidays and, as one can well believe, holidays on the seashore from a Croydon board-school were moments too precious to be interrupted even for a visit to a first editor. Indeed, as I heard afterwards, he had talked himself into such a con- viction of immediate literary success that he could not believe in the existence of a literary career at all. He had, I mean, said so often that he was going to make im- mediately two thousand—pounds, not dollars—a year and had so often in schemes expended that two thousand a year in palaces with footmen that, when he came to himself and found that he had not so far printed a word, a literary career seemed part of a fairy-tale such as no man had ever enjoyed. And there were no doubt shynesses. Obviously you cannot approach the utterly unknown without them. Yes, certainly there were shy- nesses.

It must have been on a Saturday because otherwise Lawrence would not have been free to leave his school and come up from Croydon, which was a suburb but not part—as poor Lawrence was to find to his cost—of London, and it cannot have been a Sunday because we were working. And I certainly must have been in the

relaxed frame of mind that comes just before the end of the week. I was, I suppose, reading a manuscript or some proofs in a chair that looked towards the room-door. My secretary, Miss Thomas, who afterwards won renown as the war secretary of Mr Lloyd George, presumably heard someone knocking at the outer door, for I was dimly aware that she got up from her desk, went out, and returned, passing me and saying, Mr Someone or other.

I was engrossed in my manuscript or proofs. Miss Thomas, imagining that she had been followed by the individual she had found at the outer door, sat down at her desk and became engrossed in her work. And deep peace reigned. The room was L-shaped, the upright of the L being long and low, the rest forming an alcove in which was the door. . . . And suddenly, leaning against the wall beside the doorway, there was, bewilderingly . . a fox. A fox going to make a raid on the hen-roost before him. . . .

The impression that I had at my first sight of Lawrence is so strong with me at this minute that the mere remembrance fills me with a queer embarrassment. And indeed, only yesterday, reading again—or possibly reading for the first time, for I did not remember it—Lawrence's story called *The Fox*, I really jumped when I came to his description of the fox looking over its shoulder at the farm-girl. Because it was evident that Lawrence identified himself with the russet-haired human fox who was to carry off the as it were hen-girl of the story.

And that emotion of my slightly tired, relaxed eyes and senses was not so bad as a piece of sensitized imagination. The house itself was old and reputed full of ghosts, lending itself to confusions of tired eyes. . . . My partner Marwood, sitting one evening near the front windows of the room whilst I was looking for something in the drawer of the desk, said suddenly:

'There's a woman in lavender-coloured eighteenth-

century dress looking over your shoulder into that drawer.' And Marwood was the most matter-of-fact, as it were himself eighteenth-century, Yorkshire Squire that England of those days could have produced.

And I experienced then exactly the feeling of embarrassment that I was afterwards to feel when I looked up from my deep thoughts and saw Lawrence, leaning, as if panting, beside the doorpost. . . . It was not so bad an impression, founded as it was on the peculiar, as if sunshot tawny hair and moustache of the fellow and his deepset and luminous eyes. He had not, in those days, the beard that afterwards obscured his chin—or I think he had not. I think that on his holiday he had let his beard grow and, it having been lately shaved off, the lower part of his face was rather pallid and as if invisible, whereas his forehead and cheeks were rather high-coloured. So that I had had only the impression of the fox-coloured hair and moustache and the deep, wary, sardonic glance . . . as if he might be going to devour me—or something that I possessed.

And that was really his attitude of mind. He had come, like the fox, with his overflood of energy—his abounding vitality of passionate determination that seemed always too big for his frail body—to get something—the hypnotic two thousand a year—from somewhere. And he stood looking down on the 'fairish, fat, about forty' man—so he described me in his letter home to E. T.—sprawling at his mercy, reading a manuscript before him. And he remarked in a curiously deep, rather musical chest-voice:

'This isn't my idea, Sir, of an editor's office.'

That only added to my confusion. I had not the least idea of who this fellow was—and at the same time I had the idea from his relatively familiar address that it was someone I ought to recognize. But I was at least spared —since I did not know it was Lawrence—the real pain that his 'Sir' would have caused me had I known. For I should have hated to be given what I will call a caste Sir by anybody who could write as Lawrence could.

But I was able to take it as the sort of 'Sir' that one addresses to one's hierarchically superior social equals ... as the junior master addresses the Head, or the Major the Colonel. And that was it, for when a little later I reproached him for using that form of address, he said:

'But you are, aren't you, everybody's blessed Uncle and Headmaster?'

For the moment, not knowing how to keep up the conversation with an unknown, I launched out into a defence of my room. I pointed out the beauty of its long, low, harmonious proportions; the agreeable light that fell from windows at both ends with trees beyond one half of them; the pleasant nature of the Chippendale chairs and bureaus that had been in my family for several generations; the portrait of myself as a child by my grandfather, and his long drawings for stained glass. And I ended up by saying:

'Young man, I never enter this room, coming from out of doors, without a feeling of thankfulness and satisfaction such as I don't feel over many things in this world.'
... All the while asking myself when I was going to pluck up my courage to say to this supervitalized creature from a world outside my own that I could not for the life of me remember who he was.

He continued to stand there, leaning still slightly against the door-post with his head hanging a little as if he were looking for his exact thoughts. Then he raised his sardonic eyes to mine and said:

'That's all very well. But it doesn't look like a place in which one would make money.'

I said with the sort of pained gladness that one had to put on for that sort of speech:

'Oh, we don't make money here. We spend it.'

And he answered with deep seriousness:

'That's just it. The room may be all right for your private tastes ... which aren't mine, though that does not matter. But it isn't one to inspire confidence in creditors. Or contributors.'

That fellow was really disturbing. It wasn't that his words were either jaunty or offensive. He uttered them as if they had been not so much assertions as gropings for truth. And a little, too, as if upon reflection I might agree with his idea and perhaps change my room or neighbourhood. And he added:

'So that as a contributor, the first impression...'

And he answered my immediate question with:

'You are proposing to publish a story of mine. Called *Odour of Chrysanthemums*. So I might look at the matter from the point of view of a contributor.'

That cleared the matter up, but I don't know that it made Lawrence himself seem any less disturbing. ...

He wasn't at any rate going to take any material chances without weighing them very carefully. There he was in his teacher's job at Croydon, secure, making what he considered to be remarkably good money. Forty shillings a week. More than his father had ever earned and he was only twenty-one. And with sufficient hours of freedom during which he would write. He had to perform his mission: he had to write. So that there he was, to use a later phrase of his own, inside the cage. He would have to think twice before anyone persuaded him to get out.

For before that first interview had ended I had begun lightly to persuade him to get out. It was quite obvious to me that here was a young fellow who ought to write, who, indeed would write, so the sooner he got to it the better. One would have to find some way for him. I was never one to be afraid of taking on responsibilities.

He shied a bit at that, plunging away, as if he had been a startled colt, from a too attractive novelty. It wasn't that the two thousand a year and establishment and titled company were not as real to him as his life in the cage. He felt himself as sure of the one as of the other. He was going to have them when the time came as certainly as he was going to have his next week's and all the ensuing weeks' salary from the Croydon School Board. He was quite tranquil about *that*.

And, before he had seen my office, he had made up his mind that I was the person who was to effect that translation. But the office had given him a bad shock. It hadn't seemed the proper frame for a person with influence, wealth and the acquaintance of the titled. His own acquaintance with the world had been very limited and he imagined an Office, to be reassuring, must resemble the office of the colliery company for which his father worked—the handsomest brick and shining granite building in the valley, with counters and swing-doors and brass and the clink of coins unceasing on the air.

So it had occurred to him that, even if he did take command of that ship of mine, there might not be behind it enough money to make the transition from his safe schoolmastership very advisable. . . . That was Lawrence —a continual fight between the jovial pirate father and the cautious, disapproving, Nonconformist, pale mother, going on all the while in the very current of his thought. And the struggle went on within him to the end of his life, though towards the end he was inclined to give his father altogether best. That alone should be sufficient to give the lie to those lugubrious, Freudian-psycho-analytic souls who try to explain the Lawrence riddle by asserting that he was obsessed by a mother-complex. He wasn't. He was a little boy who had been sickly and who had had of necessity to depend on his mother for all the comfort and good things of his life whilst he was told that his father—who got drunk—by that deprived him of the new pair of shoes that he wanted for Sundays. . . . If you have, in addition to that, complexes of an esoteric aspect, you had better explain him along the lines of Amen-Ra, the Egyptian All-Father-Mother, who united in himself the male and the female properties so that he was at once his own father and mother and his own wife . . . and husband. And his own children who were the other hawk, bull and cat deities of Egypt. And it is better to regard Lawrence's own preoccupation with sex and its manifestations with the same composure. As a mother-

suppressed child in a Nonconformist household he was shut off from the contemplation of all natural processes to such an extent that, when he grew to have control of himself, he was full of perfectly natural curiosities and, since he happened to be a writer, it was in the writing of speculations that he took his fling. If he had been a banker or a manufacturer he would have found other derivatives. As a child I was inhibited from ham and cream by a careful mother who considered them too expensive. So, when I came to man's estate, I indulged in orgies of ham and cream until for years I could not bear the sight of them. Now again I rather like cream but can do without ham unless it is the very best Virginian, such as one comes across only once every four years or so. Lawrence had the misfortune to become conscious of life in London and in a class in London that by a sort of inverted puritanism insisted that a sort of nebulous glooming about sex was a moral duty and a sort of heroism. That did not help him much. What he would have been if those influences had not bulked so largely on the horizon of his youth it is difficult to say. And it does not very much matter. He was good enough as he was. He had a white flame of passion for truth.

I cannot say that I liked Lawrence much. He remained too disturbing even when I got to know him well. He had so much need of moral support to take the place of his mother's influence that he kept one—everyone who at all came into contact with him—in a constant state of solicitude. He claimed moral support imperiously—and physical care too. I don't mean that he whined. He just ordered you to consider that there he was in Croydon subject to the drag of the minds of the schoolchildren for hours of every day in a fetid atmosphere.... And that is the great curse and plague of the schoolmaster's life ... the continuous drag of the minds of the pupils pulling you down... and then with the tired mind to write masterpieces in the odd moments of silence.

And then came the scourge! He was pronounced

tubercular. I don't know how we knew that he had been so pronounced. I don't think he ever mentioned it to me; perhaps he did not to anyone. It was a subject that he was always shy of mentioning. But Galsworthy and Masterman and even the solid, stolid Marwood—and of course several ladies—went about for some time with worried faces because Lawrence was writing masterpieces and teaching in a fetid atmosphere. He had to be got out of it. He ought to be allowed to resign his job and be given a pension so that he could go on writing his masterpieces. That was where Masterman, who was a Minister of the Crown and supposed to be scheduled as the next Liberal Prime Minister, came in. He was to use his influence on the educational authorities to see that Lawrence got a pension as having contracted tuberculosis in the service.

Alas, alas. Croydon was not within the Administrative County of London. The London County Council gave pensions to invalided schoolteachers. But the Kent County Council did not. Not even the Crown could coerce a county into doing what it did not want to do.... In the end, I think he was allotted a small lump sum. But one had had a good deal of anxiety.

There had been no difficulty in finding a publisher for him. The odd, accidental, as if *avant la lettre* notoriety that he had gained made several publishers be anxious to compete for his suffrages. They even paid him good little sums for his first books. He didn't have then, if ever, any very serious difficulties. And the London of those days was a kind place to people who were reputed to be writing masterpieces. There were kind, very rich people who asked nothing better than to be nice to young men of gifts. So that in a very short time Lawrence was writing home exultantly that he had dined with two Royal Academicians, several *Times* reviewers, Cabinet Ministers and Ladies of Title, galore, galore. I don't mean that the exultation was snobbish delight at mingling with the Great. No, it was delight at seeing himself by so far on the road ... towards the two thousand a year. ...

In the course of a good many Saturday afternoon or Sunday walks in the Gardens or Park, there came home to me a new side of Lawrence that was not father-mother derived—that was pure D. H. It was his passionate—as it were an almost super-sex-passionate—delight in the opening of flowers and leaves. He would see in the blackish grass of Kensington Gardens a disreputable, bedraggled specimen of a poor relation of the dandelion whose name I have forgotten. . . . Oh, yes, the coltsfoot—the most undistinguished of yellow ornaments of waste-places and coal-dumps. . . . And immediately Lawrence, who had been an earnest *jeune homme pauvre* with a fox-coloured poll, drawing wisdom from a distinguished, rather portly Editor, would become a half-mad, woodland creature, darting on that poor thing come there by accident, kneeling before it, feeling with his delicate, too-white and beautiful fingers, the poor texture of its petals. And describing how, the harbinger of spring, it covered with its sheets of gold the slag-heaps and dumps of his native countryside. . . . With a really burning language!

And it was not the starved rapture of the Cockney poets to whom flowers were mysteries. He knew the name and the habits and the growths of every flower of the countrysides and of stoats and weasels and foxes and thrushes. Because of course Nottingham, for all its mining suburbs, was really in and of the country, and a great part of the time—the parts of his time when he had really lived —had been spent on the farms that surrounded his home. . . . That, of course, you can gather from his books. . . .

Above all from his books. The nature passages of the ordinary English novelist are intolerable—the Dartmoors and Exmoors and Woodlands and the bearded tits and comfreys and the rest. (I am not talking of naturalists.) But the nature passages of Lawrence run like fire through his books and are moments when he is becoming rather tiresomely introspective. So that at times when you read him you have the sense that there really was to him a side that was supernatural . . . in tune with deep woodlands,

which are queer places. I rather dislike writing just that because it sounds like the fashionable writing about Lawrence which gloomily identifies him with Pan—or Priapus or Pisces or phalluses—which you don't find in Nottinghamshire woodlands....

Well.... He brought me his manuscripts—those of *The White Peacock* and *Sons and Lovers*. And he demanded, imperiously, immensely long sittings over them ... insupportably long ones. And when I suggested breathing-spaces for walks in the Park he would say that that wasn't what he had sacrificed his Croydon Saturday or Sunday for. And he held my nose down over this passage or that passage and ordered me to say *why* I suggested this emendation or that. And sometimes he would accept them and sometimes he wouldn't ... but always with a good deal of natural sense and without *parti pris*. I mean that he did not stick obstinately to a form of words because it was his form of words, but he required to be convinced before he would make any alteration. He had learned a great deal from reading other writers—mostly French—but he had a natural sense of form that was very refreshing to come across—and that was perhaps his most singular characteristic. His father was obviously not a dancing-teacher and minor craftsman for nothing.

And then one day he brought me half the manuscript of *The Trespassers*—and that was the end. It was a *Trespassers* much—oh, but much!—more phallic than is the book as it stands and much more moral in the inverted-puritanic sense. That last was inevitable in that day, and Lawrence had come under the subterranean-fashionable influences that made for Free Love as a social and moral arcanum. So that the whole effect was the rather dreary one of a schoolboy larking among placket-holes, dialoguing with a Wesleyan minister who has been converted to Ibsen. It gave the effect that if Lawrence had not met that sort of religion he might have been another ... oh, say, Congreve. As it was it had the making of a thoroughly bad hybrid book and I told him so.

I never saw him again...to talk to. But he did, in successive re-writings, change the book a good deal... at least I suppose there were successive re-writings.... And I suppose I hurt his feelings a good deal. Anyhow I am glad I did not have to go through his manuscripts any more. I don't—and I didn't then—think that my influence was any good to him. His gift for form, in his sort of long book, was such that I could suggest very little to him and the rest of his gift was outside my reach. And, as I have said, he is quite good enough as he is— rich and coloured and startling like a medieval manuscript.

The last time I saw him was during the War when, of course, he was a pro-German and was supposed to be a good deal persecuted. That is to say, Authority—in the shape of the Minister of Information—was afraid that he was being persecuted and I was sent down to see what could be done for him, Mrs Wells—who was as worried as anyone else about him—kindly driving me the thirty or forty miles down into Sussex where Lawrence had been lent the house of Mrs Meynell, the poetess.... But I was not talking without the book when I said that I never saw him again to talk to. The Gods saw otherwise. For the moment we arrived at that pleasant place, Mrs Wells, who was very small, and Mrs Lawrence, who resembled the Germania above the Rhine at Rüdesheim, fell into a discussion as to the merits of the Belgians. And, as Mrs Lawrence saw fit to address, on the side, unfavourable remarks to the uniform I was wearing, I thought it was better—because I *was* there to make a report to Authority—to retire to an outhouse and await the close of the discussion. So that the last image I have of Lawrence is his standing there, a little impotent, his hands hanging at his side, as if he were present at a dogfight in the beautiful, white-walled, shady, aesthetic room of Mrs Meynell. He was smiling slightly, his head slightly bent. But his *panache*, his plume of hair with the sunlight always in it—and his red beard—were as disturbingly bright as ever.

A MAN OF INFINITE PITY

John Galsworthy

I went for a walk down through the dim Luxembourg
Gardens of the end of January where they were putting
iris plants in among privet-bushes. It seemed a curious
thing to do. But of course they know what they are
about. I continued down the Rue Férou which, it is said,
Dante used to descend on his way from the Montagne Ste
Geneviève to the Sorbonne—and in which Aramais lived
on the ground, and Ernest Hemingway on the top, floors.
And how many between the musketeer and the toreador!
And so across the Place St Sulpice, more dimmed by the
thaw than even the long alleys of the Luxembourg.

Terrible things—for those to whom terrible things oc-
cur in their lives—happen in the last days of January.
The heavy drag of winter is then at its most dire and your
courage at its lowest as if in a long four o'clock in the
morning of the year. You seem to pass as if you yourself
were invisible in the owl light of the deep streets. . . .
Between dog and wolf, they say here. It is a good phrase.

Because, through such tenebrousnesses, I made my way
to a café where I sat all alone and read that Galsworthy
was dead. A week ago it had been George Moore. So the
days between—the days of black frost twilight turning to
crepuscular thaws—were days between dog and wolf. . . .
Between their deaths!

I sat for a long time looking at the words:

> Mort de John Galsworthy
> La Carrière du célèbre Romancier.

It seemed wrong to be reading of his death in Paris.
And, for me in tawdry light above tawdry *nouvel art*
decorations of a café I much dislike, I saw through the

white sheet of paper . . . dull green hop-lands rolling away under the mists of the English North Downs; the sunlight falling through the open door of the stable where he used to give me breakfast; the garden of the Addison Road house. It backed on the marvellous coppices of Holland Park and the pheasants used to fly from them into the garden.

I was some years younger than Galsworthy but he did not publish his first book until six years after I had published mine. In consequence, he being always unobtrusive and I overbearing, I got very early into the habit of considering him, and of treating him, as a much younger man. So that when I read of his death it was almost as if I had lost a younger brother in the flower of his age.

I first saw him in a sporting-club. They told of him there a curious anecdote; the fame of it hung over him like a curious legend so that, though I was not introduced to him for several years, I was accustomed to speculate as to what sort of a fellow he could be.

In those days he was the young man-about-town—at any rate to all appearances. He was moderate in everything sedulous in the effort to pass unnoticed in the best places where young men about town shew themselves. He had a little bachelor establishment; kept a small stable; drank very moderately and dressed with the careful negligence that was then required of you. So he appeared always to be in harmony with his surroundings. He seemed to sink into his background—on the grandstand of a good race-meeting, in the stalls of a good theatre, at an afternoon tea in the best of houses—as harmoniously as a thirteenth-century madonna sinks into its gold background in a dim, twelfth-century, Italian church. He was nevertheless marked out—perhaps because of his legend. I have heard elderly colonels say he was not 'sound.'

I do not know that I ought to tell that story. It is not derogatory to Galsworthy but it probably belongs to someone else and one should not tell other people's stories. But

most of the people who once knew it must be dead by now and the tale is infinitely illustrative. It is this:

One night a young man—I think it must have been Earl Bathurst or one of the Bathursts—turned up in that club with another young man—Galsworthy. Bathurst wanted to borrow a fiver from somebody. The two had been to the Derby and had done rather well. In the train with them, coming back, there had been a thimble-rigger. Galsworthy had been perfectly aware that the fellow was a swindler. But he obstinately backed himself to discover under which thimble was the pea—which was of course under none. . . . With the grim persistence that was the main note of his character he had backed himself, doubles or quits against the thimble-rigger and his confederates. He had lost his watch and chain, tie-pin, signet-ring. So they had come to that club to borrow money to redeem the watch which had sentimental associations for Galsworthy whilst the thimble-rigger waited in the hall. Bathurst had eventually got the money out of the club porter.

Grim persistence. . . . That was what it was. Galsworthy thought that the trick *ought* to be exposed for the benefit of the public. . . . 'Ought': that was even then his great word!

His face seemed to be always just about to smile, the lines of a smile being always about his lips. Actually he smiled a real smile—the product of an emotion rather than of a generally benevolent attitude—only rarely. He was 'Devonshire,' and proud of being Devonshire and proud that the chief attribute of the Devonshire man is a surface softness under which lies the grimmest of obstinacies—the velvet glove on a hand of marble. . . . Nevertheless your main impression of Galsworthy would be his smile. . . . And his softness.

In his physique too he had those characteristics. He appeared gentle and inactive as if with a continuous pensiveness. But he had in his youth muscles of iron and, in athletics, the same persistence.

I do not suppose I shall ever forget my surprise just

after my first introduction to him. It was at the Pent when Conrad was stopping with me. I was prepared for something remarkable by Conrad's really radiant expression when he said: 'Jack wants to know if he may come down.' For some days I heard then of 'Jack.' I do not know that I even heard his surname for Conrad had a trick of taking it for granted that you must know everyone whom he knew. Then, at the station appeared the smiling being of the sporting-club. . . . That was already an astonishment.

I was driving a waggonette with a pretty good mare. He swung his grips over the side of the cart and would not get in because, he said, he wanted some exercise. The road from Sandling Junction goes immediately up a very steep bluff so he walked beside the box-seat, conversing as Englishmen of his station converse . . . about the properties on either side of the road—the Laurence Hardie of Sandling; the Deedes of Saltwood Castle; Earl Sondes a little farther on.

At the top of the bluff he would not get in. He said:

'Drive on. That will be all right. I need some exercise.'

I said:

'If you mean to walk there is a kissing-gate in the hedge after the next ventways. On the left. . . . You cater the field. You'll be on Pent Land. You'll see the house.'

He said:

'That will be all right. Drive on. I want some exercise.'

I touched up the mare. She was a pretty good goer, aged, but with a strain of Wilfred Blunt's Arab blood. I did not expect to see that fellow again until a quarter of an hour after I got to the house. . . . But there he was, still beside the box-seat, trotting along with the utmost equanimity. And, as if we had been strolling down Piccadilly he continued conversing . . . about the land of the Pent which is a clayey loam in the bottoms till it runs into the chalk of the Downs; and about how the young partridges were coming on; and about Selby Lowndes the redoubtable Master of the East Kent Hounds who had once had a trencher-fed pack in the Cleveland. English-

men have to know all these things or they are not 'sound.'
So he trotted the mile and a quarter to the Pent. I felt like
Maupassant when the head of Swinburne rose out of the
Mediterranean beside his canoe and the poet swam to
shore beside him conversing joyously of Anacreon. . . .
Conrad told me afterwards that Jack had held the mile
record at Oxford for several years. That needs persistence.

Later, indeed, I happened to ask him some question
about running—it was at the time of the first Olympic
Games in Athens—and said innocently:

'You hold the mile record at Oxford, don't you?'

He really jumped a couple of feet away from me—we
were walking in the Park—and exclaimed:

'Good gracious, no! Oh goodness gracious, no! I did a
little running at Harrow. But at Oxford I never did any-
thing but loaf about the High. . . .' As a matter of fact,
he declared, the very little running he had done at the
school on the hill had injured his heart so he could not
have done anything in that line at Oxford. And, as a
matter of fact, too, he had, he said, not done anything in
any line at all. He had just scrambled through his exami-
nations for the bar. That was all.

He had duly eaten his dinners at the Middle Temple
and, like every other gentleman's son of those days, had
been called to the bar. That is to say if one was at all
'born,' one had, till about then, gone either to the bar or
into the Army. Or if one were born and a very younger
son one went into the Church. But at the time Galsworthy
was called to the bar, the Army was already showing signs
of becoming a rather serious affair, and with the fall in
the value of agricultural tithes, the Church had become a
not very lucrative profession. So he had donned wig and
gown for a ceremonial attendance on the Courts, as being
the proper thing for a gentleman's son who had no am-
bitions and intended to loaf through life. He had, I
understood, appeared once or twice in cases, representing,
as a junior counsel, the important firm of which his father
was the chief partner, and, during the voyage on the

Torrens, of which ship Conrad was the chief mate, he had rather desultorily studied naval law.

His friends and parents jeered at the idea of his writing. His father was a Tartar. I lived at one time next door to him and that was what the servants said of the old gentleman. Galsworthy *père* and *mère* separated, tired of seeing one another, at very advanced ages. There was something pixyish and hard about both those old people; the father ferocious, the mother young for her age, flighty, with bright-coloured bonnet-ribbons. It was not a usual stock, that from which Galsworthy came.

Conrad's account of his first meeting with Galsworthy always pleased me; it was like one of those fairly-tales of which there are too few in life. Galsworthy, I anticipate, will contradict it. I can only vouch for the way Conrad told the story.

Conrad then was first mate of a sailing-ship called the *Torrens.* The *Torrens* was one of the famous, teak-built, clipper-rigged vessels that carried sea-loving or invalid passengers by way of the Cape to Australia with almost the punctuality of a steam liner. Ninety days out to Sydney Headland, ninety days back to the Thames Estuary—that was her schedule and she kept to it. Conrad already had ideas of leaving the sea and making a living by his pen. It was before the days of typewriters. He had begun a novel, writing trial passages on the fly-leaves and margins of *Madame Bovary* and *L'Education Sentimentale.* I used to possess his copy of the latter book. Whilst I was in France during the War someone relieved me of it along with most of my portable property. There was a passage, that was afterwards incorporated into *Almayer,* pencilled on the front and back of the half-title page.

On the *Torrens,* bound for the Cape, was a young, blond, modest and smiling barrister. He was bound on legal business for the Cape Copper Mines in which he had a family interest. The two young men—Conrad was still in his thirties—confided each to the other that they had literary ambitions. In the starlit silence of the dog-

watches, Conrad descended to his cabin and fetched up the beginning of his manuscript. That young barrister who seemed to Conrad to possess all the gifts of Fortunatus must have been the first human being to read any of Conrad's manuscript—on a ship, in the starlight, running down off the coast of Africa. That romance would be almost enough for any one man's portion: That fortunate being was the author of—*The Silver Box*.

I say *The Silver Box* because it was one of Galsworthy's writings for which Conrad had the most unbounded admiration. I went with him to one of its later performances and his enthusiasm was so vocal as to cause me considerable shyness. The people in the stalls round us now and then hissed for silence. And indeed *The Silver Box* is an admirable work. I would give no little to see it again but I suppose I never shall. The grim determination with which Galsworthy makes point after point always reminds me of a big trout lying in a stickle of a stream on his native Dartmoor. Fly after fly comes down on his water and not one, ever, does the grim speckled being miss. In that play at least you have an object lesson in what Conrad used to call catching a subject by the throat and squeezing the last breath out of it.

I must have asked myself a hundred times in my life: If there had been no Turgenev what would have become of Galsworthy? . . . Or, though that is the way the question has always put itself to me, it might be truer to the thought I want to express to say: What would Galsworthy have become?

I might have asked the same question about Henry James, for the influence of Turgenev on James must have been enormous, but I did not know James before he had come across Turgenev, whereas I did know Galsworthy whilst he was still himself and still astonishingly young. And I remember distinctly the alarm that came over me when Galsworthy one morning mentioned Turgenev for the first time at breakfast. It was both the nature of the mention of the beautiful Russian genius and Galsworthy's

emotion of the moment that alarmed me. I had known him
for a long time as a charming man-about-town of a certain
doggedness in political argument. Indeed, I don't know
how long I hadn't known him; to find out exactly I should
have to do more delving in thought into my own past than
I care to do. But I knew that he was passing through a
period of great emotional stress, and as I had a great
affection for him I was concerned to find him expressing
more emotion over an ancedote than I had ever known
him to show.

The anecdote was this: Turgenev had a peasant girl for
mistress. One day he was going to St Petersburg and he
asked the girl what he should bring her back from town.
She begged him to bring her back some cakes of scented
soap. He asked her why she wanted scented soap and she
answered, 'So that it may be proper for you to kiss my
hand as you do those of the great ladies, your friends.'

I never liked the anecdote much, myself. But Gals-
worthy, telling it in the sunlit breakfast-room of my cot-
tage at Winchelsea, found it so touching that he appeared
to be illuminated, and really had tears in his eyes. I dare-
say the reflection of the sunlight from the table-cloth may
have had something to do with the effect of illumination,
but it comes back to me as if, still, I saw him in a sort of
aura that emanated from his features. And from that day
he was never quite the same. . . . The morning is also made
memorable for me by the ghost of the odour of a very
strong embrocation that hung about us both. He was, at
the moment, suffering from severe sciatica, and I had
spent the last half hour of the night before and the first
half hour of that morning in rubbing him in his bed with
that fluid which consisted of turpentine, mustard and
white of egg. And suddenly I had of him a conception of
a sort of frailty, as if he needed protection from the hard
truths of the world. It was a conception that remained to
me till the very end . . . till the last time but one when I
came upon him accidentally watching one of his own plays

in New York, all alone and, seemingly, very perturbed. I don't know by what.

The disease from which he suffered was pity . . . or not so much pity as an insupportable anger at the sufferings of the weak or the impoverished in a harsh world. It was as if some portion of his mind had been flayed and bled at every touch. It entered into his spirit at about the date of which I am speaking and remained with him all his life. And, for me at least, it robbed his later work of interest, since the novelist must be pitiless at least when he is at work.

And it filled me with disappointment. I think I must have been the first person really to take Galsworthy seriously as a writer. For most other people who knew him then—except of course for the lady who subsequently became Mrs Galsworthy—he was still an amiable, rather purposeless man-about-town, with a liking for racing, with some skill with the shot-gun, a proper connoisseurship in cricket. But I had already recognized in him a certain queerness, a certain pixylike perversity . . . and a certain, slight, authentic gift. So that I had expected him, if he persevered, to provide for us another—a possibly sunnier—kind of Trollope, and I very much did not want him to become overserious or emotional.

And suddenly there was Turgenev—the most dangerous of all writers for his disciples—Turgenev and emotionalism appearing in the mentality of that sunny being with the touch of genius. . . .

Immediately after the Turgenev anecdote I opened inadvertently a letter addressed to him in care of myself. It was the morning after he had gone back to town. Then I knew immediately after the reading of merely three amazing words and the signature that poor Jack had his troubles of the heart.

It gives the measure of the passion that I have for not knowing anything about the private lives of my friends—particularly if they are writers—that I went half an hour later by train up to London. I got some envelopes to match

the one I had opened. Then, at one of my clubs I imitated the address of that letter on those envelopes. I managed at last a fair likeness. Then I posted the letter to my own house in that envelope. It had thus the London postmark. Then I returned to Winchelsea, and, as soon as the letter arrived, I forwarded it to the addressee. I desperately did not want Galsworthy to know that I knew. It seemed to me that that must inevitably take the bloom off the pleasure that I had in our gentle and unexciting conversations. I knew then at once that the emotion he had shown over the Turgenev anecdote was a sign that he was suffering a great deal over his hidden affair of the heart. I knew from the signature that it was one that could not run smoothly. If he had been an ordinary layman I should have stuck the letter up, inscribed it 'Opened by mistake,' and forwarded it to its owner. But Galsworthy was by now more than an ordinary stock-broker or politician. He had come alive. And I took a great deal of trouble to get that letter to him without any indications of its having been opened.

Galsworthy gave no signs of thinking that the letter had been tampered with, and for a little time it looked as if everything was as it always had been. We breakfasted and talked about the weather and the crops; we went together to concerts that his sister, Mrs Reynolds, was organizing; we discussed the alterations that his sister, Mrs Sauter, suggested in the story he was writing . . . which was, I think, then the *Villa Rubein*, a book for which I had and still have a great affection. Then gradually the change came.

He began to talk of Turgenev as the emancipator of the serfs in Russia; about the reform of the poor-laws; about the reform of the incidence of the income tax on the poorer classes. And above all, of course, about the reform of the marriage laws, and perhaps still more about the re-estimation of marriage as an institution. He uttered one day the sentiment that where there is no love, there is no duty.

Then one evening he knocked on my door in a really pitiable state of distress. I was giving a rather large dinner, one of the motives of which was to introduce Galsworthy himself to the more formidable critics and men of letters of the London day. His book was then near publication and Conrad and I had conspired to do that amount of log-rolling. And suddenly there was Galsworthy at seven-thirty saying that he could not come to that dinner. He said that if I knew what was happening I should not want him to come to dinner; that all my guests would think the same. Mysterious things were happening to him; he would probably never again be invited to dinner by any-one. I should know all about it tomorrow; then I should see how right he was.

It was no use saying that if he had been hammered on the stock exchange or neglected to pay his racing debts it would make no difference to my desire to have him at that dinner. He said: No, no! It would be unthinkable. It would be an offence to myself such as he would never pardon if it had been offered to him. . . . It was the first time I had come up against his immense, his formidable obstinacy.

He wrote to me next day to say that he had that after-noon been served with papers as co-respondent in a divorce case. Of course my guests would have hated meet-ing him! And he wanted to know if it would make any difference in our friendship.

Times of course have changed, but I think that even then the ordinary man would have taken the matter less tragically. Galsworthy, however, insisted on considering that his social career and more particularly that of his future wife was at an end, and that for the rest of their lives they would be cut off at least from the public society of decent people. He was, of course, quite wrong. Even at that date London society took the view that, for a decent man and woman, passing through the divorce-courts was a sufficient ordeal to atone for most irregu-larities. Once they were through, they had taken their

punishment and decent society does not approve of two punishments being exacted for one misdemeanour. . . . But at the time it was no good putting that view to Galsworthy. He was in many ways singularly old-fashioned and strait-laced.

We both at that time inhabited an august, sedate hill-top in the royal borough of Kensington called Campden Hill, he on the one side and I on the other of a concreted open space given up to tennis-courts—it was really the cover of a waterworks reservoir. One of his sisters, a few yards away on the Hill, was *mélomane* and gave wonderful concerts; the other was married to Sauter, the tough, dynamic Austrian painter, and lived just down the Hill. Campden Hill was like a high-class Greenwich Village in which all the artists should be wealthy, refined, delicate and well-born. It was high in the air. In its almost country roads you met ladies all of whom wore sable coats —or at least sable stoles—and admirable children all bursting with health; and Whistler and Abbey and Henry James. . . . On days when I was not expecting Conrad, who was in lodgings not far off, I would breakfast with Jack in his sun-lit, converted stable.

At any rate that is how it comes back to me—the doors and windows always open, the sunlight streaming in on the hissing silver tea-kettle, the bubbling silver entrée dishes, the red tiles of the floor, the bright rugs, the bright screens. . . .

In those days Galsworthy was already writing, but I think as 'John Sinjohn' in order to spare the feelings of his family. I do not think I ever disagreed with anyone more thoroughly than I did with Galsworthy as to the methods and functions of novel-writing—but we disagreed very amiably—at least on my side. I wrote him immense and violent letters on the subject. For all I know they may have annoyed him, but he always smiled at breakfast. I used to declare that a writer can learn no more of Turgenev than he can of Shakespeare, both being temperaments rather than writers with methods to be studied.

That used to pain Galsworthy. He would declare that no
one could avoid being benefited by contact with that
temperament of infinite pity and charity.... And we
would talk until it was time for me to go back along the
waterworks wall and take up the interminable job of
writing, in my dining-room, patchwork passages into
Romance, when Conrad was not writing *Nostromo* up in
my study. And Galsworthy would be going to ride in the
Park....

There came the mental crash. He crossed his Rubicon.
I can place the very agitating day and after that Gals-
worthy was no more the young bachelor-about-town even
in appearance. Nor was he any longer Poor Jack. He had
got religion and his path was plain.

He never looked back and gradually our ways parted.
I still saw a great deal of him. We still lived close together
but now down the Hill. I could see the beggars and hard-
cases from my windows, going from my office of *The
English Review*, round the corner, to Galsworthy's door-
step that was never without its suppliants. My hard-cases
were all of the literary sort, such as come to the office of
a journal and go on to a Galsworthy. But he had innum-
erable others. His charities were inexhaustible.

More than anything he was sensitive to the sorrow of
other people. He was that even before he had thus got, as
it were, religion, and the long excruciation of waiting
years for the opportunity of happiness had made him sen-
sitive beyond belief. The anticipation of possible future
grief for his wife rendered him at the time almost out of
his normal mind, and the emotion was rendered all the
stronger by the thought of the suffering that, for years
before that, she had had to endure ... with, as it were,
Soames Forsyte. I really thought that, at about the time
when he had just received those divorce-papers, he might
have gone mad.... And that note of agonized suffering at
the thought of oppression or cruelty became at once the
main note of his character and of his public activities. It
led him, in his novels, into exaggerations or slight

strainings of the humanitarian note which distinguished every page of his writings of that date and, as we shall see, influenced the very framework of his novels themselves. And his very exaggerations tended to negate the truths of the morals that he meant to enforce.

To me it became apparent gradually that Galsworthy was probably never meant to be a novelist. Or it would be more just to say that thoughts of the world of injustice pressed too strongly on him to let him continue to be a novelist. That was why, at Winchelsea, I was alarmed at his rendering of the Turgenev anecdote. . . . I can assure you that I felt a genuine pleasure and impatience at the thought of coming across a person with the aspects for me of an authentic genius . . . and if I perceived a threat to the prospect of the fruits of that genius growing eventually ripe beneath the sun, I was proportionately dismayed. And I thought I perceived that threat. I foresaw for a moment his preoccupation with the unhappiness of lovers and the helpless poor . . . and that preoccupation leading him to become not a dispassionate artist but an impassioned, an aching, reformer.

The premonition was too true. *Villa Rubein* was a novel of a sun-lit quality. But its successor, *The Island Pharisees*, was already a satire, and *The Man of Property*, which came next, was an attempt to cast discredit on the marriage laws of the day. And after that, in his novels, he was the reformer almost to the end.

And unfortunately his temporal success as novelist obscured his much greater artistic achievement with the drama. His novels suffered from his dogged determination to find ironic antitheses. His one "effect" as a novelist was to present a group of conventionally virtuous, kindly people sitting about and saying the nicest things about all sorts of persons. . . . A divorced woman is thrown over their garden-hedge and breaks her collar-bone, and all the kindly people run away and do not so much as offer her a cup of tea. And that goes on forever, the situation being always forced to bring in that or similar effect. Mr

Marrot* quotes a really amazing correspondence between Mr Garnett and Galsworthy about the end of *The Man of Property*. It raged for months. Galsworthy was determined that his Bosinney—who was the last person in the world to do it—should commit suicide in order, really, to prove that the propertied middle classes were very cruel people ... with of course the aim of shaming those classes into becoming really kinder. Mr Garnett, all reformer as he too was, is shocked at the idea that Bosinney —who, I repeat, was the last person in the world to commit suicide—should be forced to take his own life so as to show the effects of the cruelty of the middle classes. What Bosinney would have done—and what the situation demands—would have been to run away with Irene and live in inconspicuous bliss in Capri ever after. But no, says Galsworthy, that would not prove that the middle classes are always cruel and victorious over the unfortunate. ... And the argument seems to go on forever, each party maintaining exactly the same ground. In the end poor Bosinney has to be run over by a bus, the reader being left uncertain whether it is the result of an accident or a suicide ... and there seeming to be no moral lesson at all.

But the same dogged determination to present antitheses which produced an effect of monotony in the later novels was exactly suited to the theatre. There effects are of necessity more fugitive and need to be harsher—more cruel. And the keen pleasure that, at the play, the mind feels at appreciating how, unerringly, Galsworthy picks up every crumb of interest and squeezes the last drop of drama out of a situation ... that pleasure is the greatest humanity can get from a work of art. It is the greatest because pleasures, shared as they are in the playhouse, are contagious and can be unbounded. And it is one of the most legitimate of man's pleasures.

When you came away from the first performance of *The Silver Box* you knew that something new had come

* H. V. Marrot, editor of *The Life and Letters of John Galsworthy*, London, 1935.

into the world ... a new temperament, a new point of view, a new and extraordinarily dramatic technique. And the conviction was strengthened by each new play. For myself I preferred *Joy* to all the others because it was more a matter of dramatic discussion than of situations, and because it had some of the lightness that had distinguished the *Villa Rubein* of our youths. But the characteristic of building up antitheses which, monotonous as it becomes in the novel, is always legitimate and exciting in the swifter-moving play, that characteristic distinguished as much his handling of situation as of staged controversy. And finally that conviction came to be shared by the large, unthinking public, the plays began to run for periods of years in both London and New York, and Galsworthy moved from triumph to deserved triumph. No other modern dramatist had anything approaching Galsworthy's loftiness of mind, his compassion, his poetry, his occasional sunlight or the instinctive knowledge of what you can do on the stage. And by himself he lifted the modern stage to a plane to which until his time it had seemed impossible that it could attain.

And so he made towards supreme honours a tranquil course that suggested that of a white-sailed ship progressing inevitably across a halcyon sea. You would have said that he had every blessing that peoples and kings and Providence had to bestow. Having refused a knighthood he was awarded the highest honour that the King had at his disposal—that of the Order of Merit. He presided in Paris at the dinner of the international P.E.N. Club, which is the highest honour that the members of his craft could find for him; and, in the end, the Nobel Prize Committee honoured itself by selecting him for one of its Laureates. It seemed, all this, appropriate and inevitable, for, in honouring him, the world honoured one of its noblest philanthropists.

The last time I saw him was in Paris when he gave his presidential address to his beloved P.E.N. And singularly, as he emerged above the shadow of all those hard

French writers, there re-emerged at any rate for me the sense of his frailty . . . of his being something that must be shielded from the harder earnestnesses of the world. I don't know that he was conscious on that last public triumph of the really bad nature of the hard men who surrounded him. The world had moved onward since the days when he had read Maupassant and Turgenev for what he could learn of them. Both those writers were what he called dissolvents and the Paris *littérateurs* now wanted above all constructive writing and would have agreed with him if he had said—as he did in one of the last letters that he wrote—that Tolstoy was a greater writer than Turgenev.

But, there, he said nothing of the sort. He seemed to float, above all those potential assassins, like a white swan above a gloomy mere, radiating bright sunlight . . . and with his gentle, modest French words he made statements that ran hissing through Paris as if he had drawn a whip across all those listening faces.

For the French writer of today, Maupassant is the Nihilist Enemy—an enemy almost as hated as the late M. Anatole France.

And Turgenev is an alien ugly duckling who once disgusted the paving stones of Paris with foreign footsteps. Nothing indeed so infuriates the French of to-day as to say that Turgenev was really a French writer. . . . And there, enthroned and smiling, poor Galsworthy told that audience that shivered like tigers in a circus-cage that, if he had trained himself to have any art, and if that training had landed him where he was, that art had been that of French writers.

A sort of buzzing of pleasurable anticipation went all round that ferocious assembly. The author of *Fort Comme La Paix* looked at the author of *Nuits Ensoleillées* and thought: 'Aha, my friend, this is going to be a bitter moment for you. When I consider the *dédicace* of the ignoble volume that this barbarian chieftain presented yesterday to me . . . when I consider the fulsome, but

nevertheless deserved, praise that he wrote on that fly-leaf, I don't have to doubt whom he is going to claim as his Master. ...' And the author of *Nuits Ensoleillées* looked back at the author of the other classic and thought exactly the same thing—with the necessary change in the identity of the author. And every French author present looked at every other French author and thought thoughts similar. And when the applause subsided poor Jack went on:

Yes, he repeated, all the art he had had he had had of the French. If he stood where he was, if he was honoured as he was, it was because all his life long he had studied the works, he had been guided by the examples of ... Guy de Maupassant and of him who though a foreigner by birth was yet more French in heart than any Frenchman—Ivan Turgenev!

I have never seen an audience so confounded. If an invisible force had snatched large, juicy joints of meat from the very jaws of a hundred Bengal tigers the effect would have been the same. They simply could not believe their ears. ... As for me, I was so overwhelmed with confusion that I ran out of that place and plunged, my cheeks still crimson, into the salon of the author of *Vasco*, who was preparing to give a tea-party at the end of the Île St Louis. And the news had got there before me. It was in the salon of every author of the Île, of the Rue Guynemer, of the Rues Madame, Jacob, Tombe Issoire, and Notre-Dame des Champs, before the triumphant Galsworthy had finished his next sentence. ... For that was the real triumph of his radiant personality, that not one of the fierce beasts quivering under his lash so much as raised a protest. No other man in the world could have brought that off!

THE LITTLE GENERAL
H. G. Wells

Mr H. G. Wells and I must have been enemies for more years than I care now to think of. And the situation is rendered the more piquant by the fact that one or the other of us must by now be the doyen of English novelists —though I prefer not to discover which of us it is. At any rate in the kingdom of letters Mr Wells and I have been leaders of opposing forces for nearly the whole of this century.

I do not think that it is immodesty in a man to claim that he is a leader of forces when his military unit is indeed a unit. One may be allowed, I mean, to say that one is one's own leader . . . for it is getting on for a great number of years since I could say that I had in England even a comrade in arms, so complete has been the triumph in that country of Mr Wells's forces. But there were good old days when the forces were more equal—and when I was hardly more than the camp-follower of a goodly Army. What we contended was that the world could be saved only by the Arts; Mr Wells and his followers proclaimed that that trick could only be done by Science. What, secondly, we contended was that if you intended to prac- tise the Arts you had better know something of the mental processes of how works of art are produced; the enemy forces proclaimed, with drums abeat and banners waving, that to be an artist of any sort you had only to put some vine-leaves in your hair, take pen or brush and paper or canvas and dip pen or brush in inkstand or paint-pot, and Art would flow from your finger-tips. The opposing doctrines were, in short, those of Inspiration and of Conscious Art.

The Mr Wells that one knew of in those earliest days

was the imaginative Scientist—Scientist professedly but imaginer above all things as far as we were concerned. In those days no one bothered his head about Science. It seemed to be an agreeable parlour-game—like stamp-collecting. And I am bound to say that it still seems to me like that. One did very well without it in those days; one will do still better without it in the not-distant future when it will be dethroned.

One heard that a singular little man had visited Mr Frank Harris in *The Saturday Review* office and had asked to have the reviewing of scientific works for that periodical confided to him. Mr Harris had said, Hell, Damn, Blast, Bloody, why don't you write funny stories about Science? . . . I don't know which of his elaborate expletives he used, but he used some.

The products of that advice began to appear on the market—and I do not have to assure you that it did not take us long to recognise that here was Genius, Authentic, real Genius. And delightful to think of all the inhabitants of London going about in the condition of the blue-behinded baboon. For one of Mr Wells's stories was about an Anarchist—those were the days of Militant Anarchism —who visited a Scientist with the idea of stealing a phial of typhoid germs and dropping them into the reservoir of the Primrose Hill Waterworks, which then supplied most of London. And he stole by mistake a phial containing the bacillus of the colouration of the stern of the blue-behinded baboon. We were delighted. We imagined ourselves—and still more our not so dear friends—going about, nervously hitching ourselves, with our backs to cheval glasses.

And we welcomed Science—Mr Wells's brand of Science—with acclamations. Fairy-tales are a prime necessity of the world, and he and Science were going to provide us with a perfectly new brand. And he did. And all Great London lay prostrate at his feet.

Mr Wells struck the Empire with all the impact of Mr Kipling. He struck everybody. He delighted the bourgeois

profane with his imagination, and we intelligentsia snorted with pleasure at the idea of a Genius whom we could read without intellectual effort. And with immense admiration for his 'technique.' One could ask no more. The other idols of the intelligentsia of those days were a little forbidding—Ibsen and Björnson and the Nordics generally, and Hauptmann and Sudermann. Gloomy and forbidding. So we devoured Mr Wells.

He liked the process; nevertheless, inspired with the gospel of Science, he snorted a little on the side . . . not loudly, but with meaning. We, his snorts said, we who delighted hilariously in his works, were poor idiots towards whom a dark shadow was swiftly drifting. Science was going to devour us as the underground working populations of one of his stories crept out and at night devoured the butterfly beings of the planet's surface. Good for Mr Wells; good for Science; good for everybody. Particularly good for us intelligentsia because we began to see that Mr Wells too was a pessimist. We slapped each other on the back hilariously. The note of the world of those days was hilarity. It was good to think that our pet Genius was going also to develop into an Intelligence.

So Mr Wells went snooping about the world, emitting from time to time a prophecy in the form of an entertaining and magnificently machined gem of fiction. And with extraordinary speed he assumed the aspect of a Dean of Letters. He was going to put writing on the social map. Pure writing, mind you. Pure imagination backed by an impeccable technique.

Gradually one realized that more and more frequently there crept into Mr Wells's work the note of exasperation at the futility of human life. . . . Or no, that is not perhaps the way to put it. I remember Henry James talking about Mr Wells one day, wondering, as it were, what had got into him:

'You'd say . . . um-um,' he said, 'that he had everything. Everything that one can desire. His enviable . . . his really enviable gift; his enviable . . . but supremely

enviable . . . popularity. His stately treasure-house on the seashore. His troops . . . his positive hordes of flushed young things bursting new into life. . . . Tempered of course with what in places of liquid entertainment, if you'll pardon me the image, they call a "splash" of elder statesmen who have seen, pondered, accomplished. . . . Troops, then, of flushed neophytes relieved by the suavely Eminent. . . . Nevertheless, there is this pervading note . . . this burden . . . this undersong and overtone . . . of the creaking door.... Upon my soul this Fortunate Youth—for compared to myself, *moi qui vous parle*, he is immoderately richly endowed with the splendid gift of youth—might be—making allowances for the differences of circumstances and, of course, cadences—your friend Conrad's monstrous master mariner, Marlow, who is always addressing to the moon his hyper-Slav complaints as to the lugubrious ends, inevitably attending on human endeavour.'

He drew a deep breath and began again rather quickly:

'You don't suppose . . . it has been whispered to me . . . you know swift madness *does* at times attend on the too fortunate, the too richly endowed, the too altogether and overwhelmingly splendid. You don't suppose then . . . I mean to you too has it been whispered? . . . that . . . well, in short. . . .' And very fast indeed: 'That-he-is-thinking-of-taking-to-politics?'

I really jumped when I heard that suggestion. Then with immense fervour and earnestness I burst into indignant denial that anything so scandalous could be imagined about my friend. . . . Alas!

Outwardly Mr Wells of those days always seemed to me most to resemble one of those rather small British generals who were so unlimitedly beloved by their men— a Buller or a Bobs. Blond, rather stocky, with a drooping cavalry moustache and with eyes always darting about, I fancy he would have been happy as a general, commanding bodies of men to do things and they doing it . . . commanding them in writing from a headquarters table and

surrounded by a deferential troop of staff-neophytes to
carry his orders.

But, in those days, when he was already in the saddle
and had glimpses of all the worlds that he might conquer,
what struck one most was his tough, as it were Cockney,
gallantry of attack—upon anything. . . . I am not being
rude when I use the word that describes persons born
within sound of Bow bells. I am a Cockney myself and so
is Mr Charles Chaplin and so was Keats. . . .

And indeed later when he left off being primarily an
imaginative writer and became a politician or something of
the sort, and when he made his determined attempt to
capture with the aid of his flushed neophytes one of the
most formidable and dangerous political organisations in
the British Isles—why then I really used to see him as
another Mr Chaplin of the days when that hero used to
attack an enormous, a gigantic, black-bearded villain—
flying from the top of the kitchen sink at the giant's neck,
being thrown through the windows, plunging down the
chimney to kick his foe in the rear, being thrown through
the ceiling, flooring the giant with tiles from the roof. And
so on for ever and ever. There was indeed a memorable
meeting during that famous struggle when Mr G. B. Shaw
and the Sidney Webbs between them managed dialecti-
cally to wipe the floor with Mr Wells. And it was all I
could do, much as I deprecated Mr Wells's desertion of
Literature for Public Affairs, to prevent myself shouting:
'Oh, H. G. There's the lecturer's bottle behind you.
Smash them on the head with it. For Heaven's sake!' So
much affection did H. G. inspire even in his enemies and
so much did one dislike to see the Old Gang, as they were
even then called—Mr Shaw and the Sidney Webbs, now
Lord and Lady Something or Other—combine with grim
coldness to get the better of that beloved general of young
things and causes that were then also young.

I remember now the sunlight over Sandgate and the
sea, and Mr Wells and I descending the steep brae that
goes down from the hutments of Shorncliffe Camp to the

narrow High Street, whose outer row of houses was so close to the sea that in great westerly gales the Indiamen going ashore used to poke their bowsprits through the windows. I have seen them do it. For that was the landscape at once of my childhood's school and of Mr Wells's *Sea Lady*. At the time of which I am thinking he had taken a furnished house on the beach whilst he waited for Voysey to build for him on the chalk slopes above what Mr James later called his lordly treasure-house. And in the days of which I am talking the rest of the personages of my young drama—Conrad, James, Crane, Hudson—dwelt in a half circle at distances of from five to thirty-odd miles round Spade House. So it was not to be wondered at if we lived rather in each other's pockets and interested ourselves rather in each other's affairs.

And Mr Wells really had for us the aspect of the Dean of our Profession. We regarded him, a little wistfully, as having innumerable things, appurtenances, gadgets, retainers, immense . . . but immense . . . sales, and influence, and the gift of leadership. . . . And we all should never have any of those things nor ever bask in those public lights. So, in some mystic way, Mr Wells might have put Literature on the map. . . . That was how it seemed. Alas, he was to become the Lost Leader!

That went in this way:

The day before we descended the slope into Sandgate High Street, intent on getting an appetite for dinner, Mr Wells had been up to town. And after we had proceeded silently for some minutes he exclaimed suddenly:

'You know, Fordie, there's something in those old Classics after all.'

On his way up to London he had bought at Sandling Junction a copy of More's *Utopia* in Dent's newly published Temple Edition, that was then putting cheaply before a very large public a number of books that they would never otherwise have read. He had read it in the train going up to town, in his hotel bedroom, and on his homeward road. And that was his verdict.

I made the sort of silence that indicates the words: 'I told you so,' for the words are not good ones to utter, and we walked on meditating till suddenly he exclaimed:

'You know, if I had the education of this country in my hands I could make something of it yet.'

And we walked on in silence some more. I imagined that we were both thinking about Education, which for me seemed to have nothing to with Instruction, and for him, as far as I could see, seemed to be nothing else. . . . That at any rate had been the lines that our arguments had taken. . . .

So we continued our walk in silence. I don't know what he imagined I was thinking about, but I certainly thought he was mentally outlining a scheme of scientific education for the youth of England—with perhaps a dash of the Classics to temper the wind of microscopic bugs and bacilli. I imagined, that is to say, that he was softening. For I had asked him shortly before at what date he considered civilisation to have begun. And he had answered with a quick snort of scorn that civilisation had begun when soft iron was discovered accessible enough and in sufficient quantity to make practicable the extensive manufacture of machines. . . . That of course finished the wiping out of the Classics. They had all been written before the discovery of soft iron. Therefore they had not contributed to civilisation.

Now, I imagined, he was softening a little under the influence of the beloved statesman of Henry VIII. He may have been. But it was not about the evolution of a New Education that he was thinking on that walk. He was thinking about becoming the one and only Arbiter of the World.

The moment you looked back through the already long list of his stories that became clear. They were all about men who might have become arbiters of the world by means of one scientific gadget or another: the Invisible Man, the Man Who Could Work Miracles, the Man Who Could See in the Country of the Blind. They might have become the Arbiters of the World; but they did not because

they had not sufficient imagination. They ended always in a sort of infuriated and dyspeptic frustration. Or, at best, in giving blue behinds to the population of London Town.

But after reading More's *Utopia*, Mr Wells saw that he, he only and no other, was actually the Man Who Could See in a Country of the Blind. Life at once became clear to him and it was *Utopia* that had showed him the way. In our Nordic world, imaginative writing is a despised, an as if effeminate occupation, and the imaginative writer a something less than a He-man—and one whom you could not introduce to your wife. His chance of becoming an Influence is almost less than nothing; his chance of saying to the world 'Do this' and of seeing it done was even less. Yet that ought to be the destiny of the Remarkable Man. He should be, as it were, a General directing forces to the attack on Ignorance and Evil.

And the way to do it was to write Utopias—to prophesy what the world would be like when the forces of Ignorance and Evil should have been forever overthrown. By the quality of your writing and your quick, brilliant touches, you would make the imagined Future look so attractive that mankind would call on its statesmen and politicians to give them that sort of world and no other. . . . If you could do that you would indeed become the General Officer Commanding the Forces of the Universe. You would shout to the world: 'Humanity will Advance by the Right! Move to the Right in Fours! Form F—O—U—R—S! . . . RIGHT!' . . . And Humanity would do it.

For one day Mr Wells said to me, 'Fordie, I'm going to turn the Fabian Society inside out and then throw it into the dust-bin.'

My heart sank into my boots. There went through my head words like

Just for seventeen tons or so of silver he's leaving us,
Just for a ribbon that would stretch from here to the
　　moon and back to stick in his coat
Gaining all the gifts of which fortune bereft us . . .

and so on. The words are perhaps not quite right. But the only anthology of English verse that I possess—that made by Mr Walter de la Mare—does not contain *The Lost Leader* or indeed any word of Browning's. . . . And I exclaimed:

'Good God, no H. G.!'

It would be as well, perhaps, to explain that the Fabian Society was in those days about the most unpleasant feature of English public life. As it were, a Socialist Tammany Hall! It proposed to reform society by means of statistics, and its publications were so dull that no one not spurred on by a sort of sadic lust to destroy his fellow-men could possibly have read them. Its members have since mostly become peers, but I cannot for the life of me remember their names. There was one who as Cabinet Minister was responsible for most of the calamities that have befallen the Jews in Palestine. . . . The Society, in short, got for a time its strangle-hold on the British Government, not so long ago.

That they would was already manifest at the time—the long-distant time—of which I am talking. They loomed already, then, very large on the political horizon. Mr G. B. Shaw, as I have said, was one of them and the Sidney Webbs were two, And what I dreaded was that Mr Wells was contemplating taking hold of that Society, jettisoning the Webbs and Shaws and Hobsons and Radical Professors and Political Economists, and so wading bloodily amongst cracked crowns to the Arbitership of the Universe.

He assured me that that was not the case. Never would he think of becoming anything so detrimental as a politician. He was just going to upset the Society for a lark because it was so dull and pompous and because he wanted to introduce some imagination into its methods . . . and because he wanted to study the methods of politicians. Then he would pull out and write political romances with all the local colour correct.

Alas! . . . The rest belongs to History. . . . That would be in 1908 or 1909.

A decade and a half or so afterwards I was sitting in the Closerie des Lilas and some French novelist or other was discanting on the disappearance of the Great Figure from the Earth. He was a violent anti-Plutarchian and declared that the war just ended had made all the leaders of men appear such feckless fools that never again would Society consent to be led by Great Men. And he turned on me furiously and asked me if I could name any one man who was known as an Influence to anything like a considerable portion of the surface of the globe.

I answered almost automatically, 'H. G.'—and no one present disagreed.

Mr Wells, then, has had a life of many glories. And fittingly . . . and of many experiences. He was watching the world before Mass Production was so much as an invented word and, during the late era of Prosperity at Any Price, he saw his prophecies come true. And indeed, mayn't he be said to have had a certain hand in bringing about that era of hilarious thoughtlessness? For I doubt if the world would have so unquestionably accepted those irrational speciousnesses if it hadn't been for Mr Wells with his prophecies of the triumphs of Science and the Machine. We accepted, I mean, millionwise production of everything, universal sterilisation, the asphyxiation of tens of thousands, the razing from the earth of whole cities, largely because Mr Wells had prepared our minds for those horrors. We accepted them as inevitable because that immensely read writer had told us that they were inevitable. Without that a shuddering and hypnotised world might have made a greater effort to shake off these tentacles.

I know that because of one of those queer coincidences that at times overcome one. It was on a day during the late Armageddon when I had seen Mr Wells in a staff car whilst bands were playing troops into the line—somewhere in France. That same night, in a perfect, clear, still moonlight, I lay in a tent, obsessed by insomnia, and suddenly heard an officer say from another tent: 'Orderly, ask

the Major if he has finished with *Mr Britling Sees It Through*' . . . a work through which once again some of the poetry and genius of Mr Wells really pierced. . . . And I will interpolate that, for myself, I had been reading, actually, *The Red Badge of Courage* by the light of a candle stuck onto a bully-beef case at my camp-bed head. And so great had been the influence of that work on me that, when at dawn I got out of bed and looked out of my tent-flap to see if a detail for which I was responsible was preparing carts to go to the Schiffenberg and draw our Mills bombs . . . against and below hill and dark woods I saw sleepy men bending over fires of twigs, getting tea for that detail, it did not seem real to me. Because they were dressed in khaki. The hallucination of Crane's book had been so strong on me that I expected to see them dressed in Federal blue.

But Mr Wells can have his revenge. For when during that same day for the first time I smelt the enemy's gas, I said to myself, 'H. G. prophesied this, years ago,' and I did not make half the effort that I might have made to get away, for I felt as if it had been wished on me. . . .

That is what I mean when I say that Mr Wells had hypnotised the world into believing that almost any horrors of Science and the Machine are inevitable . . . and into accepting them supinely.

I hope Mr Wells goes on being the eternally cheerful politician, the eternally benevolent adviser of humanity, the forever glorified snooper, the noble and ever-victorious Enemy General. And if not, then at least he can have the assurance of leaving behind him a body of sheer literature such as few others of us will have left . . . all those inspirations of the Spade House days when the world was young and hope on every bacteriologist's tongue. That should be enough for one man's lot.

The lay reader may say: Here's a tremendous pother of enmities, but what's it all about? . . . The answer is this: If this civilisation of ours is to be saved it can only be saved by a change of heart in the whole population of the globe.

Neither improvements in machines nor the jugglings of economists can do it. To have a living civilisation we must have civilised hearts. I don't mean to say that it is a very good chance. But it is the only one. And it is a change that can only be brought about convinced worlds by the artist—by the thinker who has evolved living words that will convince . . . as, say, the Parables of Good Samaritans. . . . And every real artist in words who deserts the occupation of pure imaginative writing to immerse himself in the Public Affairs that have ruined our world, takes away a little of our chance of coming alive through these lugubrious times. And when it is a very real artist with a great hold on the people, it is by so much the more a pity. . . .

THE PHILOSOPHY
OF THE
KITCHEN GARDEN

PART SEVEN

THE PHILOSOPHY OF THE KITCHEN GARDEN

BEGINNINGS...

BEFORE I was twenty I had spent three winters in Paris and two summers in Germany. In Paris I studied agriculture, or rather kitchen-gardening—at the Sorbonne under the great Professor Gressent. In Bonn I studied history under my uncle Herman, who was Professor of Canon Law at that University. Professor Gressent was the first exponent of the hoe. He used to begin all his lessons by saying, '*Messieurs, trois fois biner vaut deux fois engraisser....* Three hoeings are as good as two coats of dung.' I remember sitting for hours of a morning outside the Café des Deux Magots in the Place St Germain des Prés. I was making, for an examination, a plan of an ideal kitchen garden *à la Gressent*. I can still see it. It had a dung-well in the centre. From that all its beds radiated. But no bed was so broad that its middle could not be reached by a hoe wielded from the paths on either sides. So you did not tread on the beds when hoeing. It is a good plan for a kitchen garden. Try it if you are laying one out. I passed my examination.

...AND BEGINNING AGAIN

Yes, there is the old, grey, cracked soup-tureen. It can't be colder in the room so I open the window.* With one

* Written in New York City, January, 1936.

427

of the two silver table-spoons I trowel soil from the window boxes. The tureen is now an allotment. I scatter over it the mustard and cress seed from the Five and Ten in the Tottenham Court Road, London. I water them with water from one of the flower-vases. Next Thursday we shall astonish Mrs Odela, who is an Anglomaniac, with mustard and cress sandwiches at tea.

I *am* beginning the year as I hope to continue in it. I am a Small Holder again. I am at home again beside my plot of ground. I shall place it on my bedside-table so that first thing every morning I shall be able to see how the crop is coming on.

Just as, every dawn over there, I wander between my plots of melons and strawberries, and watch the light come in over the Mediterranean, at that other point of the circle of the Great Route.

FRESCOES AND ASPHODEL

My house in Toulon has its rooms frescoed, very primitively, by the retired naval quartermaster who built it—himself and his wife, with their own hands, using a cement, said to be of their own manufacture, made from burning oyster-shells according to the Roman tradition and so hard that it will turn any cold-chisel. How that may be—as far as the tradition of cement—I do not know—but there the pictures are: scenes of rural life, dovecotes, ponds, fish-stews, swans, wild-fowl, carp, small fish, men rowing boats, men fishing; all under the shadow of the great mountains that are in the Toulon hinterland and all amidst a profusion of leafage and flowers.... And all a very charming decoration....

Another room is decorated—I imagine by the wife alone, since the paintings are more traditional and she probably went to an art school—with bouquets of flowers,

THE PHILOSOPHY OF THE KITCHEN GARDEN 429

only some of which are naïve, alive and charming, and all this having been done about 1890 or so.

But imagine an English retired naval quartermaster, in the suburbs of Portsmouth, building, along with his lady and with their own hands, a house of Roman cement, tiled with Roman-S shaped tiles. . . . And then frescoing it! . . . Or, for the matter of that, what would be the emotion of an English or American ex-naval officer of high rank on learning that he had let one of his houses to a 'poet?' Yet the first emotion of my landlord here in Provence when he had that news was to get into his car and drive a hundred and fifty miles to fetch me a root of asphodel. Because all poets must have in their garden that fabulous herb. . . .

AN INTERNATIONALIST ANARCHISM

At a Christmas party, in 1929 I think, I was standing with Elinor Wylie, to get air, at an open thirteen-story window in Tudor City. About four in the morning. The tiniest possible poppings sounded. Infinitely tiny, clear black figures ran over the snow. Ant-like silhouettes very far below. One fell. Elinor was of opinion that it was police chasing gangsters. But there was nothing about it in the papers next day. I suppose one never sees these things.

I can't remember that I ever wanted to kill anyone. I once shot a rat at the Pent. . . . At twenty yards, to the ingenuous astonishment of Conrad. But I didn't *want* to kill the rat. I have always felt that a rat had as much right to exist as I. It destroys my goods—but so does the graceful and applauded butterfly, one day's work of which, as I know each year to my cost, will result in the destruction of a whole small field's produce. I did indeed, during the war, several times, with a specially sighted rifle, shoot at a German tin hat a quarter of a mile away

above a mud parapet. But I never personally wanted to kill a German: not for my own gratification. It was a group impulse, or for the sake of France. . . . Why in Hell must there be nations? I don't feel to belong to any nation. I feel mildly American in America, but nothing anywhere else . . . except when England is playing for the Davis Cup against the United States. Then I feel pretty English—wherever I may happen to be. . . . England *ought* to have athletic records. She has so little else, poor dear. . . .

I live in Provence, but I can't become a Provençal because that, as things go, would be to become French and I don't want to become French for reasons that would take too long to tell.

No, I want to belong to a nation of Small Producers, with some local, but no national feeling at all. Without boundaries, or armed forces, or customs, or government. That would never want me to kill anyone out of a group feeling. Something like being a Provençal. I might want to insult someone from the Gard if he said he could grow better marrows than we in the Var. But that would be as far as even local feeling would go . . . and of course I would not pretend that we could grow wine as good as the Cote du Rhône. Though we have our patches. There is one at la Valette and another in Calvaire. If you could drink their domain wines you might write home about them, if you lived at Tavel itself.

And I want the whole world to be nothing but undefined nations of Small Producers without boundaries or custom-houses or politicians.

THE *MISE À MORT* AND A PROPHECY

I ask to be regarded, from this moment, not as Moralist; nor as Historian; but simply as prophet. I am going to point out to this world what will happen to it if it does

not take Provence of the thirteenth century for its model. For there seems to be a general—and universal—impression that our Civilization—if that is what you want to call it—is staggering to its end. And for the first time in my life I find myself in agreement with the world from China to Peru.

Do you happen to know Haydn's symphony?. . . It is a piece that begins with a full orchestra, each player having beside him a candle to light his score. They play that delicate cheerful-regretful music of an eighteenth century that was already certain of its doom. . . . As they play on the contra-bassist takes his candle and on tip-toe steals out of the orchestra; then the flautist takes his candle and steals away. . . . The music goes on—and the drum is gone, and the bassoon . . . and the hautbois, and the second . . . violin. . . . Then they are all gone and it is dark. . . .

That is our Age. . . . There have stolen away from us, unperceived, Faith and Courage; the belief in a sustaining Redeemer, in a sustaining anything; the Stage is gone, the Cinema is going, the belief in the Arts, in Altruism, in the Law of Supply and Demand, in Science, in the Destiny of our Races . . . In the machine itself. . . . In Provence there is every Sunday a *Mise à mort* that is responsible for the death of six bulls. In the world outside it one immense bull that bears our destiny is at every hour of every day slowly and blindly staggering to its end.

In Provence—and of course in Spain—the bull-fight continues still its triumphant progress at the sword-ends of actors who alone today are as beloved as the boy who in Antipolis a couple of thousand years ago danced and gave pleasure. The bull-fight too may die out in the whole general collapse; it is an immensely expensive mass-art—though its essentials are neither the expense nor the immense crowds; its essentials are swiftness and skill in wielding a thin spike of steel against a furious and alert monster. For still today the most admired matadors

are not those who offer the most display of agility. They are those who with the classic nonchalance of the hidalgos who first practised this art—and who alone have the right to the name *toreador*—stroll about the arena, their sword beneath the arm, or sit on a chair till the moment comes to deliver to the bull who has meanwhile been worked into position by the servants, the *coup de grâce*. For that no lists are needed; no tiers on tiers of humanity ... no limelight, no publicity.... Nothing but a smooth place, some shade-trees, the arms, the man and the bull.

Yes, the great, shining *corridas* whether of Nîmes or Pampeluna or Perpignan or Madrid and St Sebastian may go, though it seems unlikely since that art has lasted two thousand years in these places.

But the art will not go, the courage, the skill; the alertness. In every village in Provence there is a bull-ring and on every Sunday of the year when the days are warm enough all the young men of courage face, without arms, the wild bulls of the Camargue doing nothing more deadly to them than affix rosettes beneath their horns or on each shoulder.... And they face the charging bull, place a foot between the horns and spring right over the beast, or vault over him with a jumping-pole, or catch him as he charges with their two hands on his horns and somersault across his back.... It is just a sport, like cricket, but without advertisement, carried on so obscurely that you might well say it was secret ... a sport in the blood of the people, carried on by the sons of the barbers, the furriers, the peasants, the bakers.... It is as it were the *conte-fable* as against the high and renowned *gestes* of the troubadours. It is considered that, before a man should have wherewith to pay for his seat at the *mise à mort*, he must have worked bulls himself....

It is that spirit—the tradition that a man should not eat high cooking till he can cook; shall not inhabit a house of his own till he can sweep the floor; shall not drink the juice of fabulous fruits brought from the Indies till he can grow the fruits of his own land; shall not go

to the play till he has proved himself an actor who can improvise his part; shall not travel till he has made a home ... and shall not wear a fine coat till he can grow the wool, card, spin and weave the cloth, cut out, baste, fit and sew an everyday one.... It is that spirit that could yet save the Western World.... But to do that it must be enjoined on the world that Mass and the Machine are the servants not the master of Man and a man must blush as if he were caught in a petty theft if a stranger coming into his house should find anything that was not made by the human hand or if a guest should find himself being offered food out of a can or unseasoned meat that should have been kept beyond its due season by preservatives. It is in that way and in that way only that an economic balance could be re-established, a law of Supply and Demand be re-enacted and the Great Trade Routes be restored to their beneficent function of distributing civilisation to the darkest ends of the earth.... It is that or extinction: the one or the other must come.... It does not take any great prophet to foresee that....

A LITTLE PLOT OF GROUND

The one thing that remains stable is the land in a dry, temperate-to-hot climate—and along with the land, the Arts in all their branches whether called Fine or Domestic. For it should be kept for ever in the forefront of the mind that who sweeps a room or sows seeds or plays the pear-drum in the name of humanity makes that and the action fine.

The land should be in a dry, temperate-to-hot climate because the rigors that that may present can be mitigated by skilful irrigation; but nothing can remedy damp with its attendant coldness—and there is no sense in cultivating unprofitable land when the land between the fortieth and twentieth parallels of the globe can supply unlaboriously

all the vegetable food needed for the human race.... But I will undertake, reaching my own couple of acres on the Mediterranean on the 16th May, to be able to keep in food my own family and guests entirely by the labours of my own hands—except of course for wheat and dairy products and sugar which I could perfectly well produce if I were in the mood.... And that by the 15th July.

I am aware that there will be protests. But I am not preaching a back-to-the-land crusade. I am merely prophesying. To that condition the world must inevitably come and it is as well to prepare onself in time. I am aware that I shall be told that I make enough money by books to pay for my bread, butter, tea, sugar and clothes. That is true.... But the publishing of books is drying up, like every other branch of trade, commerce and industry. In the Middle Ages, as I am never tired of reminding you, they used to say that when land is gone and money spent then learning is most excellent just as they used to say that literature is a good stick but a bad crutch. But learning is no longer a safe way to earn one's bread and there is just one stick left that can if necessary become a perfectly good pair of crutches.... So as long as trades and industries remain I should recommend you to support yourself sparingly by them and to trust to your little plot of ground to provide you with luxuries. For there is no grape sweeter than that which you pluck from your own vine nor, unless you have been raised in Putney or the Bronx, is there any sweeter occupation.

It is the strong conviction of that fact that makes France in general and Provence in particular the only stable and prosperous states in the world. But the inhabitants of Putney and the Oranges immensely outnumber all the thinking men of the world and it is the occupations of their spare times that is the real difficulty in front of us.... We must go back to the Dark Ages.... For if we do not go back to the Provençal Dark Ages we shall go back to those of the Teutoburger Wald with the poison-gas clouds for ever above the appalled tree-tops....

MAXIMS THAT WILL SAVE THE WORLD

I do not suppose we shall get rid of—or even that it would be desirable entirely to get rid of—the Machine. I do not suppose that we shall ever not have War with us, or rid ourselves entirely of the sense of property, or of Churches, or of Science or even of Law which, ever since the Evil side of the Dual First principle put a taboo on the *pamplemousse* and Eve ate the first brussels sprout, has been the primary curse of humanity. And it would be hopeless to think of ever being relieved of the final curse, national patriotism.

But all these things must—they will inevitably—be made little. They will be reduced to their proper status either because the armament firms and scientists will blot out almost the entire populations of the world, leaving here and there mere pockets of men. Or else by a change of heart in humanity!

One way or another the number of machines and of machine hours worked must be reduced to a minimum. The wars of the nations must be little wars of little nations brought about by local jeers; the religions must be little religions; the churches without temporal powers; the leisure enjoyments be individual enjoyments. The glorification of Mass must disappear. You will talk of the largest pumpkin in the village as a glory, not of the largest armament-factory in the world. There must be the change of heart—the progression.

Christianity, the distillation of the Mediterranean spirits of Judaism and Hellenism, gave us the injunction that we must love our neighbours as ourselves. The Boston Tea Party led to the declaration that all men—except niggers, Jews and Catholics—are born free and equal and that every man is as good as his neighbours—and better.

The maxim that will save the world will—if the world is to be saved—be found in the ultimate discovery that you must love your neighbour better than yourself and that, all men being born free and equal, every man's neighbour—and in particular niggers and the Mediterranean races—is as good as oneself . . . and better.

You must when you travel lay more stress on changing your soul and your cuisine than on covering the roads of the world beneath the skies. . . . I met an upper-form boy from a great English Public School the other day. . . . A superior classic, not modern, wallah. Someone in the company, appositely enough, mentioned the late *corrida* at Nîmes. . . . That English schoolboy exclaimed:

'What *damnable* cruelty. . . . The stinking French!' He added that a Frenchman in the train had given him a great sandwich that so stank of garlic that he had been inclined to throw it at the fellow's head. . . . As however he had had not enough French to venture to go into the restaurant-car he had decided to eat the sandwich. . . .

So little will the humaner letters do for amenities between nations! Truly, unless the watchmen watch the gate the labourers labour in vain. . . . I am thinking of that unfortunate boy's classic masters who should surely have told him that since he was going to the Provincia Romana, the very home and centre of such lore as he and they had, and the very region of a three-thousand-year-old, unchanged civilisation, it might be as well if he tried to improve himself according to that model. . . . After all the Athenians *did* fight one of their bloodiest wars in defence of their garlic fields.

Or again the Romans except for their armament lords and fascist Imperators lived almost entirely on, and had a passion for, a purely vegetable diet with a little fish thrown in now and then. The most impassioned writing of the grave censor of life that was Cato is contained in his treatise on the varieties, the varieties of flavour and the methods of cultivation of no—not of the red mullet which fetched its weight in gold—but of the cab-

bage. He devoted to the production of that simple vegetable the same passion that he gave to the destruction of Carthage. And an almost purely vegetable diet varied with a little fish still characterises the tables of the inhabitants of Provence today. So that their cuisine is rather picturesque than plutocratic; and, if you want real succulencies, it is to the damper regions of the Bourgogne, north of Lyons that you must go.... Nevertheless the real Provençal cuisine is exactly suited to the Provençal climate and, at any rate during the heats of summer, you are apt to have to pay for it if—as I myself seldom do—you go outside it. It has for me the defect that it is rather bulky, which is of necessity the case with a largely vegetarian diet, and there is nothing I dislike so much as a feeling of distension after a meal. So that when I am at home I eat astonishingly little—so little that the Septentrional would hardly believe that on it I can get through a fairly gruelling day of writing and gardening.... For breakfast at seven-thirty some coffee and a couple of slices of bread and butter; for lunch at one a salad and, very, very rarely, a little goat's-milk cheese; for dinner about two ounces of veal or mutton—never beef—or in the shooting season, an ortolan, a grive, a little pheasant, venison or wild boar; one vegetable from the garden—tomatoes, egg-plants, *petits pois*, *pois-mangetout*, string-beans or sorrel and some stewed fruit or jam, of which I make great quantities; and sometimes some junket. Occasionally instead of the meat or game I have two or three grilled, fresh sardines or anchovies, or a grilled *mulet*—a Mediterranean fish that is nearly as good as the *loup* and a tenth of the price of that gift from the gods.... Nevertheless I do not lose weight—which I put down to the olive oil and *fines herbes* which accompany or assist at that cuisine. For olive oil alone is a sufficient nutriment and *fines herbes* assist in the digestion of other foods. And your weight is not a question of the quantity of food you put into your mouth but of how much you digest.

THOSE DISGUSTING FELLOWS

There was once a Golden Age when all humanity combined to starve off barbarism and to shut the lust for lucre up in northern forests. Humanity has been running for millions of years. There is nothing to wonder at that civilisations wiser and richer than ours should have been swallowed up behind the veils of the years, leaving us nothing but the echoes of traditions and a faint hope of once again leaving behind us legends shining with gold and peacocks. That is really our task.

And to set about it we have to jettison most of what we regard as precious. We have to consider that we are humanity at almost its lowest ebb since we are humanity almost without mastery over its fate. I sit in Geneva and the whole world trembles at the thought that tomorrow our civilisation may go down in flames—trembles willlessly and without so much as making a motion to preserve itself. Our leaders of thought are despised and our leaders in material quests are as degenerative, physically and mentally, as any body of men the world has ever seen. Physically almost more than mentally, since they are at least capable of a sufficiency of mental activity to plunge a world into war. But if you took all the Cabinets of the western world and set them, provided with enough tools, in any rural solitude, they would starve and freeze and soak to death without the physical or mental imagination to plant a brussels sprout or to gather reeds for the thatching of a primitive shelter. . . . And those men govern. . . . Us!

It is this aspect of our times that seems to me to be the most grim, the most prophetic of our disappearance. It is in that that we most nearly approach the stage of decline at which the former great civilizations of the world disappeared into darkness one after the other. In

each the Man in the Street gave up into the hands of paid politicians the attention that he should have given to his public affairs.... Then, darkness. So it is now with us:

Our laws regulating Agriculture are made by men incapable of using a hoe; our laws regulating the art of the blacksmith by men who would die after a week of sweating in a smithy; our wars are made for us by men as incapable of holding a rifle at the present as of weeping at the death of men in battle.... And worst of all we, who have relegated our powers to these miserable stewards, accept the methods by which these greasy, chewed paper beings creep into office and in the end model ourselves upon them. For there is almost no man who would not commit, let us say, any number of gaucheries and be quite consistently untrue to himself, in order to sit in the seat of quite a minor Cabinet minister of his country—a man who is unworthy to loosen his shoe-latchet.

Our representatives are uncouth, unpleasant to the eye. ... Heavens, if you could have lunched where the patient New Yorker and I to-day lunched ... and seen them come in one after the other to feed!

How could it be otherwise. We do not choose them for their intellect, their artistic intelligence, their altruism, the mellifluousness of their voices, their physical beauty, their abstract wisdom, their seasoned knowledge of the values of Life. We choose beings who hypnotically suggest that they and they only can fill our individual purses, our maws, our stores, our banking-accounts with property that at the moment of their appeal for our suffrages belongs to the heathen stranger ... or our fellow-countrymen.

We elect them because they assure us that they will help us to take the bread out of our brother's orphan's mouth and we get the rulers—and the double-crossing—that we deserve.

And is it then worth while? Or good enough? Those fellows have got us all into this mess. It is time we put

an end to them. It is time, that is to say that we made
our voices heard ... we moderate people who read or
write books, visit picture galleries, listen to concerts,
weave things on hand-looms, make chairs by hand ...
and work on our land. ... We who are the backbone of
our countries, asking nothing of them and giving unceas-
ingly. There is not one of us who wants anyone murdered
either wholesale or as individuals; there is not one of us
who is not willing to learn of our handicrafts, arts and
cultivations from the peoples of all the other agglomera-
tions along the Route. And we are the people who shall
survive, who shall come out of the gas-filled cellars and
start again on the weary task of rebuilding our civilizations
... we who have never yet seen any civilization at all. ...
You doubt that we are the people who shall survive the
desolation that those disgusting fellows are bringing to
pass for all of us. ... Ah!

And, looking at the matter merely from the military
point of view, it is silly to say that the butchering of
civilians shortens wars and is therefore more humane. ...
Or burning their houses or crops or furniture or clothing.
I suppose that if you completely wiped out a whole nation,
civilians plus armed forces, you might stop a war. But,
horrible as they are, modern methods of war are not as
efficient as all that—and not-quite-stamped-out peoples
develop a philoprogenitiveness, a tenacity of purpose, a
vindictiveness. ... A ruthless conqueror may well shiver
when he thinks what will be the fate of his grandchildren
when, against weapons that minute by minute for a
century the Scientist has improved in deadliness, they
have to begin again on the war that he has just con-
cluded. ... Look at Austria to-day expiating the faults of
Charles V. Consider Ireland, the perpetual thorn in the
flesh of Great Britain. Remember France, impotent after
Sedan yet remembering for forty years the word 'that
they must never utter but for ever cherish in their hearts.'
What has happened to the dynasties that for centuries
oppressed and harried Poland? ... Surely a prudent people

waging a war would order their generals, whatever they did, never to enter foreign territory. . . . That at least.

THE BREAKDOWN OF DEMOCRACY

Democracy then, has broken down. . . . I think we may say it has broken down . . . because it is unsuited to deal with vast masses of human beings. We elect representatives for everything and once they are elected we lose control of them completely. We ought, when we vote to vote for laws, not for men to make laws for us. The men we now elect make not only our laws for dealing with specific instances—with murder, marriage, insurance, but also our Law—the spirit in which our laws are administered. But there exists hardly a man, far less any body of men, who can be trusted to make, for immense bodies of humanity, laws that will not cause atrocious injustices and entirely defeat their own ends. Or if such men exist they are thinkers. Thinkers do not possess the gifts of histrionic prostitution that will make them appeal to vast electorates.

OUR NORTHERN VIRTUES

I don't know why, at an advanced age, I should suddenly begin to find democratic simplicity and rectitude attractive. They are contrary to my traditions and upbringing and I don't know that they are not hostile to my intelligence and my instinctive sense of morality. For it is certain that I think that the only things that can save the world are a certain Mediterranean brand of slackening-off in everything from conscious rectitude and its brother sense of acquisitiveness to the sense of efficiency and the hours of labour worked. . . . So that it would be

dreadful if at the end of great labours and many wander-
ings I should find myself liking the New England Con-
science or States which at present seem to me to be the
most detestable things in the world and the source of all
our present evils.

It is of course a matter of climate and latitude. New
England virtues—if there are any—are northern virtues.
They consist of rectitude for the sake of gain, honesty
which is only the best policy, continence so that you may
creep into the back door of heaven, frugality for the sake
of adding to your store.

I think Franklin did a great deal towards spoiling the
world for us when he enunciated the words: 'Honesty is
the best Policy.' It is a horrible truism that Victorian
Anglo-Saxondom seized on with the enthusiasm of
Gadarene swine rushing to destruction. It is true that
honesty pays. If you do not shortweight your customer
he will come again . . . and you will get more of his
money. So it is with diffidence and misgiving that I utter
words that should be truisms: War, then, never pays.
Never, never, never. It is like the devil with whom you
make bargains thinking that you will get round him
when the date for payment comes. You will never get
round him. You will burn forever in Hell.

But that is only a very surface fact. When Christ told
you that you should love your neighbour as yourself,
very fortunately—or with the wisdom of a God—He
offered as a reward a place in heavenly mansions. . . .
Something remote. If He had said that to love your
neighbour as yourself is the best policy He would have
been a mere precursor of Poor Richard whom no one in
the deep interstices of his heart can much respect. Yet
nothing is more true than that that is the best policy.
You cannot be prosperous if you do not live in a com-
munity of prosperous people. You won't be able to get a
good price for your eggs. If you mop up all their goods
and money you will have a lot of money but your money
will become worth nothing, and you will have a lot of

goods but they will be worth nothing because there will be no one to purchase them. You cannot eat much more than a half pound of meat a day. Or sit in more than one chair at once.

These are such truisms that one is ashamed to put them down. Yet they are such truths that the world is dying because no one remembers them.

PATRIOTISM DOESN'T PAY

I think I have made it plain by now ... if I haven't I here put it in the simplest words that I can think of— that my loyalty to this country, the United States of America, is an emotion as complete as can be that of any man to any country. I wish it, that is to say, and to all its inhabitants nothing but well and if anything that I can do can conduce to their comfort and happiness and pride and well-being—except the winning of the Davis Cup—I can be trusted to do that thing. And if, anywhere any plot should be agate for their undoing, I can be trusted to do all that I can to denounce and hinder it ... except always again in the aforesaid matter of the Davis Cup, the winning of which is essential to the comfort, happiness, pride and well-being of the country of my birth. The United States having such a lot of other largests in the world, can well afford to do without it.

I do not say that my loyalty to the kingdom of Provence is smaller ... and indeed I have just as much loyalty to the south coasts of the country of my birth, and then to the Mediterranean coasts by Diana Marino where Columbus walked westwards and to those of Spain, Monaco and Jaffa. ... Which is as much as to say that I consider all the territories of the Great Route to be one Republic or Empire or Soviet or Civilization.

Still one owes, as a proper man, a little touch of special loyalty to the tracts of land which one most inhabits,

those being in my case the Eastern States from New York downwards ... and Provence; so that I seldom know exactly where I am at any given moment unless I up and think about it. I detest, that is to say, to hear any one agglomeration on the rim of that great oval collectively miscall any other agglomeration. ...

In short, there is no place along the Great Route to which I am indifferent and many I love very much. And if I can do it most people can; and if everyone did there would be an end of most of our troubles. ... There would be an end at least of patriotism and that would be a great help.

It is a queer idea of serving his country that the patriot has. He loves his land. Therefore he proceeds to make himself as disagreeable as he can to every other land. When he has made himself sufficiently disagreeable to other lands they all fall upon his country and gore its gentle bosom with the shards of war. Patriotism doesn't pay. ...

MAKING IT SAFE FOR CHILDREN

I will recapitulate and go one step further in my prescription for the saving of mankind. Your immense body politic cannot be immense enough. The whole of my oval at least will have to form one Republic, Empire or Utopia before we can get much further ... but a very loose Empire, Republic or what you will, held together by almost invisible if absolutely indissoluble Federal ties —the whole of the oval and all of its hinterlands that are of good will and are ready to participate in that enormous Pax Romana.

But the individual local units should be the smallest possible. So that their public assemblies, whether for deliberation or—if punishment still finds place in the public psychology—for punishment, should be of a complete intimacy.

It is essential, if public humanity is to make any progress, that every man of the Republic should vote on *every* measure put forward by Federal authority. This would reduce Federal measures to a minimum.

And the spirit of the little local units should be that of courts-martial with, instead of a general-commanding-the-district, the whole of local public opinion to revise either decrees or sentences.

We *must* in fact restore to the individual a sense of power, for without that he can never recover his sense of responsibility. And we must get rid of the elected professional politician to whom we give carte blanche to double-cross us over every legislative proceeding.

You will say that that can never be brought about by the legislatives we have to-day. Certainly it can never be brought about by our present legislative procedure. It can only be brought about, let me repeat, by a changing of our own hearts. Against that no legislatures can stand up. It is not law-makers that have brought about the relative softening of penal laws down the centuries. If it had been left to the professional politicians we should still be drowning witches, burning heretics, hanging, drawing and quartering starving thieves of halfpenny rolls. It has been the heavy and irresistible thrust of separated public opinions that have brought about these near humanities. It is time that all our public opinions united over areas vaster than any humanity has yet conceived of ... it is time that they took in hand the sweetening of the world ... the making it safe for children.

THE STORY OF SELF-HELP

I put that last reflection in for the sake of us Nordics. We have been made, apparently, middling honest by the reflection that honesty pays. We may divest ourselves of

other of our vices if we can be assured of the fact that War does not pay.

And that all our virtue-vices are not profitable any more. Not courage; not endurance; not the pioneering spirit; not thrift. The only thing that could pay us would be for all of us to crowd into this Principality [Monaco] and spend our time for years over the green cloth.... The only thing that could save us is degeneracy. We must become lazy, shiftless, languid, disloyal, cowardly, unadventurous, undisciplined.

Our virtue-vices are all devoted to training us for acquisition.... Self-help they used to call it in Victoria's spacious days. It was considered virtuous then to rob—deprive—your fellows. And all our training, all our idealism, since then has been devoted to making us more deft at robbing our fellows. For do not forget that every penny you make by your honesty, endurance, courage, cleanliness, technical instruction has been taken from a starving child.... It might have saved a child from starvation. ...But you have it. There were last year 270,000 starving children roaming one country in bands.

AN UNMENTIONABLE SIN

I don't profess to know anything of poverty—or of even the relatively comfortable industrial classes—in towns. I have tasted of want—or what would be called want by the majority of the people I know—in the country and I have seen poverty there. But I never felt poor and I do not think that real country people ever feel poor—more particularly part-timers. If you have no money with which to buy things from outside you say: Oh well, and go to your garden or your rabbit-hutches and get yourself a meal and go back to your book or your picture or the chair you are making. And money comes along from some where, some time. Indeed, if you own your own

plot with, if possible a spring, and are below the level of the income-tax collector and can manage to scrape together enough to pay your electric-light bills—or better still can dam your spring and run a dynamo ... why I don't see why you should ever feel poor.

But the lot of the wage-slave in a city. . . .

I don't *know* anything about it. But there are certain passions and anxieties that are shared by all humanity. . . . And then I am a novelist and it's part of my job to work myself into the minds of all sorts of people. . . . And then one has glimpses. . . .

The unfortunate commuter of the white-collared type has no life at all—except the vicarious type that emanates from going to murder-trials on off days or reading of the crimes, misfortunes, or misdemeanours and gettings quick-rich of others. Or he attempts to keep some sort of manhood alive by attending on baseball games and dreaming that it is he who performs the feats of his heroes. Above all his existence is without privacy. He lives and dies in crowds.

He is at least harmless, usually gentle, usually honest. The millionaire on the other hand is a public enemy. I do not write that from the sociological point of view. I daresay millionaires could be quite good employers of labour. Or it may be impossible to be a good employer of labour. I don't know. If you are out to sweep a whole system away the details of that system are unimportant.

But whatever is produced by mass production is deleterious to the vitality of the public: the very process of mass production is deleterious to the public. It is appalling to think that there are millions and millions of human beings to-day who never have and who never will taste pure food, sit in a well-made chair, hear good music played except mechanically—or use all their muscles or so much as cook well or properly polish the woodwork of their homes. And over all that Stygian bog of horrors the millionaire floats to be the cynosure of all those grovelling

beings. He is the final product . . . and the most felt enemy of the craftsman.

The millionaire cannot exist without mass production; men cannot exist with mass production—and remain men. But what is necessary is not the extinction of the millionaire by sociological expedients. What is necessary is such a change of the public heart that the accumulation of immense wealth shall be universally regarded as being as shameful as any other unmentionable sin. Men will then cease to wish for great, sudden wealth and the motive for mass production will be gone. Then we can begin to think of civilization.

ROLLING MY HUMP, PUTTING IT DOWN

Mr Kipling, apparently thinking that the machinery and middle classes of Pennsylvania were doomed sempiternally to endure, wrote in his hymn to the spirit of the U. S. of his time:

> The things that truly last when men and time have passed,
> They are all in Pennsylvania this morning.

Or if that is not what the hymn means it is so in tune with Mr Kipling's spirit and with the spirit of the dreadful day in which it was written that that might very well be what it does mean. It is the dream of the Technocrat of Mount Kisco;* of the Machine that has usurped all human functions, going on and on till all humanity has passed from the Earth.

It is not a new struggle this. I remember hearing years ago William Morris arguing with Engels, Marx's son-in-law, and the joint author with Marx of the manifesto of the Communist Party. And it might for all the world

* Ford's characterization of a fellow house-guest at Theodore Dreiser's in Mount Kisco, New York, Christmas 1935.

have been myself arguing with the Technocrat except that I am not, like Morris, a sentimentalist, and that Engels, unlike the Technocrat, was not a sadist dyspeptic—and that I almost never argue on sociological subjects.

I am not doing it now; I am expressing likes and dislikes and prophesying conditionally. That is to say that I am asserting that unless the craftsman takes again his position in our society, our civilization of the Great Route will, for two reasons, pass into chaos. For two reasons: the Machine will break down over its economics and mankind will become effete. We are already half-way there. And what is the good of being a Technocrat dictator if you cannot digest a slice of Thanksgiving turkey? Or have to have your stalled automobile pushed off a ferry by little boys?

It will have to be one or the other; take it or leave it, I don't care. I shall go on for as long as I live spending half my activities on my vegetable-garden and the other half doing what I am doing now. I am neither sociologist nor politician. I am an onlooker stating the result of conclusions that have taken me half a century to arrive at. . . .

During those years I have rarely been still for more than three or four months on end. I have rolled my hump along, on mule-back, in dog-carts, on liners, in carriers' carts, on trains, autobuses, army waggons, on my feet, looking at things and listening to men talking. And all the while growing something in soup-dishes or aware that something was growing itself for me on the slopes above the Mediterranean—or the Channel. . . . And now putting down what I think about it all.

THE ABOMINATIONS OF THE LAW

All laws are rule of thumb abominations because they are the expression of the voice of the political majority at any given moment. They will thus be certain to press unjustly

here and there; nowhere can they ensure the enactment of justice. Laws apply only to theoretic norms. No norms exist. That is your *reductio ad absurdum*.

It is frequently said epigrammatically that the opinion of the majority is always wrong. Be that as it may, since it is abhorrent that one man should live in subjection to another, it is wrong that minorities should be subject to the will of majorities. Why should I, a, let us say, Quietist Anarchist living in the mild climate of the Great Route be subject to the law expressing the conscientious opinions of you, an Absolute Monarchist, living in the bracing climate of the State of Maine or in the Pas de Calais? Equally why should you who are an Absolutist be subject to the no-law of me, the Quietist Anarchist? Neither is right, neither reasonable, neither alternative is even practical. One or other of us is the more intelligent. It is inexpedient that the more should be governed by the less intelligent ... but it is just as wrong the other way round.

The only way to get round that dilemma is to split great national units into smaller units without barriers each governed by its custumals ... its remembered, not written, body of customs. Then, if I live in a place where there are too many Absolutists, I can move a mile or so away and find the Quietism I require. Or if you find me and my kind too much for you you can move onto the next hill and have a coronation service once a week. There is absolutely no sane reason why you should not pay taxes so that your Sovereign by Divine Right may give you daily raree-shows and his hand to kiss as long as you do not send your tax-collectors to me. There is no sane reason why you should not do that and live next door. In a house I sometimes inhabit there are, on one floor, myself and a Jew. On the next a Hindu missionary and a believer in the Hellenic deities who wears a toga; below an Esthonian belonging to the Greek Orthodox Church and a French Royalist excommunicate by the Church of Rome. . . . All these people pay their contribu-

tions and attend the rites of their respective cults and all, when they meet on the stairs, converse for a minute or two, smile and pass up and down without the beginnings of a quarrel. If the churches have been able to arrive at such a state of relative civilization, why should not the States?

HOW LONG?

How long are we going to stand it—we, the decent quiet people who desire the goods of no man; who desire—in millions and millions—nothing but to be left in peace on our two or three acres of garden land, and to think our thoughts, and go on producing whatever it is we produce? How long?

You say the afflati of evil fly faster across the world than those of good. It isn't true. We are all so frightened today that if any really salient good thought could be put into salient and flaming words it would fly across the world faster than any black magic.

You say: How is it to be done?

Ah, I am not a constructive thinker. . . . This evening I shall be sowing in my own garden my first row of green peas. It is the 13th July. In four days' time the first green, living things will be throwing up the earth. To-day week they will all be up three inches. On the 12th August I shall eat my first dish of peas. By the 13th September I shall be in a position, should war cut off my financial supplies, to support my family indefinitely. . . . Until the War chooses to stop and I can get paid for this book. So I am safe. . . . Why should I bother about you? . . . You have only to do the same thing. And tell your five best friends to do the same thing and to tell each one of his five best friends to do the same thing. . . . You know what a chain letter is? . . . In two months' time all the politicians in the world will be shaking on their thrones. In a year they will all be gone.

THE SMALL PRODUCER...

Very soon now, the Small Producer must again inherit the Earth and the fullness thereof...whether we like it or no. It has always been so; so it must be again. It is not merely the lion and the lizard that keep the courts of Jamshydd. The peasant's plough passes backwards and forwards above where he sleeps. That no doubt gives him something to think about. And the Small Producer—the man supporting himself and his family from his plot of ground and by the work of his hands is the one human being whom currency, finance, tariff, the refrigerator, and the machine—those arbiters of the destinies of all other mortals—cannot very much affect. Even wars cannot root him out.

All the small truck-gardens along the Marne were wiped out by the iron-shod feet of troops in September 1914. But by the following March those same gardens carried as many rows of lettuce, beets, celery and spinach as they had shewn before the Germans came. Today peaceable people practise in cellars with gas-masks against the Day.
. . . It would be as well if they also practiced with hoes, digging forks, chisels, awls.

It would be as well here to define the Small Producer. He is the man who with a certain knowledge of various crafts can set his hand to most of the kinds of work that go to the maintenance of humble existences. He can mend or make a rough chest of drawers; he will make shift to sole a shoe or make a passable pair of sandals; he will contrive or repair hurdles, platters, scythe handles, sties, shingle-roofs, harrows. But above all he can produce and teach his family to produce good food according to the seasons. . . . In sufficiency to keep his household supplied independent of the flux of currencies and the tides of world supplies—and to have a surplus for his neighbours. He is the insurance premium of his race. In short a Man.

That ideal is, I am frequently told, disagreeable to the American mind. I do not know about that. I have lived too long in America to hazard impressions as to Americans. Sometimes I think one way, sometimes another. I will put it this way:

On my terrace over the Mediterranean I sit at the head of my table and, fixing my napkin under my chin and seizing my carving knife I make with that implement a circular gesture and, from the pride of my heart exclaim:

'Everything you see on this table is my own growing . . . ducks, egg-plants, strawberries, peaches, melons, sweet corn, wine. . . . Of course the wine is not a great growth. . . . Grown and cooked by these two hands.'

And the statement is pretty nearly true, though I actually do not grow or grind the wheat from which my bread is made.

The amiable Americans who usually attend those Sabbath feasts then make noises. They are not of course always the same three or four. Those who are frail of figure and lymphatic and wear pincenez produce sounds like the 'Oo-er' of Mr Kipps . . . a sign that my statement causes dismay. It is the voicing of apprehension by travellers in a strange land where cellophane is not and *everything* is touched by the human hand.

As against that, large fellows and fine dames who have jumped blind baggages and rolled their humps in all the dangerous places of the globe will exclaim: 'Swell! . . . Fine! . . . Great guy, you. . . . Put it there ! . . . What have you?' (Yes they will have been some months away from home.) And they will go off into descriptions of the two-hundred-pound squash they grew in Santa Barbara and the alligator steak from the saurian they strangled with their own hands and cooked on top of Popocatepetl.

For producing your own food becomes very soon a passion once you have entered on it. Over it you will go to great heroisms, self-sacrifices, mendacities. Every Frenchman and most English, Dutch, Germans and Italians feel ashamed when they are quite out of contact with

the earth and a good many of them, like me, if they can do nothing more will grow mustard and cress in their soup tureens. And I am inclined to believe that most Americans share that feeling once they are off Sixth Avenue. After all, are they not near descendants of kitchen-garden pioneers?

...IS THE REVOLUTION

Underneath your hut is the earth; underneath your neighbour's manor-house is the earth; under the sky-scraper that houses the bosses of your neighbour's bosses is the earth; under the flag-staff that tops the sky-scraper and displays Old Glory to the breeze is the earth; underneath the soles of your nation as of the whole comity of nations on this globe is the earth. But you alone supply eggs, sweet corn, egg-plants, string-beans, peppers, chickens, peaches, butter to your neighbour. Your example may yet save our civilisation.

A CHANGE OF HEART

After a few thousand years Great Truths become platitudes. In the days of Mithras men worshipped the sun; today you are told that if your windows and light-bulbs are of certain sorts of glass you can do without the light of the sun. This morning I read in the prospectus of a physical culture tout that fresh air is dangerous to human beings. . . . And you believe it . . . as we shall one day believe if advertisers tell us it sufficiently often that we can do without the fruits of the earth.

Like the Giant Antaeus, who preceded Mithras by a hundred thousand years, our civilisation needs contact with the earth for its renewal if it is to be renewed. This

has been said so often that no one believes it much. . . .
But that we shall either return or be returned to the earth
is for all us nations inevitable. Our civilisation cannot
escape the lot of all the proud civilisations that have pre-
ceded us. It is for us to decide whether our return shall be
merely an Antaean retouching of the earth to regain
strength or whether it shall be cataclysmic—a bepanicked
sauve qui peut after world-disaster.

In either case it shall be the hut nestling beside the
manor that shall be the last to go and the first to return.
If we have already chosen the better portion we shall long
have had our huts. Returned to our bean-rows we shall
begin once more building up our proud civilisations. Our
predecessors did that after the Fall of Rome: that is why
we are here.

The marvellous human brain has discovered how we
may fly in the face of God and from the empyrean destroy
our fellows by the million. But, fagged out, that brain has
flinched before the task of finding out how a machine that
can do the work of 10,000 men under the inspection of
one man alone can be got to find employment for the
9,999 that it has dispossessed. Still less has that poor tired
thing been able to devise how to prevent us or our neigh-
bours from razing off the earth all our cities with their
populations. So that the tired brain of the architect of to-
day has still more to tire himself over devising cellars—
into which populations skilled in the use of gas-masks—
and of nothing else—may at any moment retire.

When they re-emerge there will be nothing for them but
to set unskilfully to scratching a subsistence from a soil
of rubble from the fallen buildings. But if they have a
little kitchen-garden skill and the earth round their cities
is in good shape for intensive culture they will have a
chance of survival. They can have no other. . . . Or the
ruin of our empires will come from civil strife. The end
will be the same.

It would be better to achieve that end without the orgies
of destruction and the settings-up against walls that are so

dear to our Technocrats. Our mechanical civilization seems to be crumbling beneath its own weight. It is impossible to escape the conviction that we are in a world of weakening pulse; our intelligences are enfeebled by the blood supplied to our brains by artificially grown, chemically fertilized and preserved foods. And even if our civilization could continue in spite of our degeneration, the problem of the machine dispossessing the worker must grow more and more acute between—and then within— nation and nation.

The problem is by no means new; civilization after civilization has had to meet it. Victorious Caesars, disbanding after interminable wars innumerable legionaries who would otherwise have disturbed their labour markets and robbed on the highways, decreed to them by ukase after ukase all the alluvial lands from the shores of the Mediterranean to the Roman Wall across Britain. The legionaries were impassioned truck-gardeners; they strengthened Rome and the traditions of their methods of gardening strengthen us still. There would have been no civilization today had not the descendants of the legionaries gone on truck-gardening and teaching our ancestors how to truck-garden through the Dark Ages . . . in Provence. In England after the Middle Ages thousands of agricultural labourers were displaced and sent starving and rioting by the populating of the fields by sheep for woolgrowing. They had to be given cottage-gardens or the state would have fallen. In America from the earliest days you have had in times of depression successive Federal or state laws, like the Homestead Act, giving free access to arable lands. In France the abolition of primogeniture continuously breaks up the great estates. In Switzerland it is the same. Russia, curiously enough, went to the extreme in nationalising the land and promoting mass farming. She has been forced to re-act in the direction of forming again a possessing, small-holding class. By a decree of March 1935, as I have said, every peasant working on the communal farms has been presented with a little over two

acres of ground and his farm house. . . . As his private property.

So, swing the pendulum how it will in the direction of vast, private, communally- or corporation-owned estates on which larger and always larger scale farming shall be practised, it swings always, inevitably back to the Small Producer, the quite small owner, working with his own hands and the aid of his family, meticulously, his own little plot. That the bonanza farm and its vastnesses should disappear is by no means inevitable if soil-erosion in the United States should be checked nor need we in the least wish for its disappearance. That is not our affair. The financiers and their industrially minded opponents must arrange that as best they may according to whatever *lex talionis* they please. The growing of wheat, sugar beets or other roots in small parcels is not an engrossing occupation. It may well be left to the mechanically minded; the raising of cattle in huge droves is a sport congenial, apparently, to certain large-lunged souls. May they prosper.

The only factor of our present situation that is certain to continue progressively is that of the improvement of the machine. That means the dispossessing of more and more millions of men. There is no avoiding that. It is as certain as death. We shut our eyes to both phenomena.

A second factor only not quite so certain is the progressive mental and physical deteriorating of our populations because of indoor, mechanised occupations and the consumption of inferior food. You can safely say that an immensely large proportion of our city and near-city populations never, between their cradles and their graves, taste meats or fruits unpreserved with deleterious chemicals or vegetables straight from the ground.

Both these factors, or either one of them must lead us to disaster. Federal or World action might reduce the hours of labour worked; local regulation might ensure the supply of fresh food to small communities here or there. But only the Estate of the Small Producer, a Fifth Estate holding in an iron grasp the balance of power, can

radically restore the face of the World to sanity and health. For that a change of heart is needed. . . . A change of ideals. No legislation can help us.

You cannot imagine a population each member of which works only an hour a day spending the whole rest of its time in the cinemas. Yet the only logical and moral end of the result of improvements in the Machine can only be either millionwise exterminations or a six-hour world working week. There is no third way. None.

But you can imagine a six-hour working-week population spending considerable time and regaining its mental and intellectual health growing string-beans, attending on milch-goats, moving hurdles for sheep among roots, weaving woollen stuffs, thinning out woodlands, carving bed-posts, painting frescoes in cinema-halls, felling timber . . . and having all its afternoons and evenings and most of the winter months for the movies, the theatres, the concert-halls, the churches, the night-clubs, the dancing-floors . . . for fox-hunting, for fishing, for field-sports, hitch-hiking, for distant travel. . . . Or even for the Arts.

To reach that Estate the change of heart is needed—a profound modification in our sense of the values of life.

A CHANGE IN VALUES

The till yesterday proud, machine-minded inhabitants of New York, London, Glasgow, Roubaix, Chicago, St Louis or Pittsburgh, Pa., have, as ideals of food, something out of a tin and of entertainment something partaken of in fetid crowds on one White Way or another. They would regard the programme of our Fifth Estate with dismay.

But the civilization that has thought out the aeroplane and its routes through the heavens—and I have no intention whatever of saying that the aeroplane and its manufacture should be discouraged—that civilization, then, should certainly be able to evolve local schemes of

rural enjoyment that shall be at once dignified, health-giving and engrossing. And there is no life more agreeable than to live semi-agriculturally employed at half an hour's distance from a lively urban centre with one or two really good restaurants, a good municipal opera, seven cinemas, a great concert-hall, a fine cathedral, a good museum and art gallery—and a civic pride in these things. That local rivalry we may well approve for it will give us the ideal life.

And that life, based on individual and intensive culture and craftsmanship, is singularly stable. It cannot be over-turned because of the exigencies of the financier. Through-out the Old World and here and there, as, in North New Jersey throughout the New, communities have gone on practising the intensive cultivation of the same plots of ground for hundreds—and indeed, as in China or Pro-vence, for thousands—of years. . . . In spite of panics, pestilences, war, conflagrations, revolutions. You will find them round Haarlem in Holland as round Tiflis, Samark-and to the East of Philadelphia, Pa.—and all the cities that lie between.

And, as I have already hinted, in America itself the tra-dition is older than that of the first coming of Raleigh. The Indians were by no means all nomadic. You had tribes enough with truck-gardening summer settlements to let the settlers come upon those agglomerations and burn them to the ground. And they were skilful enough, as we have seen, to teach the settlers how to grow things—and to improve on the non-indigenous fruits and animals that the settlers brought with them. They grew and improved one species of peach in the counties of Kent and Sussex, Del., to such an extent that it was a widespread belief that the so-called Indian peach—which came from Persia—was an indigenous tree. And not only did they soon excel the settlers in riding but they developed the admirable Chikawani horse and protected it from deterioration as jealously as do the Arabs with their barbs. . . . One of the world legends that I have always found fascinating

used to attach to certain septs of the Cherokees. It is that of the nomadic truck-gardeners. You will find traces of their fame in the territory of the Dalai Lama—in the legend of the peoples, incurably nomadic but as incurably addicted to fresh vegetables. These peoples travelled with good loam, leaf-soil, alluvial earths, composts, in sleds, in waggons, in pack-saddles. When they came to lands whose exposure seemed good to them, they would dig little trenches in the soil, pour in their good earth, make sowings or prick out their seedlings. In no time they would have crops that would provide them with green things during their stay and roots and fodder during the dead months. Then they would scoop their good soil up again and journey on till another spring found them in such lands as they sought. . . . But indeed, even today—or perhaps it was only yesterday—you had a whole population of migratory small tenant farmers who would travel even from the Virginia Tidewater and Alabama hundreds of miles to the northwest and back in the course of a lifetime —staying a year here, a year there but always moving on. . . . I can imagine no happier method of travelling. For travel we must.

For myself, I look forward to a day when, the automobile being as nearly extinct as is today the railway, men shall live in great or small but intensively cultivated areas. Once or twice a week men shall fly to the power centres, do their three-hour shifts, super-intending the actions or executing the repairs of the power-supplying machines . . . or their field work in the great grain centres and ranches. The rest of the time they will occupy with the agreeable and unhurried labour of their own soil or with their own benches, chisels, easels, fiddle-bows, lasts . . . and with whatever form of night life they shall find agreeable when the day is over. Occasionally even they will take a read in a book.

SITTING OVER THE SEA, THINKING

I don't write as a Communist— or that may possibly be reactionary. . . . I don't care. I write rather as a man who should go along a road and see some sheep over the hedge who were not doing well. . . . And I should go to the farmer and suggest his throwing a little sorghum-cake on the meadow morning and evening. The cake would help the grass in the meadow. . . . And so on. . . . Talking like that.

I will tell you a secret. . . . For years and years I have been cherishing that idea for a Utopia . . . that of units of population, rather small than big, who should live side by side as the churches do, and each have their own methods of being governed or governing. . . . But I have always been too shy to write it down. I am not an Economist or a Scientific Historian . . . or in the least inclined to interfere in the affairs of my kind. What I wrote would raise a howl . . . as what I am writing will, from the Economist, the Scientific Historian and the people who interfere professionally in world affairs. They will say I know nothing about it. But really it is they who know nothing about anything. They have never sat on rocks over the Mediterranean and thought . . . and felt. . . .

CONVICTIONS

Except for the conviction that nothing but a general return to the frame of mind of the craftsman and artist can save our great, ovally encamped race, I never had any political convictions. I have none now.

I am completely indifferent to forms of Governments and Constitutions appear to me to be things harmful when

they are not, like the Constitution that the great Locke
drew up for the Carolinas, merely imbecile, I *like* mon-
archies, as I like to look at primitive Italian Nativities. But
if the Russian Soviet really puts its trust in hammers and
sickles I would willingly say that I was for the U.S.S.R.
right or wrong and let it go at that. Since, putting its trust
in the monstrous collections of wheels that are the
Machine, it uses those tools merely as emblems on its
banner—as did the French Monarchy with the lily—I
don't say anything of the sort.

My own only profound conviction as far as sociology is
concerned is that Humanity will deteriorate further and
further until the sense of impersonal property diminishes
and dies in the human brain. And only education and the
sense of craftsmanship can effect that change.

Property is obviously a necessity for men and women.
But that Property must be only something that one has
made or grown or something that has been given you by
some other craftsman or grower—something, above all,
that can take into a private place apart and examine with
a long leisure. Such intimate things are necessities.
Purchases are only another form of robbery; you acquire
them by holding a coin instead of a knife at someone
else's throat. They are only yours until, you weakening,
some one else comes and holds at your throat another
coin. Even to-day few men would exchange a hoe that
they have made for themselves for one out of a depart-
ment store. The one lives in the hand, the other is dead
weight.

But impersonal property—above all the sense of, the
passion for, impersonal property—is the source of all
evil. If Mr Conqueror were not blinded by the dazzling
thought of controlling ten thousand miles away the pro-
ducts of mines he has never seen he would not march
murdering onto distant territories. We are dying because
men have done that.

One ought to see around one, or have in presses a few
yards away, all that one owns ... one's own hand-made

spade, chisel or paint-brushes, one's own home-made best suit in one's closet; one's own small flocks of sheep and geese; one's own frescoed wall; one's own melon-patch. Nothing more of one's own.

I think I can say—but I *can* say—that never since I was a child have I had a sense even of property of my own. Certainly I never had any sense of impersonal property. I was once left some brewery shares; but the brewery one day by accident mixed arsenic instead of sugar with its malt. So those shares disappeared and I was left with a sense of having some responsibility for quite a number of deaths.... Years ago, going into my own—my very own—kitchen in London at night after the cook had gone to bed, suddenly I was like someone struck dumb with amazement. It had occurred to me that I—and no one else—owned that prodigious array of copper stew-pans, basters, flour-dredgers, pastry-boards ... a perfect wilderness of things. Like an armoury!

They were my own. I could do what I liked with them. ... Hug them to my breast; throw them out of the window; decree that they should be melted down, have them all tied on a rope and drag them behind my Studebaker. And I burst into roars of laughter.

I had never thought about them before; or, if my subconsciousness had, it had imagined them belonging to the cook or anybody else. Just a sort of public property that happened to have floated into my kitchen. That was nice of it. Because, if you permit me to say so, my cook was a damn good cook, and she probably would not have been able to do without her apparatus.

And, when I came to think of it, that was my attitude towards every other room in the house—except the book-room and the drawer in which I kept my ties, collar studs and socks. If you had come in and asked me for the wash-hand stand or the dining-table I should have said: Take them. Or I should certainly have been ashamed of myself if I hadn't. Even with regard to the books it was not a sense of property. If you had wanted my books you could

have had them on condition that you took whole rows, not a volume here or there so that there would be gaps making the remaining books lean up the one against the other ... for in that case I should go on hitching and fitching for day until I had got other books to fill in the gaps.... And then I should go to some friendly carpenter and ask for some wood and knock a washing-stand or a table together somehow. I have indeed so often done that, one person and another having gone off with all I possessed, that I cannot any longer remember possessing anything.

I usually write in my home in Provence at an extra-ordinarily knocked-together table with flanking shelves of walnut bed-panels, supported by sawn-off chair-legs, and above me an immense deal shelf supported in turn by sawn-off broom-handles and nobody is more contented than I or prouder of his atelier. And when neighbours come in and I show them my contrivance they say: '*Tiens, mais vous avez du goût!*' as if it surprised them. ... And sometimes when I shut my eyes and think of my own personal Utopia I imagine myself in a whitewood hut on one of the harsh, bare, sunbaked hillsides of Provence ... with of course a great black cypress for shade. And nothing in it but a camp-bed and a table made out of a bullybeef case and a chair made out of two—and an earthenware casserole for boiling or frying and a camp-oven which I should build myself outside, for baking or roasting. That I think would be civilization.

I don't mean to say that I don't like to have accessible to me beautiful furniture and hangings, rare books, engravings, pictures, shaded lamps, lovely bowls of flowers. That is why I am doing my thinking now in Esherick's studio for he makes the most beautiful furniture with the most romantic-looking tools. ...* How I love tools!... And his wood-engravings are a delight to me who hate all other wood-engravings. Most wood-

* In the spring of 1935 Ford and Biala stayed with their friend Esherick outside Philadelphia, on their way to the South.

engravings have an unctuousness about their blacks that make me think I am eating fat pork. But Esherick's are clean and misted and mysterious and ascetic. . . .

And when I say 'accessible' I mean, not in museums, but scattered about a countryside, in friends' houses where you can drop in at any moment and be allowed to sit about. . . . As we are doing here! I once lived in a house that was all museum pieces—and owned them. But I did not own them long; they were insupportable.

I don't see how a gentleman can live in any other way. I know, of course, gentlemen who do. But it seems to me that the meaning of the idiomatic adjective 'gentle' implies a person living in harmony with his cosmos. How can you live in harmony with your cosmos if you can let people come into your house without its being implicit that they can take anything they want except your collar-studs, your books, and your tools? . . . And even them if they want them very much.

At any rate it seems to me that humanity would take an immense step forward if that could be the interpretation given to the adjective 'gentle' in every dictionary.

GOOD GOVERNMENT AND PEACE

A dim studio in which blocks of rare woods, carver's tools, medieval-looking carving gadgets, looms, printing-presses, rise up like ghosts in the twilight while the slow fire dies in the brands. . . . Such a studio built by the craftsman's own hands out of chunks of rock and great balks of timber, sinking back into the quiet woods on a quiet crag with, below its long windows, quiet fields parcelled out by the string-courses of hedges and running to a quietly rising horizon . . such a quiet spot is the best place to think in.

And let Esherick be moving noiselessly about in the shadows, with a plane and a piece of boxwood, or swinging backwards the lever of his press, printing off his

engravings. Or pouring, a hundred times, heavy oil and emery powder on one of the tables he has designed, and rubbing it off with cloths to get the polish exactly true, and bending down again and again to see the sheen of the light along the polished wood ... those are the conditions you need for thought. Because they present to your mind neither success nor failure, but conditions coeval with the standing rocks and the life of man. There have always been craftsmen and the craftsmen have always been the best men of their time because a handicraft goes at a pace commensurate with the thoughts in a man's head. The craftsman is a connoisseur; he looks along the wood that he has planed; the table-top he has made and polished; the shoe-sole he has just stitched; the back of the book he has just bound. Until it is just so and a little more, he is not content. His device is 'Make a good job of it' and scrawled with his broad-leaded pencil on the whitewash of his workshop wall are the words: 'By hammer and hand all Art doth stand.' So, if he turns his attention to other things it is ten to one he will exact good jobs from others. He will have good food cooked to a turn; good sound wine in a good-looking glass; well-woven cloth for his back; good feathers in a well-stuffed bed ... or maybe horse-hair. He will have good stout books that his mind can chew on; he will see that his cathedral climbs beautifully to heaven; that it gives him pleasure with its frescoes, good emotion with its music and good comfort with its doctrine. He will have done his travelling as a journeyman and have seen that the world is good; now he will sit by the fire to hear what wonders there are still doing in foreign climes and he will tell such a travelling fellow to bring him at his next coming such a tool from Toledo, such woollens from Bradford or such and such sweetmeats from Montélimar for his children. And above all he will have good government and peace.

THE GREATEST JOY...

In two and a half hours' time: 'Who the blank blank blank has dared to take my hoe?' I shall be saying, with a half-pound packet of dwarf, fast-growing peas in my gallon garden-hat. The day after the day after the day after tomorrow I shall see a line of untidy, brilliant green things pushing through this lilac-tinted soil above the tideless sea. There is no greater joy. Money for nothing. Think about it, Nordics.

...AND NOTHING ELSE

I am not, you understand, a pessimist: I don't want our civilization to pull through. I want a civilization of small men each labouring two small plots—his own ground and his own soul. Nothing else will serve my turn.

INDEX

Where a person's name and page references have been italicised, the references are to the editor's introduction and notes as distinct from Ford Madox Ford's writings.

Abbey, Edwin Austin, 85, 406
Academy, The, 282
Anderson, Sherwood, 21
Annunzio, Gabriele d', 203–4
Antheil, George, *20,* 355–6
Asquith, Herbert H., 23
Athenaeum, The, 55, 208, 221, 282
Atterbury, Mrs (F.M.F.'s nurse), 52–4
Austin, Alfred, 136, 265
Aveling, Dr Edward B., 139, 212
Aveling, Mrs E. B., *see* Marx, Elinor

Baldwin, 1st Earl, 345
Balfour, 1st Earl of, 225, 238
Baring, Maurice, 225, 226
Barnes, Djuna, 20
Barney, Nathalie, 365
Bathurst, Earl of, 397
Bax, Clifford, 327
Beach, Sylvia, 345
Bede, Ivan, 375
Belloc, Hilaire, *18,* 214, 225–8, 230
Belloc Lowndes, Mrs, 214
Benét, William Rose, *20,* 246
Bennett, Arnold, *18,* 221, 230, 240–1, 310–11, 312–13, 383
Berthelot, Philippe, 309, 312, 313
Biala, Janice, 21, 464
Bird, William, 357, 362, 365, 366, 367, 374, 375

Bismarck, Prince Otto von, 81, 140
Black, William, 107
Blackwood's, 279–80
Blast, 244, 246
Bogan, Louise, 21
Booth, Charles, 89–90, 140–1; *Life and Labour of the Poor in London,* 89–90
Borschitzky, 95–7
Bowen, Stella, 19
Brancusi, Constantin, *20,* 357, 361
Braque, Georges, 20
Bridges, Robert, 265
Browning, Robert, 32, 77, 87–8, 89, 112
Brummell, Beau, 112
Brzeska, Gaudier, 245, 330
Burne-Jones, Sir Edward, 37, 40–1, 58, 114
Burne-Jones, Lady, 40–1, 114
Butler, Samuel, 101, 208, 296; *Erewhon,* 101; *Way of All Flesh, The,* 101–2, 208, 296
B.V. (James Thomson), 87, 89
Byles, R. B., 222–3

Cannan, Gilbert, 237
Carlyle, Thomas, *17,* 32, 33, 34, 35, 64, 127
Cather, Willa, 21
Cato, 436–7
Chamberlain, Joseph, 135, 212
Chaplin, Charles, 417

Chesterton, G. K., 225, 226, 230
Clermont Tonnerre, Duchesse de, 365
Clifford, Mrs W. K., 181, 182, 183, 282
Clodd, Edward, 214
Conrad Joseph, *15*, *18*, *19*, *21*, *25*, *26*, *27*, 148, 149, 164, 165, 169, 172–6, 179, 181, 182, 187, 192, 194–6, 201–7 *passim*, 221, 223, 230, 234, 236, 244, 258, 260, 266, 269–89, 290–1, 301, 304, 329–30, 341, 357, 364, 398, 399, 400–1, 406, 407, 416, 418, 429; *Almayer's Folly*, 275, 400; *Chance*, 207, 270; *End of the Tether, The*, 279–81, 330; *Heart of Darkness*, 177; *Lord Jim*, 173; *Nigger of the Narcissus, The*, 274; *Nostromo*, 174, 286–7, 407; *Outcast of the Islands, An* 195; *Secret Agent, The*, 148, 285; *Romance* (in collaboration with F.M.F.), *27*, 149, 254, 275, 278, 281, 288, 407
Conrad, Mrs (Jessie), 278
'Conscientious Objector', the 353–5, 360, 362, 368–71
Cornhill Magazine, The, 229
Crane, Stephen, *18*, 135, 164, 165, 169, 175, 176, 177–81, 192–5, 196–7, 198–203, 204–7 *passim*, 254, 258, 259–60, 325, 418, 423; *Black Riders, The*, 202; *Open Boat, The*, 199, 201; *Red Badge of Courage, The*, 199, 201, 423
Crane, Mrs Stephen, 197–200 *passim*, 202
Crane, Walter, 147, 204
Crankshaw, Edward, 22

Crawford, Marion, 107
Crosland, T. W. H., 223–4
Cummings, E. E., *20*, *22*, 367
Cunninghame-Graham, Robert Bontine, 135, 210, 336
Cusins, Sir George and Lady, 90

Dahlberg, Edward, 22
Daily Graphic, The, 47
Daniel, Arnaut, 230, 360, 370
Darwin, Charles, 101, 208; *Origin of Species, The*, 208
Daudet, Alphonse, 128, 273
De la Mare, Walter, *18*, 421
De Quincey, Thomas, 338
Delcassé, Théophile, 283
Dickens, Charles, 42
Dilke, Sir Charles, 209
Dos Passos, John, 20
Dostoievsky, Feodor, 127, 162; *Poor Folk*, 162
Doughty, Charles: *Arabia Deserta*, 224, 229; *Dawn in Britain*, 224
Douglas, Lord Alfred, 223–4
Douglas, Norman, *18*, 379
Dowson, Ernest, 85
Dreiser, Theodore, 448
Duckworth (publishers), 222
D.Z., *see* Lewis, Wyndham

Edward VII, King, 192, 283–4
Edwardes, Thomas, 193
Eliot, George, 186–7
Eliot, T. S., *22*, 245
Engels, Friedrich, 448–9
English Review, The, *18*, *24*, *27*, 205, 220ff., 244, 303–4, 352, 379–80, 407
Epstein, Jacob, 239, 245, 337
Esherick, 464–6
E.T. (Jessie Chambers Wood), 380, 384, 386; *D. H. Lawrence, a Personal Record*, 380

Flaubert, Gustave, 127, 128, 131–2, 133, 174, 175, 185, 254–5, 273, 274, 303; *Madame Bovary*, 274

Fletcher, Mrs Clara, 55; Mr Clara, 55, 58

Flint, F. S., 330

Ford North, Lord Justice, 59, 60

Fortnightly Review, The, 246

Foster, Mrs, 361, 365

France, Anatole, 230, 304, 411

Freytag Loringhofen, Baroness Elsa von, 374–5

Frost, Robert, 245

Galsworthy, John, *15*, *16*, *18*, 172, 230, 234, 282, 305, 329, 391, 395–412; *Forsyte Saga, The*, *15*, *16*; *Joy*, 410; *Island Pharisees, The*, 408; *Man of Property, The*, 408, 409; *Silver Box, The*, 401, 409–10; *Villa Rubein*, 404, 408, 410

Galsworthy, Mrs John, 403, 405

Galsworthy, John, Senior, 399, 400

Garnett, Edward, 103, 149, 182, 195–6, 269, 272, 409

Garnett, Dr Richard, 86–7, 97, *101*, 105, 106, 182

Garnett family, 104–5, 106, 182

George V, King, 247–8

George, Henry: *Progress and Poverty*, 139

Gissing, George Robert, 383

Gladstone, W. E., 78–80

Gladstone, Mrs W. E., 79–80

Goethe, Johann Wolfgang von, 34, 35, 64

Goldring, Douglas: Last Pre-Raphaelite, The, 27

Goncourt, Edmond de, 128, 133

Gosse, Sir Edmund, 89, 174, 301, 304

Gray, Euphemia, *see* Ruskin, Mrs John

Greene, Graham, *17*, *22*, *26*

Gregory, Lady, 237–8, 239–40

Gressent, Professor, 427

Gris, Juan, 20

Hardy, Thomas, *18*, 102–7, 136, 174, 214, 221, 229, 230, 237, 357; *Jude the Obscure*, 105, 106–7, 136; *Sunday Morning Tragedy, A*, 229; *Tess of the D'Urbervilles*, 105, 136; *Trumpet Major, The*, 107

Hardy, Mrs Thomas, 105, 106

Harland, Henry, 85, 86; *Cardinal's Snuffbox, The*, 137

Harris, Frank, 414

Harte, Bret, 85, 124

Harvey, Prof. David Dow: Ford Madox Ford, 1873–1929, 26

Hauptmann, Gerhart, 230, 415

Hazlitt, William, 338, 339

H.D. (Mrs Richard Aldington), *20*, *22*, 330

Hemingway, Ernest, *20*, *22*, 367, 374, 375, 395

Henley, W. E., 85, 137, 274–5

Hitler, Adolf, *23*, 367

Hind, Charles Lewis, 174–5, 282

Howell, Charles Augustus, 40, 50–1, 85

Hudson, W. H., *18*, 133, 135, 169, 175, 176–7, 179, 193, 230, 290–300, 316–17, 418; *Far Away and Long Ago*, 299; *Green Mansions*, 295; *Nature in Downland*, 294

Hudson, Mrs W. H., 293–4, 298, 299–300

Hueffer, Dr Francis (F.M.F.'s father), *17*, 32, 42–3, 64, 65, 66, 68–75, 98, 121, 183, 185, 220, 301, 324

Hueffer, Mrs F. (Catherine, *née* Madox Brown, F.M.F.'s mother), 58, 61, 74–5, 100, 103, 124, 125, 148, 236, 324–5, 390

Hueffer, Christina (F.M.F.'s daughter), 215

Hueffer, Hermann (F.M.F.'s uncle), 427

Hueffer, Julia Kaufmann (F. M. F.'s great grandmother), 68, 69

Hueffer, Juliet (F.M.F.'s sister), 66, 104

Hueffer, Oliver (F.M.F.'s brother), 65, 66–7, 74, 352–3, 355, 363–4

Humphreys, Robert, 81, 82

Hunt, Violet, 17

Hunt, William Holman, *17*, 32, 33, 59, 60, 185

Illustrated London News, The, 206

Isherwood, Christopher, 22

James, Henry, *18*, 27, 83, 85, 86, 128, 133, 136, 137, 164, 169, 170–4, 176, 177, 178–9, 180, 181–90, 194–5, 204, 206, 221, 230, 236, 251–68, 282, 301, 303, 304, 315, 342, 401, 406, 415–6, 418; *Altar of the Dead, The,* 268; *Daisy Miller,* 257; *Great Good Place, The,* 255, 261, 268; *Guy Domville,* 83; *Jolly Corner,* 236; *Real Thing, The,* 257; *Sacred Fount, The,* 268; *What*

MaisieKnew, 252; *Wings of the Dove, The,* 261

Jo (F.M.F.'s manservant), 325, 328, 329, 332

Joyce, James, *20*, 102, 342–3, 345, 357, 358, 364; *Finnegans Wake, 20*; *Ulysses,* 102, 224

Kipling, Rudyard, 100–1, 107, 135, 136, 187, 188–90, 265, 448; 'Only a Subaltern', 100

Kipling, Mrs Rudyard, 187

Kirby, Charlotte, 44, 56, 58–63

Kropotkin, Prince Peter, 90, 137, 143–5, 190–1

Kropotkin, Princess, 190, 191

Lamb, Charles, 338–40

Latapie, Louis, 357

Lawrence, D. H., *13*, *18*, 379–394; *Fox The,* 385; *Odour of Chrysanthemums,* 379–81, 385; *Sons and Lovers,* 393; *Trespassers, The,* 393; *White Peacock, The,* 393

Lawrence, Mrs D. H. (Frieda), 394

Le Gallienne, Richard, 202

Léger, Fernand, 353

Leighton, Sir Frederick, 67, 116

Lewis, Wyndham ('Mr D.Z.'), *18*, 232–3, 244–5, 330, 379

Liszt, Franz, *17*, 64, 120–1, 124

Lloyd George, 1st Earl, *23*, 311, 385

Londonderry, Marchioness of 225, 283

Lowell, Robert, 21

Lucas, E. V., 338–40

Ludwig, Professor Richard, 26

Lynton, Mrs Lynn, 102, 103, 104

McAlmon, Robert, *20*, 374, 375

Maccoll, 208–9

MacLeish, Archibald, 22

Macleod, Fiona, *see* Sharp, William

McLure, S. S., 227

MacShane, Professor Frank: The Life and Work of Ford Madox Ford, 26

Madox, Tristram (F.M.F.'s great-uncle), 340

Madox Brown, Ford (F.M.F.'s grandfather), *16–17, 18*, 33, 36–49, 57, 59–60, 64, 65, 67, 68, 75, 82, 93–4, 95, 103, 111–8, 123, 173, 183, 185, 234, 276, 301, 324, 340, 387

Madox Brown, Mrs Ford (Emma, F.M.F.'s grandmother), 31, 32, 123

Madox Brown, Oliver (F.M.F.'s uncle), 89, 99

Madox Ford, Ford, Works: *Ancient Lights (Memories and Impressions* in U.S.A.), *17; Brown Owl, The*, 99, 103–6, 145; *Fifth Queen, The, 18; Good Soldier, The, 14, 246; Great Trade Route, 22; Heart of the Country, The, 154; It Was the Nightingale, 20, 26; Joseph Conrad: A Personal Remembrance, 19; March of Literature, 21; No Enemy, 26; Parade's End, 14, 20, 26; Provence, 22; Mightier than the Sword (Portraits from Life* in U.S.A.), *18–19; Return to Yesterday, 19; Saddest Story, The*, 246; *Thus to Revisit, 19;* in collaboration with Conrad: *Romance, 27*, 149, 254, 275, 278, 281, 288, 407

Mann, Tom, 144

Marrot, H. V.: *Life and Letters of John Galsworthy*, 409

Marryatt, Captain Frederick: *Midshipman Easy*, 283; *Peter Simple*, 284

Marshall, P. P., 37, 40

Marston, Philip, 88, 89

Martindale, Elsie, 17, 18

Marwood, Arthur, 223, 228–9, 232, 233, 234, 288, 304, 385–6, 391

Marx, Elinor, 139

Marx, Karl, 139, 448

Mason, Mrs, 75–6, 78

Masterman, C. F. G., 246, 247, 391

Maupassant, Guy de, *24*, 127, 175, 186, 254–6, 273, 274, 301–2, 399, 411, 412; *Bel Ami*, 302; *La Maison Tellier*, 301; *Une Vie*, 274, 302

Meredith, George, 107, 136, 174, 186, 221, 230, 236, 304; *Amazing Marriage, The*, 136; *Lord Ormont and His Aminta*, 136

Metchnikoff, Professor, 191–2

Metternich, Count, 235

Meynell, Alice, 394

Millais, John Everett, 42, 62, 315

Miller, Henry, 22

Mizener, Professor Arthur, 27

Monroe, Harriet, 331, 333

Moore, George, 221, 301–6, 395; *Ave Atque Vale*, 304–5; *Brook Kerith, The*, 305; *Drama in Muslin, A*, 303; *Esther Waters*, 301, 302, 303, 305; *Evelyn Innes*, 305; *Modern Lover, A*, 302

Moore, Marianne, 22

More, Sir Thomas: *Utopia*, 418–20

Morris, William, *17*, 37, 38, 48–9, 111, 113–7, 139, 147, 185, 212, 448–9
Morris, Mrs W. (Janey Burden), 115

Nevinson, H. W., 245
New Quarterly Review, 70
New York Herald, The, 141
New York Times, The, 357
Northcliffe, Lord, 224, 286, 330

O'Casey, Sean: *Juno and the Paycock*, 239
O'Neill, Maire, 238
O'Shaughnessy, Arthur, 57, 89

Pall Mall Gazette, 80
Patmore, Coventry, 77
Pease, Mrs, 196–7
Picasso, Pablo, *20*, 357, 358
Pillement, Georges, 367
Pinker, J. B., 199, 200, 204–7
Poetry, 331
Porter, *Katherine Anne*, *21*, *22*, *26*
Pound, Ezra, *18*, *20*, *22*, 86, 230–1, 233, 236–7, 244, 245, 330, 337, 353–4, 355–7, 358–61, 364, 367, 368, 370, 374, 375, 379, 384; 'Ballad of the Goodly Fere', 230; *XXX Cantos*, *22*
Pressly, Eugene, *26*
Proust, Marcel, 358–9
Punch, 90, 340

Quinn, John, 357, 358, 359–61, 365

Ralston, William Ralston Sheddon-, 122–4, 125–6, 130, 133

Ravachol (Koenigstein, F. A.), 137, 142, 143
Reid, Miss, 366, 367, 368
Reynolds, Stephen, 219, 379
Reynolds, Mrs T. B., 404, 406
Rossetti, Arthur (F.M.F.'s cousin), 65, 66, 67, 94, 145
Rossetti, Christina, *17*, 89
Rossetti, Dante Gabriel, *17*, *18*, 37, 39–40, 47, 48, 49, 50–1, 58, 59, 62, 63, 64, 70, 89, 95, 111, 185–6, 202, 203, 209, 230, 236; *The Blessed Damozel*, 203
Rossetti, Mrs D. G. (Lizzie, *née* Elizabeth Siddal), 58, 61–2
Rossetti, Mary, (F.M.F.'s cousin), 65, 66, 67, 94, 145
Rossetti, Olive (F.M.F.'s cousin), 65, 66, 67, 94, 145
Rossetti, William (F.M.F.'s uncle), 40, 73, 112–3, 114, 146, 185, 186–7, 221
Rossetti, Mrs W. (Lucy, *née* Madox Brown, F.M.F.'s aunt), 57, 65, 67, 94, 124, 145, 146
Rowley, Charles, 139, 143–4
Rudall, Mr, 119
Rudy, Mrs, 197, 199
Ruskin, John, *17*, 33, 40, 43–4, 50, 58, 59–60, 315; *Stones of Venice*, 40
Ruskin, Mrs J. (Euphemia Grey), 58
Rutherford, Mark, 383

Sargent, John Singer, 85
Sainte-Beuve, Charles Augustin de, 127, 128
Sand, George, 127
Satie, Eric, *20*
Saturday Review, The, 414
Schiller, Friedrich von, 34, 35, 64

Schopenhauer, Arthur, 69, 70, 98, 127

Shakespeare, William, 132, 206, 289, 406

Sharp, William (Fiona Macleod), 88

Shaw, George Bernard, 137, 146–7, 212, 239–40, 417, 418, 421; *Why I am an Anarchist*, 146, 147

Shelley, Percy Bysshe, 112, 195, 201, 260

Siddal, Elizabeth, *see* Rossetti, Mrs D. G.

Sizéranne, Robert de la, 84

Smith, Miss (F.M.F.'s secretary), 283–4

Soskice, Dr David, 234

Spectator, The, 221, 227

Spratt (Spratford), Meary, 149, 152, 154, 156–9

Spencer, Herbert, 102, 186–7

Standing, Mr, 331–2, 334–5

Stein, Gertrude, 20, 357, 365, 375

Stevenson, R. A. M. (Bob), 276

Stevenson, Robert Louis, 137, 203

Stillman, Mrs W. J. (Marie Spartali), 124

Strachey, St Loe, 227

Strindberg, Mme August, 237, 337

Swinburne, Algernon Charles, 17, 39, 40, 44, 58, 60–3, 75–8, 89, 136, 185, 186, 209, 230, 261, 265, 282, 304, 399

Synge, J. M., 101; *Playboy of the Western World, The*, 101–2, 207, 238, 239

Taft, President William Howard, 230

Tate, Allen, 21, 22, 239

Tennyson, Alfred Lord, 17, 56, 77, 87–8, 107, 265

Terry, Ellen, 238–9, 251, 267

Thackeray, William Makepeace, 36, 44, 123, 339; *Newcomes, The*, 36, 44, 45, 47, 48, 123

Thomas, Miss (F.M.F.'s secretary), 232, 236, 385

Times, The, 17, 18, 43, 69, 119, 330

Thomson, James ('B.V.'), 87, 89

Thrush, The, 246

Tillet, Ben, 144, 210

Tolstoy, Leo, 33, 127, 143, 411

Tomlinson, G. H., 379

Torch, The, 94, 145, 146, 148

Transatlantic Review, The, 20, 352–75

Trench, Herbert, 225

Tsara, Tristan, 20, 360

Turgenev, Ivan, 15, 17, 23, 122–34, 175, 176, 254–5, 273, 294, 401–6 *passim*, 411, 412; 'Byelshin Prairie', 273; 'Death of Tchertop Hanov', 134; *Fathers and Children*, 134, 294; 'House of Gentlefolk', 124; *Lear of the Steppes, The*, 132, 134; *Letters of a Sportsman*, 273; 'Singers, The', 124; *Sportsman's Sketches, A*, 123, 126, 130; 'Tchertop Hanov and Nedopyushkin', 124

Twain, Mark, 85

Tyrrell, Sir W., 310

Vaillant, Edouard Marie, 137, 142, 143

Viardot, Mme Pauline, 125, 127, 128, 131, 132, 133

Victoria, Queen, 42, 57, 58, 127, 151

Wagner, Richard, 42, 70, 98

Walker, Meary, 149–57

Walpole, Hugh, 22, 237; *Mr Perrin and Mr Trail*, 237

Ward, Mrs Humphry, 174, 182, 282

Warrender, Lady Maud, 171, 189, 190, 264

Warwick, Lady, 191–2

Waterton, Charles, 193

Watson, Marriott, 85, 137

Watts-Dunton, Theodore, 75–8, 89, 114, 136, 185, 186, 209, 282; *Aylwin*, 77

Warren, Robert Penn, 22

Watt, A. P., 205

Webb, Sidney and Beatrice, 417, 421

Wedmore, 85, 137

Wells, H. G., 13, 18, 24, 25, 170, 221, 225, 275–7, 383, 413–24; *Mr Britling Sees It Through*, 423; *Invisible Man, The*, 275; *Man From the North, A*, 221; *Sea Lady*, 418; *Tono-Bungay*, 230

Wells, Mrs H. G., 276, 374, 394

Welty, Eudora, 21

Westcott, Glenway, 20, 336

Whibley, Charles, 85, 137

'White Russian Colonel', the, 353–5, 356, 359–60, 362, 363, 367–8, 371

Whistler, James McNeill, 85, 406

White, Gilbert, 193

Wilde, Oscar, 38, 81–7, 137

Williams, William Carlos, 20, 22

Wilson, Edmund, 22

Wilson, 'Ragged Arse', 159–62, 165–6

Wood, Jessie Chambers, *see* E.T.

Wylie, Elinor, 20, 245, 246, 429

Yeats, W. B., 18, 88, 221, 230, 238; *Well of the Saints, The*, 238

Yellow Book, The, 84–6, 137

Zola, Emile, 17, 128, 133